For
With Lyon
much warmm regards

Chuck Egan

PROFESSIONAL PHOTOGRAPHER'S SURVIVAL GUIDE

BY CHARLES E. ROTKIN

AMPHOTO
American Photographic Book Publishing

Copyright © 1982 by Charles E. Rotkin

First published 1982 in New York by American Photographic Book Pub-
lishing, an imprint of Watson-Guptil Publications, a division of Billboard
Publications, Inc., 1515 Broadway, New York, N.Y. 10036

Library of Congress Cataloging in Publication Data

Rotkin, Charles E., 1916–
 Professional photographer's survival guide.

 Includes index.
 1. Photography, Commercial. 2. Photography—Business methods.
I. Title.
TR690.R67 1982 770'.23'2 82-13918
ISBN 0- 8174-5409-8
ISBN 0-8174-5410-1 (pbk.)

Manufactured in the United States of America

First Printing, 1982

1 2 3 4 5 6 7 8 9/87 86 85 84 83 82

PREFACE AND ACKNOWLEDGEMENTS

To distill a lifetime of my experience, and that of my friends and colleagues in photography, into one small book is not only a monumental task, but a near impossibility as well. Something is certain to be left out, someone will surely be misquoted, some will applaud and others may rise to anger or insult, however honorable my intentions. Yet I want to impart as much knowledge as I can to my readers about this marvelous, exciting, and sometimes perplexing method of communication called photography. I want them to enjoy it as much as I have.

Perhaps because I grew up in a working-class environment that, fortunately, included an appreciation of the arts, I have always been aware of the problems that artists (hereafter called photographers) have had in surviving. Because if they don't survive, how can they produce their body of work? I don't believe in the "starving artist" theory and prefer to think that a photographer can better practise his craft if he does not have to spend an inordinate amount of time just scrounging for the necessities of life.

In order to accomplish both objectives—art and survival—the photographer has to learn to act as an intelligent businessman. Can this be done? Let's put it this way—if it isn't, both are in trouble.

My two-term presidency of the ASMP and subsequent twelve years on the Board of Governors did not seem to do a lot for me professionally, as I frequently found myself in the dubious position of working on assignment with the very editors I often had to do battle with on questions involving the care, feeding and rights of the photographers. If nothing else, it was a learning experience.

So many years later, after the twentieth phone call from former Picture Editor of Audubon Magazine, friend and colleague Ann Guilfoyle, asking me how I would deal with Photographer X or Editor Y on various questions, plus calls from other purveyors and users of photography with similar questions, I began wondering just what the photographer did look like from the other side of the desk. More importantly, I thought about ways of developing a mutual working ground rather than a battle ground in the arena of photography.

Again it was Guilfoyle who not only talked me into doing this book, but assisted mightily in the preparation of its outline, and for this I offer her a very

special thanks. Two other editor-friends, Ed Gruson, former Editorial Director of the Continuing Medical Education Division of Academic Press, and Robert Rahtz, Editor-in-Chief of Macmillan's School Division, threw life preservers to me when I was drowning in a sea of verbiage, proving that the blue pencil is indeed mightier than the sword. Gruson would often make my day when I would discover a marginal note in the manuscript that simply said "yucch" and Rahtz would forcibly restrain me from wandering off course when recollecting some memorable kiting of an expense account.

My deep thanks is also reserved for all those who sat patiently for me while I interviewed them and who so graciously shared their feelings and philosophies about photography and their roles in it. I am especially touched by (and grateful to) Alfred Eisenstaedt and Gordon Parks, who not only took the time to tell me how they got started and survived in photography, but also how they "blew" their first assignments, survived, and lived (professionally) to tell the tale. There are others, such as David Eisendrath, Jr., who always had time for a phone call to come up with some useful and pertinent advice about a host of things.

Unlike the movie Oscar winners who usually credit their mothers, mothers-in-law, and agents with everything leading up to the Oscar award, I do want to thank my wife Adele for not only typing the first draft manuscript, much of it with a broken arm, but also for raging at my syntax that, like the symbol for infinity (∞), is often difficult to comprehend. And the many who I have not listed here who were responsive and caring. They know who they are, and they know my appreciation.

AUTHOR'S NOTE: On Sexism and the Photographer In Language

My well-thumbed thesaurus has no synonym for the word "photographer," and I refuse to use some of the terms bandied about, i.e., "shooter" (ugh); "camera bug" (we are not insects!); "lensmen" or "lenswomen" (terrible); or to adopt what some City Desk types might roar across the room: "Send out a camera!"

A writer who is also a good friend warned me before I wrote a single word of this book that I had to be careful of the his/her, he/she designations. I want to assure my readers that I have remained totally aware of this problem in the language, but I found no better solution than the traditional one. So I did not encumber this book by adding the feminine version of "he" or "him" in each sentence where it arose. To paraphrase a famous reporter, "I have seen the future (in writing) and it doesn't work."

So there are no he/shes, men/women or other dual designations in this book— for the same reason that we do not change the name of that round, iron cover that sits in the middle of every street in the nation.

I salute every photographer, male and female.

Charles E. Rotkin

CONTENTS

PREFACE AND
ACKNOWLEDGEMENTS
INTRODUCTION 6

CHAPTER 1
THE PROFESSIONAL
PHOTOGRAPHER
AND HIS MARKETS 8
INTERVIEW ALFRED EISENSTAEDT

CHAPTER 2
ANALYZING SPECIFIC
MARKETS: THE
EDITORIAL WORLD 31
INTERVIEW FRANCES McLAUGHLIN-GILL

CHAPTER 3
ANALYZING SPECIFIC
MARKETS:
COMMERCIAL AND
ADVERTISING
PHOTOGRAPHY 64
INTERVIEW PHILIP B. KUNHARDT, JR.

CHAPTER 4
BUILDING YOUR
PORTFOLIO: FIRST
CONTACTS AND
PRESENTATIONS 83
INTERVIEW EZRA STOLLER

CHAPTER 5
GETTING THE
ASSIGNMENT:
DETERMINING
FEES AND RATES 108
INTERVIEW ARNOLD NEWMAN

CHAPTER 6
ON ASSIGNMENT 138
INTERVIEW ARTHUR ROTHSTEIN

CHAPTER 7
FULFILLING THE
ASSIGNMENT 157
INTERVIEW CARL MYDANS

CHAPTER 8
AFTER THE
ASSIGNMENT 180
INTERVIEW JILL FREEDMAN

CHAPTER 9
SECONDARY USES OF
PHOTOGRAPHS 196
INTERVIEW EDDIE ADAMS

CHAPTER 10
YOUR LEGAL
RESPONSIBILITIES:
PROTECTING YOURSELF
AND YOUR CLIENT 219
INTERVIEW BERENICE ABBOTT

CHAPTER 11
BASIC OPERATING
NEEDS 243
INTERVIEW BEN FERNANDEZ

CHAPTER 12
CAPITALIZING
ON—AND
EXPANDING—
YOUR NEW
REPUTATION 260
INTERVIEW GORDON PARKS

INTERVIEW PHILIPPE HALSMAN

APPENDIX 290
GLOSSARY 314
INDEX 318

INTRODUCTION

What this book will do is tell you how to conduct yourself as a professional photographer. It will not tell you how to make a photograph. Presumably, you know that by now or you wouldn't be reading this. Nor are you going to be told how to develop a roll of film or make a print or a transparency. You should have mastered these skills by now. Making the picture is only the tip of the iceberg, and what lies beneath those cold waters determines whether you sink or swim. This book will tell you what is important after the photograph is made, as well as give you some insight about what to do before a camera is unlimbered.

The book you hold in your hands is a guide to survival in the complex field of professional photography. It concerns itself not only with getting you ready for a shooting or an assignment but with what happens to those pictures after the shutter is released. How do you market, store, retrieve, and perhaps resell them, time and time again? The following chapters will tell you how to protect not only your rights but your skin as well. This is a guide to getting a career launched as a professional photographer—and keeping it going.

A group of thirteen special interviews are interspersed between the chapters of this book. If you think you perceive an emphasis on interviews with "older" photographers and less time spent with younger ones, there is sound reason for it. This book is a manual for survival, so I am concerned with bringing you the thinking and experience of fine photographers who have indeed "survived," and managed to stay in business, leading full and productive lives over a long period of time. Accordingly, I have concentrated on talking more with photographers whose professional careers have extended far beyond the minimum of ten or fifteen years of activity that I feel are necessary for a photographer to be considered "established." This is not to minimize the work of younger photographers, some of whom have made sensational progress in two, three, or four years. But my concern is with those photographers who have consistently produced a fine body of work over the years, and who continue to function despite the ravages of time and age.

Too few photographers understand that professionalism is as important as ability. All of you who wish to follow in the footsteps of Henri Cartier-Bresson, David Douglas Duncan or W. Eugene Smith must remember that these photographic giants would never have achieved the success they did if they had not been thorough-going professionals in the first place.

In this book I am attempting to cover as many problems as possible that the new professional can face and give seasoned advice as to how you should deal with them. But what about the problems of the *picture buyer* or user in dealing with and respecting the needs of the photographer? How does the man or woman on the other side of the desk perceive *you*, the photographer?

A good part of the behavior of the picture buyer toward the photographer stems from his personal attitudes toward creativity, productivity, honesty and dependability. Not a little of this is based on the first contact with the photographer and how the latter's personality comes through. Not an inconsiderable

part of all these perceptions arises from the needs of the buyer and whether the photographer can supply them. If the editor is insecure and uncertain of the requirements of the picture request, these insecurities will be transmitted to the photographer. Thus, the editor may be dependent on the judgment and ability of the photographer, and if that judgment is lacking, both parties are in trouble. The editor's training will, in great measure, reflect on his dealing with the photographer, and that may be the critical factor as to whether a job is a success or a failure.

While gathering the material for this book, I spoke with as broad a spectrum of picture users, editors, researchers and art directors as I could reach, ranging from the managing editors of some of the great picture publications through associate editors, art directors, picture editors, researchers, educators, copywriters and creative directors of ad agencies. In each case, I asked for a brief rundown on their personal and photographic backgrounds and how they see the photographers they dealt with, what responses they received, and if they actually got what they wanted from photographers.

Years ago, when sound motion pictures began, there seemed to be a disproportionate number of Hungarian directors, so much so that it was rumored there was a sign in the director's lounge of one of the major studios that read: "It is not enough to be a Hungarian; one must have talent as well." Maybe true, maybe not, but we borrow from the principle and remember that it is not enough to be just a good photographer—one must have professionalism as well.

Even the term "professional photographer" is an ambiguity. Take a sampling of the 3,500 photographers in the American Society of Magazine Photographers (ASMP) or the more than 7,200 in the National Press Photographers Association (NPPA) and you will find that only a small number of them ever had formal photographic schooling. Doctors, lawyers and architects, among others, call themselves "professionals" and have degrees to prove it. But a degree is only one way of defining a professional. Others point to "a whole body of work" or use the measurement of being able to *sell* as a definition of what makes a professional. I tend to define it in two other ways, drawing perhaps a little from all the existing definitions. If you are being paid to make or sell a photograph, then do it in a way that will bring credit to you and your colleagues. If you can deliver what is asked of you on time, in a direct no-nonsense way, treat your colleagues and clients with respect, demand and receive the same respect from them, keep from tripping over your own ego or from getting caught up in phony romanticism or macho complexes, and still produce fine photography, then by my definition you are indeed a professional

Professionalism is not a label to be taken lightly. Nor is the word "artist." The old arguments about whether photography is art have long been trampled into the dust. Yet this wasn't always so. It took many years before photography was accorded art status. Even today there are skeptics who still want to consider photography a cold, mechanical science. Perhaps it is, in some highly technical fields of automated, computer-controlled photographs, but I consider photography a graphic art.

How does a professional photographer balance these extremes? Only by proving he can be at one time both artist and businessman. The terms are not mutually exclusive. Can the artist survive *without* being a businessman? Probably not—that is the real reason for this book. The photographers presented here are indeed both. Otherwise they could not have survived long enough in the marketplace to be able to make it to the top.

THE PROFESSIONAL PHOTOGRAPHER AND HIS MARKETS

WHAT IS A PROFESSIONAL PHOTOGRAPHER?

Let's define the professional photographer as one who is earning a living (or attempting to do so) by producing and, presumably, selling photography.

The images of the professional photographer vary widely: he may work in a small-town studio that supplies graduation, confirmation, bar mitzvah or wedding photographs, or in a highly complex studio, photographing fashion, food and other illustration. Or he may be an artist supplying sensitive and introspective portraits. This broad band of photographers also makes sophisticated, and in some cases highly complex, photographic forays into forensic science and micro-photography. There are probably one or perhaps even many classifications for each letter of the alphabet: *A* for architecture or art through *X* for Xerography, *Y* for youth, and *Z* for zoology. But whatever the classification, there are some basics that apply to all photographers: the need for a subject and the need for some (and I use the word *some* here advisedly) mastery of technique.

Photographs can be as varied as the locales in which they are made. They emanate from those same small-town studios or from high-fashion emporiums ringed by thousands of dollars' worth of expensive lighting gear and ten-speaker stereo systems. Pictures also flow out of the labs of photographers who take their photographs on the streets or on farms, in the fields or in forests, and in any geographic location from outer space to Outer Mongolia. Any place that a camera can be transported to and operated, whether by hand, by remote control or by robot, offers photographic possibilities. But an image is only an image until it is transferred to some reproducible medium and brought to the attention of the viewer or viewers.

What is the common denominator? It is the photographer. Much has been written about the multiple roles the photographer must play in order to function—teacher, counselor, chemist, seeing-eye dog, plumber, psychologist, stage manager, coffee runner, whatever—and perhaps much of this is true. The

photographer, after all, is bringing a variety of talent, skills, and approaches together toward one final goal—a goal that requires him to bring into play every sense or sensation available. In one way the specialists do have advantages—they can limit their coverage to one particular phase of photography. But most photographers are not so specialized. They are creative persons, and like creative persons everywhere, they tend to become restless and unhappy when they are too confined to one branch of the art. They yearn to go out and do something else or to enter a newer world, perhaps as a challenge or perhaps to relieve boredom or as a means of augmenting their income.

Cornell Capa, long-time photojournalist, ex-*Life* staffer and now executive director of the International Center for Photography, summed up the requirements of the photojournalist well when I asked him what the young photographer coming out of a school or a period of apprenticeship should have in the way of training. Capa said, "What will obviously make the difference between a successful and an unsuccessful photographer is the intellectual 'baggage' he brings with him. He should have a heightened sense of curiosity and be able to foresee and predict certain sequences of events. He should have the right equipment, preset and ready, so that when an event does occur, he is in the right position at the right time to take that sequence very quickly. I think the old-fashioned statement '$f/8$ and be there!' is true even today. The ability of the photographer to 'get in' to shoot is 99 percent of the battle and requires that he be 'trusted.' "

Trust is an intangible but very critical part of the photographer's "baggage," for unless the photographer can engender a feeling of trust within those he is photographing, it is highly likely that the pictures will fail. Capa spoke of photographer John Bryson, a former magazine editor and now a much sought-after photographer of theatrical personalities, who was permitted to photograph Katherine Hepburn only because Miss Hepburn trusted him. Capa related another incident where trust was vital in the relationship with a photographer and his subject. Famed *Life* photographer Gordon Parks was put in a similar situation when he had to photograph his own good friend Mohammed Ali. Parks was admitted to the dressing room after Ali had taken a particularly savage beating at the hands of Joe Frazier in the ring. But because Ali was his friend and trusted him, Parks did not photograph Ali's condition even though he knew this was the picture his editors were looking for. As Capa put it, "He knew what he didn't take! But this can also be good and bad, because as a truth-telling, hard-hitting photojournalist, he missed the picture. But in not making the picture he retained Ali's trust as a friend. The editors were impressed, as it turned out, not angry at all, and wrote a sensitive text piece about the situation. And it also ensured Parks's relationship with Ali for future pictures."

"The basic rule," said Capa, "is for the photographer to use intelligence and sensitivity as a primary part of his photographic skill. The photographer's ability to gain the confidence of his subjects is important. Unfortunately, he can also use his abilities the other way—he can betray a confidence and create all sorts of havoc in the name of news or of a feature story. Gaining people's confidence can be either a short-term or a long-term endeavor. Even if a photographer takes a long time to build people's confidence, he eventually will capitalize on it. But if he uses his position in a hit-and-run manner and betrays confidences or trusts, he will suffer from it. If he develops a hit-and-run reputation, it won't take long before everyone puts up a guard against him, and he will find many closed doors. Eventually," Capa said with some irony, "he will get the job his reputation has brought him, what he is known for."

WHAT ARE A PROFESSIONAL PHOTOGRAPHER'S QUALITIES?

What qualities are characteristic of a professional photographer? Here is what a number of noted photographers, and others, have had to say about the subject.

The late Phillipe Halsman, one of the finest photographers of all time, once said he felt that a photographer was essentially a voyeur. He didn't mean so much that the photographer is a "Peeping Tom" but merely that he or she is an intensely curious person. A picture book published in France at the time of the Paris Commune (1871) recorded the photographer as a "faithful witness." Susan Sontag in her book *On Photography* implies that photographers are people who seem to have been robbed of their past and thus become avid photographers so that they can "steal" (by the "taking" of an image) the very thing that they are photographing. Perhaps.

In my opinion, the photographer has all these qualities, plus a lot more, such as the ones Roy Stryker, former director of the Farm Security Administration (FSA) photographic project, has listed. He said that a photographer needs "rectangular eyeballs and horse blinders to frame and focus the vision of what is seen." Among some of the other attributes required, at least for the photojournalist or field photographer, are copper kidneys, a cast-iron stomach and legs and arms of steel to drag equipment and to climb ladders and stairs. The photographer cannot suffer from air sickness, vertigo, shyness, and probably needs a skin as tough as that of an armadillo or rhinocerous. But, most of all, the photographer needs sensitivity and visual awareness of what is around, whether the view is restricted to the four walls of a studio or to the openness of a vast urban complex or rural plain.

A photographer also needs to be unobtrusive. Dorothea Lange, the noted photographer of the FSA days, had an uncanny ability to blend with the background. The pictures she made were mute evidence of her intuitive ability to "get inside" a situation. Her craft was the highest example of the photographer's role in recording events rather than creating them, as so many photographers do by their very often intrusive presence. The photographer's mission is to capture and retain an image. The characteristic the photographer most needs to carry out this mission is a good ability to interpret the subject of that image. The interpretation is what makes the difference between a good and a bad photograph.

HOW MUCH DO YOU NEED TO KNOW IN ORDER TO HANDLE AN ASSIGNMENT?

In your rush to get work and your desire to accept every challenge each assignment brings, it is understandable if you say "yes" to everything, even if you have little or no experience in a particular area. Sometimes it is true, as we shall see later, that no expertise is necessary if there are other compensating factors. But your acceptance as a photographer by picture buyers, whether in the book, magazine or corporate fields, may well depend on the answer to the question "How much should the photographer know about the subject to be photographed?" Let's look at several situations and then you can draw some conclusions.

Must a photographer of industry understand the workings of a process, machine or end product in order to do a better job of visualization? Should he or

she know medicine or science when photographing doctors or scientists? Should the photographer be politically sophisticated in order to photograph a politician? Is it necessary to know in intimate detail the personality or the lifestyle of the person being portrayed? Or should the photographer operate by pure gut reaction to the subject, tempered perhaps by aesthetic considerations?

These are troublesome matters, and after more than thirty years of experience I still have mixed feelings about the answers. Is a little knowledge helpful or dangerous? One answer given is "Let the photographer learn." Really?

Yes, we all can learn. A friend of mine who teaches film-making at a well-known school was approached by a noted brain surgeon who asked that he be given a two-week crash course in film-making because of a film he wanted to produce. "Okay," my friend said, "but I won't charge you for the course if you'll swap me a two-week course in brain surgery. That's something I've always wanted to do."

Another instance in my experience came one day after lunch with the editor of a national magazine that had just run a story on mining in which the photographs were a mixed collection of good and bad. The credit line had been inadvertently omitted, so I asked who had made the pictures, and the editor mentioned a name I had never heard. "Why him?" I asked. "Did he have a background in this type of work?" "No," she replied, "but the editors wanted an 'arty' approach so we decided to give him the assignment on the basis of his portfolio."

Well, did their decision pay off? The photographs were both good and bad. The lead was the best, a photograph of a conveyor traveling over rugged terrain. A long "establishing shot" was acceptable in showing the general site and was well composed, but the underground pictures of the miners at work were a disaster. What happened?

The editor really did not seem to know, but I have certain hunches. Having worked underground in many different kinds of mines, I suspect that the problem was that the photographer, while basically skilled enough, knew form, color and composition—all essential components—but apparently he knew nothing about mining and was terrified of working underground. Perhaps he was confused by the darkness, noise, dirt and dust, so he literally "snapshot" his pictures and got out of there as fast as he could. Not that I really blame him. The first time I went underground to photograph I had the same reactions, and so have others who have been subjected to such stressful conditions. The temptation to rush through the take as fast as one can is understandable. This may be an extreme example of why a photographer should have an understanding of what it is he is photographing, but it is appropriate.

And one may ask, "How many times does a general photographer have to go into a coal mine or shoot a huge factory that makes three-level widgets? Is experience really important? Or should he simply have a sound knowledge of his craft and adapt to each situation as it arises?" In situations such as the one above, the answer is clear—plenty! The lives of others and himself may well depend on what he does, the lighting he uses, his way of dealing with the host of other problems that arise under miserable conditions, where nothing works because of dampness, impossible terrain, dust, extremes of temperature, etc. Technical problems begin to transcend the more creative and there probably is not much room for both attitudes underground in waist-deep water in a coal mine.

How about other, less physically demanding situations? Once one of the great European photographers, noted for his extraordinary photographs of people,

was invited here to photograph the legislature of a midwestern state. He made a great many excellent individual pictures, but the story was a failure. Why? He simply did not understand the American political system with its nuances and shadings. He missed the backroom deals, the cloakroom politicking, the wheeling and dealing, the highjinks and low comedy that are the hallmarks of such a session. He didn't understand these things, and his pictures showed it, so the story failed miserably.

Another time I was called upon to do a complicated semi-technical story on a medical research lab for a medical magazine. Should I have been an expert? On this story a good scientific background was most helpful because I understood the technical problems of photographing something as minute as a live mosquito and earlier experiences enabled me to cope with working in a highly controlled and sterile atmosphere. Thus I was able to relate well to scientists and technicians in the lab who were almost single-minded about their work. The assignment was successful, thanks to prior experience in this kind of situation.

There are times, however, when a lack of knowledge can be an asset. Gordon Parks was once handed a sports assignment to photograph a LaCrosse game on loan to *Sports Illustrated* from *Life*. And Gordon came back with a great set of pictures. As he turned in his story, he said to the editor, "What did you say the name of that game was?"

I mentioned this dichotomy to Melvin Van Peebles, a multi-talented writer, director and composer, who said, "Ah, but Parks brought with him his *own* sense of beauty and movement that transcended his knowledge of sports." Without such extraordinary qualities, I am afraid the photographer who knows little about his subject will not do the best job possible.

INSIDERS: EDWARD K. THOMPSON, ARNOLD DRAPKIN

There is always more for a photographer to learn. This may not seem readily apparent to someone who is starting out and presumably has his formal instruction behind him. But it was corroborated in a recent discussion I had with Edward K. Thompson, *Life* magazine's famous managing editor from 1949 to 1961 and the editor of *Life* from 1961 to 1967, who became editor and publisher of *Smithsonian* from 1970 to 1980.

I asked Thompson to appraise the current American photographer and to comment on what he sees or doesn't see. He stated, "What I don't see is the photographer who has learned basic skills beyond the casual use of the 35mm camera." He was equally concerned about the lack of photographers who can straighten up lines, who know their lighting and who in general are craftsmen. He misses photographers who know their trade. "It's like a musician learning the scales or a skater doing the 'school figures,'" he said. "Doing exercises is very boring, but you can then use the knowledge of them as a take-off point."

This attitude was underscored almost word-for-word by Arnold Drapkin, picture editor at *Time* magazine, who, when asked virtually the same questions, said, "One of the problems with the younger photographers today is that they have not learned their craft the way the old-timers did. There have been enormous technical advances, but the young kids think they can pick up a 35mm, load it with 400 ASA film and shoot available light. They do not know how to light a subject or how to use other equipment. The old-timers started out with a Speed Graphic with one holder and two pieces of film. They knew how to wait for that precise moment, or peak of action, and bring back the picture. Today's kids come in with motor drives, and they're taking movies.

12

But," he went on to say, "there are many exceptions; there are many good young photographers who really do know what they're doing.

"With the proliferation of the single-lens-reflex cameras, motors, fast film, etc., the vast majority think they have to know nothing more. It's very difficult to find someone who can photograph a painting on an 8×10, with color bars and gray scales, and not have it 'keystone' or have any reflections and produce a good, well-exposed photograph of a painting. It's akin to artists learning to draw first from plaster casts and then studying the great masters and composition. I often tell young photographers to put their cameras away for a while and go to the Metropolitan Museum of Art to study some of these masters to see how they composed and 'lit' their paintings."

Drapkin added, "They know nothing about perspective, color balance and color meters. There are also very few photographers who know, or bother to know, how to properly develop their own film. I still have photographers who prefer to develop and print their own work, good as our lab is. Too many photographers today simply do not have a good grounding in their craft."

I asked Drapkin how he accounted for the lack of basic photographic skills in the young and where the responsibility lay. He believes that it clearly lies with the schools. He said the schools should put a greater emphasis on the uses of the enormous number of tools available in the photo industry and the great varieties of film on hand, and he reemphasized the need to know how properly to develop and print both black-and-white and color. He added, "Professionals may not often get to do their own printing, but when they are out shooting, they will have a much better understanding of what it means to have to deliver a bad negative. When they produce bad negatives, it is usually because they don't know any better. The labs lose enormous amounts of time trying to salvage the images for printing. There is not enough grounding in basics in the schools and too much emphasis on 'creativity.'" Real creativity "comes from experience and good basic grounding in the craft. Creativity will come when the photographer can look at something and, instead of shooting it with a 35mm, will say, 'Gee, this ought to be shot with a 4×5.' Too many photographers use the 35mm for everything from sporting events to architecture," he continued. "Then they come in and show me a 35mm and tell me how it can be blown up to reproduce to full-page size. They cannot see that the 35mm they shot doesn't have good quality, wasn't filtered properly or was shot on the wrong kind of film. It's shocking!"

My next question was "Where is their thinking coming from?" I also cited a statement made by Elianne Laffont of Sygma Agency, who requires agency photographers to have a deep political awareness of world politics and the politics of the area in which they are working.

"The most important attribute a photographer can have is enthusiasm," Drapkin went on. "The people I respect and like the most as photographers are those who have enthusiasm for the task, and that statement does not restrict itself to the young photographers. There are some photographers on my staff who have been around here longer than I have and whose enthusiasm constantly amazes me. In every assignment you give them, they are really enthusiastic and come up with new ideas or new ways of doing it.

"Photography, like other graphic arts, goes through styles," Drapkin continued, "and while a style may have been created 20 or so years ago and may have gone out of vogue, it may now also be coming back. The photographer should know what's been photographed and how. He should not try to reinvent

the wheel but concentrate on producing superior photography the best and most innovative way he can."

Drapkin cited his own early training in the production of graphic-arts material and its relationship to photography, and he voiced his strong feelings about what a photographer should know about printing production. To quote him: "Young photographers, if they are going to be photojournalists, must understand that a beautiful original print is useless to us, even if it's the best print in the world, unless they understand how it will reproduce for our magazine's 4½ million subscribers. They must know how to print (or how their negatives will print) for our kind of reproduction. They must realize that a print made for salon purposes is very different from a print made for halftone engraving." He also reminded us that the need for the best printing possible is not restricted to black-and-white and that color pictures made for projection are not going to print as brilliantly as on an opaque press. "When we did a piece on Ansel Adams," he continued, "it was Adams himself, one of the greatest printers in contemporary photography, who wanted to know exactly what kind of process we were going to use in the reproduction of his work. He then printed his pictures so that they would receive the maximum quality our process could provide."

Drapkin closed his remarks by saying that the best photographers get that way because they are the best businessmen. "Unless the business side of their lives parallels their creative, they cannot last long enough to achieve greatness," he said.

CHOOSING A DIRECTION

Making the leap from amateur to professional photography, while seemingly a simple and evolutionary step, is actually quite complex and often happens before the photographer is truly ready for it. Sometimes the photographer gets into it by sheer drive which starts at the soles of the feet and grows into a burning desire in his lifestyle until it becomes an all-consuming way of life.

When one compares the number of amateur photographers to the number of professionals it seems unlikely that professional photography could have been the first, and only, choice of working pros. Often they began in other ways— with an interest in art and graphic expression and a dexterity in using the camera as a tool of visual communication. Schools began teaching advanced courses in photography, some good, some poor, but all combined to fuel a new and continuing interest in photography as a profession. And, of course, sheer happenstance was sometimes the deciding factor.

Serious photography can begin in many ways. There has always been a certain amount of glamour and romance associated with the dashing correspondent, whether it was Roger Fenton (the first war correspondent in the Crimean War) or modern-day Douglas Duncans or Robert Capas, who carried the torch of tradition. Artists for years have used photography to make photographic notes of what they want to paint and draw, and some have gone on to become first-rate photographers. The late great American artist Ben Shahn was gifted as both a photographer and an artist. In recent years there has been and perhaps still is a great mystique about carrying a camera under the arm, à la Henri Cartier-Bresson, though it is no longer a five-dollar box Brownie but a sophisticated 35mm SLR along with a collection of expensive lenses.

The omnipresence of the large picture magazines, *Life* and *Look*, and the

growing use of editorial photography by middle-sized publications and books, certainly the rise of "girlie" magazines, all contributed to the mystique of the camera and what it could produce. And when some lucky amateur shot a fast-breaking news item and made a lot of money with it, the rumors of the heaps of money paid for these pictures stimulated hundreds of others to try to find markets for the pictures they took or wanted to take. Even today there is always the glamour of the big buck for a newsbreak photo. The tragic shooting of singer/composer John Lennon was a bizarre coincidence for an amateur photographer who took a picture of the accused murderer while Lennon autographed his record album. This coincidence thrust the photographer, Paul Goresh, into the limelight and accorded him television interviews and a rumored $10,000 for the first-rights sale to a local newspaper and much more for syndication rights.

Today, with the proliferation of almost foolproof automated cameras, a growing number of people are becoming entranced with the subject of photography without having any basic technical knowhow, and, it would seem, the necessity of technique is decreasing as automatic capability increases.

The World War II babies who came of age in the 1960s became fascinated with the 35mm camera as a means of recording the human condition, influenced by their predecessors who used the camera as an instrument to document serious aspects of life, social injustice and anything else that was "real" to them and photographable. Many stayed with the medium and developed into fine amateur photographers. It is what they have to do to support their interest that usually sparks the jump from amateur to professional status.

There are other circumstances, some of them odd indeed. In the advertising world there seems to be a constant parade of art directors turning photographer. Having been an art director is certainly a plus, as they understand the basics of composition and other factors involved in the production of acceptable photographs, and knowing fellow ADs doesn't hurt either.

Then there are the engineers and technical people who have to document problems in their own fields. They learn to make pictures of broken parts or factories in remote areas and ask themselves, "Why can't I sell these pictures to *Business Week* or *Fortune*?" I know, too, of reverse situations where companies and publications have thrust cameras into the hands of their field people and made photographers out of them.

But whether by design or accident, the desire to become a professional photographer *can* be strong, and with it comes the problem of developing a marketing strategy.

If commercial photography seems and indeed may be a lot less glamorous than photojournalism, there is no less a standard for quality and professionalism. A still life of a ketchup bottle or a local fashion spread should be produced as competently as a portrait of a company president or a picture of a roaring fire in an oil refinery.

But perhaps glamorous is the wrong expression to use because it is so overworked in photography—we speak of glamorous women, glamorous locations and glamorous personalities. Photography can be a profitable means of self-expression and personal fulfillment even without glamour. The creation of a fine portrait or a first-rate (and visually interesting) industrial photograph or the taking of an exciting photo of an incident that might be parlayed into a news event or be used ultimately in some educational medium—all of these are daily grist for the mill of the commercial photographer.

How does the work of the studio photographer differ from that of the photo-

journalist? Both must deal with many of the same technical problems, but the photojournalist's main function is often at an end when the last roll of film is turned in to the darkroom and the last caption is written.

The photojournalist's mission is, thus, more direct—to record visually something that has actually happened. Much of his success depends on split-second timing or an instinctive interpretation of what may happen to a mood or a situation. Sometimes, in hard-news situations, photographs of the same event are taken by clusters of photographers standing shoulder to shoulder, using virtually identical equipment, turning out pictures that are exactly the same. Or are they? A hairline move to the left or right, a split-second difference in timing, the blink of an eye, the twist of a mouth or the movement of a hand—all result in a different image. Photojournalism, in its purest sense, is truth.

By and large the photojournalist is apt to be nonstaff. Today the bulk of the membership of the ASMP tends to be made up of free lancers or small-studio-based operators. It isn't that the staffers have refused to join the society; it is simply that there aren't that many staffers around. The old *Life* magazine had a regular staff of about 35 photographers, many of whom were already in the Newspaper Guild, with almost double that number either under contract or working as stringers or in other forms of employment. Today the new *Life* has two picture editors and no staffers. *Look* is gone, after an abortive attempt at resurrection, and so are many other magazines. Specialized magazines and books have proliferated, but their publishers, too, rarely use staff people. They occasionally assign free-lance photographers or work with agencies. And while there are still a handful of staffers or contract photographers associated with various other national magazines, the numbers have diminished.

The membership of the National Press Photographers Association (NPPA) is, on the other hand, mostly staff, particularly from the smaller papers, which use one or two photographers. Happily this is a growing rather than a declining market.

Photojournalists, unlike studio owners, need not possess darkroom space, though in many cases they do. But if budding photojournalists expect to tap the resale market, they should have some sort of accessible storage and retrieval system or they should work out a deal with a stock agency so that their pictures do not become moldy in their files, unloved and unwanted.

Photojournalists and fixed-base commercial photographers differ also in the markets they serve. The local commercial photographer tends to draw from the community, and his task can be as exciting or as dull as the photographer makes it. The photojournalist must travel when an assignment is received. No, photojournalists do not have routine jobs—but neither do they have routine incomes. The local commercial photographer, furthermore, has an almost built-in repeat business, whereas the photojournalist does not.

Both photojournalism and local commercial photography have compensations and pitfalls, and often the fields overlap. As for capital investment, while there are differences there are also similarities. Field cameras and equipment may be infinitely more expensive, fragile and complex for the photojournalist, but the fixed-base operator has overhead expenses and other costs not dealt with by the journalist.

My point here is the direction the new photographer will take—to settle into the comfortable routine of working in the community and building a reliable business or to answer the call of adventure and risk that photojournalism promises. This is a decision I cannot make for you, but this book will try to help in whatever direction you take.

DEVELOPING A MARKET STRATEGY: HOW TO SELECT YOUR MARKET AND/OR AUDIENCE

Advising the new professional on how to single out his markets is tough because there are no two photographers who think or work alike; just as in every other form of the arts, interests vary widely. It would seem that basic likes and dislikes are the keys to what a new photographer should specialize in. But beyond the knowledge that you are interested and have some competence in photography, now is the time to sit down and take an introspective look and ask yourself, "What do I really *want* to photograph? Can I make a living from it, and if I can make a living from it, will I *enjoy* myself?"

I really believe deep thinking is required here, some research, and if you are young, capable, and just coming out into the world of self-sufficiency, a little outside advice might be useful. It doesn't have to be very profound or for that matter expensive. College advisors or professors can be a starting point. If you have come out of a photographic school, talk with your instructors and even with your fellow students.

What *excites* you in the way of photography? Think about it a bit and forget the so-called glamour, high pay or other fancied benefits. Are you really an observer of what is happening around you? Do you really care? Do politics, news and community affairs hold a fascination for you? Then perhaps photo-journalism is the way you should go. Or are you more interested in lifestyles, food, fashion? If so, then perhaps the journalism route is not for you and you should investigate the studio world. Your interests are the best way to determine an area of specialization. One of the best architectural photographers in the country actually trained as an architect. However, another trained architect became one of the leading photographers of nature, flora and fauna. There are no hard rules and I can only suggest that you be excited, love what you're doing, and you'll bring drama to your photographs. If you look at photography as just a way of earning of living, you may well do that, but it's going to be pretty dull potatoes (and so will your pictures). It is quite important for you not only to be deeply interested in your specialty but to know something about it, though there are those who debate this philosophy.

Give some serious thought to the bare requirements of making a living, but try also to come to a conclusion about the kind of photography that not only will provide a living but will also be enjoyable and emotionally satisfying. Make no mistake—happiness in photography is more than a good checkbook balance and a fast f-stop. If you cannot imagine professional photography as a way of life that is emotionally satisfying, try something else.

WHO WILL BE INTERESTED IN SEEING YOUR WORK?

Those who are simply interested in *seeing* your work should not be written off as a nonproductive audience. Often those who may have no reason to buy a picture may be sufficiently impressed with what they see to recommend purchase by someone else. So that brings up the questions of whom to reach and how.

Those around you are often those who are most immediately interested— your family, friends and associates—because it will be their encouragement (or even negativity!) that may spark you to higher aspirations. When you make pictures of family events, school activities or local community and political happenings, don't hesitate to send some of these people prints or even spare

transparencies—and for free! A print sent out of sheer courtesy may bring back a wealth of friendship later that could be translated into working dollars.

But learn your lessons early. Even at first crack, protect your pictures! It may seem pompous and officious for a young photographer to start putting copyright notices on the free pictures he or she sends out to friends, but it is important to do so.

Who else will want to see your pictures? Show them outside the immediate circle of your personal life. Show them to your local community leaders, politicians, office holders—they might very well be interested in the subject matter, and while they may not buy any of them, they will remember you. As for remembrance, well, that too is an important factor. It is part of establishing a professional identity.

Join local camera clubs. True, you may run into a lot of competition among other members, some of whom will be trying to carve out their own niches, but at least you will be in touch with those around you who will share common interests. Most camera clubs have exhibition programs, critiques, talks and slide shows. All of this will add to your potential of seeing and being seen.

If you go on a trip and do a lot of shooting, it is probably easy enough to arrange free slide shows in your community at churches, recreation centers, senior citizen homes. Exposure of this type is worth pursuing in the beginning of your career.

All of the above activities are directed at what I would call a nonrevenue-producing audience. Do you need it? Emphatically *yes*! A number of prominent photographers would agree. One of them, probably among the most famous in the world, has for years exhibited his photographs free, or at most charged a small door fee to cover the cost of hall rental. His interest is in increasing his exposure as a photographer.

WHO WILL BE INTERESTED IN BUYING YOUR WORK?

This is the moment of the quantum leap: the day you really consider yourself *a professional* and try to make some money at photography. This could be the day you graduate from a journalism school or the day you decide you are bored with what you are doing and are going to devote yourself more to professional photography.

If you have attended a photography school with a view toward opening a local business in portraits, weddings, school or other community photography, then the next step is to go out and find a studio to work from—or perhaps you might choose to buy into an existing business and hang out your shingle. With a reasonable amount of effort and promotion the work should come to you.

However, if you are interested in free lancing or in a studio operation devoted to either editorial or commercial work, then you have to track down your own market rather than wait for it to come beating on your door.

In order to find a buyer for your work, you must first decide what you are going to sell in the way of photography—journalism, fashion, food, still lifes, hard news, architecture, or industrials? Now is the time for you to start zeroing in on appropriate market areas. After determining a market area, you next must address yourself to finding the right people to approach in that area. In the editorial world there are editors, picture editors, designers, art directors, layout and makeup people and assistants of all kinds; promotion directors, advertising managers and advertising agencies for the publication; public relations directors and public relations agencies. All of these people and organizations and more have an *interest* in buying photography, but the authority to buy

18

may be vested in someone else. You have to determine who the right person is in each area, and contact that person.

When we get into the world of advertising, it's a whole new ball game. Here you will come up against account executives, media buyers, group heads, art directors, promotion and display art directors and market researchers, just to name a few of the people and titles concerned with buying pictures.

Then consider those in the corporate area: chief executive officers (CEOs), corporate presidents, vice presidents—sometimes not just one or two, but often groups of them may be assigned to some particular endeavor that involves photography. There is also the secretary and/or the treasurer of a corporation. Not interested, you might think? Don't you believe it! These may very well be the people who are responsible for the production of the annual report, stock offering literature and product promotion. Below this in pecking order lie the public relations people, the house advertising managers and inside copy writers and their various production and promotion people, including, in some larger organizations, complete photographic and printing departments.

And after shaking your head a few times to clear the confusion, you start down Publishers Row to run into a heap of new titles in the book-publishing world on the lobby directory board. You will find the usual listings of presidents and corporate officers, but you will also see wondrous titles such as rights and permissions, fiction and nonfiction, sales managers, editors and editors-in-chief, department editors, division editors, publicity, vice presidents in charge of customer relations, picture editors (photo), picture editors (art) and art editors for pictures.

But it doesn't stop there. In the fine arts field you will find curators, museum directors, gallery owners both private and public, acquisitionists, designers, cataloguers and even contributors and sponsors of collections.

This overview only begins to scratch the surface of those interested in buying photography. There are also the complete fields of audio-visual multimedia for both educational and commercial applications; there are interior decorators who purchase photographs for private residences and corporate adornment. Many printers and graphic specialists also buy photography for client use, as do travel organizations that publish their own brochures, guidebooks, etc. There are gift and display manufacturers who make posters and postcards and reproduce photographs for wall decoration in homes and public buildings and limited public places such as hotel rooms. The outlets are enormous and the photographer must make basic choices about what direction he will take at first.

You should try to sell your photos in the medium that can best use them. Now is the time to identify those markets that should be interested in buying.

PUBLICATIONS THAT CAN HELP YOU CHOOSE PAYING MARKETS

There are a growing number of publications that purport to be accurate market listings telling where to sell your photographs, quoting the names of the publications, their addresses and the prices they pay (or in many cases the prices they don't pay!). Some of these publications are reliable and try to be as truthful as possible, but others unfortunately do little more than pick up other publications' listings and imitate much of the same information. When using or buying *any* reference book, pay particular attention to both the original dates of publi-

cation and the current copyright dates, or you might be misled about what is current and what isn't.

There are only about a dozen basic information guides covering important aspects of photographic marketing, and while they can be found in libraries, I am also listing the publishers and current costs for those who wish to buy any of them outright. Included are reference works of value in certain specialty areas, though much of this information exists in the primary publications listed.

GENERAL PUBLICATION DIRECTORIES (BOOKS AND MAGAZINES)

There are two important publications here, both published by the R.R. Bowker Company, 1180 Avenue of the Americas, New York, NY 10036. Bowker is the major producer of many reference works in the publishing world. You should be aware of the many services this unusual company offers in the way of research materials on all aspects of publishing, but for the moment let us concentrate on:

Literary Market Place (LMP) (approximately $30 postpaid), and
Magazine Industry Market Place (MMP) (approximately $25 postpaid).

LMP is the "bible" of the publishing industry and carries detailed listings of every book publishing house in the country, as well as many magazine and periodical publishers. (It also publishes a world-wide foreign edition.) Here you will find the names, addresses and telephone numbers of everyone in an important capacity in publishing and ancillary services such as printing, binding, mailing lists, government agencies, literary agents, editorial and research services, etc. Publications are classified by specialty, from textbooks and trade books to encyclopedias.

MMP, its companion volume, deals with much the same field as *LMP* but concentrates on the magazine-publishing industry. There is some overlapping of the two editions because many companies and personnel operate in both the book and magazine worlds.

NEWSPAPER DIRECTORIES

In the newspaper field there are several volumes, some of which are enormous, but they are important because they identify in great detail most of the key people in newspaper publishing. They are highly specialized and it is doubtful they will be of enough use to the young professional to be worth the expenditure of large sums of money. They are listed here, however, so that you are aware of this source material. The most prominent are:

N.W. Ayer Guide To Periodical Publishing. Ayer Press, BalaCynwyd Ave., BalaCynwyd, PA 19004. $62 plus postage.
Editor and Publisher Market Guide. Editor and Publisher Publishing Co., 575 Lexington Ave., New York, NY 10022. $30.
Ulrich's International Periodicals Directory. Bowker (address above). $64.50.
The Working Press of The Nation. National Research Bureau, 424 N. Third St., Burlington, LA 52801. Published in 5 separate volumes according to specialty—Newspapers, Magazines, TV & Radio, Feature Writers, Photographers and Internal Publications. All five editions are $71 each and the last, vol. 5, was formerly called the *Gebbie Press Directory of House Magazines.*

CORPORATE AND ADVERTISING DIRECTORIES

There are all sorts of listings of corporations throughout the United States, but viable markets for new photographers are in the companies large enough to

advertise their products or services. The best of the publications listing this level of company is:

The Standard Directory of Advertisers, National Register Publishing Company, 5201 Old Orchard Road, Skokie, IL 60077. $100 per copy.

This is a most useful volume, published in two editions, one organized alphabetically by specialty or industry, and the other geographically by states. The latter is more useful because it gives the photographer information on markets in specific regions, enabling him to line up assignments on his home ground or to pick a group of companies to contact before a trip to a different area. It includes the names of the companies' advertising agencies and often identifies the account executive (AE) who handles their work. Useful, also, is the media breakdown of where a given company spends its money—newspapers, radio, television, magazines, trade magazines, etc. This is important because there should be an awareness of what media the company uses. Paired with this publication is:

The Standard Directory of Advertising Agencies (also National Register Publishing Company, listed above). Better known as the *Red Book* or the *Agency List*, usually appears three times a year. Annual price is $107, with single copies available at $47 each.

For those wanting to do advertising photography the *Red Book* is invaluable. Starting with an alphabetical listing of every advertising agency in the United States, it goes on to provide not only the names, addresses and telephone numbers of their key personnel but also lists the clients the agencies serve. This is helpful when a photographer is in contact with a particular agency on one account, as it is often easy enough to find out what other clients work with the same agency, and perhaps the photographer can make a pitch to these other clients as well.

Agency listings can be confusing, however, especially with the larger agencies. Sometimes there will be literally column after column of account supervisors, TV and art directors, group vice presidents, media buyers and all sorts of other people who may or may not be interested in purchasing still photography. Frequently, as in the corporate directory, these listings also give some breakdowns of where the money is being spent in the media. You can then make a judgment about whether a particular account is worth pursuing. For example, there isn't much of a market for still photography in an agency concentrating on radio and television advertising.

PUBLIC RELATIONS DIRECTORIES
While most major corporations have their own internal public relations departments, a large segment of the industry uses the services of outside public relations companies or consultants not only for annual report production, but for other media programs as well. Often there is a corporate director of public relations to whom the outside house is responsible. The public relations company will try to place material in the media, and this requires a lot of expertise not only in its preparation but in its media positioning as well. The history of public relations has had many examples of how "news" was created rather than reported.

Since the main purpose of public relations is to bring a message to the public, and because advertising in its way has many of the same goals, I think it is time to say that they are, nonetheless, *different*. Unfortunately, even some diction-

aries' definitions are remarkably vague, and in some cases lump public relations in with advertising and vice-versa, adding to the general confusion about the dissimilarities of these areas.

The outside public relations house is often deeply concerned with photography, whether it is for a simple product photo or a deep, well-thought-out and well-produced photographic essay strategically placed in a major magazine. Public relations work doesn't always go to such lengths; sometimes simple one-shot pictures are used with news releases. Public relations photos need not be of a product or service necessarily; picture needs in this area can extend to publicity photos for some new book or author, entertainer or politician. Or, as mentioned earlier, entire corporate programs of public information can be conceived, arranged and executed by a public relations staff.

I feel that the public relations market is a strong one for the new photographer and as much attention should be paid to it as to the markets for hard news, advertising or any other form of photography. This field also has some important journals, and they should be studied closely as a source of contacts. Directories that should be of interest are:

The Public Relations Register. Public Relations Society of America, 845 Third Ave., New York, NY 10022. This is the membership list of the Public Relations Society of America, a trade organization made up of active public relations people. It is also broken down into geographic and organizational listings. As it is a membership organization, the list becomes part of the membership dues package, though it can be ordered by nonmembers at $15 annually. Most public relations agencies have people who are members, or the agencies themselves have membership accounts, so it should not be too difficult to find someone who will lend you a copy or might even give you last year's.

O'Dwyer's Directory of Public Relations Firms, J.R. O'Dwyer Co., 271 Madison Avenue, New York, NY 10016. $35 annually.

O'Dwyer's Directory of Corporate Communications (same publisher as above). $60 annually. These two volumes list individual companies in the public relations world and their staffs as well and breaks down the activities of the 2,000 companies and over 300 trade associations. Both are generally available in libraries, and it might be wise to study them before considering purchase.

GRAPHIC DESIGNERS AND ART DIRECTORS DIRECTORIES

Graphic designers, industrial designers and art directors, be they in editorial or advertising, are important markets. All have membership organizations and publish annual rosters. The Art Directors Club membership is limited to art directors working in the field, but the AIGA (American Institute of Graphic Arts, 1059 Third Avenue, New York, NY 10021) does welcome membership by photographers as well as art directors. Current dues are $100 annually for New York City area residents, and $50 for nonresidents. Membership could be useful, as part of the membership package is the annual roster of 2,000 members of the AIGA, most of whom work in the graphic arts field. They might be valuable contacts for photographers. Both organizations publish annuals and other lists, but it may be that a friendly contact with a member of either group could result in the opportunity to borrow the lists.

MISCELLANEOUS ADDITIONAL DIRECTORIES

There are many other books that would certainly be of interest to the professional, but not all of them are necessarily up-to-date and many have material already incorporated in the publications mentioned earlier. Some are listed here as there may be photographers interested in the specialized areas these publications cover:

Audio Visual Market Place, Bowker (address above). $29.95.

Photographer's Market, Writer's Digest Book, 9933 Alliance Road, Cincinnati, OH 45242. $14.95.

Photography Market Place, Bowker. $16.50.

Consumer Magazine and Farm Publications, Standard Rate and Data, same address as National Register Publishing Co. (above). $45.

Business Publications, Standard Rate and Data. $45.

This listing has been deliberately limited because many of the available lists of markets are duplicative, and the photographer may have difficulty trying to figure out which to buy and which to pass up. It is much wiser for the photographer to carefully go over the major publications recommended, study the works in a library or borrow copies when possible, make detailed notes of other source material, and after reviewing the whole market, possibly make a few carefully chosen purchases of the books that will serve best.

Some available directories seem so remotely connected with the business at hand that it is not evident why they are purchased at all, though occasionally they make more sense than meets the eye. I know of one photographer who travels extensively and seemingly has suffered more than his share of fouled-up airline reservations, as well as near-misses on many air freight and express shipments of film and equipment, that he went so far as to order the *Official Airlines Guide (OAG),* which the airlines and travel agencies use for commercial bookings. He told me once that the jaws of one of his clients fell open when he opened his briefcase at a meeting and the only visible things were:

one small camera with a 35–200mm zoom lens and thyristor flash unit
six rolls of film (two each of three emulsions)
a toothbrush, razor, one clean shirt and a pair of socks
The Official Airlines Guide (pocket edition)

He assured me that he has made more than one deadline by literally chopping minutes off his connection times at airports and that the *OAG* was the most useful list he could carry with him on an assignment. So think about what you invest your money in when it comes to reference works.

Excluded from these listings are a type of new publication that is essentially listings of promotion and self-advertising for photographers, studios and services. These books are aimed at some of the same markets that the young new professional is trying to reach but are paid for and subsidized by more established photographers in the form of advertisements about themselves or their studios. Do not confuse these books with the corporate directories mentioned above. Among these directories are the following:

American Showcase, 724 Fifth Avenue, New York, NY 10019.

L.A. Work Book, 6140 Lindenhurst Avenue, Los Angeles, CA 90048.

ASMP Book 1981 (or appropriate year), 205 Lexington Avenue, New York, NY 10016.

Creative Black Book, 401 Park Avenue South, New York, NY 10016.

PROFESSIONAL ORGANIZATIONS

Photography is part of the communications business, yet I am often amazed at how little communication there is among practitioners of the craft. Much professional information does come, however, from exchange and interchange with both colleagues and competitors, and new photographers are not alone in wanting this exchange. There are many professional associations that provide opportunities for interchange. New photographers should consider joining some of them as a means of keeping up with current trends and developments.

Not all organizations are for all photographers, of course. Many are specialized bodies that operate only within their own economic framework. But many are broadly based groups that cut across a range of specialties. All have the welfare of the photographer as a common denominator.

Probably the two most important groups of working professional photographers in the journalism field are the American Society of Magazine Photographers (ASMP) and the National Press Photographers Association (NPPA). The ASMP is made up of mostly free-lance photographers, although there are a handful of staffers among its membership. The NPPA deals essentially with the staff newspaper photographer, but it, too, cuts across some lines and admits free-lance photographers whose output is essentially press directed. The ASMP has about 3,500 members nationwide, with local chapters in the United States and some representation abroad. The NPPA, with eight regions nationwide, has many more members, about 7,200 in all, most of whom are on newspaper staffs.

Both organizations have extensive educational programs that are of immense value to their memberships. The NPPA, for example, sponsors a well-known "flying short course," during which it flies a planeload of photographers and editors on a cross-country trip, holding seminars for working photographers. The ASMP has regional programs that gather the photographers in their own chapter areas for seminars and discussions. Both organizations have active publications programs. *News Photographer* is the NPPA's principal periodical. The ASMP publishes its *Monthly Bulletin* plus specialized "white papers" and booklets on business practices, copyright laws, sales tax guides, and a large and handsome yearbook volume called *The ASMP 1982* (with current year date) that lists member photographers regionally and makes available lavish four-color advertising for those who wish to purchase space. The ASMP has a medical-insurance program that is most useful to the free lancer, but the NPPA members usually rely on their own employer-sponsored programs for health and accident coverage. Depending upon the nature of your work, you should consider joining one or both organizations.

There are other specialized or regional photographic organizations that the new photographer should also be aware of. These range from local special groups such as the Industrial Photographers Association of New York (IPANY) to the International Association of Theatrical and Stage Employees (IATSE), which is essentially a union of motion-picture people, including still photographers working in the motion-picture field. Photographers interested in the field of education might investigate the Society for Photographic Education (SPE), which is largely a group of fine-arts photography teachers. Other special associations include the Professional Photographers of America (PP of A), Society of Photographers and Artists Representatives (SPAR), highly technical groups such as the Society of Scientists and Engineers in Washington, and

organizations devoted to photogrammetry, biological photography, photography in the Federal government, and photography related to the forensic sciences. The list is long. There is also an association of picture agencies, the Picture Agency Council of America (PACA).

Besides professional organizations, there are the press clubs, which include writers, editors, public-relations people, ad-agency members, literary agents and so on. There are about 30 such clubs in this country and as many abroad. All can be useful as meeting places for the interchange of ideas and information. Most have exchange privileges, and some have exhibit areas.

Photo researchers and editors have a highly respected group of their own, the American Society of Picture Professionals (ASPP). Its membership consists mostly of art and picture editors and picture researchers, but a sizable number of photographers and some writers are also represented in this group.

Major museums that exhibit photography as a fine art are worthy of your support and participation because the material they exhibit and their publications are of importance to you. The best known are the International Center for Photography (ICP), the Museum of Modern Art and the Metropolitan Museum of Art in New York, and major museums and art centers in California, Chicago, Providence, Boston and elsewhere. All presumably will answer mail inquiries about membership and benefits.

CAN YOU GET RICH IN PHOTOGRAPHY?

Can one get rich in photography? Perhaps, but probably not. There are some rich photographers but their wealth in most cases comes from their families. Some photographers, of course, have earned large amounts of money through their photography. Some individual stock sales and assignment fees can be impressive indeed. Taking the statements of some of the news agencies at face value, if they have had a total sale of one story for $300,000 and the agency takes half, even allowing for the highest of expenses that are jointly shared by agency and photographer, a photographer can obviously come out with some $100,000 or more on that single story. A large studio operation billing in the millions of dollars annually may cover the expenses of transporting as many as twenty models, actors, technicians, etc., on a single shoot. How much money does the studio make out of it? It's hard to say, but in discussing this with colleagues I find that a high-level advertising studio of this type can net more than $100,000 annually to the photographer.

What about the small studio or local photographer? What can he expect? I asked Arnold Newman, one of the leading portrait photographers in the country. While he would not be specific in terms of dollars and cents, he made it clear that he felt a good photographer who worked regularly could earn a very comfortable living indeed. How comfortable is that? Well, I can only say that Newman himself lives well, has raised a family, is much respected and works frequently at the highest level. Is this possible in the small city studio? Newman cites a former assistant of his who opened a studio in the South and now has over twenty assistants and is probably running a much larger dollar volume than Newman himself.

On the editorial side I know of a number of top-rated photographers who, judging by their lifestyles, homes and furnishings, have to be earning more than $150,000 per year. But I also know of one very promising and talented photographer who is driving a cab when he is not shooting.

As a young man, a fine photographer of my acquaintance photographed a lot of struggling young artists of his own age and often swapped his pictures for some of their early artworks. Some of these artists are today among the country's most renowned, and this photographer in effect has amassed a priceless collection of fine art that, if liquidated, would bring an enormous amount of money to him or his estate. I also know of several photographers who, while getting started, were canny about investment opportunities and selectively and knowledgeably bought small investments in securities and slowly built up their portfolios. After twenty years they now have sizable holdings that add considerably to their financial worth. Yes, it can be done. A photographer can get rich, but probably at no higher a statistical rate than his nonphotographic artistic counterparts.

INTERVIEW
ALFRED EISENSTAEDT

In Germany in the 1920s a spectacular photographic career was launched via the newspaper route, and today Alfred Eisenstaedt, eighty-three years old, is still actively producing important photographic essays for *Life* and other magazines. In recent years there has been a torrent of books, exhibitions, slide shows and lectures by this talented and prolific man, who, since he is a surviving member of the original four photographers at *Life* magazine, should probably be declared a national monument.

"Eisie," as he is affectionately known around the world, started his career in photography in Germany as a twelve-year-old amateur when, in 1912, an uncle gave him his first camera, an Eastman Folding Kodak #3 using roll film. His first professional camera used 9×12cm glass plates. As a teenager he became avidly interested in photography and drove his parents wild by preempting the bathroom of their Berlin home for his darkroom. His output was, by his own standards, amateurish, but he was fascinated by the medium and kept at it until he was drafted into the German army during World War I. Eisie was wounded but managed to survive and returned to Berlin to work in the button business where, by his own admission, he was a poor salesman. A few years after he had made a picture of a woman playing tennis while on a family vacation trip, he sold it to the *Weltspiegel* of the *Berliner Tageblatt*, the German equivalent of *The New York Times Sunday Magazine*. It was his first sale, for which he received twelve German marks, then worth about three United States dollars. But he was hooked when the editor told him they wanted more pictures from him.

Eisenstaedt related a fateful conversation with the editor, who said, "Why don't you become a photographer? You should be doing what Dr. Erich Salomon is doing." Salomon has long been credited as the father of candid photography and was a pioneer user of the Leica, although at the time Eisie first met him he was using a small German camera called the Erminox. Eisie made inquiries about him and began upgrading his equipment, acquiring an Erminox, then a Plaubel Makina (a line still being manufactured). His pictures began to "move," and he sold his first story on the Berlin chapter of the Salvation Army

to an early version of the Associated Press. He was always fascinated with art, theater and society and to his amazement found that no one was covering those events, so he began to do so and had the field to himself. As he says, "I was like a wildebeest in Kenya," and it was during this period that he began meeting the celebrities of the day and made his famous picture of Marlene Dietrich. His boss in the button business pointedly suggested that Eisie make up his mind whether he wanted to remain in business or become a full-time photographer. He gave Eisie three days to decide. When the grace period expired, Eisie said he would become a photographer. He relates that "the man looked at me as if I had dug my own grave." When he announced this career change to his friends and family, they, too, felt he was committing suicide.

He then appeared regularly in many publications in Germany and did his first AP assignment, covering a Nobel Prize ceremony in Stockholm. He relates an amusing story of how he "blew" his second assignment for AP.

"My second assignment was a disaster. I had to go to Assisi in Italy to cover the wedding of Sophia, the youngest daughter of King Victor Emmanuel. I carried 240 pounds of baggage, all glass plates and other heavy equipment. I was supposed to do the wedding but I was fascinated by the choir boys, by the pageantry. I saw King Ferdinand of Bulgaria, who had the longest nose of all royalty . . . an enormous nose . . . strutting by with Mussolini. I photographed everything and when I came back to Berlin and the AP developed my pictures, they asked me, 'Where is the bride and groom?' I said, 'What bride and groom? I haven't seen them.' The boss of the AP Bureau in London said, 'That man has to be fired immediately!' But they couldn't fire me because I wasn't employed by them."

If nothing else, this fiasco taught him a lesson that, he says, was underscored time and time again when he went to *Life*: the necessity of doing his "background pictures" first and only then concentrating on the purpose of the assignment. In other words, Eisie says, "Do the big scene first. If you are sent out to do a story on a politician or well-known figure, do all the less important pictures first—the man's house, his general lifestyle, and what he looks like—before zeroing in on the details which are the most important part of the story."

He then began traveling all over Europe on political stories. He covered the rise of Adolf Hitler and made the famous picture of Hitler's meeting with Mussolini. Even though he had met and worked with Dr. Salomon, he never really came face to face with the Leica until about 1932, when he was introduced to it by another photographer. Eisie was fascinated with the camera and its incredible flexibility compared to the glass-plate cameras most other photographers were using. After he got his first Leica he continued using Leicas. (He still has his first one.)

In 1935 Eisenstaedt emigrated to the United States. He began working almost immediately and found assignments with *Harper's Bazaar* and *Vogue*. Shortly after that he was introduced to the American publisher Henry Luce by Kurt Koroff, another photojournalism pioneer and then the editor of *The Berliner Illustrirte Zeitung*, a prominent German publication. Luce, who was then beginning to formulate *Life* magazine and was in the process of developing experimental editions, was impressed with the young immigrant, who by then had helped to establish Pix, a news photo agency that was to have a strong influence on the policy of the fledgling *Life* magazine.

Eisie's first assignment for the experimental *Life* was to go to Hollywood to do an essay on California, photographing everything from Clark Gable and Shirley

Temple to the orange groves. Back in New York, Luce took one look at the pictures and instantly promised Eisie a berth on the new magazine when it began publication. The promise was kept and he became one of the original four photographers on the staff, along with Margaret Bourke-White, Tom MacAvoy and Peter Stackpole.

From the beginning of his staff association, Eisie began making photographic history. He ranged the world for *Life* and covered probably a never-to-be-equaled roster of presidents, kings, emperors, dictators, master politicians, and an equally long list of other prominent, as well as ordinary, people. One of his many books is called *Witness to Our Time*, an apt title indeed. But he did not concentrate only on the VIPs. His work included splendid essays on nature and the elements, including masterful coverage of a savage hurricane on his beloved Martha's Vineyard, where he has vacationed for thirty-odd years. An acquaintance who was heavier and stronger tells of hanging on to him so he wouldn't blow away in the gale.

How did Eisenstaedt achieve the monumental position he holds in photography today? Part of the answer lies in the times and the availability of the tremendous showcase that the weekly *Life* was. But the real answer comes from his incredible care and attention to detail in whatever he photographed, and the enthusiasm he puts into his work. His enthusiasm has never flagged. "I am still crazy about taking pictures." He says that if he were younger now he would do different things, such as experimenting more with strobes. But he has continued to work in his own way, not requiring teams of bearers, beaters and assistants, as he puts it.

"That is the reason," he explains, "that I am still Eisie and have not changed my style and will not change my style. If I changed and started doing the things I see other photographers around me doing, I wouldn't be me anymore."

He says the pictures coming from the younger photographers now are "terrific," but he also thinks that if he were born today he would not make it in photography. He puts himself in the hypothetical position Johann Strauss might be in if he were alive now and were trying to write waltzes and sell them in a rock and country music market.

Asked about craftsmanship, he said: "Craftsmanship, as I see it, is not the way it used to be. What's missing is the more intimate feeling. Today photographers are much more interested in setting up strobe lights and doing technical things. To me, both then and now, technique is not that important." He does not consider "technique" part of craftsmanship and sincerely feels he could not master the technology needed to produce the color we see currently. But he also thinks that the content of the pictures is lacking because of preoccupation with technical perfection and not enough time spent, as he puts it, on being the person behind the camera. He believes that his style of photography is dying out. But he feels, as do others, that while there is a lack of craftsmanship, it is caused by the audience and editors failing to demand craftsmanship from the photographers, accepting instead almost anything handed to them.

I asked Eisie, as the dean of American photography, what advice he had to offer the newer photographer. His immediate reaction was, "He should never become conceited just because he has something published. It can go away tomorrow and then he has to try again and again. Whatever I have accomplished over the years, whatever I am, I am not egotistical, and a big ego in a young photographer will only hold him back."

He underlined what many of his colleagues have said, that there is much

more at stake than the money, and with tongue in cheek he continued, "We did it for God, *Life* and Luce." There was enormous satisfaction in working for a big magazine, and unfortunately, because many do not exist today, much of the team spirit this type of photography engendered is gone, too. No longer do the great still-photo coverages of major events, catastrophes and funerals of heads of state command the space they once did because the immediacy and news value have been preempted by television and the instant journalism of world-wide satellite transmissions. So the photographer has to seek other outlets as his showcase.

Eisie spoke about the current resurgence of the personal essay and cited a recent *Life* story on the great movie directors and also some spectacular fashion photographs that were the result of a different way of "seeing." He feels that this is where the future lies for the young photographer.

He also feels that the photographer who is versatile is much more useful to an editor than the specialist with only one area of skills. Eisie thinks that the best in contemporary photography is exemplified by Ralph Morse, who he feels can photograph anything he can see or hear or smell and who is just as alert and agile today as he was thirty years ago. The word he uses for Morse is "quicksilver," and he attributes Morse's success to the great enthusiasm he has always had for his work, his painstaking devotion to detail, and critical awareness of what is happening around him. These are attributes that every new photographer, photojournalist or studio photographer should have as basic stock in trade. These are the qualities of professionalism.

CHAPTER 2
ANALYZING SPECIFIC MARKETS: THE EDITORIAL WORLD

Now let's direct our attention to selecting, investigating and evaluating the needs of specific markets. Doing this kind of preliminary work before proceeding with your selling strategy is essential for getting your work into the markets where it will sell best.

The section will cover the following markets, how to analyze their products, how to contact appropriate people in the organizations, and how to evaluate their particular picture needs:

1. Editorial: Newspapers, Magazines, Books
2. Advertising
3. Corporate and Public Relations

THE EDITORIAL WORLD: NEWSPAPERS

Let's start with the editorial world. In this major group are hundreds, probably thousands, of newspapers, magazines, city weeklies and monthlies, trade publications and all manner of corporate publications, not to mention the thousands of hard- and soft-cover books which are printed by the millions every year. Add to this calendars, posters, special editions and government reports, and you have a fair idea of the demand for photography. Defining the requirements of each in general, we can break them down as follows:

Daily Newspapers: As a rule they use black-and-white and some color photographs of news events, including accidents, fires, personalities, features on homemaking, travel, books, sports, politicians and other public officials, local business developments, construction, weather (extremes of heat, cold or the elements) and pictures of people in the news, including marriages, births, deaths, funerals and other public events and happenings. In reality there is almost nothing that is not of some photographic interest to newspapers, provided they have the space and budget for the pictures. Photos are frequently used with only brief captions and no text at all.

Sunday Newspapers: Most big city and many small town daily papers also have Sunday editions that often are a bigger market for local photographers than the dailies. Sunday editions tend to use more color and run more household features. They frequently have enlarged special sections or departments. Many of the big city daily Sunday sections are themselves almost national magazines, such as the Sunday *New York Times Magazine* and *Washington Post Sunday Magazine.* In addition, a great many smaller and medium-size papers buy complete packages. *Parade* magazine services some 129 papers with 22,000,000 circulation nationwide and has the largest Sunday circulation of any newspaper magazine in the world. There are also other publishing groups putting out preprinted packages, among them *Family Weekly* and Metro Sunday Newspapers, plus numerous feature syndicates that supply picture stories, photo columns, etc., to be inserted into local papers. Many of the latter are associated with the larger wire and news services.

Weekly Newspapers: These are usually rural in orientation and circulation is for the most part via direct mail. Frankly, these publications are less promising markets for the up-and-coming photographer, except for those interested in acquiring tearsheets rather than remuneration. These papers will undoubtedly take free pictures or, if they do pay, the fees may be less than the cost of paper and chemicals used to make the prints. However, it is a showcase of sorts and after a few placements I suggest that the new photographer move to greener pastures.

There is another type of weekly paper that does use photographs frequently: the weekly personality-oriented tabloids. Some pay extremely well, but working for them may result in unforeseen complications. Whether a photographer who supplies this sort of photography could be a party to a lawsuit is being debated, though the consensus at present seems to be that photographers are not liable as long as they do not violate privacy or libel statutes in providing material to the publisher.

There are other weekly papers that fall between both payment extremes. They use pictures well and frequently pay more than the ASMP pricing recommendations. The *Village Voice* in New York is typical, and although they don't set hard guidelines, their pay scales range widely from a few dollars to $250 per photo, depending on its importance, use and position.

By and large, the average small town paper, be it daily, weekly, bi-weekly or monthly, is probably not much of a market, though it can be a steppingstone to better opportunities, even staff jobs at larger papers.

LOCATING A PICTURE BUYER AT A NEWSPAPER

Newspapers usually print the names of their important editorial personnel in front of the magazine or on the editorial pages in a time-honored format called the "masthead." Magazine mastheads are usually more precise than their newspaper counterparts, which are somewhat limited, though there is a wealth of information that can be gained from both.

Newspaper mastheads are different from the national magazines even though their working structures have great similarities. The mastheads of the big city papers and many mid-sized ones as well usually carry only the names of corporate officers and top editorial management. *The New York Times,* for instance, shows only ten high management people from the publisher through the managing editor and his assistant, deputy and associate editors. Yet we know there is a vast staff and the *Times* is big enough to require a large photographic department, including several picture editors, assignment editors and a sizable

staff of photographers, plus supporting studio and darkroom people.

This pattern is followed by most newspapers, even though the staffs will be proportionally smaller. Yet newspapers are a unique editorial market because most are dailies with tight closing times. The handling of photographs is apt to be highly departmentalized, with the department editors being more or less responsible for the pictures that appear in their sections. Most dailies have their own photo departments, usually complete with staff photographers, assignment and/or picture editors, lab personnel, etc., and when a department editor calls for a photographer, it will be the picture editor, assignments editor or chief photographer (depending on the title) who makes the actual assignment. Once a picture is made, it then starts back up the chain of command from the photo editor to the department editor or national or city desk. The larger dailies with the bigger staffs tend to group their photographers by specialty, so it is rare that general news will be covered by the sports department and vice versa, yet the versatility needed in most newspaper photography will often require that the photographer jump the barrier from one specialty to another to cover for someone on vacation, out on sick leave, or when a major news story "breaks," requiring every available hand.

With the exception of the lucky happenstance of a nonstaffer running across a hard news event, it is more likely that most of the photographs appearing in a daily newspaper will have been photographed by staff photographers or supplied by a news service or agency. But this does not necessarily apply to the Sunday editions, which are treated more as magazines than daily papers.

Does that mean the new photographer should give up on the newspaper market? Certainly not. There are many independent free-lance situations that probably won't bring in much money at the beginning, but a steady effort in these areas can eventually lead to regular acceptance, frequent calls, or stringer status, and ultimately a staff association. It can start on any level.

There are countless stories of successes that have come about because of sheer perseverance. I know of one man who even before graduation from high school in a small town in Michigan began chasing fire engines and state troopers' cars. Prior to graduation he had been submitting pictures to his local hometown daily and got a job on it after graduation. He learned to edit as well as shoot news photos and quickly became adept at feature stories as well as "one-shots." For a while he was doing both, editing and photographing, and at this stage the jobs certainly complemented each other. He then moved on to a daily in a nearby bigger city and became a feature photographer-writer-editor. Eventually he came to New York and has made a fine name for himself as the editor of one of the most prestigious nature/picture magazines around. He still has the time to produce excellent photographic stories and makes a fair amount of extra money from his continuing love of his work.

This is not an isolated occurrence. In fact, it is the norm rather than the unusual. I know of many photographers who have made it by "starting small" at the local level and moving up the ladder, more by perseverance than anything else. In fact, there are some photographers who in my opinion are much better salesmen than photographers and who appear regularly in some of the most important magazines.

THE EDITORIAL WORLD: MAGAZINES

Consumer Magazines: There are over 1,200 publications with national circulation in this group. They are usually more selective in their photographic require-

ments, often using complete picture stories, though they may restrict themselves to one editorial photograph that sets the tone for an entire article. In most magazine photography the accompanying text is an important part in which the photographer plays no contributory role, except to provide information for captions. Captions themselves may be fairly brief or elongated to function as short text pieces.

Magazines can be a very big market for new photographers because they need vast amounts of photographic material and most of them will buy only one-time reproduction rights for their particular publication, thus leaving the field open to multiple sales in other regional publications or noncompetitive areas. Although some publications have staff photographers, the majority use free lancers. Color is also more prevalent in magazines than in newspapers. Magazines, too, are more often keyed to specific audiences than newspapers. *Magazine and Industry Marketplace (MMP)*, an authoritative publication of the magazine industry, lists some sixteen specific classifications covering nearly sixty different specialties. And within these groups are literally hundreds of separate publications.

Interwoven through the list of general consumer periodicals is a new and growing field of city and city/metro magazines and the airline magazines. Some of these are large-scale, slick, modern publications which, though directed at a precise group, have in fact grown to considerable national circulation. *New York* magazine, *New West*, *Arizona Highways*, *Sunset* and *The Washingtonian* are good examples. According to the latest *MMP* listing, there are about thirty of these regional magazines and airline magazines. They are excellent markets for the photographer.

Airline magazines: Although these magazines seem to have proliferated, the actual number of original publications is reduced because many are published by one company with different covers for different airlines, and many of the same stories are used in several editions. There are, however, a number of substantial airline publications that are still individually published by the airline. Some are of extremely high caliber and should be explored as a market for regional photography. (Note: These magazines are not considered "specialized" magazines because their subject matter is general, not aviation oriented.)

Trade and specialized publications: There are a large number of trade and specialized publications in business, law, medicine, health, religion, science, aviation and many other areas of interest. These specialized publications deal directly with a specific subject, industry or trade, and range from *Advertising Techniques* through *Yard and Garden Product News*. Many of them are well produced, use photography effectively, and their pay scales are beginning to approach national standards. The trend is that quality magazines are demanding—and paying for—quality photography. Color covers are becoming standard and more color is being used inside the publication as well. Many trade magazines are indeed industry-wide publications and often have clout comparable to the big national magazines, even though their area of inquiry is narrowed to a specialized area.

The trade magazines frequently, because of traditionally low budgets, are more amenable to photographers also functioning as authors, provided the photographer knows enough about the industry being photographed to be knowledgeable and that he has the ability to write. Such magazines often permit, and in fact encourage, the more experienced and capable photographers to write the captions and text pieces that accompany photographs. Unfortu-

nately this is rare among the major consumer magazines, which are, for the most part, managed and edited by people who frequently are more word than picture conscious. These editors often take the position of "let the photographer photograph and the writer write, and never the twain shall meet." Some of these same editors also fall prey to an attitude known as "typecasting" and wait until they are desperate before they permit an expert in one particular area to cross the line into another specialization. Once photographer Dan Weiner and I wound up in the same Illinois town at the same time to photograph different aspects of the same corporate story for a large magazine. Weiner was assigned to do the executive portraits and I the heavy machinery, and both of us were bored to tears by being stuck in these niches by this magazine's constantly assigning us to covering "heads or tails." It didn't take but a few martinis at the hotel bar to plot a change in roles. The unexpected arrival of the writer quickly put a crimp in those plans, though we were both certain that the editorial office would have never known the difference. Ironically, many of the same magazines that express outright opposition to photographers as writers seem to have little hesitation about their writers acting as photographers, and some have gone to great lengths to provide writers with cameras, saying in effect, "While you're at it, knock off a few pictures for us."

Versatility is particularly important for young photographers trying to sell themselves. But the "I can photograph anything, anywhere, any time" attitude is equally dangerous and, if pushed too far, can give an editor a feeling of "Jack of all trades, master of none." So the new photographer has to determine a workable compromise and be able to handle a variety of situations without alienating editors or buyers. When the situation arises and he is called upon to write a piece as well as make the photographs, he is responsible for double craftsmanship. So, while a skill in writing is often called for, it must be used carefully, and if the photographer must pay extra attention to the copy, he should not do so at the expense of the photographs. The best way to handle this is to concentrate wholly on the pictures until the shooting is completed, and then, and only then, consider the words. An editor can alter or improve copy—but there is little that can be done to improve a poor photograph.

In general, the magazine field is an excellent market for new photographers, particularly those who are alert, creative and sensitive to the needs of the publications they are trying to serve.

One Shot Publications: The category of one-shot publications and "special reports" can also provide a good outlet for the photographer. These publications can be carefully researched educational or government projects or "quickie" magazine productions on a specialized and popular subject such as auto racing, skiing or energy-saving. They are usually published in softcover format, use many photographs and are reproduced by the most inexpensive form of offset lithography. They hit the magazine newsstands for a quick one-time distribution, and unsold copies go off to the pulp mills. The reason this type of publication is of interest to the photographer, aside from the quick money, is that this type of "how-to" or specialized subject matter usually provides a good file of photographs for secondary use. As always, care must be exercised to specify in writing who owns the rights to the photographs if they are to be sold again for other uses.

LOCATING A PICTURE BUYER AT A MAGAZINE

In a current issue of *Life* magazine, there are thirty-four titles on the masthead, beginning with Founder (Henry Luce, who died in 1967) and six other top

listings: Editor-in-Chief, Chairman of the Board, President, Editorial Director, Group Vice President—Magazines, and Vice Chairman. None of these will ordinarily be interested in seeing your work, as their roles are corporate management rather than involvement with the specifics of the structure of the magazine.

Next are the top working group and here there are four titles: Managing Editor, Assistant Managing Editor, Senior Editor and Picture Editor. Technically all four would be interested in your pictures since *Life* is essentially a picture magazine. Of these four editors, the picture editor would, in theory, most certainly be the person to see, and he will be available to as many as he has time for, but he is probably very busy because he has responsibility for many stories in all stages of production. But don't rule the picture editor out as unreachable, because part of his job is to see and find new talent. Yet you should be extremely thoughtful about making demands on a picture editor's time and be selective in what you show.

Next on the list is the art director. It is unlikely you will have any contact with an editorial art director because, unlike ad agency art directors, he is mainly concerned with dealing with the photographs he has in front of him from the editors.

Then comes the articles editor, followed by the news editor. These are people with whom story ideas should be discussed, but even they are not the ones who make the final judgment about whether you get an assignment or not. If they do like a story idea, they will probably present it at a story conference or to a senior editor who will have more to say on the subject.

Still reading the masthead, you will come to an echelon of assistant editors, all of them aides to those listed above. This is the group you will probably start with. Here you will find other important personnel: the staff writers, reporters, researchers and many who provide liaison service with the rest of the corporation's available facilities—darkroom, studio, if any, and the picture collection ("morgue" in newspaper jargon).

The editorial market is the market that is receptive to outside ideas, as compared to the advertising world, where it is extremely rare that an "outside" idea is ever accepted. But in the editorial world the situation is different. With the high percentage of free lancers competing for assignments and the relatively small staffs (if any) at most magazines, it is only natural that editors will look outside for ideas.

Pass this philosophy down to the free-lance level and you can see why magazines have always welcomed outside story suggestions. One freelancer who had had a long association with the managing editor on one publication before he moved over to another asked, "How many years do I have to have under my belt before I get a direct assignment from you without my originating it?" The editor replied, "Look, I have twelve issues a year with space for about four or five stories per issue. That makes fifty to sixty stories a year, and I have two hundred photographers clamoring for work, including the thirty-five or forty I know from my earlier years, who are top producers and whom I want to help keep alive. The only way I can deal with this is to select the photographer who comes in with an idea we can use."

This all ties in with the approach made by the new free lancer to the magazine world and why the new photographer has to be careful not only about the selection of story material to be presented but also to whom it is shown. But for now let us consider that the assistant picture editor of this particular type of magazine will probably be your point of first contact, but if it is simply photo-

graphic ability that you wish to prove, bear in mind that proving ability alone is not enough.

Newsweek, a general news weekly, has even more precise divisions of responsibility than a monthly magazine like *Life* because it publishes more frequently, requiring a more specialized staff. *Newsweek* and its competitor, *Time*, are similar in structure. They have vast staffs, while *Life* is put out by some thirty staffers along with the contributions of numerous free lancers. The two major weekly news magazines have permanent staffs of several hundred, including those at the various bureaus nation wide and world wide. Each magazine has a battery of picture editors and department editors, many of whom deal with just one section. Each has a stable of photographers whose names appear on the masthead, although they are usually photographers under contract who are located in major cities and news centers. They also use many free-lance photographers and buy heavily from picture agencies specializing in news coverage. Because of the short deadline time and the need for weekly news material, the big photo essay is very hard to come by, and though these magazines may devote four to eight color pages per issue to a major picture story, it is usually a news-oriented piece produced more often than not by several photographers rather than one.

An important point for the new photographer to remember is that each of these magazine publishing groups, as well as some of their smaller and more business-oriented competitors such as *Forbes, Business Week* and *U.S. News and World Report*, all have bureaus both in this country and abroad, from which many stories originate. In dealing with these magazines it may be easier to deal with the local bureau chief on a one-to-one level.

Not all magazines, however, are as tough to deal with as the news weeklies and bimonthlies. The monthly magazines usually have a slower pace and are more specific in their focus of interest, are less gargantuan in scope, yet many may be termed "general interest" magazines.

Even the city/metro weekly magazines, while caught up in fast closings, are a little more controlled because the staffs are smaller and they use fewer stories per issue. Usually one story per department is the norm, and it may have taken weeks to put together. Here is a better opportunity for the young photographer to get a foot in the editorial door, as the subject material is often a home-grown topic and the editors are less concerned with national issues.

The men's and women's fashion, house, shelter and lifestyle magazines are departmentalized, too, and these people are easier to locate because their jobs are generally better defined on the masthead. A food editor is usually just that. Ditto the book reviewer, sports editor and the editors for new products and services. On some magazines where the staffs are small and the jobs varied, the term editorial assistant is usually the catch-all phrase for people who are moved around from department to department and who may be involved in anything from the crossword pages to eight-page color photo essays. On these smaller publications where there is no picture editor, photography is usually handled by the art director—a title that is really an anachronism and a throwback to the days preceding reproduction of photos when all illustration in any publication was considered "art."

Let's look at the masthead of *Smithsonian*, only eleven years old and certainly one of the finest magazines using photographs. *Smithsonian*, with a circulation of 1,850,000, has only thirty-five names on the masthead. Of these names, twenty are directly involved in editorial matters, with only five or six of them interested in picture buying, and the rest handling circulation, advertising, production and the like. How do they handle their photographic coverages? With free

lancers only. The standards are incredibly high, the reproduction excellent and is magazine journalism at its best. On the masthead there is no picture editor listed *per se*, but included in the listing of "Board of Editors" is a person with "Pictures" added to her title, as well as her assistant's title of Associate Editor, Pictures. Actually these are the picture editor and assistant picture editor respectively, who are the people the new photographer should contact. At this magazine, photographers with story ideas that might normally go directly to a story or department editor at another magazine should channel their ideas through the picture department. The picture people take the idea to the editorial group, which makes the decision about whether a story is of interest or not. Then one of the picture editors gets back to the photographer for the "yes," "no" or "maybe."

As can be seen, the masthead is an all-important clue to whom to see or contact. While the terminology may change, the job responsibilities are usually easily spotted, although sometimes these may be hard to discern.

If there seems to be no one identified as responsible for pictures, particularly at smaller magazines, the next step is to contact the art director or assistant art director. Even these jobs may not be too well defined, or the titles may be obscured by fancy verbiage, such as "Graphics Editor" or "Design Director," or, going the other way, the magazine may be so small that the job of art director could be combined with production. But perseverance is the answer, and if all else fails, the solution is to pick up the phone and ask the publication's switchboard operator, "Who is responsible for pictures, what's his or her name, and how is it spelled?" Don't laugh at the question of spelling. There is nothing that will turn people off more than to have their names and titles misspelled or misrepresented.

Turning to a different kind of magazine, let's look at *Family Circle*. This is a large-circulation, family/home-oriented publication with a wide distribution through newsstands, stores and supermarkets and subscriptions. This is not a small, independent magazine, but a major one, published nationally and internationally by the New York Times Company.

Family Circle's corporate officers appear on the contents page. At the top of the masthead are six titles. Judging from the bylines, these people are active in the editorial content of the magazine rather than just concerned with corporate management, as in the case of those on the *Life* masthead. On this masthead each department is clearly identified and there is a large group of senior editors and other editorial service personnel. But note here that the art director is listed as one of the top editorial people, with no picture editor identified at all. One person carries the classification after his name of "Photography." Is this the picture editor we are looking for? Probably not, because he appears as a photographer in the credits. In a situation like this you can go directly to the story (specialization) editor, and if that person is not the right one, he or she can direct you to the right person.

What we are really saying is that while the job listings are apparently defined, precision must be used in pinpointing your first contact, and the photographer must make a careful study of the masthead before considering who is to be approached with what sort of material.

We have looked at the monthlies, news weeklies, the home/lifestyle and the general-interest magazines. All are national in scope. Are the regionals or the city/metros any different?

Let's look at *New York* magazine. *New York* is set up similarly to the national magazines, except that, as a weekly, the staff is smaller than that of the major news weeklies such as *Time* or *Newsweek*. Here the "design director" occupies

the third position on the masthead and the picture editor is almost at the bottom of the list after a large block of senior editors who really do the bulk of the editorial work. After the senior editor listing is another large group of "contributing editors" who usually supply columns in specialty areas such as theater or film, books, shopping, restaurant critiques, and the like. Photographers will have a tough time approaching contributing editors because most of them are not in "residence" at the book. So in this case it's back to the picture editor, though the picture editor on first contact may suggest speaking directly with one of the senior or contributing editors to see if there is an area of mutual interest that could be turned into a picture story. As in most of the other magazines discussed, the pattern is to funnel most picture assignments through the picture editors rather than the art directors. So, in summation, on most magazines where a picture editor is clearly indicated, that is the person to see rather than an art director, senior or news editor.

INSIDER: THOMAS HOEPKER, EDITORIAL ART DIRECTOR

Editorial art directors are generally less visible to the working photographer than their counterparts at the advertising agencies. The reason for this is that an editorial assignment is usually conceived by the editors of a publication, a free-lance writer, sometimes a photographer, occasionally a combination of them. The story script or outline may go first to a researcher, department editor or picture editor before being assigned to a photographer, and rarely does a publication bring its art director in beforehand except to get a general idea of how much editorial space is available.

It has become almost automatic to try not to preplan the makeup of a major national publication until the last minute because of the possibility of late-breaking news that will throw the whole magazine out of kilter and the art director's plans and layouts out the window. Two pungent remarks, one by a famous managing editor and the other by an equally famous art director, illustrate this best. The editor, when being pressed to guarantee the running of a specific story by someone with clout and a vested interest in the piece, is reported to have said, "I wouldn't guarantee to run a four-color spread on the Second Coming unless I knew what was in the book the week before and what we were planning for the week after." And the art director, on hearing of the assassination of a head of state, exclaimed, "What a thing to happen on the day after we closed!" Though the pressures of timing and deadlines are crucial in the editorial world, this is less true of advertising layouts that are sometimes prepared six months or a year in advance.

The impact of the editorial art director on the shooting of a story by a photographer is great. Even though he may not have been in contact with the photographer, it is the art director's influence and talent that definitely will affect how a story is shot, laid out and printed.

I talked at length with German-born Thomas Hoepker, until recently executive editor of the magnificent U.S. edition of *Geo* magazine. (Hoepker has returned to his first love, photography, and is shooting actively for the parent company of *Geo*, the Stern Magazine Group of Germany.) Hoepker's beginnings were similar to those of many other photographers. He started young, at age 14, graduated from college in Hamburg, then went to the University of Munich where, by his own admission, "because I didn't know any better," he studied art history and archaeology.

"But all along I was a photographer. I never stopped shooting even as a student and when I graduated I was offered a contract by a German magazine in

the 1960s." Ever since then he has been either a staffer or a free lancer for various German weeklies, but always as a photographer. Hoepker, much like Carl Mydans, married a writer and they traveled as a team throughout western Europe and East Germany and about five years ago both came over as correspondents for *Stern* magazine.

After two years *Stern* decided to publish its U.S. edition of *Geo,* also being produced in France and Germany. *Stern* asked Hoepker to assume the complete visual responsibility for the magazine, its design, the photo assignments. His title (executive editor) covered a broad authority that included the art direction, which he supervised.

Hoepker's three years at *Geo* gave him many insights as an editorial art director. He is of two minds on the subject of photographers as writers, thinking that in reality both skills cannot be handled by one person, yet he has written several of the pieces he has photographed and has often assigned photographers to write stories as well. "At *Geo,*" he said, "we believe firmly in the photographer being an author. I always felt that this guy is out there and very much has to report his own story. He has to tell it in his images."

There is usually little requirement for any research by the photographer because, by the time the story is assigned, most of the research is on hand. If possible *Geo* sends the photographer and writer out as a team because two talented people who go out on a story together will look at the story with different eyes. It is also possible, he conceded, that one will come back hating a story and the other will love it but that doesn't happen very often. What usually happens is a thorough understanding of the story by two people from different viewpoints that when put together results in a deeper understanding of the subject. But *Geo* does not expect too much visual training on the part of the writer because that's the photographer's job and some writers are wonderful with the photographers and some don't give a damn and will not help the photographer at all. But Hoepker also said *Geo* does not believe in photographers being just illustrators, nor do they think that a writer should prepare a story and hand the manuscript over to the picture editor, who then makes a list of pictures from it and hands the list to the photographer. He says that's a nonphotographic approach, like illustrating a textbook. That's why he sees the photographer as an author who has to go out and find his own way, even if he contradicts the text. I asked Hoepker if when this happened did they "back the photographer." He said they did.

Hoepker feels "there is no truth in photography. Everyone sees his own interpretation. The common myth is that photography is objective, which I find not true at all, because photography is always seen as reality through a temperament, and every photographer necessarily "twists" reality. He has to choose the moment, the lighting, the right film and lens combinations, and it becomes a chain of choices the photographer has to make about how the photograph is produced. Also the choices are based on the judgment of one person.

I questioned this statement by asking, "Isn't that the truth?"

He countered by saying it was a very "personal truth" but not "objective" truth in the same sense perhaps that science tries to be truthful. Keeping in mind Ed Thompson's comment on biases (see page 51), I asked Hoepker if he thought a journalist (of any stripe) should have biases, and he came down firmly in favor of them.

When choosing a photographer to do a story at *Geo,* he and the picture editor would sit down and discuss, among other things, the origins of a story and what if any special expertise would be needed on the part of the photographer.

Usually a few names would come to mind as to who could do the story best. Occasionally they had difficulties in finding the right photographer. Sometimes they would even pick an "unlikely" photographer for the assignment in order to get a very fresh approach and he told me of assigning a story on astronomy to a photographer who had a long track record in photographing pretty girls. But he became excited by the assignment and brought to it a fresh and novel approach, delivering a superb job.

On coping with the age-old question by new photographers of "how do I get my foot in the editorial door," Hoepker said he replies by giving them "a very dumb answer. I say 'surprise me' by showing me something in your work that I don't expect to see. Surprise can come from a story idea and it can come from what the photographer shows the editor, and if I see something that makes me wonder, makes me stop and think, even for a moment, then of course I will give it more consideration."

As for presentation of materials, even though there has been a change of management at *Geo*, Hoepker thinks there will be no real change in the methods of seeing new work. They prefer 35mm color in trays for projection since the magazine is essentially geared to the 35mm format. But he did not rule out the larger sizes and spoke of a beautiful story on the rooftops of New York City that was done entirely with an 8 × 10 camera. About methods of personal presentation he is ambivalent, saying "some photographers are wonderful about presenting their work and others are a pain in the neck because they talk a lot and don't express their thoughts clearly. Our normal procedure is to sit down with the photographer while he explains the background of the story, why he shot certain pictures, and then we look at the story. We generally want a photographer to do his own editing, selecting his *A* and *B* sets, but reserve the right to see all the rejects on a story. Of course if it is an assigned piece and the photographer has stayed behind in the Congo, then we will do the entire editing job." He summed this up by saying there are photographers who are good editors and those who are lousy and that he personally prefers to edit his material first.

In summation, one thing he could do for the young photographer was to demolish the myth that it took having a cousin in the managing editor's office to get an assignment and advise him to forget the fancy portfolios encased in mahogany binders, and simply show good and surprising photographs. That's what they want and that's what is needed.

INSIDER: JOHN LOENGARD, PICTURE EDITOR

Attitudes toward photographers at the level of the picture editors or assignment editors at magazines or newspapers are even more critical because these are the people the photographers will generally be dealing with on a day-by-day basis. John Loengard, himself an ex-*Life* staff photographer for many years and now the picture editor of the new edition of *Life*, is typical of the new breed of knowledgeable and responsive editors. He not only knows what the problems of the photographers are because of his former staff position, but is aware of the needs of his publication and is responsible for the production of most of the photography that goes into the magazine.

Loengard himself started as a photographer at the age of eleven when he borrowed a camera from his parents. He started taking pictures as a student in a prep school in New Hampshire, and later in college he photographed for the college newspaper. He went on to taking photographs for his college alumni magazine, his first paid assignments. This was important, because the magazine

was influenced by the photography in the big picture magazines of that time, and it was a very good training ground for Loengard. He applied for a summer job in the *Life* photo lab but was turned down. However, in his senior year Loengard received his first assignment from *Life*'s Boston bureau. After an army stint, he joined *Life*'s staff in 1961, remaining with them until the magazine folded at the end of 1972. In subsequent years he was on the team called the Magazine Development Group that put out ten special issues of *Life* that kept the format alive and the name before the public until it started publishing again. He was the first picture editor of *People* magazine and worked on several other experimental publications in 1979. Loengard has certainly paid his dues as both photographer and editor and understands the needs and interests of both functions.

I asked Loengard how he viewed the photographers who come to see him, how he feels about them, and his attitudes toward them. He replied, "We at *Life* have an appreciation of what they are doing because we are in a very privileged position. Those who come here feel that this is the very best, and they take us seriously. We know they are going to give us the best they possibly can. We think it's a wonderful attitude and we try to be as sympathetic to them as they are to us. We have a special interest in photographers under thirty. Not that we don't use the older ones. We do, and are happy to use them, but the future is going to come from those younger photographers under thirty. I think we can offer them an opportunity to do something that no other publication can today.

"Because so much material was needed on the weekly *Life*, it used to be much more common for editors to take a chance on a story and a photographer, but there doesn't seem to be as much leeway for this now. However, we are going to benefit from it and the young photographer will do so as well, making a name through our pages.

"If I were going to generalize, I would guess photographers come from two places—the New York studio that is entirely commercially oriented, where one learns technique and develops photographic abilities, and from newspapers, where one learns the editorial sense. Both kinds of photographers are invaluable to us.

"At *Life* magazine we are looking for people who not only have an interest in photography but are also concerned about the sense and structure of the story and have an interest in what's going on, and a feeling for a rough dramatic structure. We are talking here about the photographer who wants to know what's different and has the ability to go out and see what's special about a subject, not just what's going to make a nice picture."

I asked Loengard how a young photographer gets to do work for *Life*. He was both candid and sympathetic, citing the literally hundreds of photographers he and assistant picture editor Mel Scott have seen since the inception of the new magazine a few years ago. That function has now largely been taken over by the assistant picture editor, who will see you, but it will take time.

Loengard said, "We are very interested in somebody who is different, who is good. But there are lots of people who are good, so we look for somebody who makes something seem a little larger than what other people are doing. The funny thing is that most things we ask people to go and photograph are dull, and most of the pictures we print are (hopefully) interesting. Something happens between the subject and the picture, and that's what the photographer is doing. I think what we are looking for is not how *good* a photographer is, but how

interesting he can be with a camera and how interesting he can be about subjects. I think that's a rare quality and a rare ability."

Loengard feels that in journalism the photographer should find what's distinctive about a subject as compared with advertising or industrial photography, which tries to avoid the peculiar and depicts the generality.

Life magazine, either the original version or the current one, has always been perceived as a standard of excellence for the industry and a goal to be aimed at by the new photographer. But almost as important has been its influence on photojournalism in general, as the masthead of almost any important magazine that uses pictures well will attest. For somewhere on those long lists will be many who learned their skills on this unique publication or its sister magazines.

INSIDER: CAROLINE DESPARD, ASSOCIATE EDITOR

Typical of these competent and caring people is Caroline Despard, now on the board of editors of *Smithsonian* and the person responsible for pictures. Despard, in the course of getting photography made for *Smithsonian*, deals with photographers every working day and probably many nonworking days as well. She is totally dedicated to her craft and intensely desirous of seeing good photography. She has a deep feeling for and understanding of photographers and is sympathetic to their problems.

Professionally, she started in the text department of a book publisher. After a few years at standard publishing houses, she joined the Time Inc. staff in Paris, partly because of her fluency in Italian and French. Even though she had been developing an interest in photography, she was suddenly thrust into it at their Paris bureau by being assigned to work with the photographers. After an apprenticeship at the bureau, she left to get married, returned to work at the United States Information Agency, and then went on to the new *Smithsonian* magazine in Washington just being formed by Ed Thompson.

As with all new magazines under development, the planning and test issues were produced with a minimum of staff, and Despard got a very intensive education in the production of a quality picture magazine.

She feels that the significant differences apparent in photojournalism today stem from radical changes in equipment and the technical simplification of the problems of obtaining good images on film. She does not minimize the need for craftsmanship, but simply underscores the fact that so many technical aids are now at hand, that there is more room for the photographer to concern himself with content.

"Too many photographers come into my office," she says, "with pictures that all look as if they were shot by the same person." She looks for a photographer with an "individual exceptional eye." She feels that there are really very few photographers around with that exceptional approach and guesses that there are no more today than there were 20 years ago.

She thinks the attitudes of editors toward photographers have changed radically over the years, probably due to the change in markets. There is not as much "baby sitting," as she puts it (sending out researchers or reporters with the photographers) as there used to be.

"What we're looking for," she said, "is to be able to trust the photographer completely. I want to give him all the information I have, and let him take it from there, knowing I'll get a good story back. That's the guy I love. I want a good job; I don't want to have to send him back, and I want him to understand that the story is for *Smithsonian* and not for *Geo* or *Life* or anyone else."

"But the basic attribute has to be intelligence. Not only must he understand what the story is about, but he must have the initiative to go where the story is and often transform a nonvisual story into a highly visual one. At *Smithsonian* I think we do that a lot more than *Life* or *Look* did in the old days, because they often chose their stories visually and for their news value. Today we often run hi-tech, hard-science stories that don't lend themselves easily to human interest or evocative pictures, yet the photographer has to find them."

Photographer-originated stories are not as much in demand at *Smithsonian* as at other magazines because many of their stories start as text pieces already in house. Despard does not want to discourage photographers from submitting ideas, as she confirms that for new photographers at least it is by far the best way of getting into a magazine. She also suggests that one possibility of presenting an idea is for the photographer to team up with a writer so the presentation will be even more complete and be easier for the magazine to assess as an entire package. This does not mean that a finished story has to be submitted. Far from it, because editors will view with suspicion anything they are locked into in the way of a finished product.

INSIDER: RENEE BRUNS, EXECUTIVE EDITOR

Up to now we have been concerned with the opinions of the editors of the big popular and prestigious magazines. But how about the editorial viewpoint of the smaller and more specialized publications? Numerically there are many more with not inconsiderable circulations, cumulatively far exceeding those of the big publications.

I talked with Renee Bruns, *Popular Photography*'s executive editor, and her thoughts paralleled many of her contemporaries'. There seems to be far too much talent for the number of pages available. In spite of the magazine's orientation toward the amateur photographer, professional photographers have demonstrated that they like *Popular Photography* as a showcase, particularly in new areas of work. She told us that what they look for primarily in a photographer is technical competence and professional behavior in general.

She alluded briefly to *Popular Photography*'s sister magazine, *Camera Arts*, as another market for fine-arts photography, but did make it clear that her magazine wants and often uses photographs with high artistic merit. Their real desire is to run pictures that can be used to illustrate an aesthetic question or how-to-do-it story. She is amazed at how many photographers cannot really present a well-thought-out story of this type. She said, "It is a most useful ability for the photographer to acquire and would certainly help those who are not only trying to sell us pictures but stories that go along with them."

Contrary to some editors, who prefer to separate writing from photography, Bruns thinks writing ability is a plus, as the photographer will be able to communicate better with her. She said, "The photographer will make a heck of a good impression when he comes here if he can discuss his work intelligently and suggest how we might be able to use it." She feels that, while it is rare for the pictures and stories to be equally good, when it happens it is an exceptional combination and the photographer benefits from it, not just financially but also because there is a better chance of getting published if a strong message goes along with the photographs.

On other editorial projects they work with combined editor-writer-photographer teams, particularly when testing new products. Usually the photographer adds a great deal of verbal input that enhances the story and this results in an editorial style this magazine is proud of. They also issue general

assignments to photographers and then will either look for a writer in house or use free lancers. Usually the photographer fills out detailed data sheets when the magazine holds pictures for consideration in order to have material for the writers to work with.

She admitted that about half the time the photographers fill these sheets out haphazardly and often don't remember how the pictures were taken. I asked her if they would reject a set of pictures because of poor caption material. She sighed and said that if the pictures are really that good, they will try to use them somehow. There have been times also when a story was delayed because of inadequate information.

INSIDER: SUE CONSIDINE, PICTURE EDITOR

The picture editor (PE) of almost any magazine is the closest contact between the photographer and the magazine's editorial staff, and in spite of the relative importance of this job there are very few formal courses in picture editing at the college or university level. If picture editors have had any job-related academic training, it is usually in fine arts.

Not so for Suzanne Considine, picture editor at Time Inc's. *Money* magazine. She began as a secretary to Leo Leonni, *Fortune* magazine's long-time and distinguished art director, who also gave me my first assignment at *Fortune* more than three decades ago. Not only was Leonni a major publication designer but also a fine teacher because Considine attributes her considerable knowledge to Leonni's tutelage. She then worked for art director Walter Allner. Eventually she moved up the ladder to become the assistant to Seville Osborne, again one of *Fortune's* memorable and most talented picture editors. Considine's test by fire came one day when Osborne, without previous warning, said she was off on a long-overdue vacation and that Considine was now the acting picture editor. Osborne said "Good luck" and took off. Considine survived and thus a picture editor was born.

Eventually she became the regular picture editor at *Fortune*, tried a stint at *Business Week*, returned briefly to *Fortune*, went to *Time* as deputy picture editor for the "Nation" section for nearly five years, and when the *Money* job opened up, she was the ideal person for it. Reflecting on her general feeling for picture editing, she said she had always had an intense curiosity about the subtleties of all of the arts—music, dance, theater and of course, graphics. She read deeply and studied intently, and she thinks this is the kind of curiosity that gives one the ability to edit pictures and to see through someone else's eyes the images brought before them.

The practicalities of working for the various magazines were different, and each had its own set of problems that in turn reflected seriously on the options for the photographer. *Fortune* magazine, with its monthly schedule and mix of black-and-white and color was certainly the easiest to deal with from a production angle, and allowed both editors and photographers a good deal of leeway in the technologies used to produce the images. At *Business Week* she dealt primarily in black-and-white with a weekly close, and with the limited amount of space available per story the pressures began to mount. *Time* was a pressure-cooker that also had a weekly close but with color availability as well as black-and-white.

With *Time* closing at the end of the week the editors and photographers knew that they could not, for instance, use Kodachrome as everyone preferred because of the absence of weekend processing. *Money* magazine, having a monthly closing for its consumer oriented readers with photographs in color,

could be shot on Kodachrome, to the delight of the entire production team. The 35mm does produce the bulk of the photography at *Money* and though it tends to downplay other formats, from the editor's point of view it is ideal, and they use it to the utmost.

Considine did say that the advantage of working in a place like *Money* is that the picture editor can "make things happen" because news events are not often involved and they have broad choices on whom they assign to a story.

Just a few moments before I interviewed Considine, a young man came out of her office with a thoroughly abashed look about him, and when I entered her office she had a thoroughly irate look about her. "What happened?" I asked because I have known her as a calm and controlled woman for many years and rarely seen her so angry. Well, it seemed that the young man laid claim to being a photographer by calling for an appointment and when he appeared he had neither a portfolio or the slightest idea of what kind of photography *Money* uses. I overheard through the open door before Considine had a chance to recover her composure; "Young man, you have just canceled your appointment. Please go away, and when you have done your homework and can appear less disheveled and more organized, call for another one. And for heaven's sake don't make a fool of yourself or of the editor you are calling on by, for example, showing the editor of *Business Week* a color spread on fashions."

To the new photographer she says, "All I can advise is that photographers be realistic about what they show. If all they have are black-and-white prints from college work or summer newspaper jobs, let them be good black-and-white prints. Don't try to impress an editor with capabilities you don't have. This goes along with attention to personal appearance and knowledge of the publication's area of interest. The beginner must realize that if all he shows are college level black-and-whites he should not expect to be given a four-color cover assignment immediately. He is going to have to prove himself in the 'back of the book' in some small way first.

"I am not impressed with seeing untidy cuttings from newspapers, any more than I am with seeing untidy and ragged photographers. I do not like to see 35mm slides from black-and-white prints, so please show me good black-and-white prints. I prefer to look at original transparencies rather than dupes." She suggested that if a photographer has sold his originals to some organization that purchased all rights to them, he should make an effort to get back some of the originals or outtakes after use, for presentation."

Considine is aware of all the traps and pitfalls that can snare a young beginner but she is somewhat surprised and not a little shocked by what some established professionals are also showing. She suggested that even experienced pros take a fresh good look at what they are showing to see if they are up-to-date.

Although some editors object to projecting work, Considine is generally in favor of it when 35mm originals are concerned, but she does not want larger format transparencies reduced to 35mm or, as mentioned earlier, black-and-white photographs converted to slides, preferring 8×10 or 11×14 double-weight prints of good quality, well spotted, unmounted and presented simply. If the photographer already has good examples of previously published work, she wants to see them as well, but objects to being inundated by any format.

It has always been her policy to impart to the photographer every bit of knowledge she can in advance of the shooting and she takes much personal pride in giving equal attention to a one-column back-of-the-book cut as she does to a color essay up front. She expects this devotion from the photographer and does not want to see any quick "knock-offs" just because it may be an

46

"unimportant" picture. She thinks that anyone who expects to work in photography from either the back of the camera or behind the desk has to have that kind of integrity.

On balance, Considine sees that the improvement in photography in recent years has in part been fostered by the tremendous increase in technology in film, cameras and other equipment, but she also attributes part of the general improvement to the fact that the current generation has literally grown up with images, published and televised, as compared with those who reached maturity several decades ago and who did not have visual images as part of their growing-up period. Some of this growing up has spilled over into business and she spoke of calling a public relations department of a large company twenty years ago and asking for an executive portrait. She received a formal "cabinet" style photograph that was retouched to death. Today the same request would bring in several sheets of good contact prints shot by some well-established professional for her to make a selection.

She added her name to the growing list of editors who are appalled by the overshooting with motorized cameras and also complained of the recent take by an established professional who sent in 19 rolls for a single column head shot in color. What horrified her the most was that in those 19 rolls she found no more than eight different expressions. On another take of four or five rolls of film, every single frame had "eye contact" with the camera. Not one was a profile or a single three-quarter photo or anything else except the result of a flat footed stance on the part of the photographer who obviously shot the whole take from a single position. "This is inexcusable," she said, "and is also one of the pitfalls of all this high speed motorized equipment."

In projecting her feelings about the directions being taken by editorial photography, she said that technically there was no question that the news weeklies were going to benefit from the higher film speeds, the faster reproduction and better quality control. The transmission of images by satellite has made it possible for a photographer to transmit a photograph from practically anywhere to New York in a matter of minutes. She didn't think this improvement held much immediate promise for the slower-closing monthlies like *Money,* but that promise is tantalizing.

PICTURE RESEARCHERS

Photographers have to deal with editorial people on many levels below the rank of managing editor and picture editor at large circulation magazines. Frequently they are dealing closely with staff or free-lance picture researchers from book-publishing houses whose photographic needs are quite different from those of the major magazines. The latter more often use assigned stories, and book publishers work more frequently with stock photographs. Because it is rare that a photographer will have "in stock" exactly what the researcher is looking for, it then comes down to a compromise as to what is available and also useful. This is why the understanding and training of the picture researcher is important.

Photographic editing and research specifically are not generally taught in colleges. As a result, the majority of picture researchers seem to be art-history or fine-arts majors, and almost none have photographic backgrounds. True, experience on the job fills many formal educational gaps, but there is often a communications gap between the photographer and researcher so that frequently it is up to the photographer to do more than simply pull a picture out of his file. He may well have to question the researcher closely as to what is really needed and go beyond the specifics of the original requests. This in turn may

put a strain on the relationship between the photographer and researcher, so the understanding of the photographer by the researcher is vitally important and vice-versa.

A classic example of this problem arose when I received a call from a textbook researcher who asked: "do you have pictures of oil wells gushing?"

I told her I did not because oil wells no longer gushed and probably had not done so for the past 30 or 40 years except in cases of accidents at the well head. If those accidents did happen it would be probable that the foreman would have been fired for wasting oil, and it would be doubtful that any photographers would have been permitted to make pictures of the "blow-out."

But, to me, it was unlikely that she was really looking for photographs of oil spilling on the ground, so I pressed her a bit and asked what was she really after—oil production? industrial accidents? or something historic like the old wooden derrick in Titusville, Pennsylvania, which was photographed before the turn of the century and was indeed spewing oil from its head?

Her answer surprised me. She was not looking for any of the above, but for photographs of steel tower construction and thought if she could get some pictures of the steel towers that oil rigs are made of, she could enhance the drama of the picture by showing a gushing oil well.

So it was my job to put her back on course, and to explain the actualities of the situation and better translate the photo request into realistic pictures. Some other agencies or photographers might have simply said they did not have any pictures of gushing wells and let it go at that. But by probing the request more deeply, I was eventually able to come up with a saleable photograph.

But there is more to this than merely probing an odd request. There has to be clarity in what the researcher is really asking for and if for any number of reasons that clarity is lacking, then the photo source must "back into" the situation by asking what the article is about, and what the author is trying to say? Then the researcher and the photo source can work together a lot more efficiently.

INSIDER: MARGARET MATHEWS, BOOK PICTURE RESEARCHER
Reader's Digest Books is typical of a large publishing house that prints handsome picture books. To get the views of one of their staff picture researchers, I turned to Margaret Mathews, who has worked for Readers Digest for many years. She went into photography research because of her interest in art, after attending Knox College in Illinois, one of the few places that at that time offered a liberal-arts education as well as a major in the arts. After graduation she worked at the Philadelphia Art Museum. Her first job working with photography was in the Metropolitan Museum of Art's department of prints and photographs. After three years the funding of the project she was working on ran out and she decided to move into picture research.

At Reader's Digest, her initial training came from her picture editor who, besides showing her the whys and the wheres of obtaining photographs, was quite concerned about how picture researchers dealt with photographers on a personal level. He taught her how to defuse situations where photographers felt "threatened" by the picture researcher.

I asked Mathews to outline the procedures followed by her publication in producing a picture book, with emphasis on obtaining the photographs. She told us that the basic ideas for new books often come out of meetings that include the entire editorial staff, who are invited to present them in concise memo form. Those ideas that interest the editorial board are then pretested, without photographs or copy, and if the response is favorable, an expanded

outline is prepared and presented to management. If they feel this idea is saleable, it goes to the brochure stage, a full four-color mailer that is sent out as a wide-range test of the market, and if this test response is good, the project is put in the works.

These test brochures are by no means small efforts. They are complete with sample pages, sections of copy, and lavish use of color photographs. I asked her where the photographs for the sample mailers came from, and she said that the list they use for the brochure is the same they use for source material for the book itself. A book project staff is then broken into two groups—the copy group and the art group—and this is where the researchers and art editors have to do their most intensive work in bringing together the needed visual material.

Some of these projects take as long as nine months to research and two years to produce, so it is understandable why pictures have to be held for long periods of time. To reduce the strain on the photographer by this long gestation period, Reader's Digest Books set up a slide-copying system by which a photograph is copied in nonreproducible form, such as a dupe slide with a line etched across it, the data is noted, and the originals are returned to the photographers for recall when needed. This is expensive for the publisher, as sometimes thousands of pictures are brought in for a single project, but it is done when the photographer feels he needs the pictures back in his files quickly and cannot wait out the long production period. The staff at Reader's Digest are responsive to holding fees and service charges for pictures held for a long period of time, although there are differences of opinion over what is a reasonable holding period. Therefore, they leave it to the photographer to state how long his pictures can be held, as this publication group generally exceeds the average two-week free time specified on most delivery memos.

Because of the large number of pictures moving through their system, they have by now developed long lists of photographers and their specialties or regional coverages, and turn to them when pictures are needed.

The importance of proper captioning and valid information accompanying each photograph submitted was stated, and Mathews confirmed the importance of this information. Reader's Digest Books wants every photograph to carry the name, address, and telephone number of the photographer and/or the agency, as well as the copyright symbol and date. Each photograph should be captioned on the mount, if possible, or at least on an accompanying delivery memo sheet.

Mathews reiterated her colleagues' advice about protecting the transparencies submitted with sturdy, chemically inert slide or transparency envelopes. One of the "beefs" she has against photographers is that "some don't have the proper respect for their own work. They don't properly identify, protect or mark it. This is a total lack of professionalism."

On professionalism, Mathews said that they try to deal with established professionals who do their job properly. When they occasionally have to turn to an amateur or young professional without much experience, because he or she happens to have specific material from some exotic locale, they find it is difficult to get correct captions and other identification, which is a time-consuming process.

We asked her to compare the "professionalism" of the current young photographers with the work of the "greats" of 20 or 30 years ago when they were equally young. She feels there are comparable percentages of outstanding photographers but she is critical of photographers or agents who submit a vast number of virtually unedited photographs from one particular "take;" she then is unable to properly discern the quality of the individual photographer due to

lack of time. Mathews sees many pictures she would like to buy personally if she were a potential collector and suggests the photographer sign such images to increase their value when sold. These are the photographers she is stimulated by because their pictures show devotion to craft, thought to composition, care in printing, pride of workmanship and, above all, sensitivity to the subject matter. She feels strongly about photographers who take the time to do their own printing, because to her it shows a mastery of technique and that the photographer is serious about his or her work.

She says, "To me it's completely subjective. I respond because I am me, and if I think a picture is beautiful, it's because there is something in me that says I like the beauty of that, whether it's abstract, realistic or powerful or whatever. But on the other hand I get turned off by blatancy."

EVALUATING THE NEEDS OF A MAGAZINE

What to sell to whom? You must take more than a passing glance at a magazine you think might be interested in your work. You should study several issues of the publication in depth because a type of story seen in a particular issue may never have appeared previously or may never be needed again.

Studying a publication as a potential market is easy to do. Most libraries carry back issues of many national publications, as well as more specialized ones. The out-of-town bureaus of national magazines all have bound copies of every issue they have ever published. College and university libraries have many publications, and you can even go to stores selling used books and magazines and find some for a matter of cents per copy.

But it is important, when picking a market, to know exactly what the particular publication is interested in. Studying a big batch of issues of the same house/shelter magazine, for instance, will show a definite pattern of how many building stories are in an issue. Studying a general consumer magazine through several issues will indicate how many food pieces are part of the editorial plan, how much space is devoted to fashion trends or medical problems or whatever.

In a highly specialized department, knowing the *type of readership* is also essential. I remember an agonized telephone call from an editor of a shelter magazine to a photographer saying, "Please. No more stories of barbecues on high-rise balconies. Our audience is made up almost entirely of small homeowners with their own backyards."

Most major publication groups print indexes of what they have already published, and these can be found in their main offices or at their out-of-town bureaus. Some also are available in the public libraries, so when you are overwhelmed by the big story idea and feel it's perfect for a certain magazine or paper, it might be wise to check the index first to see if it hasn't already run. Can't get hold of an index? Then phone the publication and their index department will tell you the date and issue of anything they've printed on the subject. For the cost of a telephone call you might save yourself a lot of embarrassment. If the publication's index shows there was a story on the subject, get the date and issue of the magazine in which it appeared, locate a copy, and see if your story is a duplication or a whole new approach. One simple source of information on whether a particular idea has been previously published is *The Reader's Guide to Periodical Literature*, a massive annual compendium published by the Bowker Company. It is available in most libraries.

Evaluating the policy of any publication is always tricky but is, in the longrun, often rewarding. Much of this evaluation can be accomplished by a continued study of successive issues of a magazine or by analyzing editorial page

opinions. You are not going to get much of a favorable response to a story on migrant farm workers and their problems and poverty from a trade magazine in the fruit and vegetable business, but you might come up with an eight-pager from a medical magazine interested in the health aspects of food workers.

The medical trade magazines, by the way, offer a most unusual opportunity for photographers in the general-interest field. There are a great many medical magazines (four columns listed in *MMP*). "General interest" specifically refers to stories that are nontechnical, and one editor told me that she was interested in stories that doctors would *like to read*. This can be interpreted in two ways and often is. She was referring both to stories that had medical overtones, such as one about the health problems of migratory farm workers or a profile of a doctor in an Ohio River community who looks after the health of the passing rivermen, and also to "general interest" stories such as one on Rome, simply because doctors travel on their vacations. On this same *MMP* list are also a great many medical magazines that are technically oriented, to be sure, but many are not.

One interesting sidelight to the medical magazine group which is unique to the trade magazines is that several are prosperous because they have such a clearly defined audience that they publish several editions—European, South American, etc.—and pay secondary publication fees for the extra editions.

Knowing the policy and the types of photography used by the national consumer and trade magazines is comparatively easy. After all, the magazines come out regularly, and after watching them over the period of an editorial year, you should not find it too hard to understand what they are looking for. It is then up to you to think out the kind of stories you can do which they would be interested in seeing.

In assessing the photographer from the other side of the desk, consideration must be given to the personal feelings of the editor concerning photography and photographers in general. It is evident from those I interviewed that if there are biases, they are usually in favor of the photographer, although there are exceptions, and frequently the biases are not against the photographer but against the material he submits.

Ed Thompson, former managing editor of *Life* and editor and publisher of *Smithsonian* magazine, in an amusing letter to a photographer who had suggested that *Smithsonian* do a certain kind of story on railroads (he turned the idea down), wrote (referring to himself in the third person), "Because he was working late on a Saturday, his then boss, John Shaw Billings [first managing editor of *Life*], spotted him and sent him on a railroad story. He worked hard as he didn't know how much of a railroad buff Billings was and that even a sloppy story would have succeeded. Thus he was assigned to every rail story that came along, and there were a number of them. He got so sick of railroads that they lost their journalistic appeal for him. Perhaps we should say he rises to a point of personal prejudice—Billings always used to say that an editor was no good unless he had unreasonable prejudices." Here we have a case of two biases. Thompson against, and Billings for, railroad stories. In either case, however, there was no bias or prejudice against the photographer, although an inexperienced photographer, not knowing the editors, might have assumed he was disliked and therefore didn't get the story assignment on that basis.

When personal prejudice against a photographer does exist, it usually is based on behavioral problems in the field, failure to deliver what is asked of him, or the editor may perceive him to be insensitive to the needs of the publication. On one recent shooting for a national magazine, a photographer with a big name

and monumental ego behaved so obnoxiously on location that in a very short time he had everyone around against him and, by transference, against the publication as well. This situation became so difficult that it was carried back to the editorial directors of the magazine, and it is doubtful if this photographer will ever work for them again. The photographer in this case had some talent, but his talent was not so unique that the client would tolerate that kind of outrageous behavior.

THE EDITORIAL WORLD: BOOK PUBLISHING

Books are a major source of activity for the photographer, whether he is new or experienced. The number of new titles published each year is in the tens of thousands, and there are literally thousands of publishing houses all over the world. *Literary Market Place (LMP)*, the companion volume to *Magazine Industry Market Place (MMP)* (the "bibles" of the publishing industry) lists more than ten thousand publishers in the United States alone and has a listing of almost twelve hundred "selected major publishers." There are basically three major classifications of book publishing: trade, text, and specialized. *Trade books* as a rule are sold in bookstores or book departments of other stores. *Textbooks* speak for themselves, and *specialized books* can fall in other areas, such as instruction, direct mail or promotional ventures for premiums, and almost any other method of book marketing. Many books overlap in classification and are sold in multiple markets—some identical in every respect and others with changes of binding (hardcover, softcover, library edition, etc.). Some are re-edited for special markets or produced in different (often cheaper) ways for mass distributions. Some publications can be highly specialized and selective, with press runs ranging from the millions to a few hand-printed copies. Many use photographs, both color and black-and-white; many do not. There are almost as many different types of books as there are publishers.

For the photographer to enter this market, careful and detailed analysis is required. Money can indeed be made in substantial sums by the photographer who either authors a major picture book that sells well or supplies publishing houses with pictures that fill their specific needs. Unfortunately, most large, handsome, all-photographic books rarely make a great deal of money, so probably the best-paying market for the photographer is to become one of many suppliers to the textbook houses that do use many photographs and frequently reuse them in secondary editions or other publications.

TRADE BOOKS

The trade book market probably offers the most tantalizing, but not necessarily the most lucrative, opportunity for the photographer in book publishing. How wonderful it is to see a large and handsome book, well reproduced, selling well and with a jacket bearing the magical phrase "Photographs by _____" or, even better, "Photographs and Text by _____." Well, it can happen and does, but not nearly so often as most photographers would like. In order to get published in the "monograph" category, a photographer has to spend many years, perhaps a lifetime, before his name becomes sufficiently familiar to book purchasers. Only that fame will open a publisher's door to the photographer or agent, and that is only half the battle. Photographic books are infinitely more expensive to publish than general trade books; furthermore, they cannot compete with the sexy blockbuster novel in the marketplace. The publisher's interest in ware-

housing beautiful but unsold books over a period of years has been squelched by a major setback, and publishers will remain wary of producing long-term inventory unless Congress upsets a recent tax court ruling that makes the publisher's warehouse just a wayside stop before a quick trip to the remainder table in bookstores.

So the prospect of selling that beautiful photographic book for a big advance and a steady flow of royalties is fast becoming a fading dream. Yet all is not lost, as there remain a few publishers who continue to publish beautiful picture books.

There is, however, more to the trade book market than monographs. Almost every trade book uses a picture of the author on the flap if not on the back cover. Some photographers, particularly those in big publishing centers, get a good return on their author photos, especially because there is a growing trend to send authors out on nation-wide book-promotion tours and local publications need pictures of these traveling celebrities. True, many of these pictures do originate in the big cities where the books are published or where the author lives, but in many cases the newer author who may be on the way up the ladder may very well be a market for the younger photographer.

Another outlet in the trade book field is sociological coverage—housing, adventure, exploration, even news and disasters, theater and drama. Books dealing with these and similar subjects often use many photographs and are for the most part over-the-counter books, though they may be sold in college bookstores, for example.

In book publishing there is also something called the "vanity press." This is *not* the name of a publishing house but is publishing jargon for companies that profit from the vanity and egos of those who feel that they must be published and have the money to pay for the printing and distribution of their own books. Occasionally if an author is lucky enough to have a bookstore sell a few copies, he may get perhaps a 5 percent return on the initial investment. But it is in essence an expensive ego trip, and no matter how much talent the photographer thinks can be displayed, sales are too often nil. Unless you are very rich or egotistical or both, it is wisest to avoid this route of publication.

There is, however, a smaller and more "legitimate" form of publishing that can provide a good deal of recognition and a small financial return. This is in the publication of limited, unpretentious editions by small houses that can distribute and sell three thousand copies or less of a decent picture book. But in order to get even this type of book on press with a legitimate house, the costs have to be tightly controlled, with the author (i.e., the photographer) supplying virtually everything in the way of finished prints, layouts, text, and in some cases absorbing other costs with little or no advance against royalties.

There are about ten thousand general trade bookstores in the U.S., but not all of them will take every book offered, nor does the small publisher always have ready access to the more remote stores, so it is obvious that distribution is always limited, and consequently, so are sales. Therefore the photographer-author should have some knowledge about manufacturing costs. A conversation with a quality printer can result in an approximate determination of the costs of typesetting, paper, printing, binding, etc. There is an old rule of thumb for most picture books, that the list price should be about five (six in some cases) times the bare manufacturing cost. With that in mind, the author can project the maximum potential royalties on a picture book.

So, if the busy photographer-author can come up with a fine picture book in an economical format and is lucky and can sell five thousand copies, after the

year and a half or so that has been spent putting the project together, there may be a gross profit of about $10,000, before deducting the cost of materials, travel, processing and prints, all of which are rarely covered in nonreturnable advances. An experienced photographer might earn from this a standard royalty of 10 to 15 percent of list price. If a book should prove successful, requiring additional printings, the author and the publisher can both make money, because once the initial plate and type costs are recovered, the manufacturing costs of reissuing a book drop and frequently the schedule of royalties increases as the sales go up.

At first glance the budding photographer-author might say, "Swell, there is a market," but not to be overlooked are the costs of distribution, warehousing, selling and promotion, not to mention the publisher's profit, all of which have to come out of the 50 to 60 percent of list price that the publishers get to keep from the sale, providing they don't have to refund part of that to the bookseller for the unsold copies returned for full credit *before* royalties are paid. So let's go back to question number one. Are photographic books a high-income market for the photographer? Not really.

There is no question about the personal satisfaction received from the authorship of a fine picture book, and the attention drawn to it will probably lead to valuable new markets. But the author should not be misled. It's a difficult market to break into.

HOW-TO BOOKS

One growing field in the use of photography in books is the so-called "how-to" book, or what some publishers euphemistically call "self-help." They range from such do-it-yourself items as installing weatherstripping in a house to auto mechanics.

TEXTBOOKS

Textbooks requiring a good deal of specialized photography can be a fine market in the same manner that many of the "how-to" books can make money, but they too should be approached with caution. Unless the photographer is highly specialized in a single subject, it is unusual to find any one photographer who can completely supply the average textbook with stock photographs. More frequently the photographer can fill only a few of such specific needs, but if the photographer is a member of a picture agency that receives a picture request, it may be that the agency as a group can supply a larger share of the requirements of the publisher, and that may accrue some added advantage for the photographer. However, being an agency member may not be that advantageous financially, as the commission taken by the agency could offset the higher return per picture to the individual photographer. Sometimes a royalty arrangement can be worked out if large numbers of photographs on a single subject can be supplied by one photographer (or in some cases by one photo source such as an agency). Textbook royalties are usually much lower than royalties for trade books, though this can be offset because of the larger press runs of textbooks. Here again caution must be exercised because some royalties will have to be shared with the author or authors.

Another way of dealing with textbook publishers reluctant to go the royalty route is to try to work out some sort of total package deal basing picture-production costs on a time-spent rather than a per-picture basis. But this can work only when one photographer can supply most of the illustration needed and the subject matter is concentrated in one field. However, if it means trying

to supply a wide variety of material for a 250-page textbook, then cost factors will probably put it out of reach.

These contracts are rare because publishers are not eager to give out assignments. Traditionally, textbook publishers prefer to play it safe and buy only what they can see in front of them, rather than take a chance and commission a work or even part of a work. Some publishers have gone so far as to set up staff photo systems, but for the most part these have proven unsatisfactory because the broad scope of the material needed in an average illustrated textbook makes it virtually impossible to spread staff people so thin as to be in all places at all times.

There are some special problems regarding textbook photography that the photographer must be aware of. For the most part, textbooks are relatively small in format, usually not over 7″×9½″, and often are 6″×9″ in size. Also, textbook publishers rarely give a photograph much space except in chapter openers, frontispieces or occasionally as endpapers. Often several photographs run on one page, so the average photograph occupies a quarter of a page or less.

The size of photographs in textbooks poses other problems than content. Scenics and landscapes are usually ineffectual unless there is some prominent object in the foreground to indicate scale and depth. Content should be restricted to a single theme. In other words, simplicity is the key. Robert Rahtz, Vice President and Editor in Chief of Macmillan's School Division, says, "Arty and moody photographs are not likely to be accepted for textbooks where the emphasis is on hard facts."

Several new elements have been interjected recently in the content of pictures used in school books, particularly those involving the people in the pictures. Ethnic mixes are now extremely important, and in many cases photographs will not be accepted unless there is a racial mix of Blacks, Orientals, Hispanics and American Indians. Part of these specifications come from pressures by local and state educational departments, as well as from Federal statutes. Another trend is to show minorities and women in what Rahtz calls "positive approaches." "Don't," he says, "show them in the so-called traditional roles—women as secretaries or nurses, Blacks and Hispanics as porters or maids. Try finding female professionals, Black and Hispanic scientists, computer programmers and educators. Show handicapped people working in average situations. The new Federal aid to education laws mandate this, and even if the photographer's picture is perfect in all other respects, unless it meets these criteria it will be rejected. Strangely enough," he continues, "when this program started some years ago there were indeed few people fitting into these 'positive' categories, but the increasing number of photographs coming through now show that it is no longer a rarity to find people in these jobs. Perhaps this type of illustration has really forced the level of minority employment upward toward the more positive."

You must know what you want to photograph in the textbook world. Is it science, biology, anthropology, home economics, fashion, design or carpentry? Go to your library and dig out several books from competing publishers and see just what interests you. Note the publishers and their addresses. If the books in your library are relatively current, they might give you the clue you are looking for. If you do not have enough on hand to make a selection, then get the catalog or catalogs of publishers who interest you. *Literary Market Place* is an excellent source of complete addresses and the names of the people to contact to ask for catalogs and sales lists. A study of these catalogs could show, for example, that

this year a particular house is publishing a book on biology with 200 pictures or one on anthropology with 150 pictures. By going through earlier editions, you will get a pretty good idea of not only the kind of pictures they are interested in but how they may handle their new or revised books on biology or anthropology.

If they use a great many photographs in a very specialized area, you have to decide whether you are qualified to do that work. And remember, more than specialization in high technology is involved here. I am not talking only about photographing laser beams or micro-chip processors or liquid-quartz crystals. I am talking about a general understanding of the work to be done and an appreciation of the problems from the *client's* point of view, not yours.

HOW TO LOCATE A PICTURE BUYER IN A BOOK COMPANY

Having touched briefly on textbooks and their potential for photographers, let's look at them a little more closely in terms of the photographer evaluating them as a market. I talked at length with Stella Kupferberg, photo research manager at John Wiley & Sons, an established publisher of college textbooks, and she agreed that the photographer must know something about the publishing house he pursues as an avenue of picture sales.

If approaching the picture editor of a magazine requires a great deal of thought and consideration, contacting the picture editor of a textbook house is just as involved. Possibly even more so, because the magazine editor is apt to have more experience in dealing with seasoned journalists who have already worked in the magazine world. The textbook editor, however, seems to get more calls from young and inexperienced photographers who are trying to turn professional. Often they fail before they even get a foot in the door.

"This is very sad," said Kupferberg, "because they sometimes have terrific material, though it may take a crowbar to pry it out of them."

Kupferberg gets annoyed when she gets letters from photographers enclosing a list of vague generalities. "These lists," she says, "may have some value to an art director who needs a picture of a butterfly to possibly copy from, but a list that states, 'We have pictures of airplanes, bicycles, children, dogs,' and includes Wyoming in the *W*'s is of no value to me whatsoever. There is not one detail about *what kind of* airplanes or dogs or whatever, or what they are doing or where they are, or any other information of use to the editor."

Another type of communication Kupferberg gets that is guaranteed to raise her hackles is best epitomized by a postcard she received which simply said, "Please send me your wants." Her immediate reaction was to write back and say, "How about someone about six feet tall with a half million bucks who owns a liquor store?" But on second thought she filed it in the wastebasket.

She went on to emphasize that the material she looks for has to be germane to the books she is working on or will be considering. That is why studying the publisher's catalog is so important to the photographer who wants to enter this market.

She related an example where this paid off. "I got a list recently from a photographer who said, 'I have photographed in these countries,' adding a list of them and their cities and a small description of what each coverage entailed and where the photo emphasis was. The letter also had an introductory paragraph that stated, 'I think the material below would be of use to you in your upcoming volume on sociology.' This letter grabbed my attention," she remarked, "because the photographer had taken the trouble to find out what kind of material we were looking for. His list, while not perfect, nevertheless showed

his understanding of a picture buyer and reflected the thinking he had put into the situation." This photographer is now on her list for future calls when those subjects he mentioned are required.

THE EDITORIAL WORLD: CORPORATE PUBLICATIONS

ANNUAL REPORTS

Corporate publications are a fertile field for editorial photography, with the annual report as the flagship publication of most companies. Required by law when a company's stock is publicly held, there have been impressive changes in these publications, particularly over the past two decades.

Prior to World War II, the annual report was the bastion of frozen-faced members of boards of directors. Corporate art directors were unheard of, and the design of the publication was usually left to the nearest print-shop operator, who may or may not have known the difference between a pica rule and a print proportional scale. No one on the corporate level cared so long as the financial tables were readable (particularly if a profit was to be shown for that year).

After World War II a new awareness of corporate images developed, and a new breed of company executive came forward. This was the public relations director, (or some other fancy title bestowed on them such as corporate information manager, public information coordinator, etc.) While large corporations have always had some sort of public relations person around, they invariably had been ex-newspaper men who had paid their dues on the financial pages of the local newspapers, and probably know the location of the "watering holes" of the local press. Their function was to maintain a *low profile* for the company: play down accidents, tout acquisitions or mergers, and publicize community service activities such as contributions to worthy organizations.

The "new look" to corporate communications changed all this. Corporations started to polish their images. Management had begun to realize that the sale of stock (and thus the public acceptance of the company and its product) was no longer entirely controlled by a small number of financial institutions. There was a large market of people who were interested in buying not only the company's products but their stock as well. For this, an image of modernity was needed, and the influence of the big picture magazines' direct (and presumably honest) journalism began to be felt.

Some farsighted public relations people began to turn to magazines such as *Life*, *Fortune* and *Look* for talented source material. Photographers with major magazine credentials, most of whom were free lancers, began to appear on the open-hearth floors and in the aluminum plant pot rooms. The annual report began to look better, and the company public relations people found that these became impressive showcases not only for the annual statement but for general information as well.

With the growth of the more elaborate annual report, company public relations directors found that company treasurers were willing to grant substantial sums for annual report production, not only for good printing and engraving, but for first-rate photography and quality writing as well.

Not too long before this metamorphosis started taking place, there was some parallel activity going on among other large corporations needing major image rebuilding. Prominent was the giant Standard Oil Company of New Jersey

(SONJ), now Exxon, whose image was suffering badly for a variety of reasons.

Large-scale public relations programs were begun, all designed to show the public that these companies (and this was by no means confined to big oil) were in fact dandy organizations who did much to contribute to the public wealth and were not the sprawling specters that the public perceived them to be. Among the things they did was to set up tremendous photographic programs. In the case of SONJ, such a program was headed by Roy Stryker, who was known for his landmark directorship of the Farm Security Administration (FSA). Photo files were created and these pictures were distributed free, with only a photo credit requested. Fine films were made or sponsored and in general the public did indeed benefit, as did the companies themselves, though to what degree is debatable.

The establishment of a number of fine corporate photographic files gave impetus to small companies to build files covering their own industry and emulate the giants. Public relations officials found they could offer up-to-date photography from their files acceptable to media editors, and the costs could be charged to annual report production and not the department's operating budget.

A spinoff of the use of experienced photojournalists for the creation of corporate photographic files was the back-door approach to the major magazines as sources of fine photostories and major essays. Not only were business magazines targeted this way, but many consumer publications as well.

Some of the same companies that took an exceptional interest in photography and writing also established prestigious publications of their own. They are varied and interesting and often do not relate directly to the industry the parent company is serving. They fall into the general classification of "house organs" but in reality are a far cry from the typical company publication. Outstanding examples are Standard Oil's (Exxon's) *The Lamp*, *DuPont* magazine, and IBM's *Think*, which reversed its earlier orientation toward people outside the company — legislators, top-level businessmen in other industries, politicians, and other "opinion makers" — and redirected its focus internally. But its intrinsic quality did not change, and *Think* and the others mentioned remain potential markets for the photojournalist, and the new photographer should not ignore them.

HOUSE ORGANS

Most house organs are much smaller, internal publications, and there are thousands of them. Almost any corporation with more than a couple of hundred employees has some sort of publication that reports births, deaths and marriages, softball game scores and results of bowling matches, and other trivia of interest to the employees and families of a particular company. For the most part these publications are not much of a market for the outside photographer, though a staffer can be kept quite busy filling the picture needs of such a publication. In isolated areas the local free-lance or studio photographer can well find a market here, especially if there is no staff photo department at the company. These publications are by no means all dull and uninteresting—some are quite sophisticated and use photography well. They should not be ignored by the new photographer, as they are a vehicle for gaining experience, particularly as a means of learning to shoot in an industrial plant or under conditions that are less than optimum in regard to light, power, ambiance, etc. In fact, learning to shoot for company newsletters or small house organs is a good way of

developing some of the prerequisites that come with the territory of the photo-journalist.

From a dollar standpoint, the pay is almost insignificant. But if you can arrange to use corporate facilities such as darkrooms, lighting and power sources, and possibly even equipment, from cameras to forklifts and cars or trucks, then shooting for these publications may very well be worth the effort. And if a corporation is indeed blessed with an attractive publication, then a sheaf of pages from it would certainly enhance the new photographer's port-folio.

LOCATING THE PICTURE BUYERS IN CORPORATIONS

Knowing that there are thousands of markets for photographs in publications without mastheads or other identification of editorial people, how can you find the names of those who need to see your work? Photo buyers in corporations have to be searched out as carefully as their counterparts in big publication groups. Yet with diligence you can locate them with the aid of listings of corporate officers or department heads.

How does a photographer find a photo buyer in a major industrial corporation? Start with the geographic edition of the *Standard Directory of Advertisers* and find the alphabetical listing of that steel company in your own home town with which you are trying to make contact. As in magazine and newspaper mastheads, there is usually a top to bottom listing of major officers and often many of the minor ones as well. But instead of editors and art directors, or news editors and picture researchers, you will find comptrollers, labor relations officers, marketing directors, finance officers, product safety managers, product designers, public relations officers and many other titles. Some of the titles, particularly in the information field, can be either ambiguous or lofty or both, with many of the people hidden behind clouds of fancy names such as director of corporate communications, community interest director, corporate identity manager, urban relations counselor, etc. Don't let their titles confuse you — they are all public relations people in one form or another and are the people with whom you start.

But suppose there is no one listed in any of these fields. Which would seem to be the obvious titles? Consider just what it is you are trying to sell. Annual report photography? Try the treasurer or secretary or finance officer of the company. Advertising? There probably is an advertising manager. Brochures? How about the marketing director or the new products manager? None of these? See if there is an advertising agency listed, and there probably will be. If so, there should be a listing of the account executive (AE) and you can start with him. If all else fails, pick up the phone and go back to square one to ask who handles public relations or advertising.

A new wrinkle in the production of corporate photography is the use of an outside design and production company to produce the annual report, although many large companies have long used outside public relations firms not only to supervise the production of their annual reports but to serve as consultants for other publications as well. The rise of specialized design houses producing only annual reports has not done the photographer coming into the market too much good because of the tendency of these specialized firms to build a stable of their own photographers who work for *them* rather than the parent company for whom the annual report is being produced.

What happens is that the photographer is thus insulated from actual contact with the corporate management, which is unfortunate, because when the photographer arrives at the plant, he comes in as an outsider and is not perceived as coming from within management. Therefore the level of cooperation he receives from middle management is often poor and ineffectual. Another problem arises when the outside design house charges fairly stiff fees for the photographer's service but pays the photographer at lower rates. The photographer does not really know what charges are being made for his services and what the design house is actually billing, so the photographer must be careful that the design house is not acting as both *employer and agent*.

FRANCES McLAUGHLIN-GILL

Fashion photography is a branch of the art almost equally divided between commercial illustration and editorial photojournalism. Widely used editorially in fashion and other magazines, it probably receives equal if not greater billings in the advertising pages of those same magazines. There is another big outlet for fashion photographers in catalogs, brochures and point-of-purchase advertising.

Every specialty has its stars, and no star shines brighter than Frances McLaughlin-Gill, who after 40 years of superb fashion photography is still producing first-rate editorial layouts and advertising campaigns.

Gill graduated in 1941 from the Art School of Pratt Institute and started to work first as an assistant in a studio. In 1943 she joined the Condé Nast organization as a staff photographer for *Vogue* magazine. She remained on the staff until the studio closed in 1954 and then started her own studio and continued under contract for another 15 years.

She and the other photographers worked on a wide variety of subjects: still lifes, fashions, products, beauty personalities, interiors. They were directed by Alexander Liberman, *Vogue's* legendary art director. He sharpened the skills of all the photographers by moving them around into various specialties. Gill says he was wonderful about encouraging all his photographers to try new approaches and new concepts in photography, but she also spoke of his insistence on photographers doing what he wanted them to do first before trying out any ideas of their own. Because of this training, she advises that the photographer should do alternate situations gracefully and with the same devotion he gives to his own ideas, but he should never be deterred from producing a picture as he sees it. The photographer has to learn how to deal firmly with these situations without offending the client, the art director, etc.

Fashion is the one branch of photography in which it is virtually impossible for the photographer to work alone. Gill underlines the absolute necessity for the photographer to be able to work as part of a team, and although she thought this should be a trait of almost every kind of photographer, it is particularly true

in fashion. To produce fine fashion photography one has to be able to work well with the editor, art director, makeup artists and hair stylists and, most importantly, the model(s). She emphasizes that the fashion photographer, in order to keep current, must work frequently and consistently in order to stay at the peak of his craft, as fashions themselves change so radically and rapidly.

Homework done by the photographer prior to the assignment is vital to the success or failure of the job, Gill insists. It is the responsibility of the photographer to make certain that all his props are gathered, the locations are scouted, even when such chores are delegated to staff. When pictures are to be made of personalities, she recommends that everything be planned as much as possible in advance, even if the photographer has to spend an extra day to find out what the person looks like, what he or she may be wearing, and perhaps something about the ambiance of the locale where the photograph will be made.

Because fashion photography is closely akin to show business in a certain sense, Gill thinks it is hard for one to become a fashion photographer unless a whole team exists around him. Samples of the photographer's ability or good-idea sense must be shown to a prospective client, but with the need for producing in a team environment, how does the newcomer to fashion do this when he himself is new and probably unknown?

A fashion portfolio should have photographs using the best and most experienced models available, but these days four-figure rates for several hours of shooting are not unusual. So how does the newcomer get samples?

One suggestion of Gill's is to make an arrangement with model agencies to make photographs of the newer models who have yet to build up large and impressive portfolios. Some of the top-ranked model agencies will make special efforts to get good model books for all their models and will help them locate a good photographer. Some agencies have set up special departments just to do this.

Another source of professional models is department stores or larger specialty shops that use models in fashion shows and for local trade or advertising. Garment manufacturers also employ models on a permanent basis for showroom work. These models, like their more highly paid agency counterparts, are often in need of modeling portfolios, and it is possible that some arrangements can be made with them to exchange services. Models used in college or university art classes may be available, but their physical characteristics may not be right for fashion photography. But any models used should be of professional caliber.

Gill said that we would be amazed at the number of young couples around —male as photographer, female as model—who have the one-to-one relationship that is often useful in producing fine fashion photographs for portfolios and model books. She did not mean to overemphasize this relationship since a big part of the fashion industry deals with mens wear, though she has suggested that some of her women students consider fashion photography portfolios for men on much the same basis. Most outlets for male fashion photography are in catalogs, magazines and newspaper ads, with some point-of-purchase use in stores and showrooms.

Gill stressed the importance of the model to the total photographic fashion situation and said that the photographer must never lose sight of the person-to-person relationship. If too many people interfere in a studio situation, the photographer must stop such interference and assert his instincts or the shoot will be a failure. The photographer should have his own ideas and stick to them.

As for the model, Gill said that the most important role for the photographer (besides the actual shooting) is to make the model feel she is important. Too much handling (or even manhandling), too much changing of costume or accessories, will tend to upset a model. (This applies to male models as well.) It's a volatile situation for the model. It is up to the photographer to control the situation and establish a good rapport with the model in order to bring out the best and most productive side of her and all the rest of those on the set.

There is a growing policy among photographers *not* to do the model billing. This stems from state laws that interpret the hiring of a model as an employment-agency situation and thus make the commissions and fees tightly controlled. But another reason for the photographer not to bill model fees is that frequently enormous sums of money are tied up in these billings because many ad agencies unfortunately take an unconscionably long time to pay their bills, sometimes 90 to 120 days. The agencies often blame these delays on clients who want to approve the ads before payment. Most photographers are unwilling to advance the often large sums involved because they may simply not have this kind of capital available for such long periods of time. Therefore it is important that in any model hiring effort, it must be clearly specified in the purchase order that the model or model agency will bill the client or the client's agency directly.

Because Gill feels that the core of any photographic effort is the actual photograph itself, she has her own personal criteria of five components of any good photograph, feeling that if any one is lacking, the photograph has failed: (1) skillful composition, (2) technical quality and control, (3) excellent lighting, (4) the element of chance, and (5) persisting until the right image is on film.

CHAPTER 3

ANALYZING SPECIFIC MARKETS: COMMERCIAL AND ADVERTISING PHOTOGRAPHY

If you think the editorial side is complicated, try the commercial. Every letter of the alphabet could provide a classification for some form of commercial photograph. In this group are audio-visual products, real estate and architectural photography. Now add public relations, passport and wedding photographs, fashion photography and display and point-of-purchase efforts—you have still only just begun to scratch the surface of all the opportunities in commercial areas.

The overlapping of editorial and commercial work became so complex and involved that at one point the ASMP went so far as to change its name to the Society of Photographers in Communications to include that very broad band of photographers who were producing advertising photography for the most part. Certainly the work of advertising photographers met all other ASMP criteria—information, news, and opinion. The only real difference was the way the work was physically intended for use in the magazine or publication. But the 35-year-old image of the ASMP was so firmly fixed in the minds of the photographic world as that of magazine photographers that the new complicated name was dropped and the advertising photographers remained as members by interpreting the term "magazine photography" as including photography for advertising in magazines.

Complex as editorial photography is, the world of commercial photography is even more so. The editorial side is more or less limited to the familiar forms of print media plus the now growing electronic video display. The commercial world goes way beyond the printed page or the video screen; it reaches out to three-dimensional displays, whether in a store window or point-of-purchase cutout figures on a drugstore counter. The worlds of fashion, food, still life, house furnishings, and lifestyles are at once different and similar for the photographer. Each division can be broken down into minute subsections of specialization. Public relations photography, product promotion, political coverage, audio-visuals for schools or commerce or just plain entertainment, TV stills, motion picture clips for still use, real estate, architecture, biological life sci-

ences, and aerial photography, photogrammetry and forensics, catalogs for mail order houses such as Montgomery Ward or Sears, or swinging all the way to the chic, exotic and exquisitely printed multi-color productions from Neiman Marcus and Sakowitz offering his and hers helicopters or private safaries for 50 people for Christmas—all of this and more is grist for the commercial photographer's mill.

Most commercial photography requires the use of a studio, and often (but not always) demands the availability of highly complex lighting equipment, although much can be accomplished with relatively simple gear. High-fashion photographs, and even many on a simpler level, are often shot on location. In some situations where there is a great demand for fashion and product photography by a single organization, the clients may provide the studio locations and equipment yet not employ staff photographers. In these shops a photographer can turn out a variety of photographs on subjects ranging from lingerie to ball bearings. Often banks and large advertising agencies have their own photographic departments with completely equipped studios and yet utilize free lancers to give them variety and a fresh approach. In the world of forensic science, health, medicine or even biologicals, many facilities are available at law-enforcement or health-care organizations, since the average free lancer or small independent studio can ill afford to install electron microscopes, computer capability or other sophisticated equipment.

PUBLIC RELATIONS PHOTOGRAPHY OR COMMERCIAL—WHAT'S THE DIFFERENCE?

One branch of commercial photography that is often difficult to categorize is the broad spectrum called "public relations" photography. Frequently it takes the appearance of editorial matter yet in truth is a form of commercial photography because it often is used to promote a product, service or even the good name of a personality who in turn may be selling a service. Theatrical personalities have as much a need for public relations photography as product managers do. Corporations and their executives use photography to improve corporate images (or disguise them if necessary) to win public acceptance in multitudinous ways, even though the corporate annual report has arbitrarily been put into the editorial category of this book, where I think it rightly belongs.

What is the real difference between advertising and public relations photography? Ask 30 experts on the subjects and you will get as many different explanations. Ezra Stoller, for example, an internationally famous architectural photographer, defines publicity as "everything except paid media advertising." Other pros have other definitions. This question can be reduced to basics by applying the rules of editorial usage versus paid space. Simply put, when space and/or time is purchased by a client, through an ad agency or otherwise, and material is delivered ready for printing (or airing on TV or radio), it is considered advertising. If the public relations department or agency calls an editor from whatever media and "sells" the idea of using this material as editorial or new matter, it is considered publicity and/or public relations, and it should not be confused with paid space advertising, yet it often does. (See section on model releases.)

It would seem simple, but it's not, because there are many interpretations of the word "publicity." Even dictionaries seem to differ, some holding only to the "dissemination of information" concept and others going so far as to define it in the world of "paid advertising." The definitions we use have to be specifically

oriented towards photography so I tend to reject most common dictionary definitions.

Evaluating the public relations field is complex. I have talked about public relations photography and its general need and use for good photography. After all, the public relations agency is being hired to get space in the media for the client, and just as magazine editors are interested in fresh ideas from outside sources, so the major public relations firms are interested in ideas that they can present to (or for) their clients in the hope of the same accomplishment—story space.

HOW TO PRESENT A STORY IDEA FOR PUBLIC RELATIONS

As a photographer looking for new markets, what do you do when you see, hear or read of a great new machine, process, scientific breakthrough or even a pattern of news events that point up some common nationwide problem (pollution, floods, accidents) and think that perhaps you can report it better in a way with photographs?

At first you explore the idea of dealing directly with magazines or newspapers by memo or phone call and you find out that, while they may be interested in the subject, they are not very happy about spending a lot of money on a new approach to it—or they may not know enough about the story and would like more information in the way of pictures, copy, etc., before they commit themselves, or they may not know enough about you to entrust you with the idea. You should be able to tell from their conversation whether they are really interested or are just trying to get rid of you. But don't drop it there. Go back to your little guide books, get the name of the manufacturer, his public relations people in or out of house, and go to see them, or if it's a news or public information item, check the indexes and see who has already done what on the subject. In other words, research. research. research. After some effort you should be able to come up with some workable information:

1. What is the subject—be it machine or situation.
2. Who would be interested in seeing publicity on it?
3. What does it do and who makes it, or what is the trend or pattern?
4. Where would it be published?
5. Why should it be published?
(Simply a variant on the five *W*'s of journalism.)

So if you have explored the media directly without positive results, you try the back door, by dealing with the public relations people. You should be able to convince them (if your information and assessments are correct) that such-and-such magazine is interested in doing this story and how about getting their (client) company to put up the money for you to shoot the photo essay on the subject for presentation to the management. You give enough information to show that you've researched the story and can do the job. But keep to generalities until there is a need for detailed planning. Ideas cannot be patented or copyrighted, so you cannot protect your "idea" as such from being copied and given to someone else. Chances are, if you are dealing with a reputable organization, your idea will be either accepted or rejected but not stolen. If by chance it is, there is little recourse.

By proving your knowledge of the field or your expertise in the subject, and learning the policy and interests of the publication you are dealing with, you stand a pretty good chance of working your way into the assignment. One little side benefit worth mentioning is that even if a PR house or their client pays you

to shoot the story and a national magazine uses it, it is likely that the magazine will also voluntarily pay you a space rate for the use of the photographs. This is a right you should reserve when you shoot an editorial piece for PR use, provided you place the story directly, not the PR shop. From here on it's up to you. My experience, and that of many colleagues, indicates that these approaches are often the most promising in all fields of photography with one glaring exception: national advertising.

If you are on the outside looking in, particularly if you are young and just starting, the presentation of ideas to an ad agency or ad manager of a corporation will often fly like a lead balloon. Just as publications and corporate public relations operations are eager for fresh approaches, the ad agencies seem to be as determinedly closed to outside thinking, which possibly says something about the staleness of some advertising photography.

Advertising photography is a broad term that has to be broken down in many ways. It includes fashion and lifestyles; still lifes from food to household appliances and all manner of liquid products from alcohol to coffee and teas, anything that can be bottled, canned, frozen, sprayed or dehydrated; there are still lifes of still lifes, that is, copies of paintings and works of art and other visual works; there is architecture and construction and land and real estate to photograph. Each of these is a specialty area and yet all have many things in common. What has the architectural photographer, for instance, in common with the biologist who is working in a laboratory? Has the studio photographer any problems similar to the aerial photographer who is trying to chart a road through a jungle or steamship sinking 50 miles out to sea?

Of course there are common denominators outside the technology of cameras, film, processing and lighting. One common denominator has to be the love and desire for the field in which the photographer is specializing. There is no sense in a photographer who has neither interest nor knowledge in clothing styles becoming a fashion photographer. One certainly can learn, to be sure, but the key word here is *interest*. The love and desire for the craft of photography and specialization in a field of interest are the watchwords for the newcomer, and nowhere is this more apparent than in the world of advertising photography.

Each specialization will bring variations in methods of operation. What applies to the still life photographer does not necessarily work for the architectural specialist. The aerial photographer has many problems that the photographer behind a microscope would never understand, and vice versa.

INSIGHTS INTO THE FIELD OF COMMERCIAL PHOTOGRAPHY

I asked some friends in the ad world why advertising agencies weren't interested in outside thinking and their answers seemed similar. There is a hierarchy in advertising-agency account structure that starts with the group head or the creative director, who is usually the supervisor of a team that includes the copywriter and the art director. The latter usually are responsible for creation of the ad, including the photography, word copy and layout. When a concept is worked out, it is visualized in a layout composed of sketches, "swipes" from clippings of other ads or publications, or dummy type and photographs. This is called a composite, or "comp."

From here it goes to the client, who may or may not approve. If not approved, the ad is reworked until approval is received and then the photographic part is sent out for execution. In some but not all cases, execution might be the

key word, because any photographer who tries to deviate from the approved concept is invariably discouraged.

I recently attended a seminar where art directors were asked about the lack of room for photographers to move beyond the fixed layout into creativity of their own. A number of the art directors said, "Oh, but we always allow the photographer to shoot what he wants after the original layout is done exactly as we have ordered." When another participant asked how often they use those photographs in the finished ads, the silence was deafening. Ideas for advertising photography rarely are accepted from outside sources not connected with either the agency or the client directly.

Does this mean that the photographer should not come up with fresh ideas in which an advertiser might be interested? Certainly not. But it is far better for the photographer to concentrate on including smashing photographs in his portfolio (or "book" in ad lingo) rather than attempt to do the thinking for the art director on how a message should be presented. That great photograph may well be the trigger for a whole slew of ideas from the agency on how to use this photographer's particular talent.

Another friend in the advertising world told of one photographer who decided he wanted to do liquor advertising. However instead of trying to create an entire ad layout, as many young photographers try to do, he photographed many liquor bottles in every creative way he could and showed those pictures to an art director. This stimulated the art director to think how ads could be conceived using this photographer's approach and thus an ad idea was created and the photographer indeed got the assignment.

INSIDER: BILL STETTNER, PHOTOGRAPHER

While fashion is a very important part of advertising photography, it by no means dominates it, nor can it be ranked accurately as to its relative scale of importance. Gross billings for advertising, still life, product and illustrative photography are probably equivalent to fashion. Over the years advertising photography has built its stable of stars and high earners. And even though the creative director of one ad agency felt that the fashion photographer had to be "totally engrossed" in fashion, it does not seem to be the case of the advertising still life photographer, who evidently can be a lot more flexible and eclectic in his devotion to craft.

Highly regarded and extremely active, photographer Bill Stettner runs a busy studio on New York's East Side, where he turns out fine still life product and illustrative photographs for major advertisers that include Smirnoff vodka, Gordon's gin, Winston cigarettes, American Airlines and many more. He does not restrict his activity to working and making money, but has been active as a trustee on the board of governors of the ASMP and as Treasurer of Advertising Photographers of America (APA), and is deeply concerned about the life of the photographer in general and his or her ability to function and be productive.

His training, classic in part, was not unusual since his father was a photographer before him. He tried the wedding photography route and he photographed Robert Kennedy's wedding. He went to an industrial arts school, then joined the Navy in 1957, and was classified as a photographer. He then began a series of apprenticeships with several leading studios and opened his own studio in 1964 in partnership with John Paul Endress.

After initial hard times he began to build a volume of traffic that now grosses over half a million dollars per year. But lest the new photographer enter this kind of business with the expectation of becoming an instant millionaire, let

him be warned that a million-dollar-plus gross or even single billings of $120,000 or more do not indicate what the photographer earns. The large productions that Stettner mounts often involve 15 or 20 people, ranging from stylists and assistants to darkroom and front-office help, not to mention overhead costs. So when the total amounts are boiled down, the bottom-line net-profit figures are more aptly represented, at best, as a good though still modest income.

I asked him: Can a photographer get rich in advertising? His answer: "It's not easy. When I started I had the same horrendous problems that so many others had, a lot of struggles, cash flow problems . . . always problems. These are the first two years after sixteen in the business that I have felt I was earning anything near what I expected to earn when I first started."

Asked if he uses a "rep," Stettner said he has always worked with an agent, except for the first few months when he went into business for himself. He said, "I didn't have one, and when I tried to sell myself, it was terrible, facing the art directors with my own work and being reluctant to accept any kind of criticism of it."

His rep works on a commission which is a percentage of gross fees and she has been with him for four years. When I asked him about the number of reps he has had over the years, we began to get close to a question that has become increasingly uncomfortable for many in the advertising business. That is the problem of kick-backs, pay-offs, or down-right bribes to greedy and unscrupulous art directors or art buyers. (Fortunately, it seems more a problem of the past than a current one.) So when I asked Stettner about the reps he has used and why he changed, he said that when in two cases he found that they were indeed "paying off," he promptly severed relations with them.

He was not reluctant to talk about this because he is very emphatic about refusing to go along with any such demands and said that his reps had been approached several times over the years. On two occasions when the approach was direct, he refused to pay. On a few other occasions when there were hints, he ignored them and simply "played dumb." He thinks that pay-offs are totally unnecessary and feels that the good photographer, when teamed with a good rep, can make a very good living in advertising without resorting to questionable methods of getting work.

When I asked Stettner how he structured his fees, he was open and candid. He operates on a minimum (current) day rate of $1,500, and while he does not have a maximum rate, the highest day rate he has been able to achieve is $3,500. These day rates represent the use of one picture per shooting day; any other pictures have to be paid for additionally.

The use of a photograph plays a part in determining rates—that is, where a picture is to be used, the number of times an ad is inserted in one publication or a number of different publications, etc. But rates for use, he said, are almost always determined by the agency, rather than the photographer. Traditionally agency fees are determined by a percentage of the media rate, so the greater the number of insertions of a photograph, the larger the billings to the agency and consequently the larger the fees to the photographer. Some agencies allocate about 10 percent of media cost to art and production, and the original "art" (photography or graphic art) can be expected to receive half of that. But that rule is used only when a few national magazines are involved, not a nationwide blanketing by media.

However, the basic fees are set by the photographer, who in turn bases his fees on an assessment of the client, the type of ad that is inserted and the ultimate usage and times of use. Stettner reminded me that talent charges (i.e.,

models) are not billable by the photographer and do not figure into his fees or expenses. All other expenses are calculated and thoroughly discussed with the client before the shooting takes place, with the fee being set as an independent item. Everything above the fee is billable and that includes darkroom, prints or color processing and materials. He said that he felt he could usually estimate a job within 5 percent of the final figure, even though accepted trade practice is usually to calculate within 10 percent.

For Stettner, stock photography has not been truly worthwhile, and if on occasion he gets a rare call and can quickly lay his hands on a picture that suits the request, he follows the ASMP recommendations on pricing and usually lets it go at that. He also has little interest in producing fine-arts photography for gallery use, preferring to use his creativity in designing his photographs around the composition of the ad as specified.

INSIDER: TANA HOBAN, PHOTOGRAPHER

Tana Hoban, a well-known photographer who specializes in children and books for children, is widely recognized in the advertising and editorial worlds as top-rated. She began her career as an art student at the Moore Institute of Art and Design for Women in Philadelphia. In her first year she convinced her dean that she could draw better than many other students there, and won a scholarship for the next three years. Photography was offered in the final semester. She then won the John Frederick Lewis Fellowship to paint in Europe.

When getting started, she would spend much time tracking down appealing children, photographing them over a period of several days, producing romantic, nostalgic images of little boys and girls. While her backgrounds were carefully chosen, she would encourage the children to respond spontaneously to the environment. Her pictures developed a special flavor that soon brought her professional prominence. Very early in her career, she took some of her pictures to the largest ad agency in the country, J. Walter Thompson, and they promptly gave her a show. That led to her being included in a magazine article on successful women photographers, and her career began to mushroom. Her work appeared in *Good Housekeeping* magazine, *Ladies' Home Journal, Vogue, Life* and other magazines. She was put on retainer by Kodak, to experiment with the early Kodacolor films that were being pushed by Kodak for the "family" market.

Hoban did just about everything right in getting new work to survive as a photographer. She did not rest on her laurels. She actively followed ad and editorial campaigns that used children and family situations. She would then track down the various art directors who were responsible. In this way, she was assigned to shoot ads for baby food, children's fashions, and family situations. More important, she kept a notebook of every interview she had, what the art director said, what they were looking for, and would then prepare and deliver new samples of what she wanted to show.

At the beginning, she shot a lot just for herself, without assignments, to refine her technique and approach. She would shoot color in the spring when the blossom and foliage background would be complimentary to the feeling for young children she wanted to evoke. Her decision to concen rate on children was not based on her own emotions as a mother, but more from a desire to deal with human relationships rather than inanimate objects such as products. She discovered she had an especially good rapport with children. She preferred dealing with them because of their naturalness of response, and felt less com-

fortable with adults who were too conscious of things like make-up, poses, dress, etc.

Hoban feels it is extremely important for a photographer to keep shooting constantly whether there is an assignment or not, because in the process he learns a great deal and improves approach and style. Even now when she has time between assignments, she is continually shooting and experimenting in new ways of lighting, of using new film and camera combinations to create wholly new effects.

INSIDER: WILLIAM TAUBIN, ART DIRECTOR

If there were such a thing as a dean of the world of advertising photography, that title would be bestowed on William "Bill" Taubin of the Doyle Dane Bernbach agency in New York. He was nominated for the "Hall of Fame" by the Advertising Club of New York in 1981, an honor that is hard to beat. A quiet, distinguished-looking man, Taubin has been with DDB for 27 years. It is only the second job he has had in the advertising world, after graduation from the Parsons School as a graphics design and advertising major.

I asked him which of his advertising campaigns he likes best. Among his favorites is Levy's Jewish Rye, a sparkling campaign using photographs of people with strong ethnic features under a headline that says, "You don't have to be Jewish to love Levy's." Taubin also put together the fine advertising for Olin Industries, American Airlines, El-Al Airlines and the French Government Tourist Office.

When asked the question that interests most photographers, "How does the new photographer get started in advertising?" he answered, "It's not easy. Most photographers start by going to some sort of photography school, though I don't think that is absolutely necessary. Often a new photographer will start by getting a job as an assistant to another photographer for several years, learning the basics. Then if he has developed lots of experience and has lots of money, he opens his own studio. And of course if he is smart, he won't do it in a recessionary period such as we have now." He went on to say, "If I were a young photographer now and had a good job in a studio, I would stay there for the present."

Taubin was not encouraging, but went on, "I think if a new photographer can get a reasonably good rep, in itself hard to do, it will be a great deal of help to him in the advertising business, particularly if the photographer is very young. I will see a rep I know and respect a lot more quickly than a young, inexperienced photographer I do not know. In dealing with a good rep I know that he will not take my time for people he knows I cannot use."

He did say, however, that he was apprehensive about working with untried and inexperienced photographers because he felt most could not cope with the pressure of heavy deadlines and possible client disapproval of the results of a given shooting, even though the photographer himself might not be at fault. Taubin said he wants to "at least lead with an ace" so that the ability or experience of the photographer is not a vulnerable point.

I asked him, "How, then, does the young photographer get his foot in the door?" He said, "It's a hard question and I have to admit that one word you used earlier probably is the most important one . . . persistence." Persistence is more than coping with being rejected a number of times and still coming back. Persistence means the continuing presentation of good photographic work and interpretation of problems, and this can start on a lower echelon than the Bill Taubins.

Taubin felt it was not a bad idea for the young photographer to contact art buyers rather than art directors at the beginning of his career. At DDB the art buyers' primary role is to tell art directors about existant photographs (i.e., stock pictures) and they are also in a position to recommend a photographer who has shown them something they like and who could very well produce a needed picture when it cannot be obtained from stock.

When discussing working from sketches or "comps," Taubin referred to the necessity of having a client approve an idea in advance, leaving only the execution to be performed. When I suggested that this removes or reduces creativity by the photographer, he defended the practice by saying, "Perhaps, but the experienced photographer will probably bring an undefinable little extra, an unplanned thought . . ."

He also defended the "comp" as being a lot more carefully thought out than we were giving the agency credit for, and he said he wants that covered first and then he does want input from the photographer. He also said that good, experienced photographers always will improvise and bring something more to a shooting than what was asked of them.

Taubin is quite critical of the level of the craftsmanship of many photographers. He is strong on sharpness in a photograph as an indication of craftsmanship. Craftsmanship to Taubin also means precision and the indefinable quality called "good taste." It comes down to the photographer's knowledge of lighting, optics and film and selection of the most appropriate format. Taubin also said he is disturbed by a lot of young photographers who produce work in terrible taste. Good taste is extremely important, though hard to define. Nudity can be vulgar and in bad taste, but it can also be absolutely beautiful. The photographer's dress and appearance are indicators of his taste, or lack of it.

At Taubin's level he much prefers to deal with "specialists." When he is working on cars, for instance, which are very difficult to photograph because of the reflections of the metal, he wants someone who not only understands the problem but has dealt with it successfully before. This applies to other types of work and he tends to gravitate to those with the most experience in whatever category he is concentrating on.

Taubin reserves for the agency the conceptual approach to an ad, and when I asked him if they ever call a photographer into conference before a comp was prepared he said that this is never done at DDB. Yet this is by no means a universal advertising concept. Phil Franznick, president and creative director of the recently renamed Franznick & Cusatis (formerly the Advertising Workshop Agency) thinks his agency's approach probably falls in the middle, without any hard and fast rules concerning the photographer's creativity and input before an ad is shot. Taubin says that the responsibility for developing the concept for an ad lies within the agency and the photographer cannot expect to participate seriously in its planning. Thus, while every art director does say he wants the photographer's creative input, about the only place ideas will be accepted will be in a limited number of situations after the comps are fulfilled. This differs from editorial photography, where it is extremely rare for the art director to become directly involved before a shooting, leaving such direction to editors and picture editors.

Taubin also feels that despite the great skill and ability among many photographers he knows and deals with, very few of them have what he calls an "advertising sense." He judges many shows and thinks that what many photographers think is "good advertising photography" is not the case at all.

Taubin has a relaxed attitude on portfolios, though he feels there is a correlation between the photographer's attitudes and how his "book" looks. If the portfolio is sloppy, he suspects that the photographer is sloppy as well and his pictures might show that he was not very interested in producing pictures of high technical quality. Taubin is ambivalent about the physical format of the portfolio. He will view whatever is presented and does not particularly care whether work is presented as transparencies or prints, but since he personally likes the large-format camera and the clear detail apparent in large transparencies, he much prefers to put them on a light box rather than deal with 35mm slides, projected or otherwise. "It boils down," Taubin said, "to showing what the photographer feels most comfortable with." As for content, he would prefer to see material that the photographer specializes in. He also likes to see a mix of other material. "Often," Taubin went on, "it would seem that those who have a great love for still life might not do as well with people, so I want to see what interests each photographer most."

INSIDER: PHIL FRANZNICK, ART DIRECTOR

Phil Franznick, president and creative director of Franznick & Cusatis, a well-thought-of but smaller agency than DDB, said he was startled to hear of the system at one ad agency where the copywriter and art director plan the photography, but he also explained that since the copywriter is part of the overall team consisting of many people involved in the production of a print ad, it is total input of everyone concerned that helps bring the ad together.

Television commercials are probably the influential factor in the group approach to preparing a print ad, since so many more people are involved in a television commercial. Some years ago the practice in preparing a print ad was that the account executive asked the art director to come up with a visual idea, but it doesn't seem to happen that way anymore. Now the creative director sets the direction of the ad and guides the creative people. The creative director can influence the direction of the ad and probably is influential in deciding what type of photography is needed, perhaps who is used, and is responsible for the "image." Because of this, the creative director is probably the most important person on the account involved in selection of the photographer, though the actual shooting is most often supervised by the art director. It is also highly likely that the creative director will be present along with the copywriter and others.

At Franznick & Cusatis they work a lot more loosely, Franznick says. They establish the AD's general concept with the client, but will not produce, or expect the photographer to work tightly from, a finished "comp." Franznick does not believe it possible for the photographer to produce his best effort in this manner. They will do rough comps to give the photographer an idea of what they are looking for, but the rest is up to him. In the world of fashion or personal products such as fragrances or jewelry, he thinks the tight comp is too restrictive on the photographer's talent. Franznick went on to say that to satisfy their accounts, there has to be a "certain poetry, a certain romance" in the kind of photography they choose for the job, and that can come only with freedom for the photographer. If freedom in creativity is not involved, the ad will suffer, and it is nonsensical for an agency to spend thousands of dollars on a photographer who just pushes a cable release. It is on this type of account that there is perhaps the most leeway for the new photographer to come in with creative ideas that can be translated into sound work.

It is easier for the new photographer to approach this type of agency than the bigger and more formal competitors, but this is not to say that the photographer will have an easier time of getting work since he still has to sell his ability and there are fewer accounts to pursue.

I asked Franznick the same questions I asked of Taubin: How does the young photographer get his foot in the agency door and does he share Taubin's views on using the more experienced photographer rather than taking a chance on the new one? Franznick shares some of Taubin's feelings about calling upon established photographers to produce advertising photography because if the ad is a success, the agency comes off looking good, and if the ad is less successful, at least the failure cannot be laid at the feet of an inexperienced photographer. But he also is pragmatic and says he will use the best talent his budget will allow. All things being equal, he knows he can count on the more experienced photographer to come through in a pinch and thus make the agency look good.

Franznick is sympathetic to the young photographer and agrees that the system is hard insofar as getting started. He, too, thinks persistence has become a factor. He recalled his own 25 years in the advertising business and said he believes that any photographer can ultimately get to talk to anyone he really wants to talk to if he knows who it is he wants to see. "There are many ways of reaching people," he commented, "and perhaps if I were a salesman of some other service or commodity, I might not be able to do so, but in the creative world I really think it can be done by the kind of persistence that does not annoy or infringe on another person's time or function."

"Does the advertising photographer need a studio?" I asked Franznick, and his answer was an unqualified "yes." He wants the photographers he uses to have studios available even though they may be shooting on location, because often a client's products have to be photographed in a studio.

He confirms the feeling of "uniqueness" in fashion photography that Frances McLaughlin-Gill spoke of and added that the fashion photographer has to be "totally engrossed" in his work. This attitude (or lack of it) will most certainly show up in the photographer's dealings with the production team—models, stylists, hairdressers, makeup artists. In the "high-fashion" world of luxury jewelry, couturier design and expensive furs, this total commitment is even more needed. Franznick also thinks that there are perhaps only a dozen or so models in this world that he can use for certain products. The photographer must be aware of this, even to the extent of knowing what stylists are "in," what the newest fashion trends are, etc. All these things and more that would seem to be beyond the responsibility of the photographer are, in fact, not. Product photography differs markedly from fashion work and there are highly skilled specialists in both areas. In spite of the desire of many photographers to be able to deal with both branches of the trade with equal ability, the differences are vast and thus difficult to bridge successfully.

Often in the case of photographers, Franznick refers them directly to his art directors rather than dealing personally with every hopeful who comes through. He said, "The good people in this business understand the need to be seen and they will make a sincere effort to see new talent as often as possible, so the photographer should not be discouraged at occasional turndowns for interviews."

Franznick said he prefers not to have the photographer present when he reviews a portfolio, though he will often tolerate a rep's presence since he knows that the rep understands the situation a lot better than the young photographer might and thus will not be breathing down his neck in anxiety. But this

is where the presence of the rep stops. If an assignment is given, then the agent or the rep has to step out of the picture immediately. This feeling is not Franznick's alone. Most agency people or producers do not want the rep in the picture beyond the moment of the sale.

Franznick's preferences differ in some ways from those of his professional colleagues. For instance, while Taubin likes to see large transparencies displayed on a light box, Franznick feels more comfortable with projected materials. He warns that if a photographer does want to project his portfolio or other pictures, he should first let the agency know so they can make a conference room and projection equipment available, since an art director's often cluttered office is no place to look at presentations or portfolios. He prefers to see work in finished print form but also is interested in tearsheets. He is interested in not only how a transparency was separated, but how the photographer feels about the outcome of his work. He believes that a photographer, like a copywriter or art director, should be a "universal talent." He doesn't believe that a photographer should be only a still life photographer or only a portrait photographer, though he admitted that the outside world is full of specialists in only one branch of photography. He really does not want to work with a person who has a narrow point of view. He wants to work with photographers who are many-faceted and multitalented, those who have a broad understanding of lighting and other important specifics of photography.

What Franznick says, in essence, is that he really wants to see a photographer's "mind." That's more important to him than anything else. He thinks, like so many of his contemporaries, that because of the great strides in film, optics and camera construction it is very difficult to make a technically poor picture, and so he is concerned about seeing composition and thought expressed on film. He is interested in what the picture is saying to him, not how it got on the film or paper. So when it comes to presenting a portfolio, the photographer must understand all this and be extremely careful about what he shows, and his method of showing has to be thoughtful and intelligent.

Franznick added another element to the explanation of "mind." He also added the word "wit." He thinks a good word for the interpretation of "what is out there" is "wit." This was much the philosophy of Philippe Halsman, whose core of interpretation of a subject was just that, a deep and incisive wit.

Another aspect of advertising photography that Franznick's is concerned about is the gray area of billings, and he cited instances of friction developing over the billing of a job because somebody was not listening. The somebody might have been the photographer but could have been the agency, and he suggests that the photographer (or agent) be totally aware of all the terms. He feels that fees and charges have to be discussed at the point of the assignment, not after the shooting.

He told me that he tries very hard to tell the photographer up front, "This is what I have, this is what I can spend." He does not want to be hit with a "sleeper" of a couple of hundred or a couple of thousand dollars more than agreed upon. Yet it appears this happens far too often. He feels strongly that the word "budget" means just that and has to include not only the fees but the out-of-pocket charges, the materials and anything else including the assistants. The only time this can vary is if there is a clear discussion of the pricing of a job that is based on a fee-plus-cost basis. And even when this happens the photographer is expected to give a pretty clear estimate of the amount of those costs.

His final advice: Get a purchase order at the beginning, specify what it covers and then deliver according to those specifications.

INSIDER: JILL JOHNSON, PROFESSIONAL MODEL

I talked with fashion model Jill Johnson of the Zoli Agency of New York about her career in fashion photography and her dealings with photographers and how she perceived them. She started her modeling career almost by accident, and though she is currently appearing in many U.S. magazines, her first job as a model came when she was in France spending her "junior year abroad" as a student at the University of California in Berkeley. She stayed on for some time and eventually returned to New York to finish her college education at New York University.

When she returned to the U.S., she realized that while she looked just right for the European market, she was not right for the U.S. She had to change her appearance as well as her model book, and this was when she first came in contact with U.S. photographers. Even though she is American, she felt she looked "too French" or "too Italian" and wanted that "well-scrubbed American" look. Her new look succeeded, and she began to appear in ads for Pantene, a women's hairspray, and cigarettes, jewelry, and fashion photography in newspapers, magazines and catalogs.

Johnson said when she needed pictures she went directly to the photographer she felt could best do the job she wanted, and if he decided they could work together then they would do so, producing what they both needed for their portfolios. As for the photographer and model forming shooting-modeling teams for the production of portfolios, she cited several well-known photographer-model teams that not only produced excellent portfolio material but also went on to work in the industry as a team and have been successful.

Many of the larger model agencies have set up separate departments for their newer and less experienced models who need portfolios and they have a routine method of contacting photographers to work cooperatively with the new girls to help prepare books. So the photographer who is looking for talent of this nature might well contact these departments directly.

I found Johnson's frequent references to "the camera" instead of the "photographer" most curious. She felt the photographer had the same role a director might have in a movie or TV coverage, and thus her response was more to the person giving the directions than to the person holding the camera.

It was in discussing her role as model and how she performed that the references to "the camera" came up, as I asked her to describe her methods of work and what feelings she had about photographers. She emphasized how important it was to take this attitude, saying, "You really have to block out all other elements, everything else except the shooting, because with so many people around on a major ad agency shooting—art director, creative director, makeup artist, hairdresser, stylists, other agency people, even the clients—if you let yourself become aware of them it's going to hamper you. You have to concentrate on what you are doing, what image you are portraying. Up to the shooting you have to work with everyone, but once the shooting starts, it's you and the camera alone."

I asked Johnson if she contributes to the planning of a shoot or does she leave it entirely to the photographer or the art directors. She plays it both ways; she likes to participate and offer input and is pleased if her suggestions are followed, but if she senses the photographer does not want anything from her, she backs off. She said that photographers vary in their acceptance of her ideas.

I asked her if, when she is working with a less experienced photographer and the shoot is not going well, does she have the urge to steer the photographer.

She responded that she doesn't because she understands that the younger photographer is in a learning situation, just as she too went through early learning.

Referring to an industry attitude that models don't show up on time or arrive really prepared to work (hair, nails done, etc.), she agreed that there was some truth in it and photographers were becoming increasingly concerned since it affects the shooting. She mentioned one case where a model on a national cosmetic ad did not show up at all and even her agency didn't know where she was. It does not happen too often, but evidently it has been happening often enough for photographers to start contemplating action through their union, the newly formed Advertising Photographers of America (APA). She assured me that she and most of her colleagues are thorough professionals and that they arrive on time, ready to work, and most have strong feelings of ethics. If enough complaints seep down to the agencies, it will hurt the models, she explained, because their own agencies will stop assigning work to them.

Fashion photography has its own star system both among the photographers and the models. Whenever Johnson runs into a photographer who she thinks is acting like a star, she tries to defuse the situation by keeping things in a light vein, without bowing to any pomposity or unreasonable demands, and generally proves her value by behaving as a professional. But she acknowledges that some models develop the same "star" attitudes and then it's up to the photographer to deal with it on a level that will ensure getting the pictures wanted. Unfortunately, when stardom hits, whether it is the photographer or the model, it makes it difficult for all the others and this attitude should be avoided at all costs.

SPECIAL REPORTS AND SPECIALIZED PROJECTS

This is a smaller but no less active field for editorial photography. Thousands of special reports and projects are published every year utilizing photography. What are these reports? Who publishes them?

The prime originators of this type of publication are engineering and construction companies that need background materials on city planning, urban redevelopment and housing organizations, conservation (or the lack of it), land use and impact reports. Many of these are published by private firms and many by hundreds of government bureaus on all levels, from Federal government departments to state commissions and local interest groups. City and county and state legislators frequently make use of area studies, aerial photographs and street scenes to prove some political point. It is not always easy to find out what's going on and how to make contacts in these fields, but many of the groups involved in a publishing venture will seek out the sources of photography, using professional or trade lists and many classified listings including telephone books. Specialized picture research groups such as Research Reports in New York have come to know the sources of photographs, as do many art production houses specializing in corporate annual reports and other company publications.

Another area of the special report lies in the field of consumer testing and technical analysis. Public interest groups frequently need photographs of environmental conditions. Unfortunately, most of them have little money to buy such photography, but frequently there are public funds and grants available for such purposes.

OTHER MARKET OPPORTUNITIES FOR SELLING PHOTOGRAPHS

We are now getting down to smaller (but not necessarily less lucrative) outlets for editorial photography, such as posters, postcards, calendars and other promotional items. The use of photographs in postcards goes back as far as photography has been a reproducible medium. As in most other publishing ventures, there are the giants and the small operators. The giants have nationwide promotional plans to acquire material for postcards but invariably pay little for the pictures. I have a handful of cheery letters from postcard printers from all over the country offering to buy my photographs almost by the pound, with no mention of distribution or royalties. My advice? Stay away from them unless they offer a system of clear (CPA) accounting procedures and rights acquisition, not to mention a fair price.

On the other hand, this is also the kind of business a photographer can go into in his home town without any great capital outlay, provided he works out some sort of distribution system in *advance* of getting involved in expensive four-color reproduction. I know of a good amateur photographer who by profession was an innkeeper in a small but popular resort area. He made his own photographs, had them well reproduced in postcard format, and sold them literally by the thousands in the area where he lived. Even after his recent death his cards continue to sell and his estate has a steady income from their ongoing sale.

I did a little research and found that, surprisingly enough, even though there is a good deal of competition, especially from the large printing companies, the postcard and poster markets are so localized that photographers can easily work up distribution of their work in this form without great cash outlays. Ditto slide shows and audio-visual corporate promotions.

So much for the editorial market. As the reader can see, there is a potential for vast usage of photography and for some substantial returns, provided the photographs are well marketed and the clients competently serviced.

THE FIRST SALE: BREAKING INTO PRINT VIA LOW-BUDGET AND FREE PUBLICATIONS

This is your moment of truth. But sometimes one doesn't even recognize it when it happens. I didn't when I sold a photograph of a string of bagels to the *New York Sun* in 1941 for 10 dollars. Ten bucks? Why would anyone want to pay me for something I enjoyed doing so much? But there it was, a two-column cut with byline, and a couple of weeks later a check for 10 dollars. And the circulation of the *Sun* went up that day by 50 copies.

This is not what caused me to turn professional, but it was the first photograph I sold, although I had been dabbling in photography for a couple of years while holding down another job at night so that I could learn to photograph during the day. Most of my dabblings seemed to be in the direction of dragging carrying cases for established professionals and doing other "gofer" chores. This is the classic way of getting started for many a photographer, even now. There are many who advise that the best way to become a photographer is to get a job as an assistant in a studio. For those who are interested in studio work, I agree that while it may not be the best way, certainly it is a good way. But after three or four years of photojournalism school or an equal amount of amateur shooting with other jobs paying the rent, finally making that first sale is a joy indeed.

How do you actually break into print or make that very first sale? I spoke earlier of young people chasing fire engines, state troopers' cars and ambulances. There is also the high school yearbook routine, either in portraits of your fellow students or some small sports photo feature from your school days.

Breaking into print, especially if it's of no cost to the user, is not particularly difficult. There will always be someone who can use a photograph. Selling your work is tough but becomes a way of life if you are to be a professional photographer.

In any business or professional art form, starting at the bottom is traditional, and probably the first photographic markets to be explored are the so-called free markets. They have their value to you. The upcoming photographer needs a showcase. He needs to build a portfolio, and while a portfolio made up of prints or transparencies is fine, one that is made up in part of actually reproduced photographs is even better, provided the reproduction quality is good and the display meaningful.

The fact that a photograph has been published is a plus. It means that someone else thought enough of it to print it—to pay for the cost of the engravings or separations and the resulting paper and presswork costs.

THE FREE MARKETS OR PUBLICATIONS
WITH VERY LOW BUDGETS

What are these so-called free markets that are important to the new photographer and should they be exploited? The latter answer is yes, exploit them, but not for long! Try them perhaps just long enough to earn some reasonable credit lines.

Probably the easiest publications to reach are the small-town or rural "give-away" publications that carry a little advertising and whose audiences are strictly limited to their immediate areas. There are also the close relatives, the local county or village weeklies or monthlies. They will probably offer 5 to 10 dollars per photo, which for them might seem like a lot, but you will probably spend an equal amount to shoot, process and print.

Times are changing, however, and with the wider use of cold type, cathode-ray tube (CRT) and video-display terminals (VDT), other electronic and computer technology and faster total offset reproduction, the smaller papers are proliferating. They are spending more proportionately on original photography. Why? Even though this new equipment is expensive to purchase, the unit cost per picture drops considerably, thanks to the new technology, and there is not much difference in cost between reproducing a page of pictures or a page of type.

These newer papers are one step removed from the so-called free market and are a steppingstone for the new photographer. They probably will be grateful for pictures of local news interest that they can get for very little. After the photographer has made his contacts with the editors, has proved that he or she can produce the kind of photography they can use, then it's time to ask for remuneration. This will not hurt you in the eyes of the editors, because they have an understanding of what a young photographer must do to get started.

So, after a reasonable amount of low-cost service, you should either move up the ladder or out the door. And by the time you have appeared in a fair number of issues you should also be developing some expertise as to how pictures are used in these particular types of publications and you will begin to develop a sense of what is worth printing and what isn't.

Perhaps then you are beginning to approach the time for making the decision

about whether to specialize or not, and you should be getting ready to explore wider markets and broader horizons of specialization.

Where you direct your pictures is then your next major move. *MMP, LMP,* and *Gebbie's All-in-One* directories have pages upon pages of current listings of publications classified by areas of interest. Most of the publications are probably low budget and need low-cost photographs. For instance, if you were to approach a labor newspaper or magazine with a story on some part of a local labor situation, the chances are the editors would be most happy to publish the piece (provided it reflected their point of view on the story) and probably would pay a small fee for both the pictures and the text, if necessary.

But be realistic. Don't approach a labor paper with a Chamber of Commerce position on a local labor story, or vice versa. Be sure of your facts and information before you try to sell a story. This is also "professionalism" and it pays to learn it from the beginning of your career.

Bear in mind, however, that because you allow your photographs to be printed either without a fee or for very little, it does not mean that you should give up your rights to them. Make sure your pictures are protected by copyright (see Chapter 10). It is simple to do, not costly, and it may save you a lot of grief later.

GOVERNMENT AND STATE PUBLICATIONS, SMALL LOCAL PAPERS

Another source of placement for the new photographer is with government publications, on all levels from Federal down to the smallest municipality or county organizations. There is always a need for photographs here, but frequently little or no money to pay for them. Agricultural organizations, conservation and land development groups, natural resource, pollution control and environmental violation review groups are among such agencies.

On the Federal level, the General Services Administration, the watchdog and procurement arm of the U.S. government, will put you on a list for possible bids on things photographic. The U.S. Government Printing Office has lists of U.S. government publications that use photographs. Virtually every branch of the government has some publications, from the smallest department to some large cabinet-level bureaus. Much photography on the state and municipal level is done by open bidding. Write your own state, city or local procurement offices to be placed on their bidding lists.

When you are starting small and your overhead is minimal, chances are you can beat the bids of many larger and more experienced organizations and thus land some substantial contracts or parts of contracts. But be careful when making your photographs available to the government for little or no fee, to protect your rights for future and possibly more lucrative uses. Under the old copyright law, works prepared by U.S. government employees and/or for U.S. government publications were not afforded the protection of copyright. The new law still carries forward this concept as it applies to government employees, but it would appear that under the new law, pictures used in government publications but produced by free lancers or other nongovernment employees can be protected by copyright. Check this aspect thoroughly before you offer a picture to a government publication.

PHILIP B. KUNHARDT, JR.

I talked with Philip B. Kunhardt, Jr., until recently managing editor of the newly revived *Life* magazine, about his views on photographers of today.

"I grew up in a family steeped in historical photography," he said. "My grandfather, Frederick Hill Meserve, was born in 1865, the year Lincoln was assassinated. He set out in the 1890s to illustrate his father's diary of the Civil War and put together a really unbelievable collection of old photographs. He tried to collect every single image of Lincoln, then put them in order, dated them and preserved them. His daughter, my mother, became very interested in that subject, too. She became a Lincoln authority and wrote many articles about Lincoln. I grew up in that atmosphere and became fascinated with photography, too.

"After I graduated from college in 1950 there was only one place I wanted to work, and that was *Life* magazine. I finally got a job as a cub reporter and have been with the company ever since. As managing editor of *Life*, I was asked quite often who *Life's* competitors were, and I don't think *Life* ever had any real competitors. I think the biggest competitor is the memory of the old *Life*.

"People who grew up on the old *Life* were accustomed to that great breed of photographer who spent years as an apprentice and applied real dedication to learning that craft. I grew up largely in Gjon Mili's and other people's studios and watched them painstakingly get ready for an assignment, doing it with unbelievable thought and care and knowledge. They developed their own film and printed their own pictures. I don't know where you learn your craft today; that's one of the problems. You don't have many of these wonderful dedicated craftsmen working anymore. There are obviously some very good young photographers, and they are mostly natural light, 35mm candid photographers. They are painstaking, very careful, very perceptive, very sensitive, and I think some are as good as most of the photographers of the 1940s and 1950s."

On the subject of story suggestions presented by photographers, Kunhardt said, "Editors do look for them, but that presents some kind of problem with us and I don't know if it is for any other magazine. A lot of photographers merely

read the papers and come upon something they think might make a story and suggest it to us. That's not the kind of suggestion I want from a photographer at all, because we read the papers, too. The kind of suggestion we really want is something unique to that particular photographer that we would never know about without his or her suggesting it to us. The last thing we want is someone telling us 'There are going to be 10,000 boats in New York harbor this summer and I think it's going to make a terrific picture so could I have the assignment?' That's the kind of suggestion we don't want and it's hard to handle because a lot of photographers are suggesting things all the time and just because they suggest them and we do but do not give them the assignment they think we have taken their idea. So it presents problems. On the other hand if he has spotted what could be a potentially good news story and comes up with an entirely different way of trying it, that's entirely different.

"I think the major problem on *Life* has always been that if you don't come back with a unique and beautiful or exciting and imaginative set of pictures, you have no story, and that takes great care and thought and tremendously hard work. I know how hard it is to be a photographer and pull off a story because I've worked with so many of them. I see some people kiss off assignments so you don't want to use them again. I see some people work with enormous dedication and thought. With them it's not just when they are taking the pictures, but when they are getting ready to take the pictures, that the moment comes to decide what exactly is wanted of them, and they have to make an effort to achieve some kind of special vision. I warn people who want to become professional photographers that it's not only difficult financially but difficult to break into in general because the whole publishing field is small and the job itself is very, *very* hard."

CHAPTER 4
BUILDING YOUR PORTFOLIO: FIRST CONTACTS AND PRESENTATIONS

Making the first contact is often an emotional experience frequently blown out of proportion to reality. Some photographers approach this event with feelings of trepidation; others with confidence based on their own perceptions of their abilities, and this is as it should be. What most new photographers fail to realize is that the people who buy photographs or photographic services have a need to buy the product as much as the photographer has the need to sell it. They would not grant interviews if it were otherwise!

The goal of the photographer is to have his work seen and accepted. All other factors are secondary, and the photographer should not try any psychological ploy or approach other than simple, no-nonsense procedures of dealing directly with those interested in seeing and possibly using his photographic abilities. This is important. There is little you can do to preplan your psychological approach. The chances are that the people you will come in contact with are experienced in their fields, perhaps are older, and maybe just a little wiser, and any attempt to con them or fool them will only result in failure at the interview. While there are some photographers who are better salesmen than craftsmen, there aren't too many of them around, and it is your pictures that will prove to be the ultimate measurement.

THE PORTFOLIO: BASIC PREMISES AND CONCEPTS

Primary to any interview or bid for work is your showcase, portfolio or, in ad lingo, your "book."

Putting a portfolio together is probably one of the most important things you do before entering the marketplace, and your second most important professional decision (the first being the decision to become a professional). What you present, and to whom, is paramount. It is the only way you can demonstrate to the buyer what you are capable of doing and perhaps trigger ideas for work.

Portfolios are as individual as photographers themselves. There are no fixed ways of presenting your work. It can be in the form of prints, tearsheets (pages from printed publications), transparencies either for projection or viewers or even, as we have recently seen, motion picture reels and videotapes complete with soundtracks. Some photographers and agents have even transferred all material onto slides and show it on Carousel trays.

Here is some general advice for selecting the material for your portfolio.

Don't show everything. Too many new photographers make the mistake of including everything they have ever shot, without real thought as to whether the pictures are good, bad or indifferent. If you are just starting out, it is highly likely that your material will have a scattered effect because you are probably trying to get a foot into too many doors at once, with the result that you disperse your photographic energies. A bank of experience is required before most editors are willing to take a chance on you by giving you an assignment or starting to use you as a source of stock photography. In effect, you have to develop your own experience and prove your own creativity and/or competence.

I suggest that you build your portfolio by presenting pictures you made on your own "assignments," until such time as you can collect actual reproductions of photographs in print that will substitute for the self-assigned photographs.

Demonstrate your ability to handle an assignment. Also remember that the editors or picture buyers don't want to see a lot of unconnected, unrelated photographs that merely say, "I know how to make an exposure and get a roll of film developed" and nothing more. What they want to see is your ability to handle an assignment intelligently and produce a fine set of photographs from it. Be warned, however, about "speculation" photography. It is one thing to create your own assignments, produce the pictures, and use them either for your own portfolio or even try to market them independently, but quite another ballgame to do a "trial" assignment for some magazine that thinks they are going to get you to work for them for nothing, or owe you nothing, if the "assignment" doesn't pan out.

Be appropriate: analyze the market to determine your selection. Do not approach any picture buyer without having a pretty good idea of the kind of material their organization uses. Do your homework. And don't insult the intelligence of the person you are seeking by coming unprepared or with inappropriate material.

Demonstrate the quality of your work. In assessing what to show, the experience of the photographer is vital. It is, of course, advisable to show reproductions of work already in print, but I realize this can apply only to those who have had extensive publication of worthwhile photographs. What are the alternatives for those whose work has not been reproduced? For openers, try quality black-and-white photographs with content that has meaning for the person to whom you are showing, presented in a way that can be accomplished easily, quickly, and without flowery or confusing ostentation.

GUIDELINES FOR COMPILING AN APPROPRIATE PORTFOLIO

Portfolios have to be developed according to the needs of the picture buyers you are going to approach. Here are some guidelines for assembling a portfolio for editorial, advertising, fashion, public relations and industrial purposes.

THE EDITORIAL PORTFOLIO:

Newspapers The key here is an understanding of the form of journalism you are trying to practice. If it is spot news, the pictures to show are obviously news situations—fires, accidents, political occasions of interviews, sports events, homemaking or entertainment. As a beginner, you are unlikely to have many tearsheets. But local news is one medium you have a reasonably good chance of covering without formal press credentials. And while on that subject, let's talk a little about credentials and the so-called "press cards."

Unless they are specifically issued by a bona fide press organizations such as newspapers, press syndication services, agencies, major wire services, or a magazine publications group, forget press cards. The use of a sticker with the word "Press" on a car is for the most part meaningless and will cut no ice with anyone in authority.

In most major cities, if you have proper press accreditation, those letters or cards should be honored by the local police or other authorities for the issuance of their own working press credentials, as the original identification cards are not usually honored on the press lines themselves. I have seen ads in photo publications for "genuine" press cards for a price. Don't waste your money: they are not worth the paper they are printed on.

Covering local press events in a small town or local area without official press credentials is easier because there are generally few local newspapers issuing press identification, and crowd control is of such limited effort that almost any medium-length telephoto lens will get you "over" the police or fire lines. In this way you can easily cover news events that happen, and you need not be on the line to make good photographs.

These events make excellent material to build a portfolio of pictures for presentation to news editors. Frequently they can be sold on the spot to papers or publications, and when reproduced, you have the added advantage of a bona fide tearsheet for your portfolio. A few sales or placements in your local paper should in time also accord you some recognition, and it is likely that local papers will eventually issue you some sort of credentials that will get you in a little closer to what is happening.

The installation of a "scanner" type radio in your car or studio will be of help in getting you to a site where something of news importance has occurred. But we must remind you that crashing police lines and developing an overinflated sense of importance and a disregard of the authorities are the quickest ways to get you tossed out or put on a permanent blacklist among police and fire officers. Also, creating a false impression of being affiliated with a particular press group can sometimes run you into serious problems.

Aside from spot news, there are many other photographic situations that should be covered in order to prepare portfolio material for the news world. Sports, for example, can easily be covered from the stands with long lenses.

Feature stories for papers are even easier to shoot and require even less accreditation. You pick the subject—a school, library, public building or road situation that's come under fire, or a water crisis. All of these items are of interest to a local paper, and how you handle the coverage of this sort of story and its presentation in your portfolio are what will make points for you.

Magazines The editorial world of magazines is not much different. One good method is to conceive short story plans and execute them the way you would if you were on assignment from a magazine or book publisher. They don't have to be complicated, expensive stories requiring travel, lighting or very special ar-

rangements. Simply choose a theme you think might be of interest to the magazine you want to approach, contact the people involved to get their cooperation and shoot the story on your own, but do not give the people you are photographing the impression you are on an actual assignment. Edit it professionally. You might try laying it out with prints scaled to the layout, using the publication's page measurements.

Vary this approach, depending on whom you are planning to contact. I suggest you present more than one story. By presenting short, tight coverages on hypothetical situations in several departments you should be able to convince the editors that you have the flexibility and skill to handle a variety of assignments within the same publication.

The same is true for rural-oriented publications. If you are in a rural area and the scene there interests you, this is where you should start cultivating your personal crop of stories.

Consumer and Trade Magazines The same rules apply here, only the focus has to be narrower and in line with what they publish or what interests them. Again there is an infinite number of story ideas, but the important thing to remember is to study the publication closely and shoot material along those lines. We do not suggest that you copy their layouts—try to show *your* creativity by demonstrating how you would handle this story, either differently or better or both. Remember: a little humility can go a long way.

Even a travel magazine can be approached in this manner. You don't have to have a ticket to Paris to do a story with a French flavor. A barge trip down the Rhine or Seine can be imagined from the banks of the navigable river nearest your home.

THE ADVERTISING PORTFOLIO

The advertising market is totally different for the most part from the editorial, public relations or book-publishing worlds, though their media goals are almost the same—the printed page of a magazine or newspaper, or the small screen of the television. Not only is the advertising market totally different from most other commercial markets, but there seem to be special ground rules about presenting portfolios and other materials. Tailor your material accordingly and consider the opinions of the agency art directors contained in this book.

Look at the work in the different media and isolate them by product. Is there any strong point of similarity in the liquor ads, the fashion layouts, the house furnishings or the material prepared for the airlines, auto companies, whatever? Study those similarities and differences. See what appeals to you. Think about how you would approach the problem. Can you do better? As well? Or not even come close? The answers you get are your working decisions. If you think this is the kind of work you want, then show what you can do to fill comparable spaces.

There is a time and place in your portfolio for photography not directly related to a specific campaign you are targeting. This section should be tight and be well presented simply as either an introductory group or at the back of your portfolio.

There is no question that art directors want to see fresh and unusual work not directly related to what they are trying to sell to their clients, though it is often hard to get these ideas past them. There is room in a portfolio for purely experimental work, presented as such simply to demonstrate your own creativity to the art director. Thoughts that spring from these presentations may well lead to assignments.

THE FASHION PORTFOLIO

You do not need an expensive studio to make fine fashion photographs, nor do you need 10,000 watts/second of strobe capability, two assistants or a stylist. The fashion magazines are not as much interested in the picture story approach as they are in great takes of various types of clothing. The closest most fashion magazines get to the story treatment is the coverage of a designer's "collection." If fashion is your interest, then talk with buyers at your local department or specialty stores to find out what is currently in vogue.

Models for fashion and theatrical shooting are relatively easy to come by. I do not recommend using your friends, spouses or siblings unless they have had some modeling experience, because they will be just as green as you. Many men and women have some experience as professional models and most will gladly trade off a set of pictures of themselves for some of their time posing for you. Clothes can frequently be borrowed on the same exchange basis.

In making fashion photographs for portfolio use, it is wise to watch the major fashion magazines to see their *trends*. But observing a trend and being aware of it is not a license to slavishly copy it. Closely watching the kind of photography that is being published, however, will give you opportunities for creating your own visualizations and your own ideas for pictures.

You can find substitute backgrounds for the exotica that the fashion books are always pushing. Remember, it is not so much the background that is important but the foreground—the clothes on the model and how they are displayed. While it is true that a great many fashion pictures are made against rolls of seamless paper or front or rear projections of the South Sea Islands, a good many do use locations that, while not dominant, are nevertheless important. Include some location pictures in your fashion portfolio even if the locales you are using are just a local park, beach, restaurant or airport.

Above all, don't settle for one fine photo of one fine garment, but approach it from many angles. This holds true for any product photographs you are directing towards advertising. Show your ability to deal with them in a variety of ways and do not submit just one view or application.

THE PUBLIC RELATIONS PORTFOLIO

Is it a product or situation that a public relations house wants pushed? Think about it and show how it should be handled. Picture this approach on your own and show it to the public relations house or the public relations director of the company you are seeking an interview with, along with some idea of media use.

INDUSTRIAL AND ANNUAL REPORT PORTFOLIOS

Once again try to find some credible situation that you can get to and create your own concepts. There are many industrial photographs that can be made without access to a steel mill floors or the machine shops. Give thought to the end product or result that the corporation is trying to achieve in its annual report and work backwards to it. Get copies of the company's previous annual reports from banks, brokerage firms, or even by calling or writing the company for copies of annual reports covering the past few years so you can get their viewpoints.

I have discussed major market areas and what I feel portfolios should contain in order to reflect your understanding of them. Obviously I have not—and cannot—advise you on how to approach every possible outlet for your work, but I am trying to encourage you to analyze any field in which you are interested, to present relevant material and not to inundate your viewer with nonessentials.

PORTFOLIO FORMATS AND PRESENTATION

There is no single method of effectively presenting one's work. What may be good for the editorial world could be all wrong for the advertising market and vice versa. Portfolios somehow have to be flexible and easy to change as one grows in ability, understanding and accomplishment.

Regardless of where the portfolio is directed, the characteristics it should have are simplicity, accessibility and portability. Prints have to be carefully printed, clean, fresh-looking, spotted and neatly trimmed. Transparencies should be mounted in protective sleeves if they are small, such as 35mm or even 120 formats. Larger sizes should be on lightweight cardboard mounts with the surfaces of the transparencies protected by frosted glassine or acetate.

A note of warning: Film chemists are now saying that some of the plastic sleeves on the market may cause chemical reactions and damage to color emulsions if the pictures are left in them for extended periods of time. Be sure that the brand you are using is totally chemically inert and will have no effect on your transparencies.

Color prints or tearsheets from magazines or books should be either dry-mounted on thin cardboard or plastic and laminated or carefully dry-mounted on the paper insert sheets of the familiar plastic ring binders that are so popular for art portfolios. The plastic sleeves themselves should be kept clean and free of scratches and be replaced regularly to preserve the appearance of the photographs they are protecting. Because of the expense of the sheets and the constant need for replacement, some photographers have given up on this system and have substituted ring-bound laminated sheets that can easily be wiped off and resist scratching.

PORTFOLIO ASSEMBLY

The most common portfolio format is usually a leatherlike (leather, vinyl or other fabric) covered volume of ring-bound envelopes of cellulose or plastic with paper inserts that can be bought at most art-supply houses. The sizes range from 5 × 7 to newspaper-page-sized envelopes with pages as large as 18″ × 24″. They frequently are paired with large zippered enclosures, or the ring mechanism is sometimes bound into the enclosure itself. Some ring-binding mechanisms vary with the manufacturer, ranging from simple holders with three snap rings; others have whole rows of sharklike teeth pretending to be snap rings, some with as many as 20 to a page. All come with open sleeves, some with black or colored paper inserts that allow the photographer to use both sides. Most of these plastic holders scratch and tear easily and thus have to be handled gently, and there is no way of guaranteeing this when someone other than you is leafing through the pages. The zippered enclosures tend to sag at the bottom where the weight is and this frequently makes for a messy and difficult-to-open presentation. Nor are they cheap. A portfolio with a hard cover and ten insert sheets lists for about $50, with extra acetate sheets costing about $2 each.

Another option is a strong fabric-covered light wooden case which looks like a king-sized attaché case and is large enough to accommodate larger portfolio pages plus extra materials such as mailing pieces, entire annual reports and even some books. Its higher cost, however, pays for itself in durability.

Another method of displaying portfolio material is to dry-mount the tearsheets, photographs or other artwork on very lightweight cardboard and have them laminated. If you have a dry-mounting press in your studio, you can buy

the laminating material in rolls and apply it yourself, saving money in this way. When using this system, you can usually punch the edge of the laminated boards using vari-colored plastic binding rings. This requires a special machine for an attractive binding but the advantage is that the material can be changed easily according to the market, and you can prepare specific portfolio presentations for specific projects. If you are reluctant to invest in plastic binding equipment, you can easily find a printing or binding shop in the classified pages of your phone book that will ring-bind your laminated pieces inexpensively.

One alternative for laminated cardboard is to use foam-filled mounting boards that, while somewhat thicker than cardboard, are extremely light, and a large number of them can be carried in a portfolio or attaché case. The problem with this material is that it does not lend itself to punching and binding, as do the thinner materials, and tends to crumble at the edges unless bound with tape.

Another attractive method is to preplan a showing of a group of photographs or a story layout and determine the number of mounting boards you will need to accommodate the pictures *in advance* of placing them on the boards. Instead of ring-binding them, join them accordion-style in sections of two or four or even five boards, using hinges of 2-inch aluminized binding tape ("gaffer's" tape). After the tape has bound the boards together, the photographs can be dry-mounted in place over the tape hinges and laminate materials can be subsequently applied. By using this method you can keep the boards together and in the presentation order you wish.

The board sections can easily be displayed by standing them up easel style on a desk or table, or your viewers can leaf through them on a desk in what amounts to double-page spreads as they might in a large picture magazine. This method of display can even be used for mini-exhibits on a conference table where people can walk around and view the layouts from both sides, as there is nothing to prevent you from using the backs of the easels for other layouts. Or, since they are free standing, a number of them can be set up simultaneously on one table. This method is so effective that the University of Missouri "Photographer of the Year" contest *requires* it (single side only) for display of entries. Eight to ten of these story boards can be carried in an attaché case, giving you the opportunity of displaying anywhere from 10 to a 100 photographs, and you can control the pace of the exhibition. I think this method is particularly effective in showing editorial material, and it has been used well in advertising.

PROJECTING YOUR PORTFOLIO

There has been a growing tendency toward projecting photographs, particularly 35mm color, by assembling portfolios in Carousel trays and presumably saving a lot of weight that way. However, many editors do not like to view projected transparencies on a screen, preferring instead to examine them on a light table with a magnifying loupe or even holding them to window light with the loupe in hand. There are several schools of thought about physical projection of 35mm color transparencies and the dangers involved; while most color material manufacturers are evasive on the subject, there is no question that continued exposure to light will in time fade almost any color material. A great many photographers (and some photo agencies) therefore feel that shooting a concentrated blast of high intensity light from a projector through a transparency will hasten fading and possibly cause heat damage to the picture from the projection lamp, even if there is a cooling fan built into the projector. As the editors of one magazine found when dealing with photographs of women with large areas of exposed skin, the regular projector lamps were not color-corrected, and what

appeared great on the projection room screen failed badly in the color engraver's cameras. Hence most color transparencies for reproduction are usually viewed on table or wall viewers featuring fully color-corrected light sources.

If you are considering using projected materials in your portfolio, have good copies made for projection rather than using your originals, which should be released only for engraving.

I remember an amusing incident which occurred when I was ready to deliver a finished story to an old pro of an editor I had known and worked with for years but who had since changed magazines. I had not formally presented a story to him for some time, and when it was ready, I called and said I was coming down to show it, and asked if he had a projector at the office. He said he didn't.

"Okay," I said, "I'll bring one."

"The heck you will!" he growled.

"How come?" I asked. "Don't you want me to project my work?"

Over the line came a roar I could have heard over those 200 miles without the benefit of a phone. "I refuse to be a prisoner of the photographers!" Those photographs were examined on a light table with a glass.

This is not only true of this particular editor but of many editors who don't want to be trapped into a rigid viewing format or simply don't like projected materials. So bear this in mind if you are thinking about projecting when you are preparing to show a portfolio. Find out in advance how the editor or art director feels about projection of photographs. If there is no objection, ask if a projector is available at the office that is compatible with your method of projection (Carousel trays, stack loaders, boxes, or any other system).

For some odd reason, however, this feeling does not extend to ad agency art directors, probably because they insist to a great degree on larger format film sizes—120, 4×5, 5×7, and 8×10—formats that are difficult to project. Even when using 35mm color, they usually have color prints made from the original so that the prints can be retouched. Or, in some cases, color prints are montaged from several original photographs. Furthermore, there appears to be too much of an attitude of "we don't really care what happens to a color original" because the agencies usually buy all rights to a photograph and don't concern themselves about posterity and how long a photographic image will last.

However, while agency art directors do not necessarily object to projection of materials for the same reasons as the editorial people do, many object for other reasons. Some, whose offices are piled high with all sorts of sketches, art materials, coffee cups and other working paraphernalia, don't want their desks disturbed. Others have no room for a screen or to place a projector, or their walls are either nonwhite or covered with art materials, posters, mailers, etc. Some are simply too lazy to walk down the hall to a projection room or don't want to wade through an entire tray of photographs. So even if the art director has no real objection to viewing projected materials, try to find out if projection is feasible without disrupting someone's office (or even blowing the fuses on the agency's floor.)

Even your best black-and-white photographs can be shown in this manner and look quite handsome indeed. One way to do this is to copy the black-and-white photographs onto 35mm Kodachrome stock which can then be projected as crisp black-and-white images on the screen. Or, using the same system, reproduce a newspaper or magazine page in black-and-white, making new prints to the scale used in the publication. You can also use this system to copy from magazine editorial or ad layouts. Color film will work beautifully. You can

also use color background sheets to add to the attractivenes of a black-and-white presentation.

THE VIDEO OR FILM PORTFOLIO

Except for the addition of a soundtrack for motion picture reels or videotape, the general manner of presentation of slide or videotape material is not dissimilar. You must present good slides of the images photographed, and the whole showing should be crisp and professional. Remember, the material used has to be exactly the same kind you would use in a print portfolio.

Videotape should be prepared only for ad agency presentations because most editorial houses do not as yet have video playback equipment. Ad agencies, however, generally do. Here, too, you had better do some research because of the growing number of video playback machines coming on the market and the variations in tape widths, cassette handling and playback machinery.

Use the camera as you would a still camera in copying. Do not go in for cinema verité effects in trying to present a video still portfolio. You will only confuse your audience and show your own confusion as well.

The soundtrack can be used advantageously by prewriting your commentary or descriptions of the photographs so that when you actually put your voice (or someone else's) on tape it is free of hemming and hawing. Music? I haven't seen any with a soundtrack yet, but I see no reason why it couldn't be interesting and enhance the photography.

Variations of synchronized soundtracks on reels or videotape might also be considered with cassette cartridges, and if you are dealing with the audio-visual market in the preparation of film strips, most of these houses will have film strip projectors with electronic soundtrack keys that can be indexed with your sound tracks. But this is highly specialized and advised only for those photographers trying to break into the audio-visual area.

These are some of the ways of making the physical presentation, but the decision has to be made by you as to whether you want to present your material in portfolio, single-unit form, projections via Carousel trays or videotapes. Whatever method you select, you should make several editions simultaneously. It's easy enough to do so when you are actually working on the prints or slides. This will cover you when one set is tied up or you want to make changes. By making duplicate prints or slides at the same time, you can then even rearrange your presentation material for different audiences, in many cases reusing the same photographs.

One photographer's representative told me that she knew of materials taken from portfolios by art directors or other personnel in the art departments, not for illegal use in the sense of reproduction without payment, but for personal home or office decoration. These usually were prints or unusual tearsheets, and although this doesn't happen very often, it evidently has occurred enough times to warrant asking the question: How do you prevent this?

I don't know. Accusing an art director of theft is not the best way of making a friend in an agency, and other than fastening the pictures securely via the dry-mounting process or putting a little card in with the portfolio saying, "Please don't walk or spill coffee on or swipe the artwork," there is probably little you can do except look at it from the bright side. If it was so attractive as to make it worth swiping, then maybe it was that good as art material, so you quietly replace it. If it's swiped a second time, then perhaps you really have something.

SELECTIVITY IN A PORTFOLIO

I have repeatedly remarked on the necessity for selectivity when showing a portfolio to a potential buyer. Selectivity also means not burying the buyer under a flood of pictures. To paraphrase the adage that "less is more," this concept couldn't be more applicable than in this situation. Not only do editors get cross-eyed after staring at hundreds of pictures in the course of a day's work, they probably begin to feel threatened by the constant barrage of images over their desks that begins to take on the appearance of a flood.

If you approach an editor with a huge number of photographs, he is going to be turned off even before he starts to go through them. But there are the other extremes, too. I knew a well-known and talented photographer who was famous not only for his great photography but for his incredible ego as well. He was once sent abroad to do a major assignment on a foreign country. The trip was sponsored by some business interests in the host nation. After about six months he was asked to show his backers some of the work he had accomplished during that first phase and he agreed. When his sponsors appeared at an elegantly catered meeting, our photographer friend, with great panache, showed just three photographs. "That," he announced, "is the overture. In a year I'll present the entire symphony!" And he did.

The new photographer is not the legend this man was, and will have to show a lot more productivity for six months' work. But the incident does demonstrate the faith this photographer had in the efficacy of just a few photographs. I am not suggesting that you limit your showing to three pictures; I am suggesting that you choose what you show wisely and sparingly and not inundate your viewers. They won't like it and probably will not like you, either, as a result.

GETTING ATTENTION WITH A MAILING PIECE

One increasingly used method of attracting the attention of picture buyers is via the mailing piece, which seems to work well in the advertising market and perhaps less so in the editorial or regular commercial fields. Again, because so much advertising photography involves a single photograph in a single layout, a mailer made up of smashing individual photographs is bound to attract attention. Because they are attracting attention, there are more and more of them to compete with, and the young photographer is going to be hard pressed to come up with anything to compete strongly with an established pro in the field who by this time can afford an art director for design and possibly first-rate engravers, typographers and printers. But it is certainly worth considering, although your ability to finance a production of this sort will of necessity be a determining factor. Also, many mailers are prepared in conjunction with the purchase of advertising space for the photographer in the various source books mentioned earlier. All of this can be expensive and the young photographer must determine whether he can (1) produce outstanding material, (2) afford to have it printed well and (3) actually distribute large mailings.

One way of producing mailing items at relatively low cost is to make a deal with a local printer who often has extra space on a printing form. A "form" is a term used in printing for the actual assembly of several pages on a printing press, usually in multiples of 8 pages. Depending on the actual size of the page and the capacity of the press being used, as many as 32 or even 64 pages can be printed on one side of a single sheet of paper before it is folded and cut to page size. So if you can get together with a printer who is going to run some material

in four-color on a form and he has unused space because some publication may, for instance, be only 6 pages on an 8-page form, or 30 pages on a 32 page form, he probably will be perfectly happy to run a piece for you on that same run. You then might have to pay only for the separations and plate-making but not the press work and possibly not even the paper, as the unused paper that is trimmed off the form would normally be scrapped. An arrangement like this, and even for the original separations and engravings, might be made at even lower cost if the printer is willing to "gang up" your picture and others he is making up on a single large separation to be cut to size later. You might get a quality four-color mailing piece for as little as 20 percent of the normal costs of one that is prepared exclusively for you.

What should a mailer have in it? There should be at least one eye-catching and distinctive photograph or perhaps even several. I have seen some complicated mailing pieces that run to several pages of beautifully reproduced material, and I have seen many single pieces that have caught the eyes of art directors to the extent that they hung them in their own offices as display pieces. But the mailer is here to stay and is often used as the first means of contact with a photo buyer.

Along with smashing photos it should include perhaps some biographical material on the photographer, listing his credits. There should be some compelling reason why the art buyer should hire you instead of someone he already knows or has used. Geography can be a factor too, as many buyers prefer to save location expenses by using local people. Expertise in a certain field is also important. Are you a graduate engineer in mining, or a graduate of a school of journalism, or what studies have you completed in the arts or sciences? Any background material that can make them believe you could be more useful to them than another photographer is important, and of course *complete communications* information. That includes name, addresses and phone numbers, and even cable addresses, telexes and beeper numbers, if you have them. Make yourself easily reachable. Forget the self-addressed stamped envelope. Any art director or buyer who is interested in reaching you is not going to worry about the price of a postage stamp or telephone call. And you shouldn't either. That's the least of your costs after you have spent years in school or thousands of dollars on the purchase of equipment. Not to mention some not inconsiderable sums on promotion.

DRESSING APPROPRIATELY FOR INTERVIEWS

After devoting so much attention to effective presentation of your work, do not forget *your* appearance. For the most part you are dealing with stable and probably conservative companies or business institutions. Dress is important, if for no other reason than that it may be an indication of your personal ideas of tastefulness. In recent years the image of ad agency art directors has been cultivated to make it seem that their code of dress is strictly blue jeans and denim shirts. Don't believe it. These are for the most part affectations put on by a very few.

One picture buyer in a major agency told me recently that she has given standing orders to her receptionist that if anyone, male or female, shows up for an appointment in extreme casual dress—ragged or torn jeans, sneakers, worn-out jackets or sweaters—the appointment is to be broken on the grounds that the person to be seen was suddenly called away, even if there is a clear ap-

pointment. There is a definite consciousness about dress even in the supposedly casual atmosphere of the "typical" ad agency.

Appearance is even more important when dealing with conventional business firms. Large manufacturers, major publishers, financial institutions, educational organizations, etc., are apt to be less receptive to the photographer who comes in with total disrespect for his surroundings. Be aware of those you are dealing with and try to make your photographs the only criterion of whether you get an assignment or not, not other factors such as poor appearance, which may negatively influence their decisions about your work.

I suggest that men wear a business suit or at least a sports jacket or blazer, shirt and tie. For women, simple classic dresses or skirts and blouses with a jacket or blazer are wise choices.

There are other appearance factors such as personal cleanliness, and even smoking, which may have some effect on the person you are trying to see. And you might ask (justifiably, perhaps) what all this has to do with your photography? You are probably right, but if the buyer takes offense and a dislike to you and you aren't that strong in experience or reputation, you may never get a chance to present your work—or at least present it in a favorable atmosphere.

I am not suggesting that if you are going for an interview with a steelmaker you should appear in a hard hat, nor are you expected to be wearing a business suit once you get on the mill floor. You should pay as much attention to your personal appearance as you can and try to avoid offending or annoying anyone whose standards may be different from yours. It may not always be possible, but at least be aware of the possibilities and think these things out. It's all a part of professionalism.

MAKING THE ACTUAL FIRST CONTACT AND PRESENTATION

Earlier I touched briefly on areas of concentration and tried to allay the fears of the new photographer in making his first contacts, presentations, or getting his first jobs. Specialization is the key and the decision about what to do has been made by now, I trust. For those trying the journalism track the route is well marked by precedent and statistics.

Approaching the editors of the small-town papers is comparatively easy. Simply approach them—they are usually accessible. A cold mail presentation is just as dubious as a cold "walk-in" to an editorial house. What does the new photographer do about reaching people who are some distance away from home base? What does he do about reaching people in his own area?

If at all possible, the initial contacts should be in person. This can be costly and discouraging from a logistical standpoint, and there may be a tendency to want to use the mails instead. But if you consider the amount of time and money already invested in your career, the additional cost of some personal visits should be built into your general cost of getting started.

Choose a group of market possibilities in one locale and begin by making appointments either by phone or mail. The approach is similar; simply call or write, getting the names and addresses, or phone numbers, from the directories listed in Chapter I. Make your conversations or letters direct and to the point. Give your name and the fact that you are a photographer specializing in a certain area and that you think your work is worth seeing because it may be of use to them. Say that you are going to be in the buyer's area for a limited period of

time, and since you live a long distance away you would like to have an appointment to show your portfolio and meet him during that time. That's about it. If you have a mailer or some tearsheets you can spare, by all means include them in your mail contact.

It is inadvisable to mail photographs or portfolios for the first contact, and you should make that clear in your conversations. When an appointment is scheduled, try to build up a series of other picture buyers to see during the same time period given for your primary contact. Allow enough time between appointments to cover goofs in the schedules the others give you. If you are contacting people in a large city the most you can hope to see in any one day is no more than four or five people—two in the morning and two or three in the afternoon of each day.

You may not yet be at the level of the "business lunch," but if you feel you can afford it and think it might be worthwhile to pursue this course, there is no harm in trying to take the picture user to lunch, dinner or cocktails. But I advise against it until after the first contacts are made.

If you tell someone you are coming from out of town for the express purpose of seeing him he will probably respect this and be responsible about keeping the appointment. A few won't. Also, some picture editors and art directors set limits on the time they will spend on seeing new work and try to make you fit into their schedules. Some won't even see you at all. But these are the hazards you must face.

But for the moment, you have made an appointment. Keep it and be on time. Even if you are kept waiting for what you think is a long period, be patient. It's your work that has to be sold and you are at their mercy. Don't show your irritation and don't get angry, especially when you are finally called in for the interview.

Remember the discussion of dress. Manners, too, are important. Egos are fragile in this business, and it's very easy to feel rejected or equally easy to come on too strong. Be at ease. Be confident in your own ability and don't let personality factors intrude. Build yourself up, but do it gracefully and with tact, and don't put yourself down. It's okay to say you're the best in the world, but only if you do it with some humor. Explain as briefly as possible beforehand what the photos you are showing are all about, but then let the pictures speak for themselves.

Many years ago when I made a presentation to the picture editor of a national magazine, I started to comment aloud on the pictures as he was looking at them. That in itself was all right because I kept my comments fairly brief, until we came to one particular photo and I started to say, pointing to the upper right-hand corner of the print, "Now up in this direction, out of camera range, was . . ." And that was as far as I got because the editor exploded and said, "Dammit! Don't ever tell me what's not in the picture. I'm only interested in what I can see." Not only was he angry, he was *right!* So don't get caught talking about something that isn't there.

DO YOU LEAVE YOUR PORTFOLIO OR NOT?

What happens after you have had your interview? What do you leave behind, if anything? Some art director or picture editor may ask you to leave your portfolio with him because he wants to show it to others. Do you accommodate this request? Not if it's the only copy you have, and particularly if you have others to show it to.

You should have had some business cards printed by now which you can leave. Also, some photographers have made up small 3×5 index cards with their names and pertinent information which are useful for a secretary's file. Others leave their mailers if they have any, or extra tearsheets. Do not leave original prints, whether black-and-white or color, original transparencies, or any other material that is difficult or costly to duplicate. If you do leave *some* material behind, it is perfectly in order to state, "Please be responsible for this and get it back to me as soon as you have shown it." Or if there is going to be a long period between showings, say, "I will be happy to send you materials at a later date when you are ready to show it."

You should be proud of your work, and you have a right not to have it abused or disregarded. You will find this approach quite in keeping with the practices of the editorial world. Again, advertising is something else.

Some ad agencies have people who do nothing but screen portfolios. These are the toughest hurdles to get over because for the most part they have been installed to keep photographers and agents away from art personnel because of fear of time loss or inundation. Other agencies are very generous. Some set up conference rooms for visiting photographers and then herd all the art directors in at the same time to look over the material and meet the photographers or agents.

Some agencies want you to leave your portfolio and return later to pick it up. It is tragic how many portfolios that are dropped off this way are never examined.

There is an on-going controversy among photographers, agents, and art directors about leaving portfolios in general. On the surface, the problems of the art director having the time and opportunity to review incoming work are real. But the situation has not been helped by the practice of using prescreening committees or "art secretaries" who are basically untrained in graphics and who usually have no say in the hiring of a photographer.

The sad truth is that a young or new photographer's portfolio must truly be a smashing one to make the average art director vary from his accustomed practice of dealing only with photographers he has already used or heard about through his associates. Confronted with this, most art directors will deny it, but I have been told in confidence that this is really true. It is not a new problem. Several years ago some photographers decided to try to prove their suspicions. They did it by tacking tiny pieces of double-sided cellulose tape at strategic intervals between the pages that would leave telltale marks if the pages were opened. Over a three-month period some 30 portfolios were left at some 20 agencies, and only three ever showed signs of having been looked at. Of those three, one photographer did get a call from an art director to say how much he had liked the work, but he never heard any further. I know of another photographer who, when he leaves a package of individual prints, casually puts in a few upside down and once in a while flops them completely. He told me that in almost a dozen viewings, only two packets had the pictures returned all right side up, confirming that the art director had turned the pictures so he could see them properly.

I had an experience some years ago that was quite shocking and tells a lot about this problem. I was called by a major agency to make a presentation on a subject on which I was an acknowledged expert. I was given an appointment, and arrived with what I felt was an impressive presentation. The receptionist said I should leave the portfolio. I replied, "Nope. I was called in to make the showing, and by gosh, I am going to make it myself or there will be no show-

96

ing." She hurriedly got on the phone and relayed the message. In two minutes the art director came charging down the hall full of apologies and ushered me into his office. He called in a fellow art director and proceeded to go through my portfolio. Both of them said that it was exactly what they were looking for. They told me that I would be hearing from them in a few days. Curiously, I was never asked at any time about production costs, fees, expenses, page or ad rates or anything at all regarding money.

Guess what happened. Right: nothing. After a week I phoned the art director and asked how his project was coming. "Oh," he said, "we gave it to so-and-so because his price was way under yours."

It happened that I knew "so-and-so" very well, so I called him and talked to him about it. "That's funny," he said, "I already had the purchase order for the job ten days before you even went up there."

"How about your prices?" I asked. Since he knew me and had a pretty good idea what I charged, he said, "I know what your rates are, and I assure you mine were no lower—in fact, they were probably a little higher." He even sent me a photocopy of the purchase order, and it was exactly as he had stated. It was issued *before* my interview and his price *was* slightly higher than I would have bid if I had been asked.

Still puzzled by all this, I started to question other photographers and reps who had dealings with the same agency, and finally worked it out. It seems their client had a long history of wanting their agencies to see more than one photographer on any job they did. So the art director went through the mating dance of having other photographers come in, knowing full well he would not be using them, because he had already made up his mind as to whom he wanted to use.

How prevalent is this sort of thing? It's hard to say and harder to prove. I do know of certain agencies that make it a rule to have their art directors look at many portfolios at one time, and some other agencies do this with the photographer present. Under these circumstances, or when there is a proven record of the art director actually looking at books with the photographer *in absentia*, I think it may be worth taking the chance of leaving your book—provided you have a duplicate for other uses and further provided that a specific deadline is made for it to be picked up and returned.

For the more experienced photographer who already has some reputable credits and who perhaps has been called in previously to make a presentation, my advice is no, do *not* leave your book. If they don't show the courtesy of looking at the pictures in your presence, then it is fairly likely they are not going to look at them at all.

SHIPPING PHOTOGRAPHS

Shipping portfolios by mail puts you in virtually the same category as leaving them at a receptionist's desk. You have no guarantee that they will be looked at, particularly if you ship them in unannounced. Yet there may be times when it is physically impossible for you to call on an art director or picture editor in person because of distance, cost or other valid reasons.

However, if you do decide to use the mails or other transport as a means of contact, the basic question of what to submit to what type of publication or market remains unchanged. You have to be every bit as selective (if not more so, in order to keep shipping costs down) as you would in a *vis-à-vis* presenta-

tion. You must be every bit as well organized in presenting your material and you must know precisely what kind of market you are looking for.

I suggest writing or telephoning the picture editor or art director of your choice and giving the same information you would be giving if you were asking for an appointment in person, but this time state clearly that you cannot come in and ask if you may send in your material. Or if you have prepared a mailing piece, send it in first and then telephone for clearance to ship.

Let us assume you have received an okay to ship. How do you do it? I am reluctant about using the mails because my experiences have been discouraging insofar as the handling of photographs is concerned, so I suggest outfits like United Parcel Service (UPS) or Purolator Courier, and/or some of the better air-cargo or air-express companies such as Federal Express or Emery Air Freight. All of these companies will pick up, deliver to your client, pick up again, and redeliver at your order. Use good, strong, reusable containers such as those made of fiber that are often used to ship film or flat packets in interstate commerce. They are inexpensive and durable and can be reused when your pictures are returned.

You should prepay the shipping charges, of course, and also work out some arrangement with the shipping company by preparing a return prepaid waybill or shipping order to be charged back to you when the pictures are ready to be returned. Using this procedure will ensure the safe return of your portfolio. It will also give you a record of the portfolio's receipt and dispatch, which will minimize losses. You can use this method for Carousel trays, stand-up easel mounts or any of the other methods discussed for presentation.

THE INTERVIEW FOLLOW-UP

The first thing you should do to follow up on an interview professionally is to write a note of appreciation to the art director or picture editor who took the time to see you and/or your work. As for yourself, start keeping a log book or card index on calls or mail presentations, including dates, whom you saw, and perhaps a small commentary on your assessment of the interview. Were your pictures really examined? Were they liked or disliked? Criticized or praised? In what way? Was there a request for more material? If so, what did you send? *Anything* that's germaine to the interview should be noted and logged, even your personal reaction to the person, perhaps the secretary's or assistant's name. If you don't record this information, a hundred interviews later you may be hard-pressed to remember what happened. And it may also help you avoid the future embarrassment of forgetting that you have already seen this person.

If you feel you were well received and that your work impressed your audience, a note or phone call in two or three weeks' time is absolutely in order. This is the time to start submitting story ideas in writing to the editorial publications you have contacted, again making certain the ideas you submit are the kind of material they can use.

With advertising agencies I am not optimistic about sending in ideas, but if you should produce an exceptional set of photographs for a layout, even for a competing client, and can get your hands on extra prints or tearsheets, send them in to the art director or account executive. Some prolific photographers have made up little printed forms announcing the appearance of a specific layout and offering to provide more information.

I have mentioned the use of tearsheets before as samples, but how does one go about getting them, short of buying several hundred copies of the magazine or newspapers or books in which they appeared? Most publications have a tearsheet or reprint service (for advertisers), and they will provide copies as additional run-offs if you let them know *in advance* of printing that you will want perhaps 500 copies of a specific article or layout. Since magazines and unsold newspapers are returnable for credit by the publishers, it is frequently possible to buy large numbers of back issues cheaply by requesting them, again *in advance* from a publisher's circulation department.

The problem of follow-up is a nagging one that must be faced. Memories are short, yet you are reluctant to make a pest of yourself. Art directors and picture buyers do not object to being reminded of the photographer's existence. It is easier if you have a reason to call or write about something other than just to ask "Do you have any work for me?" Here is where the constant flow of story suggestions or ideas fits best. Do not send in inappropriate story suggestions just to keep your name up front. But by maintaining a flow of good ideas, your name will be at the top of the list of those to call when a particular type of story comes up.

I handle story suggestions in a carefully planned routine. When I spot a story idea in a newspaper, magazine or even on radio or TV, I either clip it or make notes on it if it is something I feel will be of interest to any of the several magazines with whom I remain in contact. I outline the piece in a brief *précis*, giving the basic facts, an idea of the illustrations required, the amount of time it should take to produce, and a rough travel and expense budget based on the distance from home to the location(s) involved.

If the story seems unusual and I think it will be especially tempting to an editor, I frequently spend some additional time and money on research in the way of phone calls and trips to the library, checking the *Reader's Guide to Periodical Literature* to see who may have covered the story earlier. When I submit a story idea, I think I know enough about the subject to be able to answer any reasonable question an editor may throw at me as to its feasibility and the mechanics of producing it. Occasionally, when I am in a remote area and see something interesting, I'll knock off a few rolls of film if it can be done without complicated arrangements or disruption of my schedule, just to show what the possibilities are, and send those along with the story idea. I don't include much in the way of photography—by no means a complete story, just enough to show what the potential is and what I am capable of doing. Sometimes it works, sometimes it doesn't, but since I run a stock picture operation as well as work actively in the assignment field, I consider that anything unsold of this nature is an addition to my stock picture collection.

Do *not* make this suggestion in a letter to a specific editor, but simply as a short report on your own letterhead, making several clean photocopies of the story idea. Write a personal covering letter addressed to the most appropriate editor and in it simply refer to the suggested idea, giving the publication a deadline for the acceptance of the idea. If no reply is forthcoming, or a negative one is received, then feel perfectly free to start the idea around with another editor at another magazine.

Can you send the same story simultaneously to different editors? Yes, if there is a time factor in the story itself—such as something happening that has to be covered by a certain date. But if you do send it out to more than one magazine at once, it is only fair to tell the editors you are doing so, but you are not

expected to state exactly to whom it's going. The editors will know from the idea content who their competition is, and it might even stimulate one of them to take prompt action on a first-come, first-served basis.

In your treatment of the story idea, you have to make it clear somehow that you are qualified to do this story as well as or even better than some other photographer, and it may very well be that you will get the nod simply because you suggested a piece that might have been done anyway. After all, editors do see more national news sources than you do. Where you have a particular advantage is when something is happening on the local scene which has national overtones and the local situation can be used to illustrate the piece as a microcosm of the national implications. Desirable as travel may be, the chances are the magazine is going to be reluctant to send a photographer on a cross-country trek when stringers or regional staffers can often put together a story that will serve their national needs. But you will be recognized for initiating the idea and may even draw a lot more out of it than simply the local shooting. In any event, your name will become familiar, and once a fresh flow of useful ideas starts, the chances are you won't be forgotten.

INTERVIEW
EZRA STOLLER

The star-studded system of contemporary photography has many beacons attesting to the brilliance and accomplishment of the leaders of every branch of our craft. There are great names in fashion, news, personalities, documentaries and myriad other specialties, and if the star in each group moves on or falls in disfavor, there always seems to be someone waiting in the wings to take his place, and perhaps that is as it should be. With one exception—Ezra Stoller.

I immediately hear howls of protest over that statement, and the names of other architectural photographers are thrust before me, but somehow I am not convinced. Maybe it's because I have known Ezra Stoller almost all of my working life, have seen his photographs reproduced in the finest architectural journals and general magazines, and perhaps because the ASMP has seen fit to honor him in 1982 with a Lifetime Achievement Award. I put Stoller at the top of the world's architectural photographers. Perhaps that too is as it should be.

Stoller grew up in architecture, studied it, lived it and has breathed it all of his life. He took his degree in Industrial Design because he did not want to spend another year studying when he was already working as an architectural photographer. He did learn the language of architecture and worked with architects, and although he was deeply interested he really didn't think he would be a great architect. He thinks that by now he would have been as good as most of them, but at that time such a thought wasn't good enough. And anyway, he felt there was nothing exciting enough going on in the architectural world at that time to entice him and he said he remembered making the rounds of architectural offices where there were whole drafting lofts full of empty drawing tables with no one designing new buildings. By then he concluded that he was more of an architectural journalist than a working architect and thought he could be more directly involved in the medium in this way than as a draftsman working on one job at a time.

He became so involved that at his peak he was doing some 130 assignments a year—a staggering amount of work then or now. It may account for the broadness of his shoulders, developed perhaps by toting an 8 × 10 camera to the far

101

corners of the world. Stoller finds having the opportunity to work with the world's great architects infinitely more rewarding than slaving over a drawing board. Moreover, he was earning a good living while his colleagues were still trying to find work as architects.

He said, "I couldn't have these feelings if I were involved in any other kind of photography. I could never be a portrait photographer because while I am interested in people, I could never have the necessary objectivity and would forget all about the camera in my dealings with them. In architecture I have a fine sense of space, a thorough understanding of construction, and it still turns me on.

"And even when my feet start hurting at three o'clock in the afternoon, if I'm on an exciting job I continue to work and am often amazed at how much I can turn out in a day. I learned a little of the jargon while in school, but mostly I learned on the job and architects began to appreciate that I took their work seriously. Most would hire a photographer who would simply take the pictures without thinking through what the architect was trying to say with that building. When they met someone who not only understood them but tried to bring out the best of their work, they were truly appreciative. Architecture, like any art form, is a language, and when they met someone who spoke that language they were interested. It's hard to separate the economics and business aspects from the aesthetic aspects because they go hand in hand, and very early on I worked out a system where I could work for architects who couldn't pay much money but who needed the kind of photography that takes a lot out of you in time and effort. Production expenses were often horrendous and started mounting while I waited for one good day after seeing five bad ones go by. A system had to be worked out so the costs were distributed among all the users of photography, not just the architects, who could not carry this load. So they paid for what they used, the record and exhibition rights, and the bare expenses."

Stoller got into the journalistic aspects of architectural photography from the very beginning. His earliest assignments came from the now defunct *Architectural Forum* magazine, then published by Time Inc. Early on he formed a close friendship with famed graphic designer Will Burton, and when Burton became art director at *Fortune*, he brought Stoller with him. He continued to produce interesting work for them that led him into industrial assignments, pharmaceuticals, and other work.

There is a great deal of similarity in the way an architect plans a building and a photographer faces his problems, and Stoller's knowledge of architectural planning led to his expertise in architectural photography. He said, "In all my work, the same architectural approach prevails because there is a strong cross-discipline here. The discipline is that first you have to state the problem, and if you state it well and clearly you are already halfway home." He applies this thinking to the way he photographs. Stoller does not photograph on impulse; instead, he very carefully plans what he is trying to say. His pictures work out well because they are well thought out before he takes a camera from its case.

I asked him if he looks at the plans before he shoots and he said, "I really don't like to talk to the architect beforehand because architects always want to talk about their buildings. If they want to explain and talk about their buildings it's like trying to explain your photographs. If you have to explain them there is not much point to them.

"On the other hand," he said, "since I am educated in and responsive to architecture and I understand it, I know what to do, what the architect is trying to say, and if the building in actuality isn't too good (and after all, some jobs don't

come out well), at least I know what to hide behind a tree or a bush. Above all, I am interested in what the *architect* is trying to say. I am not documenting a construction job nor am I interested in the space the editors give me, since there is little to be gained.

"By the same token, by understanding what the architect is trying to say or put into a building, I can, by judicious use of light, angles and lenses, uncover some things he may have given up on, and I am able to bring them out photographically."

With pride he quoted a telegram he once received from Frank Lloyd Wright, who called him a "wizard" for having successfully photographed a job that Wright found disappointing. But because Stoller knew and understood what Wright was attempting to say architecturally and was sympathetic to those ideas, he could bring out the best features of a building and play down the less successful things the builder or owner may have done subsequently.

Stoller is critical of photographers who are more concerned with what comes out from their side of the camera than what appears in front of the lens. In other words, he feels that more often photographers are interested in bringing off the assignment photographically than being concerned with what the architect was attempting to say in his design. Stoller is deeply concerned with the spatial aspects of the building as a structure and what his photography can do for it.

He feels fortunate that he began his career at the time modern architecture was coming into its own. He was trained in the classic Beaux Arts school of architecture, where "eclecticism" was the key word—that is, making effective use of things that have been done before. In architecture this is particularly true, and he feels that the whole mode has almost come full circle during his career lifetime. He defines eclecticism in architecture as "reassessing the best of the past and reworking it. A good architect who knows these things works like an orchestra conductor who can play Mozart in the morning, Bach in the afternoon, and Berlioz in the evening, and knows how to interpret each style of music," Stoller said.

"As it applies to the architect, so must it apply to the architectural photographer. Functionalism is the key to any building. It has to express what it is doing, how it is built, and show the honest use of materials. The same things happened in photography with Edward Weston. Before his time photographers went to great lengths to produce misty scenes on bromide prints with canvas textures, trying to imitate painting. Weston was dealing with the realism of photography, and everything was in terms of the photographic medium. He wasn't trying to imitate painting."

Stoller reflected a little on the attitude of the photographic community toward the importance of architectural photography. He mentioned a recent show of his that was reviewed extensively by two different critics at *The New York Times*, plus every architectural publication of note. It attracted a great deal of attention, yet he said "not one single photographic magazine even mentioned the show, let alone sent a critic."

Stoller thinks that "architectural photography is one of the most demanding disciplines in the photographic world. The difficulties lie with the numbers of people you must deal with and perhaps please and the demanding force of quality. Quality also means being allowed to produce according to your own standards." When I mentioned an ad agency creative director who said that the fashion photographer more than anyone else had to be totally engrossed in his specialty, Stoller went beyond that and said he thought every photographer had to be totally engrossed in whatever branch interested him, citing numerous

colleagues outside the fashion world who were as totally involved in their respective fields as Stoller is in his.

Stoller also discussed technique, and he has strong feelings about photographers who become so caught up in "technique" that when one looks at their pictures it is obvious that they are using it as a coverup for their own deficiencies in interpretive photography.

He feels that photography is a tool only and that its main function is to document ideas, in his case the ideas of the architect, which are spatial concepts. He also feels that the magazines are no longer the essential showcases they used to be, and this affects the craftsmanship of the photographer because if that essential showcase is missing or fails, the demand for craftsmanship must falter as well. He ruefully remarked, "Look at the big magazines of twenty years ago and those same magazines today; they just don't count any longer. The magazines are being taken over by the bookkeepers and quality is no longer the driving force. Only a few years ago there were seven architectural magazines and now there are two, plus one that pretends to be one but is only a fancy guidebook to the homes of Hollywood stars. Quality is what it's all about, and a guy has to beat his brains out to be allowed to get any quality in what he is doing."

He is also angry about the quality of materials, of film and paper available, and predicts that in not too many years the silver-based image will disappear completely. He spoke of an exhibition he had seen of photographs with prints made in India before the turn of the century, old platinum prints that even today shine with a brilliance that outstrips anything on the current market. He described the incredible tonal range achieved by an unknown photographer shooting inside a temple with excellent shadow detail, a fully exposed street scene outside and, beyond, the temple walls. "Try that today," he said "and you couldn't do it. And that was probably accomplished eighty-five years ago or longer."

While decrying the reduced market for editorial architectural photography, he mentioned a small-circulation, large-format architectural magazine published by an excellent Japanese photographer named Yukio Futagawa, who superbly photographs, edits and prints it. The publication, called *GIA (Global Architecture)*, is beautifully done, although its small distribution limits its market. This publication serves mainly to remind Stoller that fine architectural photography can be shown.

Despite his pessimism about the quality of architectural photography, Stoller feels there will always be a market for it and a chance for the good photographer to earn a decent living because buildings are still being built and architects still need photographs of them. But he warns the new photographer not to expect too much in the way of a fine showcase for his wares. He also reminds newcomers to the field that in spite of their talent, especially if they rise a cut above the competition, there will always be someone willing to work more cheaply, so they must be on guard against loss of integrity by competitive price cutting. Stoller is a firm believer that the public will respect integrity and quality and be willing to pay for it even in a declining market.

As for education, when he started there were only two or three schools that adequately prepared architectural photographers. He is appalled that with all the photo schools, seminars and workshops around, the proportion of fine architectural photographers hasn't risen appreciably. Part of the answer lies in the fact that new photographers won't use or don't know how to use the view camera, and even though the perspective control (PC) lenses for the 35mm

camera have helped somewhat, they still cannot do the job. Stoller thinks it is terribly hard to make a good architectural photograph with the 35mm camera, and the results are glaringly obvious. He says, "The smaller the camera, the tougher it is to shoot a job." He concedes that high operating costs are driving the 8 × 10 camera out of the architectural market because "Who can afford to shoot a hundred sheets of 8 × 10 color film per day (a modest production for the good architectural photographer) when the film and processing alone will cost around $800? And if the photographer is using Polaroids as well, add another 30 percent to the daily material costs. So we have had to go to the smaller camera and I am exploring the 2¼" × 3¼" view camera that keeps the swings and tilts but reduces the operating costs considerably and still gives the architectural photographer a chance to produce decent work."

But he finds that even though the smaller camera works quite well, it is still hard to operate, and those who were trained to compose their photographs critically on the ground of the large camera find the smaller format restrictive and more difficult to deal with.

He expressed a critical part of his philosophy by saying, "In architectural photography almost more than in any other field, you have to organize yourself so that you have total control of your pictures and can resell them. In this way, you spread the cost between the architect and everyone else interested in using those pictures. That is how the architectural photographer makes his money. But don't have any illusions about it. Maintaining a file of architectural photographs is not something that takes care of itself and runs unassisted."

The market for architectural photography does not depend on the legwork of the photographer or his agent to sell the photographs, but on the architect, who becomes the salesman by spreading the word that pictures of the building he designed are available and can be obtained from the photographer. This is where the original agreement with the architect becomes important, and the photographer must make certain that he has retained the distribution rights to the pictures. If he has not, the architect in his eagerness to have his building seen in the architectural, construction or real estate pages will try to give the pictures away, which is not very profitable for the photographer. It is incumbent on the photographer to make certain that all the architect can say to his clients and audience is "All I own are record and exhibition rights to these pictures. I cannot sell them, I cannot authorize their reproduction and you have to contact the photographer for any other use."

So the architect, not the building owner, who seldom is involved until the structure is built and occupied, and not the editor, is the primary client of the photographer. If the building owner has commissioned the photographer, then he pays a fee commensurate with the contemplated use.

Architectural photography is usually divided into three pay scales:

1. Record and exhibition: This is usually the lowest cost (for the architect) and entitles him only to prints for record and exhibition. The photographer owns the negatives and other subsidiary rights and usually charges a day rate plus expenses.

2. Publicity rate: (Usually charged for commercial buildings.) This includes publicity rights for the person to whom the pictures have been sold. Publicity is everything but paid media advertising. Stoller was very careful to define these rights as belonging to those who commissioned the photos and excluding any third party who may have an interest in the building. For instance, while he may sell publicity rights to a building owner for any publicity

program he has, a third party, such as a manufacturer of some construction component, does not acquire those rights. If that manufacturer wants to use those pictures for publicity of his products, he has to pay the photographer for those rights. Special rights can be granted, as Stoller did for a professional association to which an architect belonged, for an option to use one of the photographs of a building the architect designed only if that architect won a prize in a forthcoming competition. Stoller granted this right on that contingency basis.

What Stoller is clearly telling new photographers in architecture, as well as other disciplines, is to always specify and clearly state what rights are being bought and sold.

Reflecting on the new copyright law and the "work-for-hire" agreements that are now bones of contention, Stoller said he has no problem with this law since he does not accept any work-for-hire agreements and refuses to make photographs for any client that demands them. When I asked Stoller if he recommended that new architectural photographers refuse to sign work-for-hire agreements, he laughed and said, "I recommend that no photographer sign a work-for-hire agreement except in an 'all rights' situation for which he is paid an appropriate fee." So much for that.

3. All rights: Stoller said there is a third scale that is simply called "all rights." If the client pays enough, he can buy any rights he wants and do whatever he wants with the photographs. But Stoller keeps possession of the original negatives. In an all-rights situation a work-for-hire agreement is essentially signed, but Stoller has no quarrel with this since presumably the client is paying enough to cover any potential loss of secondary sales.

When producing editorial photography, that is, a direct assignment from a magazine or other publication, Stoller works on a day rate that he says can be quite reasonable and modest, but also charges a page rate in addition when the photographs appear. The rates vary with the space used.

I asked him if a magazine will normally accept this kind of arrangement since the trade custom is to pay either space or time rates (whichever is higher), but not both. He said it was tough to uphold initially but he usually worked it out by charging a very low day rate (usually the ASMP minimum). The magazines accept this because they know they are getting the best in the field and the total price becomes a bargain. I asked Stoller if he felt that the younger and less prominent photographers could command this pricing structure and he said he thought so if they charged a very low day rate as a floor for their work and relied on their skill and ability to raise the final price to a fair and equitable one. He also pointed out that architectural photography is usually assigned a specific space in a magazine and unless the photographer fails abysmally or the printing plant burns down, the chances are the photographs will be used as planned. This is different from the general editorial policies of most magazines, where the space often varies with the news of the day and the happenings of the minute. I reflected on the number of 16-page cover essays I had seen shot down in national news magazines by the ring of a teletype bell announcing some catastrophe. So Stoller thinks it is quite safe to work for an editorial architectural story on a very low day rate plus the general space rate published by the magazine. But production expenses are always in addition to the day rate and the photographer must never forget this.

Another reason this method of payment makes sense in the architectural world is that Stoller, like many of his contemporaries, frequently makes com-

bined lengthy shooting trips since the stories ordinarily are not hard news. However, it may be up to two years before some are actually used. By using this method, Stoller is at least assured that his expenses and his minimum time needs will be taken care of. With these primary requirements protected, he is content to wait until publication for the balance of his money. Also he finds that the same pictures are frequently published more than once by different or even competing magazines since they are not bucking a time factor and are dealing solely with their own audience. Thus the magazines are given some flexibility in their space budgets because the initial outlays are not great.

Part of the drift toward lighter and smaller equipment comes from Stoller's feelings about the terrible reproduction quality of most magazines; he thinks it a colossal waste of time for a photographer to lug an 8 × 10 camera around anymore. Hence the newly redesigned a new lightweight kit based on a 2¼″ × 3¼″ view camera compensated by the better quality of film emulsions and that this size transparency can deliver all the color quality necessary to match the best reproduction available. But while the trend to lightness and compact equipment continues, Stoller reemphasized the importance of the view camera in architectural work and the care and devotion that the photographer must show in order to produce the finest possible photographs.

CHAPTER 5

GETTING THE ASSIGNMENT: DETERMINING FEES AND RATES

The phone rings late one Friday afternoon. Why late Friday? Did you ever know of anything to happen in this business except at the last minute?

"This is Joe _____ , director of public relations at the American Producing Company. You were in a couple of months ago and we liked your work, so would like you to come in and talk about covering our plants for our annual report. We would like you to start at the end of next week. Are you available and can you present some sort of budget?"

So you say, "Of course. What time do you want me to come in?" You make a date for the following Monday morning and hang up in a state of euphoria.

By then it's 5:30 in the afternoon and Joe Smith has left for the weekend. In your excitement you didn't ask him where the plants are, how many plants there are to be covered, and some other general information that could have helped you plan the budget he wants Monday morning.

But all is not lost, because you still have the weekend ahead of you. So you do a little scrambling. First you try to find a copy of a previous annual report. Since Smith's firm is a local company, you try the bank, if it's open on Saturday, or the chamber of commerce, or a resident stock broker, until you come up with one. In it is a listing of all of the company's plants and subsidiaries, their products and the names of their corporate officers. You become familiar with the information in the annual report, because it is essential to planning a budget.

The scenario can vary. It doesn't have to be a corporate annual report you are assigned to do. It can be a small editorial piece for a magazine or maybe material for a brochure for a public relations program or possibly an advertising layout to be shot on location. The essentials are the same. Any budget you prepare has to take into consideration every factor involved in the production of the photography, and you have to be able to justify your costs and fees.

CHARGING FOR YOUR SERVICES

Charging for one's services can be unnerving, particularly for the new photographer. Learning to produce a realistic budget is of utmost importance because planning a budget and negotiating its acceptance can determine whether you succeed or fail in the business of professional photography. Fees are calculated

and governed by all sorts of factors—uses, space, circulation, whether it's for editorial public relations, annual reports or advertising—or almost every different category of photography you can mention. Knowing what to charge for a particular job involves:

— an analysis of the client's budget and needs;
— knowing what to charge for your time or, if it's an editorial production, what the potential for space rates may be;
— and a totally realistic appraisal of your total costs in doing the job, including overhead.

Thirty-five years ago when the ASMP was first formed there were no guidelines, and it took several years, even after the organization started to grow, before early guidelines were set down. Over the years these guidelines have been implemented and minimum recommended fees raised periodically to keep pace with the times and inflation. When it comes to fees, you, the photographer, have to decide what you think your work is worth. (You should also know what is being paid for comparable work in order to establish an equitable price.) In some editorial photography this causes no problem, as many magazines operate on a *space vs. time* system, and most photographers accept this. Space vs. time means that you are paid either for the space you achieve in layout or the time you spend producing the photographs. Most major magazines have published space rates and pay the ASMP minimum for time spent, and if you work under these arrangements you get the higher amount when the story "closes," as it's called in the publishing world. The ASMP guidelines at this writing call for $350 per day plus a certain percentage allowed for time spent in travel, making other arrangements, weather standby, etc. Many magazines such as those in the Time-Life group pay $350 per page and up to $1500 for a cover.

Historically there has always been a squabble over the differential payment for color and black-and-white, and now the whole question is up for review again. Photographers and their agents want the color/black-and-white differential done away with on the ground that it actually costs more to process and print a black-and-white photograph than it does to process a reversal color transparency. It is the 35mm transparency that numerically accounts for most professional color photographs today, except perhaps those dealing with food and architecture, where larger format work is generally the rule. Even here, inroads have been made by the 35mm, especially with the development of the PC-type lenses and better film emulsions. But photographers are in conflict because, while they would like to see the differentials eliminated, they don't want to see it done at the expense of their color work. What they are trying to do is raise the level of black-and-white prices to a par with color. This works on general assignments, but it is not working as yet in the stock-photography market where a differential is being charged to advertisers, not only for color but also for color position in the various media. Also, textbook publishers are still printing most pictures in black-and-white and they object vehemently to raising the price of black-and-white to the same level as color. So it is becoming a long educational procedure for the photographers to bring picture users around to their point of view.

The newest guidelines published by the ASMP indicate a variety of rates. In advertising there are other rules and guidelines that have to be considered. In the appendix to this book you will find a list of the current rates suggested by the ASMP. Whether you can live with them or not or can do better (or worse) is entirely up to you. However, what they will tell you is what is currently being paid in the marketplace.

PAGE RATES

In some ways the contemporary photographer is lucky because of the pioneering of his predecessors in the professional societies and groups. Much of the credit, too, has to be given to some of the major publications of only a few years ago that used photography as a major component of their publication and set some standards and norms in the form of page rates. Many photographers did feel then, and still do today, that many of these rates were hard-nosed guesses based on what publishers felt they could get away with, but it wasn't always the case. In some of the earlier mass picture publications, page rates were sometimes set pretty high, only to retrogress a few years later or fall behind the times. For example, one major magazine set a rate of $300 per page for color in 1939, and that same magazine in 1982 is paying $450 per page. Another monthly paid a color cover rate of $3,500 in 1950 and in 1980 was paying $1,500.

Today, with the differential disappearing between color and black-and-white, it is imperative that a photographer base his fees not only on a realistic appraisal of publishing costs and profits but also on the multiple uses of a photograph, frequently by the same houses that hired him in the first place. This is not simply a matter of charging for the additional uses, as we have discussed before, but for the concept in producing photographs that have a "half-life" for years to come. It is the consideration of these ideas that makes one photographer more useful to a publisher or corporate, user of photography than another. In other words, if you can convince your client that you are unique in getting your photographs (of his product, service or concept) moved into other areas, you are entitled to seek more money than the photographer who says, "I will do your job, pay me for it, and call me again some time."

DAY RATES

The professional societies have long tried to establish minimums for day rates that would give the working photographer a realistic return for his efforts. A reasonable goal but difficult to achieve, because in the free-lance world there is no assurance of how many days a photographer will find work for in any given year. Some photographers seem to be always working and others, equally as good technically and aesthetically, seem to have a tough time making ends meet.

Much is due to luck but also much is due to how well the photographer (or the agent, if there is one) is able to sell or be sold. With the current day rate of the ASMP at about $350, in order for the photographer to earn $35,000 per year on assignments, he has to work 100 days or about one-third of the year. Is this realistic? If he wants still to earn that $35,000 and can only get 50 days per year, he has to be able to ask for and get $700 per day. Can he do that? How does that compare with the competition?

One of the problems the ASMP ran into over 25 years ago, when they first established the "minimum day rate" formula, was that while it was helpful and a starting point for many photographers, unfortunately it often became the maximum and a fixed fee for everybody. Over the years, as the cost of living increased and inflation began taking its toll, the ASMP and other groups began to raise their minimums. While the dollar numbers did increase, the percentages and comparative returns did not, and the concept of the minimum remaining the maximum continued.

There does not seem to be any alternative, however. The professional photographic organizations are always quick to point out that these fees are *suggested* minimums and it is really up to the photographer to negotiate his own

rates with his client. But another nagging question persists—why should the young, less experienced photographer be hired when the client can get an old hand for the same price? I have always had strong feelings about this issue and believe that the younger photographer should *not* be discriminated against in price because of his lack of greater experience. If the young photographer has shown in his portfolio the capability of fulfilling the assignment, he should get it, all other factors being equal. Never was this more true than when one of the earliest managing editors of *Life,* in looking at a story, would have the pictures from every source laid out on the floor of his office, walk around them and choose the pictures according to what he saw, not caring one bit about who supplied them and often not knowing who the photographer was.

YOUR TIME—WHAT IS IT WORTH?

In the meantime photographers can operate only with the primary day rates of professional photographic associations as "hunting licenses" rather than fixed fees. What is a photographer's time worth today? The news magazines are currently paying about $300 to $400 per day for any kind of shooting, against page rates of $250 to $350 for inside use and $400 to $1,500 for covers (usually all color). Corporate work tends to be two to three times the editorial rate. The philosophy here is that this type of shooting is frequently a once-a-year job, as in an annual report, and does not have a comparable space rate to give the photographer a chance to do better if the pictures are played more widely and in better display, and credit lines are rare if given at all. Advertising rates, as discussed previously, are frequently based on a combination of media usage, audience and space. A double-spread national color ad today should bring from $7,500 to $15,000, depending upon the variables listed above. Specialists with high degrees of scientific achievement involving extremely sophisticated equipment and scientific knowledge may earn fees in excess of $1,500 per day, as do some top-level corporate photographers specializing in major corporate annual report work.

The ranges are wide. An agreement made in 1982 with the three major newspapers in New York and the Newspaper Guild puts starting staff salaries at approximately $425 per week, or slightly upwards of $22,000 per year plus fringe benefits, which can be considerable in the way of health and pension plans. Private portrait sittings by highly skilled portrait photographers run from a low of $300 to a high of $2,500 per sitting and may include a number of different photographs and some rights to reproduce them in certain publications or for corporate public relations use. A studio portrait sitting by a competent but less experienced and less well-known photographer will probably not exceed one-third of these fees, however. Some of the finest and most prominent portraitists will also produce editorial portraits for top magazines at a lesser fee— usually a minimum day *vs.* space rate—because of the prestige and resultant publicity and because of the repeat work and secondary rights usage of many of the pictures they shoot on editorial assignments.

These fees fall into some fairly standard brackets, but rates are finally dictated by the market as well as the experience and prominence of the artists. Photographers like the late Philippe Halsman and his contemporaries can and did command impressive fees because they were at the very highest level of artistic achievement and delivered their work with that added quality that set them apart from most others.

In the appendix you will find one list of suggested minimum fee guidelines for editorial and advertising for a variety of situations, both original shooting and

stock. These figures are recommended by the ASMP to its membership. It is not a "scale" or a rate charge, but merely advice to members as to what they should be charging as a minimum for various types of work. The ASMP has always taken the position that these fees are the barest minimum a photographer should charge for his work and still stay alive economically, with a constant reminder that these are indeed "floors" and are not to be considered fixed prices.

DEVIATION FROM PAYMENT STANDARDS

Young photographers who would like to compete but simply cannot command the prices paid to some of their seniors often ask, "How far can I deviate from the professional codes?" The answer: "As much as you want to." The codes of the ASMP are recommended for their members, who are expected to uphold them. But keep in mind that the ASMP also believes that to photograph or sell below those minimums means working at a loss.

What is an acceptable deviation from codes such as these? There are no hard answers, but by custom those photographers who profess to operate under these guidelines but accept a lower rate of payment may be excused if they are under a contractual relationship for a specified amount of work or a guarantee of page space or a fixed fee for an entire package involving many days of work. Then, too, there is often the simple fact that a photographer needs the work and there may not be anyone else around whose throat is being cut by your working for a lower fee. Photographers will often find themselves faced with appeals to wait for acceptance of a project before full payment can be made. This happens frequently, when material is needed for presentation use. Here there is a way of controlling it. If a buyer comes to you and says "Look, I need certain kinds of photographs that may take a certain number of shooting days for a presentation of an idea, but I can't afford to pay the full fee unless we sell the project, will you do it?" The answer can conscientiously be "yes" provided that, if the project is sold, the photographer will either be paid additionally or guaranteed to be the photographer on the shooting that the experiment generates at guaranteed full regular fees and those guarantees must be in writing.

SPECULATION

Continuing our discussion of times when it is appropriate to deviate from standard fees and rates, we now encounter the concept of working "on speculation"—doing the work and (theoretically) being paid later, upon acceptance. This is a practice that has damaged many a professional photographer's career and something the new photographer should understand perfectly before starting out.

The requests a free lance photographer or agency gets can often seem like utter simplicity itself—for example, a group of pictures that can be "knocked off" quickly without much effort. There is a great temptation to do the photographs on a speculative basis—producing them without an assignment and then expecting to sell them. What usually happens is that the photographer is left holding a very large bag mostly filled with empty promises and his costs from shooting the pictures. One of the situations to be wary of is the "I'll take care of you later" syndrome, when you are told that the budget is too limited for current prices for photography, but if you give the editor a break now, he or she will take care of you later and the money will be made up. Somehow it never seems to happen. Though as long ago as the 1950s ASMP rose up on its heels and "outlawed" speculative photography, the practice still arises in the markets for professional photography.

Sometimes photographers are trapped into situations through no fault of their own by requests from people who are too low on the pecking order of some organizations to really have authority to issue such orders. An example occurred last year. A photographer I know who also runs a small stock photo agency received a call one Friday afternoon from a researcher at the publications department of a very large bank in New York that was making a slide presentation covering many different aspects of marketing and business management. The researcher gave the photographer a list of about 25 subjects, all of which had to be ready for duplicating by Monday evening so as to be presented to the bank's client Tuesday morning.

The photographer told the caller that he had about 15 or 16 of the subjects already on hand, and since the others were all concentrated in the New York metropolitan area, he felt he could shoot the rest over the weekend, not as a formal assignment, but on a "guaranteed use" basis in the slide presentation, and that he would have the slides ready for duplicating Monday afternoon. The researcher at the bank was extremely grateful, and while there was no discussion of an assignment fee, she did say there was no question that they were going to use all 25 of the situations. The photographer did some rapid calculations, and since the going fee per frame for this type of presentation was in the $135 to $150 class, the thought of a $3,000-plus fee involving two days of shooting plus pictures from stock was indeed appealing. When he got home that night he received a confirming call from the researcher's supervisor, not only confirming the package deal but adding two more stock subjects to the list.

The following day (Saturday) it rained unexpectedly, but Sunday proved to be clear, and the photographer doubled up, doing two days' work in one, covering over a hundred miles of local driving through the 50-mile radius of New York. He got his film to a lab that could do Sunday night processing, collapsed in a heap at home and collected his pictures the next morning. They looked good, he edited them, worked in the stock pictures from his files, added a completed leasing memo and delivered the entire package to the client as promised.

At noon the following day the package was returned. The photographer called the researcher who had ordered the pictures, and she calmly said, "Oh, we only used one, which is now at the duplicating lab. Thank you for your help."

The photographer checked his returns and, sure enough, all of the pictures were back with the exception of one. However, he noted something else. Each group of transparencies had been mounted in plastic sleeves, and over each sleeve the photographer had securely taped a caption sheet. The plastic sheets could not be screened on a viewer without removing the captions, and not one single caption sheet had been lifted off the plastic sheets, with the exception of the sheet that contained the picture used. Conclusion? The other pictures were *never even looked at*, let alone considered for use.

The photographer called back and asked the original contact about payment for all his efforts. "Sorry," was the answer; "we didn't *assign* these pictures, you have no purchase order, so we cannot pay you anything except for the use of the one picture we used."

The researcher continued sweetly, "Oh, by the way, the duplicating lab seems to have lost your original, so would you accept the dupe they made instead?" After a few appropriate comments (expletives deleted) the photographer, who had (1) used a good leasing memo form and (2) had protected his photographs with proper notice of copyright, called the researcher's superior

(the one who had earlier confirmed the agreement), but she promptly passed the buck to her boss, who took the position that, "Since you had no purchase order, and as a matter of fact the researcher who called you didn't even have the authority to make such an offer, nor did her superior, you are simply out of luck, buddy boy!" and hung up.

The photographer called back and told him that while it was true there was no time for a written confirmation, as it had all started on Friday night for a weekend shoot, and since such bad faith was being exercised by what he thought were honorable people at the bank, he had no recourse but to (1) apply the terms of the lost transparency clause in the leasing memo and (2) instigate action for *infringement of copyright*. There was a sudden "whoosh" of air over the phone as the big-shot bank vice-president deflated quickly, and finally a verbal settlement was reached for both the lost transparency and its use. The final price also gave consideration to some, but not all, of the time and money spent shooting the nine new photographs. It would seem that this would have ended the matter, but it didn't—ninety days later, not having been paid, the photographer had to practically do battle to receive payment.

I have related this story in detail because there is a lot to be learned from it, and I will be discussing various aspects of it as we go on. But the primary lesson here is to avoid speculation, no matter how tempting it may be and how much verbal assurance you get from the person wanting the pictures. There are many ways of handling these situations: purchase orders, written memos, telegrams or mailgrams or, in the case of studio sittings or still lifes, advance down payments or any other businesslike methods of proving good faith and responsibility on the part of the client.

NONPROFIT GROUPS AND PROFESSIONAL COURTESY

Another ploy often used by so-called nonprofit organizations, foundations, public institutions, educational groups or charities is to approach you and ask for services for either nothing or at low cost or for the use of stock pictures at prices bordering on the ridiculous. Their excuse always is, "We are a nonprofit organization." They forget somehow to tell you that they themselves invariably are on good salaries, the printers are being paid in full, the paper suppliers are being paid in full, the postage is being paid, and the office rent and help are also being paid at current rates. Somehow they expect the artist to accept lower prices. I handle the situation by sending them a form letter such as the one included here, which politely reminds them that selling photographs is a business.

MEMO TO:

Your request for special pricing consideration has been received most sympathetically, but unfortunately we cannot respond positively. We too are a nonprofit organization . . . it wasn't designed that way, but that's the way it seems to work. We trust you understand.

> PHOTOGRAPHY FOR INDUSTRY
> Charles E. Rotkin

Sometimes these requests are genuine in that the groups or individuals really have no funds and you want to help. What then? Just do it as a charitable gesture and simply shoot the pictures or provide the photograph free, but don't do it at a reduced rate. By donating a free picture worth a specific amount, you can take legitimate deductions on your income tax if you are so inclined.

Another minor but frequent occurrence is in the matter of professional cour-

tesy. Many times I have been asked by other photographers or editors who are friends or professional acquaintances for pictures at reduced rates. I always refuse the reduced rate aspect but give the picture without charge. Why not accept a lower fee? Well, I feel that to do so would be to diminish the value of one's work or service and that is unacceptable to me, but I have no reluctance about giving freely to my friends and acquaintances.

THE ETHICS OF FREE PHOTOGRAPHS

The entire issue of "free" photographs is a complex one, reaching far back into the history of photography and the evolution of the role of the professional photographer. So let us digress a bit in order to address this issue, as it is something every beginning professional may have to deal with at some point in his career.

Today photography is probably the only form of visual communication in which amateurs outnumber professionals by such vast numbers as to be virtually uncountable. Therefore, competition to get into print is very great.

So how does one get into print, especially the young and inexperienced photographer? Even loaded questions such as whether the amateur or young professional should be paid as much for his time as a professional, or whether space rates should be equal for all, can never be fully answered honestly without having some bearing on the ethics of the "free" photograph.

The industry thought there were some answers when the ASMP put into effect some 25 years ago a minimum standard for a day's work and began pressuring the magazines to establish space rates for the unassigned work they used. It seemed right then and is today a valid concept, but what happened is that the minimum became virtually a maximum, and a fixed price was more or less set for all editorial photo work by the major publication groups even though it was never intended that way. Editors started to ask young photographers just coming in, "Why should we pay you the same money that we pay one of the big stars?"

Even before getting to the concept of what a photograph is worth, we should make some distinctions or perhaps narrow the definitions. It may not be a question of how much a photograph is worth, but how much is it worth to (1) the person who makes it or (2) the person who sees it and wants to reproduce it?

Pursuing this philosophy a bit further we might even consider the feeling of some artists that every image made should be seen by someone other than the image maker. If we accept the theory that a photograph should be seen once it is made, then the idea of the "free" photograph becomes more palatable to the professional. If we (grudgingly) admit this dictum, then perhaps there will be less hostility towards the *new* and *needy* photographer who sells a photograph for less than current market value in order to get started. But many still look askance at the well-heeled photographer with an income from some other source who uses these same giveaway methods for becoming known and recognized.

The next question to be considered is: If we accept the use of a picture without charge, should the artist be expected or obliged to produce this work without compensation? Obliged, of course, is not the answer—no one should be *obliged* to do anything at all without some compensation.

Or perhaps there is the question of the message. The photograph is a message, whether it concerns a social theme, a news item or a hard sell of an object or service. We seem to have no objections to leaving those messages, but the

only question is, how should those messages be paid for? And, by whom? Is there a universal right to know? (For free?)

I am introducing these thoughts only in the hope of stimulating some thinking on the part of professional photographers about what is to become of their output and how it is to be handled. In considering that output and its ultimate use, whether paid for or not, we cannot ignore the impact of the society in which we live and the role our own government has always played in the dissemination of information, from general to political propaganda or hard news.

From the earliest days of photography, the government has consistently played an active role and the pictures were made available without copyright protection. Even so, the earlier making of photographs for free distribution did not have too much impact on the economic lives of photographers except in a positive way, as photographers who were hired to shoot for the government would not have been hired at all if the government did not employ them. There is one aspect of the free government photograph that does merit some discussion and concerns the pictures, distributed by the White House Photography Office, of activities of the President when the photographers of the White House Press Corps are excluded. There are no fees or charges made to the press associations for these pictures nor is there any substantive feeling that the White House is taking jobs away by having their photographers cover the President. There is some unhappiness over the fact that the working press of the White House is excluded from a journalistic point of view of making that great picture of a cabinet level officer being fired or some equally newsworthy event that would give the press photographer a chance to show his expertise as a newshawk.

Certainly it was the informational concept behind the establishment of the famous photographic files of the Farm Security Administration (FSA) set up during Franklin Roosevelt's administration in 1935. We were in the depths of the Depression. The country was literally in upheaval since the topsoil on the farms was blowing away to become a vast "dust bowl." The poor, rural and urban, the landless and homeless began a trek across the country that assumed near-avalanche proportions, in search of a promised land. Television didn't exist, film-making was limited, and the Department of Agriculture, faced with the responsibility of bringing the plight of these Americans before the public and getting support (i.e., congressional appropriations), began using photography in a major way.

Photographers and artists were hired and put to work, among them Dorothea Lange, Ben Shahn, John Vachon, Marion Post Walcott, Russel Lee, Walker Evans, Carl Mydans, Arthur Rothstein, and others all gathered under the direction of a then obscure historian and archivist named Roy Emerson Stryker in the newly formed Historical Section of the Resettlement Administration later to become the FSA. In addition to the photographers in the field, complete support services were established in Washington in the way of laboratories, storage, and distribution of pictures to any and all who had a use for the material. The pictures were free to any media that could use them. No editorial opinions were disseminated, as the directors of the program were content to let the pictures speak for themselves, to emphasize the tremendous need for help of these people. All the information provided was simply accurate captions, dates, places and a description of the situation photographed.

This landmark coverage became one of the great historical documents of our time. From it came many of the concepts of the great photo magazines. In fact,

Mydans left the FSA to join the early *Life* staff. It became the training ground for some of the best-known photographers of our time.

With the onset of World War II most of the male photographers went into military service, and the whole program became absorbed by the Office of War Information and then eventually disbanded. The files of pictures went to the Library of Congress, where they are still available and remain unparalleled in their concept of documentary photography. (They are still free to the public except for a minor print charge.)

The point is that the key component of this vast program was the free photograph. The idea of the free photograph did not, however, die with the dismemberment of the FSA program, because Stryker was then asked by the Standard Oil Company of New Jersey to join its staff and bring along his crew to use the same principles in the oil information business. A new program was set up, this time under private industry, but the idea was the same: disseminate as much information photographically as possible without charge to the media, to tell them all about the oil business.

So, just as the FSA free photograph became widely accepted, so did the pictures distributed by Standard Oil of New Jersey become a major fact of photo documentation. So successful was this program that several other oil companies tried copying it, notably Cities Service, Texaco and some smaller corporations. But none had the impact of the SONJ program. In film-making, just as the earlier government programs were responsible for Pare Lorentz's great documentaries, "The River," "The Plough that Broke the Plains" and others, so was Esso to follow with Robert Flaherty's "Louisiana Story." That, too, became an American classic.

When the Standard Oil of New Jersey program began to be phased out after the end of World War II, Stryker moved on, this time to Pittsburgh, and brought his free photograph program to the Jones and Laughlin Steel Company and the University of Pittsburgh. Both organizations used this system of free distribution to obtain media attention for whatever messages they had to impart. By now the ideology behind the use of the free picture was accepted by American business as a valid method of getting its messages across to the public. Other corporate files were established and free picture use became pretty widespread.

Proponents of the free system take the position that it promotes the employment of photographers. But they do not take into consideration the fact that the photographer who is hired to shoot for free distribution is locked into a situation over which he has little or no control. There are few or no secondary use rights available, and in some cases the stigma of the company handout has become an anathema to publishers who care about editorial independence and integrity. Yet many publishers do try to project budgets for books and encyclopedias which rely a good deal on the availability of the free picture and this does hurt the independent photographer who either depends on assignments or builds a stock file.

I talked with Rosemary Eakins, a member of the highly respected Research Reports group, which obtains much of the photography for the books they are producing for their clients. I asked her about the free photograph concept, and whether it brings economic harm to photographers. Her answers were somewhat reassuring in that she feels the availability of the free photograph is not particularly hazardous to a photographer because the concentration is in highly specialized scientific, medical or historic photographs that the average free lancer would be unlikely to be able to supply, though she did say that in dealing with

geographic subjects they can obtain many contemporary free photographs from chambers of commerce and convention and visitors bureaus.

Research reports, too, base their support of the availability of the free photograph on the fact that a photographer was hired to make these pictures. But the lines become blurred here in the question of real benefits to the photographer. The story behind the Federal DocuAmerica project of eight or nine years ago is particularly interesting in the context of the free picture programs.

There is no question that the cultural benefits of the historic FSA programs were enormous and will forever stand as landmarks of creativity. But they were produced at a time when there was no competition to private photography and there was a downright *need* for these photographs.

After the programs were phased out, World War II ended, and national recovery was on the way, there were many in the photographic world who decried the fact that contemporary America was not being photographed in any consistent way despite the efforts of the oil companies and some other enlightened corporations. Several plans were drafted to try to re-create a "little FSA" program that would, perhaps on a more modest scale, get the photographs made, give employment to photographers and get the pictures before the public. Even Dorothea Lange, in her days of declining health, voiced optimism that such a program could be started and talked with many about its possibilities.

Eventually, after several working plans were proposed, a program was developed in 1970 called "Docuamerica," to be administered under the EPA (Environmental Protection Administration). A staff was hired and photographers were called and given assignments, some running several weeks in length, to photograph a wide variety of subject material around the country. An elaborate system of microfiche retrieval was established in cooperation with private custom color labs, and the images were released to the public free of reproduction fees. The photographers, who had been hired at ASMP minimums, were asked to surrender all rights to the photographs to the U.S. government (under Federal law it seemed they were obliged to that old copyright law again, remember?) though, as it later turned out, there were loopholes where the photographers could indeed keep some secondary rights. But photographers began to fret when some of the pictures appeared in national commercial advertisements that normally might bring $1,500 to $3,000 per photo and the advertising agencies were getting them for nothing.

The fretting continued and finally the ASMP took a hard stand on the matter. In a "white paper" released during the height of the controversy, the ASMP agreed, and in fact encouraged, the idea of free distribution of pictures to small newspapers, magazines and other publications who could not afford to buy professional caliber photography, but objected violently to the free commercial uses of the pictures. The ASMP then suggested that its membership not participate in the program unless some system of remuneration could be secured for the contributors.

The controversy reached high into the U.S. government, but no agreements were ever forthcoming. The program sputtered along, a few more photographers were hired, but eventually the whole thing died, and its images now are gathering dust in the National Archives.

So the ethical question of the free photograph is still debated. I feel there is limited merit to the system. It is obvious that a small-town paper or low-circulation magazine, or even a limited-edition book could never hope to spend the money required to make many photographs in the field. Yet should a

118

publication be denied the use of them for pecuniary reasons only? Why shouldn't large corporations or the government make these pictures available? Should profit-making organizations be subsidized in this manner by the taxpayer? The danger lies in the control of distribution and the bias, if any, of the source of the photograph.

Anyone who has ever been in the business of selling stock photographs either through an agency or independently has received calls for pictures, and when a price is quoted the reply often is: "We don't know why you charge so much when so-and-so agency or photographer will do it (or sell it) for far less." These allegations are rarely true, especially when they concern the well-established agencies or the more responsible and better-known photographers.

Where there can be deviation in prices is in bulk sales, when the buyer is usually purchasing substantial quantities of pictures (50 or more) for one particular publication. There is a tricky situation here that may put a strain on the photographer-agency relationship. On one hand the agency is in a position to supply a large number of photographs for a single project, something it could not do if it did not have a large number of photographers in its "stable" and an equally impressive file of pictures. Yet the individual photographer's contribution to this project may result in the sale of only one or two pictures, so he is getting very little out of the sale—way below the normal 50 percent of the regular fees for that picture. Does he accept this or not? The agency's position is that he should, because it is simply a little extra money he would not be earning at all, and by so doing he also helps keep the agency solvent for future efforts on his behalf. But some photographers won't accept this and refuse to let their pictures go into a large pot for joint sales unless they have a high percentage of the sale. This is very much an individual decision and is one of the factors that should be taken into consideration and discussed when a photographer elects to join an agency.

Now that we've discussed many aspects of the issue of what photographs are worth and how you, the photographer, must charge for your services, let's move on to another important area, preparing a budget. Remember, Monday morning you have a budget meeting.

PREPARING A BUDGET

Armed with a concept of space *vs.* time rates, you should now be able to establish a budget. What should that budget include?

overhead	assistants, models
time planning	travel costs
field expenses	special needs
equipment rental	
materials, processing, printing, copying	

Until the photographer knows what is to be shot, where and when, what the potential weather factors are (if they are a factor at all), it will be impossible to calculate costs accurately, especially with the spectacular rise in cost of hotels, film, airlines fares, car rentals and other services. About the only thing that has not risen in the same proportion has been, sadly enough, the average photographer's fee.

So, when you appear in Joe Smith's office you had better have some clear idea of what the job is really going to cost for the entire package.

OVERHEAD

Even before you ever get to the point of quoting a job, there are certain "intangible tangibles" that must be considered. Some people call it "overhead"; some, "general operating expenses," but call it what you will, it has to be considered part of doing business. If you are at the point where you are actively seeking work, then the chances are you have already set up your shop. Wherever it is, you are going to have many costs in the way of rent, office expense, possibly lab or studio space, insurance, taxes, equipment purchases, as well as a host of other items that are not directly recoverable in your billings. Unless you are earning so much money, or have other substantial income, and feel your overhead has no bearing on what you charge your clients, you have to figure out some method of building recovery of these expenses into your job estimates, or else you are not going to be able to make the profit you anticipate from a job. In other words, being paid just for your time is not enough. However, if that is what you want, then you should have a staff job that will keep you on a salary.

If you are to operate independently, you should realistically sit down and figure out what your basic overhead is or what it may come to if you can project just a few years ahead. You should also try to make an educated guess about your gross income goals. The gap between the two (projected costs *vs.* projected income goals) is the minimum amount that somehow has to be filled. It probably is too early in your career to know how busy you are going to be, although perhaps by now you are getting some inkling of how many non-revenue-producing days there can be in a year. If you can anticipate, however roughly, your annual number of shooting days, you can come up with an overhead percentage to be built into your fee schedule. In other words, if your annual overhead from all nonbillable expenses (and don't forget to include amortization of your equipment) comes to $10,000 per year, it is costing you 50 cents per minute to breathe. Or putting it another way, if you are shooting at a rate of 100 days per year, the first $100 per day of your fee goes just to paying your rent and overhead before taking out a dime for yourself. When you start looking at the pricing schedules, you will now have a better idea of why certain fees are charged and what you have to get in order to survive, let alone earn a living.

It may be extremely difficult to allocate an accurate fixed percentage of every job you do to overhead, yet it must be worked out by some method, even if at the beginning, until you can stabilize your activity, you take arbitrary percentages and add them to your day rate or package rate. Again, being arbitrary and taking the 100 days of work I quoted earlier, an average fee of $300 per day would represent a gross income of $30,000 per year to physically run your business (and that is cutting it pretty close). Then adding 10 percent to cover overhead to the "standard" fee of $300, making it $330, becomes somewhat more realistic in terms of recovering your fixed costs.

I operate a stock photo library and from time to time employ outside sales representatives in foreign countries who work on a commission basis. I have also spent much of my working lifetime accumulating a vast library of photographs that have to be sorted, classified, mounted, captioned, filed safely and all the other work entailed in the maintenance of such an operation, not to mention rent of the floor space and other expenses necessary to running this file. How do I charge to recover these costs? I have to make arbitrary judgments simply for lack of realistic guidelines. When I sell certain rights to a photograph, I take 10 percent off the top of the sales price *before commissions are paid*. I do this with the hope that this more or less covers the cost of physically maintaining the file.

My accountants tell me I am probably not far off. You now know that a fee of $350 per day is not a $350 per day *profit*. And using the figures above you will also realize that your annual overhead may indeed take nearly a third of your average day rate. If you are to survive, your budget must reflect all of these items as well as anything that is special to a particular job on which you are bidding or budgeting.

TIME PLANNING

The only way you are going to estimate time for budget purposes is to find out quickly what the client wants in the way of coverage and at how many locations. You will have to build your own time schedule as to how long it is going to take you to work at each location. That should give you the minimum basic number of days you'll be on the location. Since nothing ever works according to schedule, particularly on an industrial or plant job, you also have to build in some additional time to account for margins of error. You have to calculate your travel time, not only to the primary location, but travel time between plants, conferences and arrangement times. Be very careful in this area of time planning.

Long ago I was asked to do a major coverage of a large mining corporation with extensive properties in the Southwest. The purchasing agent of this company was responsible for "buying" photography although the selection of the photographer came through their public relations department. The purchasing agent treated the whole project with the same interest as he would buying several carloads of cement.

I was young, anxious, and didn't know any better. As the entire job required outdoor photography, I asked the PR man what to expect in the way of weather. "Oh," he said, "after February 1st there won't be a cloud in the sky until September 1st, so don't worry about it." So I didn't. I gave the client a tight price based on the number of days I thought the job would take, and a reasonable estimate of materials and other costs, and proceeded to shoot. All went well until I got to the third of the four locations in southern Arizona, and it started to rain. It rained for seventeen consecutive days! The PR man said, "Don't worry, we'll adjust the whole package when you come back." So I didn't worry and waited out the rain.

When I returned the PR man said, "Gee, I am sorry but the purchasing department won't adjust the price. They said we had a delivery contract and that's the agreed on delivery price so it has to stand."

Make your plans for shooting as tight as you wish, but remember to keep an escape clause in your agreement for weather contingencies, strikes or any other catastrophe that could cause delays. Depending on the time of year, the locations, prevailing weather patterns and similar factors, any price based on time alone has to be carefully thought out.

The same goes for almost any other aspect of the assignment. What about availability of plant personnel to help and assist? If the plant provides this help, there can be a considerable saving in your budget. What happens if a process or machine is delayed or breaks down? Be sure to clarify all of this with the client before you present your budget.

When dealing with delays in the field beyond the photographer's control, realistic measurements have to be used. It is traditional to charge from one-third to one-half the day rate for all "nonproductive time" spent in the field, and when there are lengthy delays there can be friction over resolving the charges.

Travel time has to be considered the same way. If you can fly to a site from your own home base in an hour or two and start shooting almost immediately, do

you charge for a full day of travel or a full day of shooting? In a situation like this, while the professional societies have laid down guidelines covering productivity and travel time, it might be wiser to be flexible in the pursuit of better public relations with the client. For instance, a compromise might be to charge for a half day of travel plus a half day of shooting, which should lower the first day's cost somewhat but still allow proper compensation for time. What about traveling in the evening between plants or locations? These are things that have to be considered in scheduling your travel time.

FIELD EXPENSES

Other considerations are field costs other than the expected ones of housing, shelter, transportation and subsistence. Are you going to need a forklift truck or a cherry picker for shots made from high elevations, or will you have to rent an airplane or helicopter if the client wants aerials? How about ladders, props, models, set construction, electricians, plant security and personal security and safety? All of these items must be cleared *in advance*.

What about entertainment, food cost limits and bar bills? Most major magazines, such as those in the Time Inc. group, pay a fixed per diem allowance for meals but have to throw in the towel when it comes to hotel rooms, car rentals, etc., although they try to make some effort to persuade their correspondents to find inexpensive accommodations. One editor recently mumbled at me when I left his office en route to the West Coast, "The heck with the Palace Hotel. Save money—find a friend to sleep with—it's cheaper."

Company policies vary and they can also play havoc with your accounting. Tales of wild expense charges throughout the journalism world are legendary, and they vary from the cost of renting a ladder to the cost of renting a helicopter. The picture editor of a major magazine called me once when I was president of the ASMP, and knowing that I had a wide range of friendship among his staff members, he felt free to ask a favor. He wanted to know "Why on earth would Tom Jones need a 16-foot ladder on a Pullman train trip between Chicago and New York?" "Why indeed," I said. "I'll ask but I won't tell any tales out of school. If I can find out without getting Tom in trouble, I'll let you know." The editor agreed that since the expense account in question had already been approved for payment, he was more curious than righteous about it and wanted to know the answer to this intriguing question. So did I. I called Tom and told him of the query I had had from the picture editor's office, adding that he didn't have to tell me if he didn't want to but that I was overcome with curiosity.

"It's no secret," he said "You know our company has a strict rule about bar bills for the staff when entertaining is not an issue. On this particular trip I put in a couple of hellishly tough days before barely making it to the train in a state of complete exhaustion. I wanted a drink—in fact several—and I was determined I wouldn't pay for them. I also remember that they had never questioned us on ladder rentals. So for every drink I ordered on that train trip, I charged it off as a foot ladder rental." Later I called Tom's boss, told him the story, and his response was "No objections!"

Creativity, taste and ethics all play tremendous roles in the making of photographs and their ultimate delivery. And when these forces come into play there are bound to be differences of opinion and errors made by both. The client may not have enough visual experience to understand that ideas are not always translatable into images as one might preconceive them. Photographers, too, have to understand that what the client wants and/or needs may not agree with

his own sensibilities or interpretations, and this is where thorough discussions have to be held in advance about every conceivable problem that might come up in the field.

What about some costs that are a little harder to define? I once closed a story in Paris on a foggy night and had to be in London with my film by early morning. Everything was grounded, the trains were all booked, and my editors were not interested in my "problems." Well, I did get there. (Amazing how 20 bucks' worth of francs to the *Wagon-Lits* [Pullman] conductor suddenly helped find a "cancellation.") But how do you bill it to your client? There are no receipts, no proof, yet it's a thoroughly legitimate charge. One way I handle this is to agree with the client *in advance* that X percent of the total bill will be added for intangibles such as the unexpected tipping of porters, gratuities, or whatever you want to call them.

PLANNING SPECIAL EQUIPMENT AND RENTALS

When it comes to special equipment for a job, you should discuss this quite carefully with the client. Is the shooting going to require a piece of very special equipment? Is this something you should own? Can you rent it? And if so, at what cost? Or should you consider buying it and charging a rental fee for this specific use if no rental equipment of this nature is available? Take lighting equipment, for example. If you are operating even a modest-sized studio, it is likely that you have already invested several thousands of dollars on strobes or other lighting equipment. Are you expected to tote this equipment out to East Boondocks? Should you subject it to the strain of travel? Sometimes you can—sometimes you can't. It depends on where you are headed. If you opt to take the equipment, it might cost $200 each way for air freight alone if you are heading cross-country. Weigh that against renting the same type of equipment for, say, $50 to $100 a day for the two or three days you will be needing it, and see how it makes sense to rent the gear and charge the client for the rental.

You may own a car and probably use it for business in your neighborhood, but it is doubtful you would want to drive it or ship it cross-country for use on location, so of course you will rent one and the rental is a chargeable expense. The same applies then for a truck or a forklift, or even an airplane or helicopter if used for shooting. Cameras fall into this classification too. Most working photographers have a basic kit of professional equipment, but there can often be calls for very specialized equipment you are not expected to own. Yet your client may not understand this. The major magazines such as *Life* long recognized this problem. In addition to paying each staff photographer an annual amortization payment in order for him to keep up with the basic equipment he was expected to own, the *Life* lab also maintained a large inventory of sophisticated and specialized gear for use in situations where the photographer could never be expected to own such equipment. These included ultra-high-speed sports cameras with oversized film magazines, underwater rigs and housings, cameras that could be hooked onto a missle gantry and perhaps even be destroyed by the blast-off. There were all sorts of radio-controlled triggering devices, motorized units, etc.—all very expensive and all quite beyond the reach of even the most highly paid staffer.

So there should be no hesitation in building into your budget any specialized items that may be required on a rental basis. Sometimes the use of these rentals or "on the spot" purchases has had funny results. Because of my required mobility and the fact that I often had to be in two climate extremes almost at the same time, I have had to purchase clothing and other extras on the spot.

Once I had to go from southern Texas in the summer to northern Canada two days later without a chance to hit home base. So when I arrived in Canada, I bought a coat. The magazines until then had been usually generous about this sort of thing, but this time some cost-conscious hawkeye said, "It may be true that he needs a special coat to do this job, but if he is going to keep it afterward he ought to pay for half of it." So a regulation was made to this effect and applying it for clothing seemed fair enough. However, the company from time to time ended up with some strange things when they enforced the "half-interest" rule. Once while using my own four-wheel drive vehicle in a rugged, remote area to haul a heavy load of lighting equipment. I not only broke both rear springs, which were repaired at the company's expense, but it became evident that nothing was going to get to the location unless additional "helper springs" were installed on the truck. I had this done, and then submitted my bill for the expense incurred. "Oh no," said the accounting department, "if you keep them you have to pay half the cost." When I threatened to unbolt the 190-pound, grease-covered springs and put them on her desk as king-size paper weights, she quickly put the bill through for payment.

MATERIALS, DEVELOPMENT AND PROCESSING

In addition to obvious travel costs and other special items, there are the so-called "normal costs" that have to be carefully calculated in your budget. Even the ordinary supplies you use can make a serious dent in your eventual profit if not properly planned. In your preliminary discussion with the client, find out what he is expecting in the way of a finished product. Black-and-white printing or color printing? Contact sheets, transparencies? What kind and what shape and size? All of these items are now very costly. There was a time some years back in advertising when art directors would never accept film and processing charges because they always felt that was part of a built-in cost. Their attitude seemed to be that they were buying only a single image for a single ad layout so why should they worry about the price of a piece of film? It wasn't until they began to leave their offices and start spending time either in a studio or on location that they suddenly realized that the amounts of film and processing used on a single job, even a simple one, could be enormous and could involve staggering costs.

The prices of materials billed are a serious consideration. How do you buy and how do you sell, considering that you are in neither the photo supply nor the processing business? Many professionals like to use color materials that have been pretested so that the qualities of each emulsion are known, as well as how the color ranges will relate to each other when pictures are assembled for layout. There are differences between emulsions of the same grade and ISO/ASA that may not be apparent to the naked eye. (Only your color engraver knows for sure.) So I and many of my colleagues buy large quantities of pretested emulsions (or we test certain samples ourselves) and then buy in quantity and store them in a freezer until ready for use. Invariably there will be some leakage, spoilage or waste that cannot be avoided. How do you protect yourself? Simply by buying your supplies at trade or wholesale price and billing your client at regular list prices. There is nothing unethical about this. You will just about break even after losses due to waste, spoilage, expiration of film dates, and yet have material on hand so you can leave immediately on some fast-breaking story and not have to worry about getting a supply of film or other materials you will need.

The same goes for processing. Either you do it yourself or you farm it out. If

you do it yourself, you or your lab technician is worth something per hour. If you farm it out, then those costs have to be paid for. Again, you should charge a modest mark-up to cover the cost of the paperwork, the inventories of chemicals and paper, the messenger time or lab equipment repair bills, etc. And for that matter, the carrying of the financing until you get paid. Do not feel awkward about this. It is a straightforward and honest way of doing business, and you can arrive at better-defined budgets without having to worry about what each item actually costs you.

ASSISTANTS AND MODELS

Assistants and models have to be preplanned too. With the growing complexity of lighting equipment and increase in the use of large-format cameras for corporate or advertising work outside the studio, there has been a corresponding increase in the need for physical help on location. In many advertising shoots there is often a large entourage at the location—photographic assistants, models, stylists and ad agency people—and the whole affair can take on nightmarish cost proportions. But I am not talking about all that now. I am referring to the photographer who has to go into a plant or to a location and work out complex lighting or other physical situations that quite often require help—often a good deal of it. Some photographers who are well established and have generous budgets take their own assistants with them, which not only means their payrolls have to be built into the budget, but the field expenses of the support team as well. The same is frequently true for models. In corporate (annual report), industrial, or public relations photography, I rarely bring assistants with me but insist, usually with approval of the client, that this kind of help comes from within the plant staff. When dealing with a manufacturing operation, I usually ask for two people, preferably one from the electrical department because a plant electrician will usually be able to work anywhere in a plant and not be restricted to any one department or union jurisdiction. Naturally he will know where the electric supply sources are for your strobes or other gear and will not get you plugged into a 440V DC line instead of the 110V AC. The second person I ask for is usually a general maintenance man who will know where to find a ladder, a dolly or handtruck, and also have unrestricted access to all plant locations. The advantages of working this way are manifold. It's a lot cheaper for the client, it will give you total access to a plant, and you will have the benefit of company people with you to overcome the onus of being an outsider.

When it comes to models, *some* of the above rules can be followed. If you are going to be working in a city not large enough to support a model agency and you need a model in a layout, a phone call to the fashion buyer or coordinator of the largest department store in the area will often put you on the track of someone who can fill the bill, and it may be a lot cheaper than bringing one from home base. Even having to transport models short distances may well offset the overall cost of including them as part of your entourage. I once had an advertising assignment in a western farm state and knew I would never find a professional model within 500 miles of the location. With some reluctance I pressed a local woman into service who did not have the slightest idea of what professional modeling was about, but since she was intelligent and attractive, I took a chance and used her. She did work out satisfactorily, but that was an exception rather than the rule, and only because this particular shooting did not require close-ups or critical makeup was I able to get away with it. Another ad in the same campaign, also shot in the West, did require finding a professional

model in Denver and flying her by charter plane to Cheyenne, where I was working. She, too, worked out fine, and the total cost was far less than it would have been to fly a model in from either California, Chicago or New York.

So in budgeting you have to consider these things and clarify it all *in advance*. There are other problems involved in hiring models for location work, and most photographers now insist that the client assume responsibility for hiring models. Hiring and billing for a model may put the photographer into the position of being considered an "employment agent" in the eyes of the law. The photographer should be careful when he makes the final selection of a model and determine ahead of time who will do the billing to avoid unfortunate complications.

BUDGET FORMAT

It is the preplanning of the assignment that we are concerned about here and how much you can be specific about, especially if you have never been to a particular location before. By making up a checklist such as the sample in the appendix section of this book, you can figure out fairly accurately what you are going to spend on a job under normal circumstances. The form is the one made up and recommended by the ASMP. There could be many items on it that will be of no interest to you or your client, so I suggest you go over it carefully and make up your own form on your letterhead. These forms can be used in many ways: (1) simply as a work sheet for estimating the cost of producing a job, (2) a confirmation sheet that the client may sign to show proof of the assignment, or (3) as an itemized bill to be supported later with actual receipts, tickets, stubs, etc.

On the reverse side of this form are some "terms and conditions" recommended by the ASMP for its members' use. They represent an optimum set of conditions, and it is doubtful that a new and less seasoned photographer is going to be able to get a client to agree to all of them. Yet they are worth studying and drawing upon, particularly in the area of ownership and rights.

It should be emphasized that the above-mentioned optimum terms and conditions should be looked upon as goals, but practicality has to come into play also. By being too "hard-nosed" you can lose an entire job and continued relations with that client. But if the client is equally hard-nosed and demanding, then perhaps it might be advisable to pass up the opportunity and let him seek his photographer elsewhere.

What I am trying to do is establish an awareness in the new photographer that he or she is a unique person with creative abilities who must not be treated with general indifference. Respect for the artist has long been established in Europe (by law in some countries) and there are increasing efforts here to bring forth some of the same principles of the *droit de suite* (rights that follow) of an artist (see glossary).

WHAT IS BEING BOUGHT AND SOLD

In dealing with clients you must be careful that all sides understand just what is being bought and sold. I discuss this here because the prices paid for a photographer's work will eventually reflect the use the client can expect from a photography project, and the photographer, too, has to understand just what rights are being transferred after an image is created.

The most worthwhile lesson to be learned from an examination of ASMP's suggested budget form is in the specification of the intended usage of the photographs. There has long been a gray area in what a purchaser thinks he is

buying and what actually is being sold. In current usage, fees are determined for the most part by the intended usage, and other usages over and above the purpose of the assignment have to be very clearly spelled out. The client, too, has rights and needs, and not only should they be respected, but there should be an air of accomodation on the part of the photographer to make the whole package desirable.

Over the years of working in this field, I have gradually evolved a system of terms that I and most of my industrial clients have found fair and reasonable. I differentiate between editorial, advertising and industrial (or commercial) rights and establish all terms up front with my clients.

Customs of the trade have pretty much determined how editorial fees are arrived at. Advertising fees are generally determined by media usage, and until the more widespread use of regional editions of national magazines became prevalent, photographers' rates frequently were based on a percentage of the media cost. There was a rule-of-thumb that the production of photography or artwork for an advertising layout generally amounted to about half of the total *production* cost of an ad, those costs including design, typography, proofing, and all the usual costs that an ad agency encountered in making an ad ready for printing (but not the printing). The second general rule was that the *total* "art" costs was budgeted at about 10 percent of the media cost. Thus, if in the days of the old *Life* magazine, a double-page spread advertisement had a media cost of $70,000, for instance, then the art cost of the preparation of that ad didn't exceed $7,000. And if the production of the photography or art represented half of the total production cost, it followed that a photographic layout for a spread over two pages was worth about $3,500 to the photographer. For a long time this rule-of-thumb worked pretty well until the regional editions began to proliferate, since it was the only way such editions could effectively compete with TV for the advertising dollar. But before we discuss the regionals, you should understand a little about the rating systems generally used in advertising.

Advertising rates for television or print are generally based on what is known as the CPM (cost per thousand) of viewers—of a magazine or television program. That is why the "ratings" are so important to advertisers and their agencies. Advertising fees are determined by the number of readers or viewers that any one of several neutral organizations such as Nielsen or Starch or the Audit Bureau of (magazine) Circulation (ABC) determines is the actual audience of a program or readership of a magazine. These determinations are made by many methods. Some companies attach (for a fee to the set owner) indicator boxes that can send back messages as to what programs are being watched at what time, or they make telephone polls, and there is some sophisticated scanning equipment now in use that can collect this data from actual electronic emissions. There are many competing methods and you can see why even the variance of a percentage point or two can mean a difference in millions of dollars of advertising revenues.

Thus when the competition increased for the advertising dollar and television began to crowd out the magazines, it became important for the advertiser to get the most out of his expenditures for media space. It did not make any sense for a beer manufacturer, for instance, who marketed in only six states, to buy space in a magazine that was distributed nationally and thus pay for circulation in 44 states that did not carry his product. Yet selective buying of time on regional television stations could effectively deliver a specified audience in a specialized region.

Therefore the only way the print media could stay competitive was to establish regional editions. The regional is a hybrid. From an editorial viewpoint it is exactly the same nationwide or perhaps even worldwide. But the advertising is broken down by region and even by state and the ad pages change with the market. *Time* magazine, for instance, publishes some 50 regional editions; that is, the magazine is the same editorially but the advertising content is determined by the demographic makeup of each geographical region. This is complicated and costly, but it does effectively lower the media cost to the buyer who has the need for placement in the magazine but only in the area where he has a market.

So it is no longer really applicable to use the 5 percent of production cost factor for photographic space unless the ad is running nationally. But while the broad system cannot apply evenly to regionals, formulas can be worked by circulation comparisons but so that the use of one layout in several regional editions of a national magazine can be a guideline in calculating average space rates. Therefore, the ASMP figures shown in the appendix section of this book can be used as guides, but consideration has to be given to many other factors: total circulation, number of insertions and usages planned—whether they are open-ended or for a specific campaign and so on. More recently there has been a trend toward having the advertising agencies set the space rates because they have better methods of determining the audience for a given ad. The agencies are not too interested in penny-pinching because their fees are usually based on a percentage of media costs.

Even with these qualifications, there is enough usage and custom to pretty well set the parameters of what an ad is worth, as the appendix will show. But the photographer should be alert to what is being asked and what he can deliver within a specified time period.

When I first became involved in the production of advertising photography, I was once called by an agency to bid on a job. The client told me there were five locations to be covered and that all the photography had to be completed in a ten-day period if possible. Each shooting was technically comparatively simple, although some complicated prearrangements of men and equipment needed to be made. My experience at that time was pretty much limited to the editorial world, and I was used to working with day rates or space rates. So when the art director asked me how much I wanted for the shooting, I did some rapid calculations, first figuring ten days at the then-acceptable ASMP minimum, and built in a 50 percent bad-weather factor. Since this was for advertising, I knew the editorial rate was too low, so I tripled it because I was giving up all the rights to the photographs. That was the custom then, and it doesn't differ much now. I came up with a fee of $2,500 plus expenses, thinking I could easily cover the five locations in the alloted time. This was more than I would have received from a magazine for the same amount of time spent, even at going space rates for an essay. The art director nodded, said, "Okay, you can pick up your purchase order on the way out," and proceeded to discuss the assignment.

When I left his office his secretary handed me *five* purchase orders for $2,500 each! The art director had been talking about the price of *each* job at $2,500 and, naïve as I was, I had been thinking of $2,500 for the entire five locations and would have been happy to get it. No wonder he must have thought I was somewhat chintzy when I insisted on certain costs as extras. I must confess there haven't been many assignments like that since. In this case it mostly worked in my favor, but it might have been just as easy to interpret the meaning the other way around. So be clear in what you perceive, what the client is expecting you to do, for how much, and what the usages are going to be.

To arrive at commercial or public relations fees, you must cut across both editorial and advertising lines. Here an editorial concept is frequently handled by advertising-oriented people.

My method is to work out a system with the client so he can get full value for his dollar and not compromise my ongoing rights to future earnings or usage of the materials. First I usually discuss the whole question of negative possession, and if the client is unaware of precedents, I carefully explain that numerous legal decisions, including the new copyright law, state that a photographer, in the absence of any other agreement, does indeed own the negatives to a shooting because they are considered as *intermediate* materials and not really a part of the finished product. The primary concerns here are: Is the client getting what he is paying for? Is the photographer retaining the secondary rights he is entitled to? Actual negative possession is a big part of the answers to those questions.

Suppose the client says to you, "We have a photo department within the plant" or "We have our own system of photographic archives and we want the negatives." Do you turn down the job? Certainly not, even though it may go against your grain to give up the negatives. On the few occasions when this has arisen, I have compromised by shooting extra exposures or in some cases making good copy negatives in one-of-a-kind situations and increasing my fees to the client with his knowledge.

Sometimes clients simply do not understand all the ramifications of negative possession and why there may be certain advantages to not having that possession. In New York, for instance, I cite the unusual conditions regarding sales tax. When a photograph is made for reproduction and only the reproduction rights are sold, no sales tax is applicable since there is no transfer of the material. But if you do a job with an overall figure of $50,000, for instance (and this is not a high amount after the expenses, travel costs, etc., are all thrown in), the transfer of the negatives to the client alone would entail a tax of $4,250, which is considerable when there are budgets to be considered. So the client may well say, "Okay, you keep possession of the negatives so long as we control the use of the pictures and *own the reproduction rights.*" That, too, can be a trap, and again you can agree in writing to restrict the use of the photographs to only noncompetitive uses, or even nonthreatening ones. It certainly would not be ethical, for example, to release any of those photographs to be used in an investigative report on the company or use the pictures against the company to back up some environmental or OSHA (Occupational Safety Hazard Administration) complaint. No company, or person for that matter, wants to be put in the position of paying for something or underwriting something that can be turned against him. Also, many companies want complete control of their material, to prevent industrial leakage of secrets, which is, of course, understandable. So there are many valid reasons why a company might want to know where their negatives are tonight.

Yet the photographer, too, has to be able to share in the "fruits of his vineyard toils." So here is where compromise can come into play. The photographer can agree that he will make the prints for future use available to the company at reasonable prices and in a reasonable amount of time. He can restrict the use of the pictures to situations that are completely noncompetitive or nonthreatening to the company, and he can clear any borderline usages in advance and abide by the company's decision provided a refusal is not unreasonably withheld.

It must be made quite clear by the photographer that he retains the right to

use these photographs for his own purposes as described above or for self-promotion. If he has agreed to release the negatives, there should be a written agreement that he, too, can have reasonable access to them just as promptly as the client would expect to have them if the client were to retain physical possession.

There are other aspects regarding the secondary use of assigned photographs that we will talk about in Chapter 9. We will also deal with the whole question of copyright in that chapter, but it is important the photographer know at this point that the new copyright law of January 1, 1978, clearly gives the *photographer* the copyright to anything he produces except under certain specific circumstances that will be detailed in Chapter 10.

PAYMENT, ADVANCES, EXPENSES

The final area for budget discussion is the method and schedule of payment. If you are dealing with a reputable company on a clearly defined assignment, there should be no question of prompt payment, but there is a gray area when it comes to advances and repayment of expenses. In motion picture projects, where the sums are usually much greater than for still photography projects, it is customary for payment to be made in three parts. Usually one-third is paid immediately upon signing a contract, one-third when the shooting is finished, and the remainder when the final film is delivered. In book publishing there are sizable advances to be considered, so the custom can vary from the entire advance being delivered "up front" to a prepayment of one-half to two-thirds of the advance on the signing of the contract and the balance on delivery of the manuscript.

In still photography advances follow no formal routine. The magazines have always permitted decent advances against expenses without hesitation, and yet advertising agencies and some general business companies are reluctant to do this. I have had occasional problems when trying to apply editorial guidelines to advertising, especially when it comes to asking for advances. Sometimes the photographer's demand for an advance is not so much a matter of getting money "up front" for out-of-pocket expenses, but also is in some measure a guarantee that payment for his services will follow. This, then, becomes a matter of negotiation and I feel that you *should* have advances if there are considerable outlays to be made in the field for airline tickets, car rentals, hotels and meals, and other monies necessary to properly complete the job on time. I have never had any real problem in getting these out-of-pocket advances from commercial companies, though sometimes they have tempered cash outlays by providing airline tickets and authorizing hotel and car rental charges to be made directly to them. I once had an argument with an advertising art director about an advance to cover several thousand dollars' worth of airline fares and equipment rentals. I could have charged much of these costs to my own credit cards but didn't choose to do so because of the reputation his agency had begun to acquire in stretching out reimbursements for an unconscionably long period of time. The art director argued, "Oh, we never pay advances. How do we know we will get the pictures we need?" To which I responded, "You don't, but you are paying for my time, and your approval of my work *is not part* of the deal. Even if I don't bring back a single picture you like, you still owe me for my time and expenses. You are going to have to pay anyway, so why make it hard for me to make this job come out properly? Furthermore, you hired me on the basis of what you think I can do, and statistically the chances that I will perform according to your

hopes are pretty good, so cut out the nonsense and get me the $2,000 I need to get going." He did.

LEASING AND DELIVERY MEMOS

In the appendix you will see a suggested leasing memo form that should be studied carefully. The photographer should make his own judgment about its specifications and what combination of terms best suits his needs. My standard leasing memo is more general in nature than some but also more restrictive and specific in some areas. I freely recommend the use of this one or a combination of parts of other professional leasing forms, such as the one suggested by ASMP. The photographer must examine all the terms discussed in the references and be sure he understands what they mean and what their implications are. I favor a memo that is fairly free of "legalese" and so-called "fine print" clauses, because when terms and conditions become too complicated and too demanding of time and study by the recipient, there may be a tendency to ignore the terms and thus create problems that need not arise. "Fine-print" clauses do not inhibit the validity of a memo; they just make the memo more difficult to deal with, and if the photographer expects strict adherence to all of the terms in every possible memo, he may be in for a rude surprise. Enforcement of all terms may simply be a time-consuming and litigious effort that the photographer may not want to pursue. But many of the "fine-print" clauses should not be ignored because, while in most cases enforcement of all the terms of a memo may be difficult and costly, there could also be times when you need some clause spelled out precisely to defend a point or correct an enormous wrong.

In preparing leasing memos, care should be used to describe each photograph accurately, either by reference number and/or a brief description of its content and its physical format—black-and-white or color (sheet or slide) print, size, its paper's weight and its finished form as a contact or enlargement. Memos should be incorporated into a logging system for "in" and "out" dates, "due back" times and any other clerical procedures that make the tracking of materials sent to a client feasible. I also use another memo form as a follow up to remind clients that the pictures are due back by a certain date and that holding fees will be charged if the pictures are not returned by that date. Note also a special warning reminder on the listing side of the memo about holding fees.

HOLDING FEES AND SERVICE CHARGES

Holding fees and service charges evolved because of constant abuses on the part of picture buyers. Pictures were often withdrawn from a photographer's archive and kept for long periods of time—even as long as a couple of years. Then more often than not, they were returned to the photographer damaged, physically abused, and often not used at all for reproduction. The photographers and the agencies finally had enough of this kind of treatment and started charging holding fees, service charges, plus other charges for damaged prints and research time incurred, not so much for the money but to force the users to make decisions and return unused pictures intact within a reasonable length of time.

Policies on these various charges vary with each photographer and agency. Most allow a period of viewing time at no cost, an average of two weeks or possibly a little longer. Most are charging fees for each day that a photograph is held beyond that time. These range from 50 cents per day for a black-and-white photograph to two dollars or even more per day per color transparency, and may include a flat one-time service charge in addition. How hard do photographers

press for the collection of these fees? Most will not press too hard if the client is a regular customer or if the holder of the pictures had called or written and asked for an extension of time. If there is a guarantee of sale even though the pictures are held beyond the free time, many agencies will not pursue the collection of holding charges. Some have a policy of charging the full holding fee and then crediting all or part of this amount against the sale. However, if there is no sale the full charge is made. One thing is certain—the rules and amounts charged for holding photographs must be clearly stated, and it is up to the photographer to make the decision as to how these charges are implemented. After my follow-up memo is sent, for example, if I get a prompt response requesting extension of time, I am usually generous; if I get no response, however, I charge. With chronic offenders I either have stopped supplying them with photographs, or in some cases have actually sued for recovery under the various business laws of my state. Today almost all advertising agencies and business corporations will pay holding fees without too much protest, but it is the old-line textbook houses who traditionally take long periods of time to put books out who will grumble the most, possibly fight the charges, or sometimes refuse to pay them outright. Then you have to go back to the question of whether you want to do business with them or not or sue them if the violation is unacceptable.

Much the same attitude is taken by some of the agencies concerning service charges. Some photographers or agencies charge a service fee the minute a researcher walks through the door; others are less rigid. All agencies agree, however, that too much time is spent searching for photographs that clients ultimately do not buy, often because they make the same requests for competitive material simultaneously at several agencies. All too frequently researchers call for excessive numbers of pictures from too many agencies at one time, resulting in a massive amount of paperwork and time expended on pictures that never have a chance of being sold.

Service charges came into being as a means of controlling these abuses. Some agencies charge on the basis of the number of hours spent in actually retrieving the photographs from files, and in an agency with a large collection of pictures, these hours can mount up. Since there are no computers that can independently make the final selection of pictures to go to a client, a large "call" can swamp a small agency. Others charge flat rates or a minimum charge for picture searches. Some will credit these amounts against a sale and others will not. Many of the smaller agencies with more limited collections are flexible. If they can locate a picture or a set of pictures in a very short amount of time (and this depends on the filing and classification systems being used), they frequently will not charge for search time, unless the request is a massive one. The more reputable publishers expect this and are willing to pay reasonable research fees. As with the holding-fee clause in the leasing memo, be sure you make provisions for adequate service charges and be prepared to enforce them. I suggest that you do charge service fees; then if you wish you can credit these in whole or in part against sales. Do not, however, be trapped into supplying "on approval" large numbers of pictures without some guarantee of payment, either for your time or efforts, and insist on a guarantee of careful protection of your material.

Most of the other items in the sample memo are self-explanatory, but I wish to draw attention to the terms on all memos that *no reproduction rights* are granted by any leasing memos. Rights for picture use are granted only on invoicing and are contingent on the specifications in the invoices being met totally. In other words, if you have billed someone and he hasn't paid you or

132

hasn't paid in full, the rights he was granted in the invoice are not valid transfers, and you are free to proceed in any legal manner you wish to stop the use of the photographs, including injunctions against printing and lawsuits for copyright violation, if copyright does exist on those photographs. When preparing your own leasing or delivery memo, get an attorney's advice, drawing what you can from the samples and trade customs presented. Especially if you feel uncertain, it is advisable to pay a reasonable fee to an attorney now in preparing these forms, so you can avoid paying considerable amounts later for legal assistance. In selecting an attorney as your general legal advisor, choose one who is knowledgeable in the fields of copyright, publishing or related graphic arts areas.

GETTING IT IN WRITING

With all of the above issues spelled out, the assignment is yours and you are about ready to start packing your bags, so what is left to do? A very important matter: getting *written confirmation* of all the decisions made verbally with your client. This can take the form of a purchase order, a letter of intent, a contract if the project is big enough and involves enough dollars or, in the event of a telephone agreement, a telex or Mailgram outlining the specific points of agreement. Warning—unless you have dealt with a particular client before and have had no financial problems with him, make no move until a confirmation is in hand. A client once asked me why this is necessary. "After all, we are both anxious to have this project work," he said. My answer was, "Well, it will keep us both honest."

ARNOLD NEWMAN

Arnold Newman is one of the finest portrait and still life photographers I know. Somewhat younger than Rothstein, Eisenstaedt, and Mydans, he too has a 44-year record of achievement, and he is still as active as he can be with current portrait sittings, magazine assignments and lectures. When he is not on assignment all over the world, his busy studio on Manhattan's West Side is buzzing with activity as he, his wife "Gus" and assistants keep a demanding schedule of work going full steam.

Newman started as an art student and while he doesn't feel it is absolutely necessary, he considers it great training and extremely helpful for the new photographer to have an understanding of the history of art and photography. He said he was very lucky to have had very good art teachers who gave him the basics and then encouraged him to examine new and "crazy" artists of the mid-thirties—Picasso, Matisse, Braque, and others.

He started at the University of Miami, even though he had had his eyes set on the Art Students League in New York, which he was unable to attend because of the Depression. After two years in Miami he was offered a job in a Philadelphia department store making cheap (49¢) portraits. More importantly this put him in close touch with good friends, Ben Somoroff, the late Ben Rose and Sol Medneck, all young photographers of the time. These men had studied earlier with the legendary Alexey Brodovitch, who himself was beginning to make a name as art director and graphics editor of *Harper's Bazaar*. Somoroff, Rose and Mednick were all to become fine photographers, and those student days and early times were important stepping stones for all of them. They worked all day in the classrooms, studios or at outside jobs, then gathered and spent half the nights talking and exploring this whole new visual world. Newman feels this was one of the most exciting times of his life. He did a lot of experimenting in photography during that period, but without losing sight of his "art" perspective and training.

In 1941 he came to New York for three days to seek the advice of friends and others as to whether he should pursue photography seriously as a profession.

Among them was Beaumont Newhall, then head of the newly formed Department of Photography at the Museum of Modern Art. In addition to offering advice, Newhall astounded Newman by offering to buy some of his pictures for the Museum. He also sent him over to see the famed pioneer photographer Alfred Steiglitz, who also offered considerable encouragement. Within the three-day period Newman was also offered a two-man show with Ben Rose, which opened that fall. That show changed both their lives.

Newman returned to Florida to take a better-paying though similar job. His salary doubled—to $30 a week. This job also helped him sharpen his executive and business skills, as the marketing strategy was based on a cut-rate coupon system. Newman's function was to manage the studio, shoot the portraits, keep the people there working at their jobs, and holding the salesmen in line.

He also earned enough money to buy a Speed Graphic, received permission from his employers to set up his own darkroom, and started to learn how to process and print the photographs he began to make on an experimental basis. There was neither time nor opportunity to take any formal courses in photography, so he began learning in a rather unique way—by sending contact prints of his pictures up to his friends in Philadelphia for critiques—and he continued to experiment.

Newman spent the war years in Florida, moving to New York in 1946 where he got his first editorial assignments from *Life* and other magazines and participated in group shows at the Museum of Modern Art, which had bought some of his first portraits of artists earlier. So it would seem that Newman started at the top instead of by climbing the rungs of the ladder slowly. He began getting work at *Harper's Bazaar* and they tried to make a fashion photographer out of him, but he did not care much for the medium and resisted those pressures, preferring to broaden his horizons by doing still lifes, which he loved and in which he soon became expert. He is known as much for these still lifes as he is for his masterful portraits.

Advertising, always a lucrative outlet for the top-rated photographer, crooked its finger at him, and after acquiring an agent he began getting assignments. He told me that while it was always traditional in editorial photography for the photographers and editors to discuss assignments in a *vis-a-vis* situation, it rarely happened in advertising. He felt then, and still does, that many creative directors, art directors, and copywriters always seem to limit the creative input of the photographers. The photographer comes into the picture relatively late in the planning or at the studio level when the shooting starts. While he personally likes and gets along with many of the advertising people with whom he deals, he also thinks it was the personal insecurities of others that taught him to be more selective in the type of advertising work he would accept and thus the need for an agent disappeared. Accordingly he branched out into corporate work where he could command equally high fees for annual reports and executive portraits, without half the aesthetic inhibitions.

Over the years Newman has increased his income significantly through the sale of prints via the gallery route, which he finds personally satisfying and lucrative. In the early 1970s when he began selling to galleries, his early sales brought about $125 per print. Today the same print sells for a minimum of $750 and often much higher. He is in the enviable position of not only selling prints but on occasion has had difficulty in keeping up with orders. But Newman was quick to point out that there are only a limited number of photographers in the world who fall into this category.

The mailer is an important promotion tool for the younger photographer, and

Newman told of his success with this method. He continues using one that was originally produced ten or twelve years ago. The initial response to it was far in excess of anything he had anticipated, and he told of many letters from corporate executives who replied regretting the unavailability of an immediate assignment but promising to call later. Many of them did, some as much as four or five years later. So Newman is a strong believer in keeping one's name alive and before the public.

Portraiture, Newman says, is quite different from other forms of photojournalism because so much effort must be spent in producing a single usable photograph. While other photo assignments can frequently produce several finished pictures in one day's work, and may result in many printed pages, a single portrait or still life can take much more time and not achieve any more than the one or two pages already allocated for the layout. Thus the end result has to be total satisfaction of the photographer. This is the critical issue and may not necessarily be what the client thinks he wants. Obviously, when one is doing a private portrait sitting, there has to be satisfaction on the part of the person photographed, but if the portrait is being made of some prominent person for editorial purposes, the views of the editor and the photographer become paramount. Newman's spectacular portrait of the head of the Krupp works in Germany, Baron Alfried Krupp, portrayed the man in a sinister manner, which obviously made the sitter quite unhappy, but the editors who used it were ecstatic. This has become one of Newman's most famous photographs. These are the criteria Newman operates by and why his high fees are accepted.

In discussing fees for a young portrait photographer, Newman is reluctant to have his pricing scale used as a guideline because of his professional stature, but he freely advises young photographers who approach him on practices and procedures. He said that what seems apparent is that in their eagerness to make sales, young photographers tend to forget the hidden costs of printing. Unlike editorial work, which usually results in the delivery of a single print or transparency to an editor, the portrait sitting often calls for many prints, most of which will not be used for graphic reproduction, but as "display" items, so the need for meticulous print quality is extremely important. If the young photographer does not charge enough for the sitting, or fails to charge enough for the required number of prints, he will ultimately lose money or at best make very little.

Newman tells the young photographer that he must not only be realistic about the time spent on the sitting but that he should give equal consideration to the darkroom and printing time, without forgetting travel time to and from a location, even for preshoot viewing.

As for specific pricing advice, Newman suggested that the young photographer use the well-thought-out ASMP guidelines to calculate the time spent on sitting, along with a careful accounting of darkroom time. He commented that the beginning professional also has to carefully assess where in the "pecking order" he stands in his profession in order to arrive at appropriate fees.

As he feels he is essentially a "location" photographer, Newman depends a great deal on assistants, and usually the charges for them are built into his fees as part of the overall package, sometimes on a specific cost basis. Early in his career he saw psychological value to this. If he were sent by an important magazine to photograph a high official or other prominent person, he would himself lose credibility if he had to shuffle around dragging huge cases of equipment and setting up lights. As his creativity is what is being paid for, it is a waste of money for the client to pay him large fees to be a pack horse.

When a photographer reaches Newman's status, especially when he has built a file of portraits of famous people, another problem arises over secondary rights. What happens when some news magazine or paper suddenly calls Newman and wants to use one of those photographs in their publication? Under the new copyright law, if there has been no signed "work for hire agreement," and there usually is none in the case of a portrait sitting of a prominent personality, the photographer, in theory, would have the legal right to resell that picture for publication elsewhere. But Newman treasures his personal relationships with his clients and would never under any circumstances release a photograph he made without the prior permission of that person. If the photographer expects to maintain the trust of his clients, he must scrupulously guard their privacy, even though it may mean the loss of an extra buck or two.

Newman talked of occasions when he made photographs of situations, not people, while under assignment to some corporation. What happens, then, if there is an outlet for one of those photographs? Again Newman says this is a negotiable matter and should be discussed with the client, but in finality the client's wishes should be respected, certainly in the interest of good personal public relations.

Even though he does much location work, the studio is an important base for him. It is his anchor and perhaps his security blanket, and for this reason, even if there are slack periods, he told us with some gallows humor, "You have to build in the cost of a couple of nervous breakdowns." He does his best to keep his staff going with back-up printing for galleries, cataloging, contact printing, filing, etc. He also considers himself a good businessman and when he is busy and making money, he does not rush right out and buy every electronic gadget on the market or a new sports car or stereo system whether he needs it or not.

Freelance photographers (at least some he knows) seem to have a penchant for building up lousy credit ratings but he has always maintained the highest possible rating. This is all part of professionalism and building the aura of reliability. His editors know from experience that, come what may, Newman will be available to deliver something exceptional, on time and to the point. This is survival at the highest level.

As a general business procedure, he suggests that in every portrait sitting, especially those involving business executives or personalities who may rise to some higher fame (or notoriety), there should be a letter of agreement as to what is being purchased and what secondary rights each party obtains. Newman feels that his clients are entitled to any use of one (or a few) pictures of each take, but when unanticipated usages come up, while the rights to use those pictures clearly rest with the client, there should also be additional remuneration to the photographer. He reserves for himself the right to use some of them in books, exhibits, lectures or noncompetitive media. If on occasion he gives up all the rights, then he feels he should be additionally compensated. Most professional societies recommend a fee equal to three or four times the original fee for the surrender of all rights. This, too, is another form of keeping the photographer's work alive and having the photographer share in the fruits of secondary usage.

CHAPTER 6
ON ASSIGNMENT

The assignment is yours, the knots have been unraveled, the purchase order has been issued, a cash advance is on the way, and you have ordered your materials. Now what?

Probably the first thing you should do is spend time at the company office if it's a corporate job or checking previous story layouts if it's an editorial or advertising assignment. If you are at the home office of the company you are going to cover, it probably has some sort of photo library or collection that you can look at to see what has been done before, how it was handled, and draw whatever conclusions you can as to whether the company was satisfied with earlier photographers or if you were called because they were dissatisfied. If, by chance, the previous photographers' names are available and you know who they are, it might not be a bad idea to call them and ask about the problems or pitfalls they may have run into. This is a delicate matter and you must use good judgment about whether to do this at all. The main thing is to find out as much as you can about what you are going to face on the location(s). Again, it's a matter of the five *W*'s of journalism: What? Who? Where? When? and Why?

TRAVEL AND HOUSING ARRANGEMENTS

How about choosing transport, housing, car rentals? This is important except in small towns where there is little or no choice and you are completely at the mercy of the company or that particular location. I like to make most of my own travel arrangements even if the company or client has supplied me with open-date travel tickets or travel cards. When there is a problem of sizable equipment movement, I prefer to ship sturdier gear by air freight rather than subject it to the mercy of baggage "handlers." You can also thus avoid the side effects of the airlines' bad habit of "breakfast in Chicago, dinner in Los Angeles, and your baggage in Karachi." There is nothing more debilitating to a case of strobe lights than a ride down a conveyor chute from a curb-side check-in. It's not going to do your film any good, either, to face the increasing use of X-ray in *checked* baggage.

Shipping your equipment by air freight requires a special trip out to the airport several hours in advance of your departure, and if there are any international legs to your assignment, you will also have to arrange with customs, both here and abroad, for return of equipment and film, and find out about the import-export idiosyncracies of the country you may be traveling to. All of this takes time, and time is what you have to allocate to these problems. If none are present, then move on.

I have also found that shipping sizable amounts of equipment by air freight is not only cheaper for the client than shipping it as excess baggage, but also results in better handling and better insurance evaluations. By insuring your equipment heavily (the rates are very low), your equipment will get special handling, will not be dropped down a conveyor chute and probably will be personally escorted on and off the airplane in good shape. You will also have a pretty good idea of what flight it will actually be on, should you and your equipment's schedules come apart.

There is nothing to object to in the use of travel agencies, but for the most part they are not interested in handling one- or two-night reservations in hotels or motels, except for resort areas. Because your schedule is apt to change abruptly, do your own travel bookings. Almost every major hotel and motel chain, car-rental agency and other travel organization has a toll-free phone number. If you use your own charge cards to make reservations and later have to change, be sure not only to cancel but also to get a cancellation number. Otherwise you may be stuck with paying for a reservation you made and didn't keep. The same holds true with the airlines. Always cancel rather than be a no-show. You could need that cancelled seat yourself someday. I have a cardinal rule that I never travel if I can possibly avoid it, without knowing in advance exactly where I am going to sleep, whose car-rental service I will use, and without knowing as much as possible about the city I am traveling to. One thing I do not like when traveling on assignment is surprises!

Once when I was lecturing at a photographic society meeting, someone in the audience asked, "What is the first thing you do on arrival in a new city?" My answer was, "Make a reservation to leave." I wasn't kidding, either. When you arrive at the airport, it takes only a moment to stop by the counter of the airline you will be using on your next leg or return trip and make that critical reservation that you may or may not be able to get a few days later, particularly if it falls at the end of the week. You can always change it if your schedule changes, but at least that's out of the way and you can forget those last-minute scrambles.

EQUIPMENT AND SUPPLIES: PLAN AHEAD

With your travel schedule and housing arrangements set, the next step is organizing your equipment and supplies. Think carefully about what you are going to do, what you are going to need, and then add extras for emergencies. Pretend there is no camera or supply shop in the world except your own and that you are going to have to work only with what you bring from home. The only possible exception is working on location in the largest of the major cities, and supply sources there should be used sparingly. This may sound silly, but if you are as demanding of critically tested color emulsions as I am, this makes sense.

What about batteries for all purposes? Strobes? Meters? Recharging units? How about the units themselves? Have they been tested? Are they working properly? If there is any doubt in your mind about a piece of equipment continuing to function in the field, do you have a back-up? What about the

cameras? If you are using small cameras (35mm or 120-size), do you have extra bodies? How about convertible multi-focal-length lenses for emergency use with large-format cameras? Extra film backs or carriers when that critical one jams? How about some small tools? Tape?

Marty Forscher, probably the best camera repairman in the world, has often said that he feels a camera for professional use in the field should have two major attributes. First, it should be built like a hockey puck, and secondly, instantly repairable with a paper clip and roll of black camera tape. So far such a camera has yet to be built, so you may be called upon to make some emergency repairs in the field. But don't try it unless you really know what you are doing. Instead, *before you leave,* telephone the manufacturer's representative of the major equipment you are using and ask where the nearest qualified repair shop is to where you are to be based. Get the names, addresses and telephone numbers. Some manufacturers provide special services to professionals working in the field in the way of emergency repairs, loan lenses and other equipment, and can be generally very helpful. Chief among them is Nikon, which has established Nikon Professional Services offices in New York, Chicago and San Francisco. Contact them through Erenreich Photo Optical Industries, 623 Stewart Ave., Garden City, NY 11530 for details, membership cards, etc. Other companies provide services and help at major news-gathering centers such as political conventions, Olympic events and other public functions where there is a guarantee of a huge concentration of news photographers. Your own membership in some professional groups can be helpful in providing contacts in the field. If you are already a member of the ASMP or the NPPA, take a copy of the membership lists along with you. Not only might they be very helpful in providing some names for emergency assistance in the field, but these lists might also give you someone to have a drink or a meal with when you are tired of the motel dining room or when you've had enough of listening to the woes of the local public relations man or factory superintendent.

Getting your equipment ready for travel is something that has to be thought out carefully. Throwing everything helter skelter into a case and shipping it off by air freight or as excess baggage is one sure way of having trouble on location. It was bad enough in the old days when flashbulbs were used. It's worse now with strobes that won't fire or that misfire or are off exposure calculation. Ditto cameras and lenses. They have to be packed *very carefully!*

I have worked out a pretty good system of dealing with the X-ray problem at the security gates of the airlines. If I am shipping any sizable amount of film and am using air freight for the bulk of the shipment, I make sure that the major portion of the film supply goes into *one* case and that case is clearly marked *Sensitized materials—Keep away from heat, cold and radioactive materials!* These labels can be purchased or they can be made up by a printer easily and cheaply and are well worth the minor price. They should be affixed to every shipping case that can contain film. Airlines as a rule do not X-ray air-cargo materials, except for some lines that serve the Middle East and other sensitive areas, although this of course can change. When you take your shipment to the air-freight office, you can easily find out whether or not there is a possibility of X-ray being used on freight shipments.

The film you carry on board and your camera bags and/or lens cases should be packed for easy inspection. All film should be in one bag, either a shoulder bag or lightweight case that can go under your plane seat. No film, *exposed or unexposed,* of any sort should be left in a camera body. When you get to the security gate, ask for a hand inspection or a visual inspection and under no

circumstances permit the attendant to shove the bag through the X-ray scanner, regardless of his assurances that the X-ray dosage is so small that it won't affect the film. To some extent this is true. One pass through the average airline scanner will not affect the film to any degree that can easily be noticed, but what the attendants never tell you (perhaps because they do not know themselves) is that X-ray radiation is *cumulative* (and every time you go through a gate from one line to another and let your film pass through the machine, you pick up an additional small dose of radiation), so after three or four or more passes through the scanner, you have trouble.

Once while I was going through the security gate in Seattle, the young attendant tried to convince me that the X-rays were minimal and harmless and she was getting quite insistent on having me pass my film through the machine. That is, she was until I asked her, "Are you married?" "What has that to do with anything?" she replied. "Oh, nothing really," I said, "since this machine is so harmless, but if you are planning on a family you shouldn't be hanging around this place very long without a ten-foot pole." I passed on, after still insisting on a hand inspection of the film, and as I walked down the corridor, I happened to turn back and look at the security section. The girl by then had acquired a very long stick and was busily pushing all the incoming baggage through, literally with a ten-foot pole! So don't let the airlines people kid you. X-rays *are* harmful in accumulation, and the FAA has recognized this fact by issuing authorization for visual inspection of film and other sensitized materials. I have also been told, though I have not had any verification, that these machines, on repeated use, can also affect magnetic sound tapes to some degree, so if you are carrying similar material you might be well warned to take the same evasive action as with photographic films.

PERMITS

The last item of preplanning is the question of permits, if necessary, and other problems that might involve dealing with authorities. If you are going to be working on a busy street photographing buildings, traffic activity, installations of some sort, and you might have to block or step into the mainstream of traffic, be it pedestrian or motor vehicle, be prepared for it. Many municipalities will not permit a photographer to block traffic, whether it is with a tripod or a motor vehicle, unless permits are issued for this purpose. On the other hand, this can be a blessing instead of a problem because it may make your job easier.

In New York City, for instance, in order to encourage the motion picture and television industries to produce films, the Office of the Mayor has established a special bureau just for this purpose, and their courtesies are extended to still photographers who require much of the same space to work in on the public streets. All they ask of you is some proof of the assignment and enough insurance to cover any contingency that might befall the public. A simple permit has to be secured, usually a day or two in advance, in order for the bureau to notify the police precincts involved. There are no fees, nor are any gratuities expected.

This sort of permit is required in many cities around the country, particularly the bigger ones where population density and traffic are factors. Most cities and many states have some sort of convention and visitors bureau or chamber of commerce or other official or quasi-official organization that can brief you on the necessities for such permits. Frequently these groups can also be helpful in making other arrangements for services.

There are a few other legalities that you should check before you leave for your assignment. Are aerial photographs required as part of your job? If so, have you, or perhaps your clients, lined up an adequate aircraft and pilot? Does the pilot or flight service you are going to use have the necessary FAA waivers and required insurance for you to make the kind of pictures you need? It is quite possible that in order to make these aerials properly, the door of the aircraft is going to have to be removed. Is the flight service authorized to do this? There are very stiff FAA regulations that have to be complied with if this is going to be the case. Check this in advance so you can enjoy my "no surprises" rule.

INSURANCE IN THE FIELD

In Chapter 9 I discuss many legal points including insurance, but I would like to call your attention, in the context of the assignment, to the necessity of adequate liability insurance while you are in the field. What happens, for instance, if you knock over a light and damage an expensive painting in a museum? Or someone trips on a cable either on location or, for that matter, in your studio and hurts himself? What kind of insurance do you have, if any? Liability premiums for even vast amounts of coverage are quite reasonable, though sometimes the amount you may be asked to carry can seem excessive.

Once, just as I was about to photograph a huge oil refinery from the air, I was questioned by the refinery people about how much insurance I had and what would happen if the plane crashed and set fire to the refinery. I said that I normally carried about $300,000 in general liability insurance. The oilman laughed and said, "Do you know what the replacement cost of this refinery is? Five hundred million dollars!" I laughed, too, and suggested gently that he take it out of my fee if I did set fire to the place. What else could I say? On another location I had to take out a special insurance policy for 20 million dollars to cover the sea trial of a tanker. This was a more modest demand than insuring an entire refinery, and the premium came to several hundred dollars for the half hour that I was in close proximity to the tanker. So I bought the policy and added the premium cost to my bill. There was no objection from the client.

You should carry a decent general liability policy, and if you wish you can divide the cost over each job as part of your general expenses. It may only come to a few dollars per assignment, depending on how many assignments you pro-rate the policy over and the total liability you carry. But carry something.

Once the late Bernard Hoffman was doing a story on natural gas exploration in Texas and was photographing a seismograph crew that was using dynamite charges in carefully spaced holes in the ground to activate the seismograph recorders. Because the terrain they were shooting at the time was dull looking, the crew agreed to move their operations to a farm that looked better and was slated for exploration later, long after the story would have closed. The farmer who owned the property agreed to let them work there, and the chief of the crew decided to help enhance the visual by using extra-strong dynamite charges and adding a little water so that the picture would be more dramatic looking when the charge went off.

Well, the crew chief got carried away a bit and put in such a strong charge that he blew the roof off the top of a natural underground canyon on the farm, and it took some 200 truckloads of earth to fill the crater! All Bernie could say was, "Wait till Thompson [the managing editor] gets the bill for this one." Had he

been a free lancer rather than a *Life* staffer, he would have needed a sizable insurance policy to protect him. So you can see why liability insurance is so necessary for the photographer in the field.

SAFETY: PERSONAL AND PUBLIC

Pressures in the field sometimes create unusual situations that can result in physical danger. Behavior on an assignment must always be governed by considerations of safety and avoiding personal injury. But safety for yourself is only one aspect of this; safety for those around you is just as important, perhaps even more so. While knowledge of dangerous situations has improved and most responsible companies do make reasonable efforts toward employee and visitor safety, it is still the concern of the photographer to be careful to follow every possible safety regulation, even if he thinks it inhibits him as a photographer.

For years I railed against wearing safety glasses, hard hats and even safety shoes on industrial or construction sites, claiming that the glasses interfered with my vision, the hard hats were uncomfortable and the shoes hurt my feet. In a couple of situations I got down-right testy when safety inspectors insisted that I wear them while on their locations. More than once, due to my own ignorance and (let's admit it) arrogance, I threatened to walk off a location when they insisted on my wearing these items. One day when I was just about to be "invited" to leave, I got a chip of metal in one eye. That cost me two days' shooting time, and when I reported back to work, I was further saved from a couple of badly smashed toes by the insistence of the safety inspector that I wear hard-toed safety shoes. After that I was more tractable and in time even acquired my own prescription safety glasses, a hard hat and comfortable safety shoes, as well as my own coal miner's safety lamp and battery pack.

As a photographer you frequently have to set standards not only for your own safety but for those around you. Once while on assignment for a major magazine, I was doing a story on a large conglomerate that, among other things, had opened a new potash mine in Utah, and I had to go out there to make some pictures of the new underground operations. As I drove into the basin where the mine was located, I saw abandoned oil rigs rimming the valley, indicating that this mine was in a depleted oil field. Scheduling had been carefully worked out because I knew that the miners had just finished cutting through an underground salt bed that covered the potash deposit and that bringing out the first loads of ore would begin at the time of my arrival at the site.

A few hours later, properly clothed in oilskin miners' gear, including hard hat, miner's safety lamp and glasses, hard-toed boots and other paraphernalia, including explosion-proof nitrogen-filled boxes for my strobe packs, with spark-proof electric connectors, I descended nearly a mile in a large iron bucket suspended from a cable that was serving as a temporary mine skip (elevator) since the main head frame and hoist complex had not yet been finished. I arrived at the first working level to find a beehive of activity, only it was a scene that would have caused instant cardiac arrest to most of the toughened hard-rock miners I ever knew. All around me were men smoking, using welding torches, equipment without explosion-proof motors, and open lights dangling from temporary lines without safety electrical connections.

The foreman himself greeted me with a lit cigarette in his mouth and asked what I would like to have them do for me. I said, "Just one thing—call the skip back down because I'm getting out of here."

"Why? What's wrong? Don't you like working underground?"

143

"I don't mind working here," I said, "I just don't want to die here. When was the last time you ran a gas test?"

"Oh," said the foreman, "about eight this morning."

"Well," I said, "it's now two-thirty in the afternoon and any high school kid who studied elementary geology would know that underneath any salt bed in any oil field, depleted or otherwise, there is always a good chance of hitting gas."

"What do you want us to do?" asked the foreman.

"Either shut down every welding torch, compressor or other non-explosion-proof motor, put out every cigarette and turn off the bare bulbs, or I'm getting out of here in the next bucket!" I responded.

So, in order to humor the wise guy from New York, they did all those things, and I hurried through my pictures. I did indeed get safely to the surface in about an hour. The moral of this tale? Sad to say, that mine blew up two weeks later and killed nineteen men, including the foreman.

The lesson is, when the occasion demands it, be tough. Avoiding getting hurt on the job is your responsibility too, and your responsibility to your client. If you get hurt you can't produce your story. If you don't produce the story, someone is left in the lurch.

MEDICAL EMERGENCIES

I have always been terrified of getting hurt or becoming ill on location. This is not because of the pain or discomfort, but because of what it can do to a working schedule and ultimately, delivery of the job. Merely paying attention to appropriate clothing is not always good enough. On one occasion while covering a roaring steel mill in the midwest in the dead of winter I was faced at alternate four or five minute intervals with the fiery blasts from ninety-ton, 2300 degree heat of molten steel and then stepping outside the confines of the furnace building into the icy blasts of sub-zero weather. Steel workers in those days used neck-to-heel heavy woolen overcoats made of natural wool that was spark resistant. Today they use metal refractive fabric that will reflect heat but won't keep out the zero cold as well. So the photographer in a situation like that is a candidate for pneumonia or perhaps worse. But even a simple cold can make a shambles of a schedule, and an accident, however minor, can be costly in many ways. Ailments due to steel mill exposures can seem exotic, but what do you do when the venetian blind in your hotel room comes off the wall and cuts your hand open, requiring several stitches, and you then have to hire a couple of assistants to keep you propped up somehow while you try to work?

There are no answers or sure preventatives to these kinds of literally off-the-wall situations except to warn the photographer to be doubly careful of his movements and actions while in the field. Carry a small emergency first-aid kit among your personal effects, plenty of "home remedies" such as aspirin, cough medicine, insect repellent, poison ivy preventatives, and the like. And as for eyeglasses, what happens if you break or lose the pair you are wearing now?

If all this seems elementary and slightly smacking of the over-indulgent mother hen, wait until something happens and you don't have what you need. Getting competent medical attention in the field can sometimes be tricky, and if required at off hours or in unusual circumstances as that described below, be prepared for the worst because the worst sometimes happens. Make sure you have whatever medical or health care membership documentation you own,

copies of prescriptions from your doctor if special medication is called for, or even emergency prescription drugs that can be administered by a local doctor. I once came down with a violent attack of gout in Salt Lake City and needed a newly developed medication that wasn't locally available. What to do? First a call to my own doctor for the name of the drug, then a call to the manufacturer to find the nearest distributor (in this case San Francisco), and then a complicated and expensive emergency air shipment to Salt Lake. All of this could have been avoided if I had had an emergency supply of the medication in my travel kit. If this could happen in Salt Lake City, imagine the problems in Yugoslavia.

There are other ways of getting hurt and requiring medical attention on location that are more difficult to project, as witness what happened to my friend Adam. He had not only built an enviable reputation as a fine photographer for one of the big magazines, but an equally impressive one as a "Casanova of the Camera." He arrived on assignment in a midwestern city once, only to find the job delayed. Having nothing better to do, he decided to look up an old girl friend who had since married a leading local orthopedic surgeon. Her husband was on duty that evening at the hospital and, as she had nothing better to do either, she decided to visit with her old friend.

Exactly what transpired is not clearly documented, but it seems that at about 2 A.M. Adam wound up on the floor of his room clutching a badly broken arm and howling for medical attention. With pain developing rapidly and panic setting in, the only doctor the friend could think of was, naturally, her husband, who agreed to come down and see to the situation. Meanwhile they concocted a story explaining that he, Adam, had fallen out of bed, broken his arm, and knowing that she had married a doctor, decided to call her for assistance. The husband bought all this but after examining the injury decided he had to have Adam removed to his hospital so he could be placed under an anesthetic and operated on. He immediately left to make preparations, saying that his wife would ride in the ambulance with Adam.

Adam's immediate thought was: "Oh God! If I go under an anesthetic and start babbling as people do, and I say the wrong thing, and this guy has a knife in his hand, I may never come out of this!"

His friend assuaged him by saying, "Yes, it's true that people talk while under anesthesia, but my husband told me that if you concentrate on a single thought before going under, the chances are any talk will be in relation to that. So Adam said, "Let me alone, I'm concentrating." Which he did all the way to the operating room. He woke with the doctor present and looking at him with a quizzical expression on his face. "Did everything go okay, Doc?" asked Adam.

"Oh, yes," was the reply, "but you were doing an awful lot of talking while I was operating on you."

"Did you understand what I was saying?"

"Yes."

"Well, for heaven's sake, Doctor, what was I saying?"

"That was the strange thing," he replied. "You kept saying over and over again: 'Adam is the best photographer in the world, Adam is the best photographer in the world!'"

FIELD COOPERATION

Your personal approaches to people are important, and how you come across to them could have a lot to do with the cooperation you get as a photographer. One

of the big business magazines used to have an unwritten internal policy that if you were sent out to do a story and were given the names of various people to interview or contact for assistance on the job, the chances are it would be a story that was reasonably objective and fair or even possibly laudatory. If they told you to stay outside the plant site and deal with people not connected with that corporation or operation, you knew what the story line would be. Looking at it from the corporate side, if you as an executive heard that there was a team from *X* magazine in the area and they *did not contact* you but were asking questions about you, you would know it was time to take to the storm cellars. So, as a photographer you must decide from the start if you are going to turn up the rocks and see what crawls out from underneath or whether you are going to do a straightforward approach and make the people and plant installation look as good as possible. While the investigative journalism approach may be more exciting and glamorous, the chances are the other kind pays better and more often.

FIELD APPROVAL

When working in editorial photography you can be put in difficult positions by people who want to see your photographs before they are printed, which of course you cannot allow. Sometimes you have to use all of the charms of a snake-oil salesman to get the person you are supposed to photograph to hold still for a portrait sitting or allow you to photograph the situation you have been sent to do. Frequently when photographing either persons or places, those in control will ask (or demand) to see what you have produced, implying a right of refusal if you do not show the work to them for approval. How do you deal with this? Firmly. But politely and not by "dealing" at all. When it comes to editorial matters, no editor is ever going to allow prior censorship or approval, and if this becomes an issue, then the chances are the assignment will be canceled, either by your editor or the client. Often there is an area of compromise. If you are using Polaroid pictures for testing and you wish to show them, you can do so *if you want to*. But it must always be with the clear understanding that you are showing what you have done out of courtesy rather than for approval. Frequently the use of a Polaroid picture under these circumstances can be beneficial, but you must always reserve the right to make the decision as to what pictures are forwarded to the editor.

In factory or industrial situations I often use Polaroids as a starting point. I make a test shot, then show it to the foreman on the mill floor or the company representative who is with me, and ask if anything is out of place or if there is anything that will disclose a process secret or if there is an unsafe operation being depicted. These are all legitimate reasons for showing a Polaroid picture, but not for the decision as to whether "we don't like this so you can't use it."

Field approval by clients is always difficult to deal with. Once on an ad campaign I ran into an unusual situation where (1) I was working from a composite layout and (2) had an art director with me who kept insisting on looking through the ground glass of the view camera before he gave the okay to shoot. I was able to handle this easily enough, but a funny thing happened on the way back to the agency office. After the art director had "approved" the picture on the ground glass and I got the finished "chromes" back, the art director looked at them and said, "Oh, this isn't what I wanted—I really can't use these. But I'll tell you what I can do. Since these pictures will now have to undergo a lot of

retouching we hadn't planned on, if you will accept a lower price we'll use them."

This was a pretty nifty ploy to cut my price even though I had a purchase order with a "reshoot clause" and the art director had approved the shot in the field. However, when I balked at the price-cutting effort and offered to reshoot (which would have cost the agency a great deal of money needlessly spent, since there was really nothing wrong with my original photographs), the art director backed down and the campaign went forward. In talking with another photographer who had worked with this particular art director before, I found that this was a pattern with him, a gimmick he tried with every new photographer he worked with. So the next time, I took along a Polaroid and would not let him look through the ground glass, but instead showed him a Polaroid of the setup.

"Is this what you want?" I asked him.

"Yes, it's fine." (Which is what he had always said after looking through the groundglass.)

"Okay," I said, "Initial this print, please."

End of argument.

Also what frequently happens when working in the field with a large-format camera is that when I shoot Polaroids for test purposes I knock off a few extras as gifts to the people I am photographing. Usually I do not even have to make the extras, because in the course of checking exposure and lighting, I usually have a couple of near-misses that will do handsomely for this purpose, and I might add, I have made many friends on the production lines this way. But even in this kind of situation you have to be careful. I know of one photographer who was extremely embarrassed because he gave an "extra" Polaroid to a local public relations man only to find that the picture ran the following morning in the local newspaper. So caution must be used to not break your own deadline security.

A parallel problem arose when I once shot a story for a business magazine and the public relations man, in good faith, asked me if I minded if their company photographer went along with me and shot some of the same situations as I did for their company magazine. Because I had brought in some large banks of lights to illuminate the area that the local man could never afford, it seemed like an easy request to fill graciously, until I remembered a similar situation when a company photographer followed me around and, after I made a major effort to arrange a picture, shot the very same photo over my shoulder and beat me to my own press deadline. The company photographer, in his eagerness, released the pictures to a competing national publication that ran the photographs, and the whole nasty situation came very close to evolving into a major lawsuit involving copyright and plagiarism. When using release forms, by the way, a Polaroid print can be considered "other consideration" in addition to a fee paid, if any, for the release.

So I had to politely refuse the presence of the company photographer this time. I know of more than one occasion when the photographer assigned actually had to threaten not to shoot unless the company man was withdrawn. These things must be done tactfully but they do have to be done, and this is part of your field behavior so as not to compromise your employer.

Sometimes you run into situations where you yourself create a monster that can bite, and the bite can be nearly fatal. Recently when a massive public celebration took place (New York's bicentennial Op Sail event), I sweet-talked the Navy into lending me a helicopter to cover the story and I agreed to

let a navy camera corpsman come along with the express promise by the navy public information officer (PIO) that they would not release any of his pictures until long after my deadline was past. They kept their promise, but at the last minute I suddenly found that three or four other photographers from rival news services were given permission to join me on this same aircraft and we all were expected to shoot simultaneously from the same door position. Fortunately I was able to kill the idea with a lot of group kicking and screaming. I won my point with the argument that if there were four photographers all trying to shoot at the same time through the same door, two things were bound to happen: someone—most likely the PIO himself—would be pushed out the door for setting this up or none of the photographers would get any decent pictures at all because of the confusion and danger of everyone crowding that small open door. The navy solved the problem by putting up four choppers instead of the one they had agreed to make available to us.

There can be other problems in getting your work done because of uncooperative personalities, and often you have to walk on eggs.

A business magazine that was part of the same publication group that published a major news magazine once assigned me to make a portrait of a man who had just been indicted in a major stock swindle case and had already been severely treated by the news magazine. I didn't think I had much of a chance of getting him to cooperate, but I called anyway for an appointment. He agreed to see me, but would not commit himself to whether he would permit me to make any pictures of him. When I arrived, he said, "Why should I allow you to photograph me when I know you are probably not only going to blast me, but your sister magazine will probably get its hands on the pictures and murder me completely?" Good question indeed. I said, "This is the situation. I am assigned to make these pictures and my editors *are* doing a story about this whole problem in which you are now involved. That story is going to run whether you approve of it or not. You have a number of choices: You can either cooperate, and I promise I will do the best possible job I can to make a good portrait of you. Furthermore, you may restrict the use of this photograph to this publication only, and my editors will honor that restriction and so the sister magazine will not have any right to use it. Or you can throw me out and tell me to get lost. That is your privilege. But if you do, I think I know what will happen. I will go back to New York without a photograph of you, and then the editors will hire some stringer to hang out across the street from your office, home or club with a long lens on his camera, and the first time you pick your teeth or scratch yourself or do anything else of an uncomplimentary nature, you can be assured that that is the picture they will run—because they *will* run something."

So the man said, "You win," and he sat for some portraits, one of which did run in the story, and it was a picture that said he was neither sinner nor saint. In my captioning notes to the editor I did put a specific restriction on the picture for use by that magazine only, and that effectively prevented the sister magazine from using it without the sitter's specific permission. This did create a bit of a furor within the company, but after I assured the editors that it was either that or nothing, they backed me completely, and that is where the matter rested.

Not only can you expect cooperation of the client or the subject, for the most part, with the possible exception of situations like those mentioned above, you probably will need it if you are working in unfamiliar territory. In addition to the usual mechanical problems of housing, regular transportation, factory assistance, etc., there are many times when you will have to depend on the people

you are dealing with in the field to make appointments, do the unusual and sometimes the unexpected. Cooperation on the job by the client or subject can well make or break the assignment and I cannot repeat too often the warning that the visiting photographer must never make a nuisance of himself, make unnecessary demands, detract from production or even simply get in the way of the normal functions of the operation you are there to cover.

COMPANY PHOTOGRAPHERS

Another word of caution about "company photographers." In many cases some of the companies you may be called on to deal with have their own in-plant photo departments. This can be both a blessing and a bane. Their presence in the plant can provide emergency technical service, an extra light or last-minute supplies, but it can also cause problems for the visiting photographer in that personal problems may hamper or reduce the efficacy of the visitor. The plant photographer can truly resent the newcomer (and perhaps with good reason), thinking he has been bypassed when he should be doing the work. I have often tactfully told local public relations people that I do not want assistance from such in-plant people, preferring (as mentioned earlier) electricians or maintenance people to best fill my needs. But I always ask to be introduced to the staff photographers and try to make friends with them by showing them, and perhaps letting them use, new pieces of equipment or telling them about some recent technique they may never have heard of and could put to good use later in their own work. But mainly I make an effort to get across the idea to them that, yes, I really would like to have their help but I know how busy they are with their own work and wouldn't want to detract from that by overloading their schedules. Thus I can feel free to call on them in case of a genuine emergency where some photographic expertise or help is needed.

You can also make friends by being helpful. I once met an in-plant man who complained bitterly that some of his electronic equipment was working erratically even though it was brand new. I explained that it probably was being affected by the huge amounts of "wild" electrical field energy in the area because of excessively high industrial voltages and amperages creating certain electrical effects that affected some of his sensitive equipment. By behaving in this manner, instead of acting the "big shot" who was imported over the head of the lowly company man, you can make more friends for yourself and make your job a lot easier when you are in strange surroundings. If I ever have to go back to those locations, as I often have had to, I know that in many cases I have a friend in the area.

FIELD BEHAVIOR

YOUR ROLE: REPRESENTING YOUR CLIENT

When on assignment, you are, for all practical purposes, the representative of the company that has hired you, and whatever you do or how you behave (or misbehave) will reflect on the company.

Just as the photographer has to learn to avoid situations that might arise because of a conflict in political ideology between the client and the publisher, so too must care be taken that whatever you do does not reflect adversely on the publisher or employer. In other words, you do not have the right to speak for your publisher. You cannot say to those you are photographing, "Yes, we are

going to print *this* picture," or talk about *that* in the text, knowing that you have very little to say about what finally appears in print. Nor can you make any promises, minor or major, on the part of your publisher without his direct approval. You are not authorized to make policy statements about the story you may be working on, nor can you promise to honor the requests you usually get for copies of the magazine or extra prints or anything else that requires the publisher to do, send or say something after the shooting is over.

Whenever I get a request for a copy of the magazine article I am working on or an extra print of a story, I never make a formal promise to fulfill such requests. I do say (and also do) that I will put these people's names on the list of cooperative persons and turn it over to the editors, hoping that copies will be sent. But I never guarantee this.

Frequently on an editorial assignment you are perceived as carrying the political banner of the organization for whom you are doing the story. You may have a pretty tough time dealing with this, especially if you are covering something that is politically sensitive. And by politically sensitive I am not referring solely to who is running against whom but other issues as well.

If you are doing an annual report for a public utility, particularly one that has a couple of nuclear plants, don't walk into the office or onto the plant site wearing a "no-nukes" button in your lapel. If you are photographing a mining company, forget your personal anti-strip-mining attitudes while on location. Of course you can't and must not always hide your feelings about the subjects you are photographing, and there are some purists who say "if you don't approve, don't take the assignment." But I suggest that when you are on someone's payroll, play it cool about your personal beliefs. If you don't, you'll more than likely be taken off the job.

Your personal behavior on the location is important. Make no demands as such but rephrase your requests as politely as possible for whatever you need. If an area has to be cleaned around a machine or process, don't order it to be done but tell the supervisor or liaison person what you need. If you are in an industrial milieu, be careful about interrupting production of anything without clear approval from management. Discuss carefully with the local foremen or supervisors if anything you are going to do, or ask some employee to do, will create a labor or product flow problem.

You may very well be photographing a machine operator at one moment and half an hour later have to make some portraits of the president of a multimillion-dollar company. You have to be able to earn the confidence of both. If you have to change your clothes between takes, do so.

In nonindustrial situations where you may be dealing with executive portraits or portraits of other people important to your story, pay attention to their surroundings. If there are piles of papers or books or other objects that are not really needed or do nothing for the picture, ask to have them removed, but do not under any circumstances make that removal yourself.

Never forget for one minute, regardless of whom you are working for, that if you are on someone else's property, no matter what the story (unless you are clearly trespassing), you are still a guest and must always behave like one. If you are arrogant or discourteous, intentionally or otherwise, even if you get away with it, it will reflect on the next photographer following you. Not only is this unprofessional conduct, but if you put yourself in the place of your colleague, think how you would feel to have doors slammed in your face or have to deal with total noncooperation because of a photographer who preceded you. This is all part of behavior in the field, whether it is an open-and-shut hard-news

coverage or a more subtle story dealing with sensitive elements. It boils down to my deep belief that a photographer should observe and report the news, not make it!

I was once asked what it was I dread most on arrival at a new location. Tongue-in-cheek, I said I hated to follow too closely behind a certain famous photographer because of his reputation for leaving a trail of shattered egos and a heritage of ill will toward journalists. By a crazy coincidence, I followed him on the next assignment I drew. It was to be shot in the same area and on the same social program he covered but for a different publication. The location was in the Appalachian Mountains in a rural area of Kentucky. I telephoned the regional contact there to say I was coming down. His reply was, "Well, if Mrs. So-and-so [a somewhat formidable lady who was the director of the program] hears about this, there is going to be hell to pay, and perhaps you had best not come down for a while until tempers cool." But a deadline impended and I had to press forward.

Just before I left, I received a call from the fearsome Mrs. So-and-so, who said, "If you show up in Hazard County, don't be surprised if someone takes a shot at you!" I asked why she objected to my coming to make pictures of what certainly was a worthwhile social program. She told me that my photographer friend who had preceded me had spent several weeks in the area a year earlier. She emphatically did not like the photographs that appeared, as well as their accompanying text, and most of all she didn't like the photographer because of his behavior. I never did find out how he behaved because she hung up on me immediately, but I went down anyway and managed to get the story without attracting her attention until the deed was done and I was on my way out. No one did shoot at me, and our story ran well.

I brought it off not just because of photographic ability but by paying particular attention to the sensitivities of the people in the region in which I was working. My research also indicated that Mrs. So-and-so herself was not entirely liked by the community and I subtly used that knowledge in my approaches, making friends with certain people for just that reason. So it was most gratifying later to learn that the lady in question was grudgingly complimentary after my story appeared, and threats of future mayhem were withdrawn.

I probably could have done the story anyway even if I had openly defied her and bulled my way through by coming in like the marines and yelling "freedom of the press," but I chose to handle it on a low-key, almost invisible basis. I think I got a better story for it.

RELATIONSHIPS WITH YOUR TEAM

There is much more to field behavior than the points raised above. Not only are your actions with regard to those you have to photograph important, but so are your relationships with those on your team—art directors, reporters, picture researchers, public relations representatives or simply your own or hired assistants, drivers, etc., as all of them have a direct relationship to how well you perform with the camera.

Over my many years of professional photography I have had my share of conflicts within my own team, from disagreements with writers whose perceptions were essentially nonvisual or who had such airs of superiority that they would neither listen nor even consider someone else's approach to the visualization of a story, to clients who, once away from their own home territory, felt it was their sacred duty to prove their manliness by picking up every waitress or barmaid they came across.

There are many occurrences that can delay you, inhibit you or simply make it impossible to function properly, and a lot of them stem from social or semi-social situations that arise once you arrive in the field.

Until I learned better, I was at first grateful to the local public relations man or woman who invited me for drinks, dinner or other social activity after a day's shoot. It seemed infinitely more appealing than spending an evening alone in a dreary hotel room, but as I became saturated with boring tales of woe, local politics within or without the company, or with being expected to pick up checks that I could not justify for reimbursement, I became increasingly wary of accepting these invitations because invariably they would have some effect on my production the next day.

There are other situations worthy of comment that crop up primarily in advertising photography. Instead of traveling alone, the photographer shooting for an advertising layout, particularly in the fashion field but by no means restricted to fashion, can often have a huge entourage with him: assistants, stylists, makeup people, and most of all, from one to five people from the agency, plus a few representing the clients as well. The agency people often include art directors, copywriters, account executives and group heads, all of whom seem to offer very little in the way of real assistance to the project. What they frequently manage to do is to raise the bills to such a level that the very shooting of a job becomes questionable in terms of the total expense of field production. Assignments have been cancelled for this very reason, and studio pictures are frequently substituted, or drawings and sketches used instead of photography. I've run into this time and time again, and there seems to be some direct mathematical proportion in that the number of nonproductive free riders increases in direct ratio to the interest of the location.

On some of these shoots I probably wouldn't mind a number of people around because it might get pretty boring without them, but when their travel charges are added to your bills or you are expected to provide fun, games and amusements for the client and friends, you can wind up "eating" the bills, as has happened to many of my friends, and it's no longer amusing. In fact I know of one situation where the agency lost the account and the photographer the assignment because the client insisted not only on coming along when the shooting was in Europe, but also on bringing some "pets" along which the a-gency was expected to pay for, without rebilling the client. Perhaps most of the bigger agencies with bigger budgets can carry on this farce, but when it happens to the individual photographer or small agency, big problems can result.

ARTHUR ROTHSTEIN

Photojournalism is a lot more than hard-news photography, as I once pointed out to a young documentary photographer who had been photographing social conditions in Nepal under a university grant and who was confused about the precise definition of her work. I explained to her that a 20-page essay in *Geo* or *Life* that takes six months to prepare is just as much a part of photojournalism today as is photo coverage of a fire or a hurricane. Documentary photography as practiced by Lewis Hine or Jacob Riis and later honed to a fine art by the Farm Security Administration photographers is also very much part of photojournalism. I talked with Arthur Rothstein, who started as a documentary photographer with the Farm Security Administration, went on to be a photographer and technical director of photography for *Look* magazine, and now is an editor at *Parade* magazine. He is a classic example of how a photographer evolves through the various opportunities in the photography world.

"I was a photographer when I was in school and a member of the Camera Club at Stuyvesant High School in New York City," Rothstein said, "and when I got into Columbia College I founded the Camera Club there. I did a great deal of photography in my junior and senior years to help with my tuition. It was there that I met faculty members Rexford Tugwell and Roy Stryker. Tugwell was a professor and Stryker an instructor in the economics department and they were putting together a book on American agriculture that unfortunately never was published, but as a result I got to know them very well. Tugwell went to Washington as a member of President Franklin Roosevelt's 'Brain Trust,' and he became the undersecretary of agriculture and head of the Resettlement Administration. He brought in Roy Stryker to head the historical section of the Resettlement Administration. Stryker loved the use of photographs and in his work at Columbia got to know Lewis Hine and became familiar with Jacob Riis's work. He used photographs from a variety of sources and became very knowledgeable as a picture researcher, and when he came to Washington he persuaded Tugwell to let him produce a historical record of the Resettlement Administration in photographs. But not knowing anything about photography

153

and knowing that I was a science and chemistry major who was a good photographer, Stryker asked me if I would work with him.

"As soon as I graduated in June 1935, I started working as the first photographer hired by the Resettlement Administration. That was the beginning of my career, but it was not my original aim. I had not intended to be a photographer but rather had planned to either study medicine or get a Ph.D. in chemistry and go into biological research. However, it was the height of the Depression, my folks didn't have much money, and I didn't know where I would get the money for tuition or to sustain myself. So when this job came along it was a fantastic opportunity and I thought I would make enough money to go back to school. In those days it was a very good job. I got 30 dollars a week and two cents a mile for the use of my car and five dollars a day for food and lodging. My first job was to set up the lab. Nobody there knew about 35mm film—that was a totally new concept. I was a pioneer Leica user and I set up a separate laboratory where I recruited some lab technicians to use a Leitz 35mm enlarger. We also had some very good printers for the larger negatives and by October I was ready to go out on assignment.

"My very first assignment was to go out to photograph the people who were being resettled in the Blue Ridge Mountains of Virginia, and I photographed them mainly with a Leica camera and got some of my best pictures. From that point on, I continued to travel the country, and one of the most famous pictures in my whole life was made very early in my career. It was the 'dust storm' photograph. This puts me at a great advantage, because some photographers go through their entire careers and don't make any famous pictures at all. Other photographers make their most famous pictures at the end of their careers. I took my most famous picture in the spring of 1936, and it was widely published, much appreciated and highly regarded.

"So after barely starting work I had become a famous photographer, and it became impossible for me to drop this profession. I stayed with it and I've been a photographer ever since. I don't regret it. It has been a very rewarding and satisfying life and I think that I have done some good with my photographs. I have benefited from being a photographer in many ways. I think because I was and am a photographer I am healthier both mentally and physically. It's the best thing that ever happened to me.

"I stayed with Stryker for five years and in 1940 I joined the staff of *Look* magazine, which was only three years old. But World War II came along and I went into the Army and OCS. From there I went overseas as a photographic officer, serving in China, Burma and India. At the end of the war I was the photographic officer for the China theater and was stationed in Shanghai. I earned three battle stars and some medals, and I took a big convoy, as its commander, over the Burma road. I had a lot of adventures; fortunately, I survived everything—being shot at, a variety of diseases, some of them pretty bad. I was in Shanghai in 1946 when the United Nations was mounting a big relief effort there, and they wanted someone to document their activities. I resigned my commission and worked for the U.N. for a short time, which was a good experience.

"I came back to New York in 1946 and was offered two jobs, one by Wilson Hicks as staff photographer for *Life* and a chance to return to *Look* magazine by Dan Mich, who said that if I came back to *Look* I would soon be director of photography. With Hicks I knew I would be one of 36 photographers, and while it was very tempting to work for *Life,* which was bigger and maybe a little more prestigious, I went back to *Look.* It was a good move, and I was able to

build up a staff of fine photographers, many still my good friends and who have become successful. I stayed with *Look* until it folded in 1971. After that I worked on some special projects and then became an associate editor at *Parade*, where I am picture editor and can also do photography.

"*Parade* does have its limitations as far as space is concerned, but the space limitation is more than made up for by its immense circulation, the largest in the world—22 million every week. No other publication has that kind of circulation, and one picture in *Parade* is seen by millions and millions of people."

When I asked Rothstein how he saw photography today—what he liked and what he didn't like, as compared with 20 years ago—he replied, "I think 20 years does not go back far enough. Let's take the period of the 1940s to 1960s. During that period there were fewer photographers. Photography was not easy—professional photography of any kind was hard to do, that is. You had to be extremely skilled and knowledgeable to be a good photographer, but now technology has created cameras and equipment that make it very easy to take pictures. I'm not saying that it has become easier to know what to take a picture of or easier to know when to release the shutter. Productivity of the photographer has increased. It's also technically possible to take many, many more pictures in a given amount of time. As a result we now have many more photographers and it doesn't require great training or skill. It does require a certain amount of talent, but mainly it's a matter of dedication and desire to be a photographer, so if I say, 'I'm going to be a photographer,' there's little to prevent me from being one, so while there are a tremendous number of photographers competing with each other, there are fewer and fewer stars.

"In the early days there were big names, the stars, the well-known photographers. Part of this 'caste system' was nurtured and fostered by the big picture magazines, which were great showcases. Today there are few of them. There are fine magazines that publish photographs well—*Smithsonian, National Geographic, Geo, Audubon,* and others—but they don't have the format and they don't have the circulation. The new *Life* has a very small circulation, and while it's well printed and acts as a showcase, it isn't a news publication, it's a monthly, so it has certain limitations.

"Photographers today have to resort to other ways of having their works seen and having their pictures appreciated as creative efforts. They are going in heavily for books, and there are more picture books being produced now than ever before, but most of them are vanity-press-type publications with no money or very little money return. While it's wonderful to have a picture book produced, nobody is ever going to make a lot of money from it. There have been very few picture books that have made much money. Few have even been lucky enough to return the cost to the publisher. Another showcase is exhibiting in galleries and museums. Photography has become a fine art and is being collected for investment, and it's possible for the photographer to make some money out of it. Portfolios or individual pictures can be sold, and it's wonderful to see that a photographer in his or her own lifetime can benefit financially from photographs being considered a collectible fine art. However, there are only about 150 photographers in this magic group. I don't know how you break into it. I don't know how I got into it. I'm one of the 150 and I know I benefit from it because my work is wanted by museums, it's collected, and the auction prices of my photographs keep going up. But I also think of Edward Weston, who died in the 1950s, and he was very happy to sell anybody one of his prints for ten bucks. Ansel Adams is still alive and he's benefited handsomely from his sales. But poor Edward Weston died in poverty."

I asked Rothstein to comment on craftsmanship and he said there is a general sloppiness but doesn't think the photographer is entirely to blame. He thinks the responsibility lies with the editors, picture editors and art directors who permit this to exist. "Most," he said, "are not sufficiently knowledgeable themselves to know what good quality is. There is a classic definition of the art director who knows what he wants but doesn't know what it is. That's what we have today. We also have a lot of young typographical experts and graduates of art and design schools who know nothing about photography.

"For too many users of photography, the photography is an embellishment, it's a decoration, and the way that photographs are treated in so many publications with a lack of respect is an indication of that. These practices are too prevalent and they can make the photographer feel disgusted and not inclined to a high level of craftsmanship. Yet I think it's possible today with modern technology and modern photographic techniques to produce photographs that are better than those in the past.

"I would suggest that a photographer consider specialization, although I have never specialized—in fact, when people ask me what my specialty is, I always say 'versatility.' I think the photographers should decide whether they want to specialize or whether they want to be versatile. I'm very proud of the fact that I can do any kind of photography. I can photograph food, celebrities, still life, and industry. I can do anything from A to Z—from astronomy to zoology—I can do the photography. And I'm proud of that—that gives me a great deal of satisfaction and I enjoy all photographic areas because I think that taking pictures is a worthwhile activity and I approach every assignment with great enthusiasm. It makes little difference whether I am photographing something for an ad or editorial use, or if I'm photographing somebody's birthday or wedding. Whatever the assignments are, I approach them all with the same degree of quality and professionalism. I think that this is the only approach to be considered by the photographer.

"Another thing I think about is that many photographers start out today with the concept that they are artists. I never considered myself an artist. Some people *think* that my photographs are works of art, and I'm delighted that they do, but I have always thought of myself as a photographer who is performing a useful service or a function of some kind, but never art. I don't believe in photography as art for art's sake. I do believe in photography as art for humanity's sake—that photography is a useful, valuable service, and if incidentally some of these photographs which are taken for useful purposes are considered works of art, that's great. I never take any pictures as artistic efforts, and I think that those photographers who become fine-arts photographers are missing out on some of the satisfactions of producing pictures that can influence public opinion or inform or entertain people. I also think they are missing out on an added dimension in photography. It's a universal language that's easily understood by people all over the world. It's a great way to communicate."

FULFILLING THE ASSIGNMENT

Fulfilling an assignment, from hard news to simple public relations or product photography, requires thought and careful procedure from the time you first arrive on location until you finally pack your camera cases and get your film off to the labs. There are no hard rules; each assignment is different and each has to be treated as an individual situation, but there are basic routines that must be followed if the assignment is to be successful.

INSPECTION AND ESTABLISHING CONTACTS AT THE LOCATION

You should start by checking in immediately with your local contact, be it by phone on arrival if you have traveled from another city or directly at his office or plant if it is a local assignment. If you are meeting someone at an office, announce yourself (politely) to the receptionist. And if you are kept waiting, simply wait, relaxed and without making a nuisance of yourself or showing any anger or hostility at being kept waiting.

On any kind of job involving a broad coverage, a walking tour of the entire plant or location is a must. Not only should you see those subjects that have been earmarked for photography, but you should also look at everything else around because, as the visual expert, you might well see things that the editorial contact or public relations man never considered as having photographic interest.

For one annual report I went through the plant with the local public relations man, and as I walked around I made notes, keeping up a running commentary about what I would like to photograph, what I thought would make for interesting or exciting pictures, etc. When the tour was over I noticed that my client was amused, and I asked him what he thought was so funny. "Well," he said, "you are the first visiting photographer who walked around here and told *us* what he would like to photograph and didn't say, 'What would you like us to do?'"

At first I was a bit nonplussed, but my client quickly put me at ease and told me that he was very pleased because it meant that I was looking at things from a

fresh viewpoint. Later we sat down and discussed at length what was important to him and finally worked out a list that combined the best of both viewpoints.

Also during the tour of a location, as you come to each department or section, you should ask to be introduced to the department head or foreman or unit supervisor and also note not only their names but also their telephone extension numbers, a necessity if you have to reach someone in a hurry in some vast complex.

At the preshooting conferences also discuss what assistance you are going to need and, if you have not brought your own crew along, who the local assistants are going to be. One important thing to do is to confirm production schedules or the availability of the people you plan to photograph over those next few days. Will they be there, or on vacation or at some conference, seminar or lab? Until I learned to precheck this availability, more than once I arrived on a site only to find that our man in Chicago was actually in New Orleans that day. It all adds up to the idea that you must work your shooting time into the operation schedule of the plant or location, and not vice versa.

If you are covering a large operation, whether an industrial plant, political situation like a convention, educational institution or anything else of sizable physical scope, and have spent the better part of the day inspecting the area and having conferences and meetings with all concerned, the chances are there is going to be very little left of that first day. But it is not wasted by any means, because it is much more important to move into an area prepared for what you are going to face than to be surprised at what you find without any opportunity to do something about it.

Now is the time to start making your immediate advance preparations. Is a certain area going to need cleaning up or possibly painting? What are people wearing? Remember. I am now talking about shooting a situation for a client who is paying you to make them look as good as possible. I am assuming that you are not doing a piece of investigative journalism and are not out to make your client or subjects look like fools or worse. This approach applies also to editorial coverage. You probably would not be on the site if your editors did not want you to produce an attractive piece of photojournalism. Even if an area is spotless when the shift or work day starts at 8:00 in the morning, by 2:30 or 3:00 P.M. the place and the people may look a lot different. It is only fair that when you are on this kind of assignment you should do your very best to make the operation look attractive and interesting. When photographing certain people, particularly those in the arts, their messiness and possibly sloppy environment become part of the charm of a warm and friendly photograph, and if you are doing a purely documentary approach, then you photograph it the way it is. But if you are dealing with an annual report, commercial assignment or an editorial piece for a business or consumer publication, you have to look to the details and fine points of appearance of the plant location or personnel.

Factories and industrial work areas are notoriously dirty and frequently unsafe, yet you are expected to make photographs that do not show this dirty or unsafe condition. It often does not take much effort to make tremendous improvements in the visual aspects of a location, and paying attention to such details will enhance your images. Just the removal of a few oily rags, a couple of lunch buckets or paper food containers, even the "girlie" calendars on a wall, will often work wonders. Sometimes the repainting of a handrail or machine protection device in the customary yellow or red warning colors will brighten an otherwise dull color picture remarkably. The preshooting preparations can get

complicated and possibly costly to the client or subject, so you have to use good sense about such requests.

Many years ago I was assigned to cover a new oil refinery for a petroleum company that had just begun building a massive photo file and wanted pictures that would show the newness and the up-to-date quality of their installations. Arriving at the site, I found everything in pretty good condition except for three large Hortonspheres (those huge, ball-shaped, spherical tanks) that are designed to hold gases under high pressure. The forms are interesting and make for exciting visual patterns. They were finished, but unpainted, and covered with a rusty scale that, in contrast with the rest of the gleaming installations, looked simply awful. I talked with the painting contractor about this, asking him how long it would take to paint those tanks and when he thought he might be starting. He surprised me by saying that he was planning to start that very week and that it would take three days to do them all. I suggested that he do just half a tank at a time and only from the side I was photographing. In that way he could finish the camera side of all three tanks in a day and a half, and I could wait only until those sides were painted. He agreed and went on with his task and several days later I made my pictures. The funny thing was that about ten years later I passed that refinery on a train whose tracks ran alongside and the backs of the tanks were still unpainted!

Some of my friends and colleagues have teased me that I've left a series of half-painted plants all over the world, and perhaps they are right. Cooperation on the job by the client or subject can well make or break the assignment and I cannot repeat too often the warning that the visiting photographer must never make a nuisance of himself, make unnecessary demands, detract from production or even simply get in the way of the normal functions of the operation he is there to cover.

You also should be concerned with how people are dressed and how they look. I do not expect you to demand white tie and tails for a production-line photograph, but it will probably enhance your pictures considerably if the workers on the line or the people you choose to photograph in offices or elsewhere are reasonably neatly dressed and if the work areas are clean and tidy. These are things you should arrange before you arrive with camera in hand. It is a colossal waste of time to have someone scurrying around for a broom or to empty a refuse bin or do some other chore that could have been taken care of hours earlier.

PREPARING YOUR CREW
With the physical situation regarding the site arranged for, the next thing to do is prepare your crew if you are using one. If you have brought your own people, there is little you need to do other than familiarize them with the location. But if you are going to use local plant personnel, arrange to brief and possibly instruct them, and the first afternoon of your arrival is the best time for this. When in the past I was using massive banks of synchronized flashbulbs that had to be changed every time an exposure was made, I used to set up a mini-school right on the factory floor. Later, when I started using high-capacity strobe units, new lessons were necessary to teach the assistants in setting them up, stringing the power cables, hooking up the slave cells, and the very special care needed to avoid knocking them over on cluttered floors and smashing $300 heads. So what I still do on bigger mobile set-ups is to hold classes for an hour or two until the crew is used to handling the equipment safely and efficiently.

A reminder here is to make sure that, if you are going to be on the same location for more than a day, you get the same people back each time. It is silly and costly to have to retrain a new crew each day. Determine also what their hours are and if there is any conflict in their starting and quitting times. Make sure all bases are covered before you start using this crew. It may be pretty embarrassing for you to be photographing a shift of workers that normally quit at 4:30 in the afternoon, only to have your electrician walk off at 3:30 because he started an hour earlier and will miss his ride home.

Sometimes if you are working in industrial or commercial situations and are running over from one shift to another, you may want to hold your crew over. Can you do so without causing a labor problem? Often I have asked individual workers to work overtime, and if the company won't pay, then I do and add it to my bill. I also arrange to send them home by cab if they belong to car pools, as so many industrial workers do. These are all little things, but they can make your life a lot easier.

GET READY, GET SET, GO!
On corporate or industrial locations you should arrive at the site at least a half hour before the shift starts. Your equipment, if it has not already been unloaded from your car, should be accessible on a loading dock or wherever you are going to gain entry to the location, and a good-sized flatbed dolly should be made available to trundle your gear around, your new assistants on hand. If you are working on a roving field assignment and are going to be mobile and using small hand cameras, then have everything with you, loaded, and ready to move.

By all means be dressed properly for the situation, and, as discussed earlier, if safety gear is required for the area, then have it on hand and *use it!* Dressing for the job is important. If you are going to be working out-of-doors in some miserable hot or cold and nasty environment, be sure your clothing will keep you comfortable and, if necessary, protect you and your equipment from frostbite, dust or just plain foul-ups. Pay attention to your shoes. Make certain that you are as nimble and sure-footed as the occasion demands, whether you have to climb a ladder or to the top of a car or up a tree or scramble along a rooftop or a cliff for a decent vantage point or have to waltz out on some highly waxed or polished floor.

Preplan how you are going to separate exposed from unexposed film after each shoot so that if you have to dash off to the airport that afternoon you won't be shipping 200 sheets of blank film, as I did many years ago, taking ten years off the life of the lab chief who came up with 200 blanks and thought he had somewhere run the film through the hypo instead of the developer. Also, if you are shipping daily, make sure your shipping containers are on hand and that you have everything else you need, from preaddressed labels to light-proof boxes, packing materials, bills of loading, etc. Whatever you need, have it with you before you start shooting. And last but not least, ridiculous as it might seem, know in advance what flight you are going to get your film on and where the airport really is and, what is more important, where at the airport to take your film.

OVERCOMING "PHOTOGRAPHER'S BLOCK"
I think I have covered all the preshooting contingencies and it is time to move forward. Making that first picture on a new location, for myself and many colleagues, has always been a psychological hurdle. Call it stage fright, writer's block or just plain panic—it's in all the arts in one form or another. You can feel

160

vulnerable or alone even if you are surrounded by a large team. Everyone before you has had this feeling, but as soon as you make the first exposure, it will disappear and you will settle into the routine of working and producing. But work methodically and carefully. Instead of worrying and stewing, think methodically and carefully about your first shooting site, what it requires, what kind of cameras, lighting, cooperation on the line or from behind a desk.

GETTING PEOPLE TO RELAX

It is possible the people you are to be photographing are even more nervous than you or more uncomfortable. Some people are simply shy in front of cameras or, because of self-consciousness, feel they have to "perform." You will find this particularly true if you are in a production area of a large plant, a very large office space or other situations where there are many people working in sight of one another. Whatever the location, your function is to put them at their ease so you can photograph them in a natural and relaxed environment.

When I run into problems like this, I often try to disarm the people and put them at ease by using a little light banter, which I find often works very well. Working with production or clerical personnel who are too camera conscious requires other methods to put them at ease. Usually getting the key personnel aside and telling them that I am really interested in the situation and not the individual, and that all I want from them is to do whatever they would be doing if I were not there, is enough. If I am using Polaroid prints for testing, I make a couple of tests and involve these people in the photograph by asking their advice on their own appearance or something in the background or a procedural process to get their minds off the brief "celebrity" status that making the picture affords them and to give them a sense of participation. Or often I will joke with the production line workers, telling them I won't compare the photographs with those in the post office as "most wanted by the FBI."

Very often you'll be all set and have your subject relaxed when some clown in the background will yell "Smile!" or "Say cheese!" or something similar, which will be just enough to distract your subject and make him feel edgy or self-conscious all over again. When that happens I very ostentatiously stop, turn down the lights and take out of my supply case a small placard which I have had previously lettered: "Assistant Director," plus an extra cable release, and go over and hand them to the guy who opened his mouth, saying, "There is only one director on this set and that's me, but here is your union card and you can take over if you want to." That's usually enough to cause a laugh from the others around him and the loud-mouth to shut up long enough for the next exposure. Once I acquired a railroad engineer's cap and was wearing it in a shop location and when a "big mouth" opened up, I walked over and offered him my hat, saying "If you're driving this train you may as well wear the hat that goes with it." That too did the trick.

DEALING WITH MURPHY'S LAW: "IF SOMETHING CAN GO WRONG, IT WILL"

Remember not to get visibly upset when things go wrong or you feel harrassed or pressured. Do not rely too greatly on the latest camera or some new hotshot lighting equipment; rather, have faith in your own knowledge of the craft of photography. If a piece of equipment fails in the midst of a shoot, as it often seems to do at a critical moment, it's time to call a coffee break or send out for a

round of soft drinks for the people with you and go calmly about repairing the equipment, if possible, or replacing it with the backup gear you should have brought along. Remember, Forscher's hockey puck camera hasn't been invented yet, so expect technical failures and learn to work around them—coolly and without panic.

Field performance is only the tip of the iceberg. What you bring back and what you ultimately deliver in the way of finished photographs are still only part of the answer to the client's needs. Yes, you have been assigned to cover the plant operations for the annual report or have received an assignment from a magazine to shoot an editorial piece that you may be particularly well suited to do. You did all your homework, ordered all the materials you thought you'd need, arrived at the location, and found that nothing was as planned or expected or that the weather was lousy or that the people you were supposed to photograph just weren't around. Or for some other reason you have run into stone-wall opposition on the part of someone on the local scene who is determined to be uncooperative or down-right antagonistic and may even go so far as to try to prevent you from doing what you are supposed to do. What then? Do you throw in the towel, or try somehow to get the task done? Or suppose you find you simply cannot complete the job for any number of reasons, whether your fault or not? What happens then? Do you reshoot it? Is it possible to reshoot it? When do you make the determination to commit yourself or your client to a large expenditure in order to get what's needed done?

This is all part of the responsibility factor between you and your client. You cannot simply say, "Well, it wasn't as they said it would be, so the heck with them, it's their fault," and go home. They might or might not pay your bills, but forget about hearing from the client again if you have this kind of reaction.

One thing you don't do is give up. If you are having trouble with someone on the local level, don't argue with him or even with his immediate superior, but get on the phone and call the person at your home office to whom you are responsible and report what the problem is, asking what *he* wants to do about it. Is the weather impossible to work around within your deadline or day-rate commitment? Again, back to the phone to tell the assigning office what's happening. Can you have more time? Should you shoot regardless of the weather? Be sure to explain to your client, if he is not knowledgeable about the reaction of film to weather, what he will be getting. In some cases, particularly editorial situations, the production of the picture is more important than whether it's a good day or a bad one. But you must let your client know what the realities are and get some answers from him about how you should proceed.

However, you cannot lay it all on the client and always ask for his advice on what to do. One of the reasons you were hired was because of your ability to solve certain problems, so work out good alternatives to offer as options to your client before you call him. How close your alternative possibilities are compared to what was originally desired should be the deciding factor in what you tell your client. Even losing an assignment because of the impossibility of photographing something that isn't there or isn't as it was expected to be is a chance you may have to take, and those are the breaks in the game. But whenever it's possible, try to communicate and discuss your problems with whoever hired you.

One of the trickiest areas to deal in is when your client has been oversold on a situation and you go out and find it impossible to produce his bill of goods. I had a problem once with *Fortune* magazine when a writer came back with a glowing report of an impressive piece of equipment. He raved about a drying tower in a

fabric mill that soared three stories through the building and had thousands of heat-drying lamps in it, and he insisted that it would make a spectacular one-shot picture to illustrate the entire story. He sold the editors so convincingly that those were my instructions, one picture of this machine for a full-page lead, but he neglected to tell us that the tower was a sealed steel box 6 inches deep, 30 inches wide and 150 feet high and that all the lamps were inside the box so there was no way to insert a camera in there without melting it down! What he had seen was the inside through a couple of one-inch-diameter heat-proof glass inspection ports placed 30 feet apart on the tower. He did not understand the impossibility of photographing this unit as he had projected, so I ignored his request and went on to photograph other things to illustrate the story.

When I got back and sat in on the layout conference, the writer was furious and demanded that some other photographer be sent back to photograph this great visual triumph he had discovered. Fortunately the managing editor wouldn't hear of it and simply said, "If the photographer says it's a photo-graphic impossibility, the fact has to be accepted." And there the matter stood; he backed me up completely.

The important thing is to find other strong visual material and come back with something to equal the high expectations that were being held at the assignment desk. So, while it is important that you keep in communication to discuss problems with the people who have assigned you to the project, there may be other factors which could prevent you from doing so and you have to make quick judgments and may even have to commit your client to large expenditures. Are you prepared to do this and do you have the confidence that your client will back you in your commitments?

I became involved in a tough and ultimately expensive value judgment that could have cost me my career with one magazine if the editors had not backed me in making an on-the-spot decision that normally should have been cleared with them. I was doing an off-shore oil-drilling story one cold winter that required a big twin-engine helicopter capable of flying sixty miles over a stormy sea to the rig and bringing me back without refueling if necessary. The story on a U.S. government agency had been cleared after many hours of conversation with them, and arrangements were made for me to use the government machine, after signing the waivers, and I was told to appear at a given time and place and did so.

On arrival I found that my "authorization" had been canceled and the officer in charge was suddenly "unavailable." But there was still a story to be shot, layouts to be finished, deadlines to be met, all within the next 24 hours. There was also a deep and violent storm moving in from the west, and I only had a few hours at the most to get everything done before being "socked in" or, worse, marooned on a rig for a couple of days. There now was also the matter of getting permission to land on the privately owned platform.

I called my editor and she said to do the best I could and I had to work it out myself. I called the oil company, "sweet-talked" their public relations man into getting me permission to land, even though I had no idea whether the story was going to be a hatchet job or not (it wasn't), and called the only helicopter-rental operator in the area with aircraft big enough to do the job. I told the dispatcher of my needs and asked him how much it would cost. He mentioned a heart-stopping $1100, a figure I immediately passed back to Washington. They gasped too, expecting as I did to hear a $350 to $400 rate, but said go ahead anyway. So I dashed for the pad, and we took off with a near 90-mile-per-hour tail wind breathing down our necks. The pilot then came back and said that,

because of the wind, we couldn't refuel on the oil rig, and I had ten minutes to make my pictures, and the total engine time would be well over three hours, or about $3500 in rentals.

I had been under the impression that the $1100 figure was the total price, but it seemed it was only the hourly charge. I could have aborted the mission and headed for the nearest phone, but it was lunch time in Washington and I knew I couldn't get hold of anyone in authority. Even if I did, there would be a meeting of a couple hours' duration before they granted the permission, and by that time we would have lost our weather anyway. So I made a decision and said go ahead to the crew, knowing well that it might be my last assignment for this magazine. I had my ten minutes' shooting time on the pad (I used my motor drive), grabbed two rolls of film, clambered back into the big bird and shuddered back wondering what would have happened if some new photographer had run into a situation like this. Even then I was not at all sure that I wasn't going to be asked to "eat" $2400 of that bill. But my editors did back me and the picture editor said, "You made a value judgment, and even though we might have canceled the shoot, we accepted your decision to go ahead with it."

One sidebar to this is that my editor said she would try to bury the bill so the managing editor wouldn't see it and have a cardiac seizure, and I heard nothing more from her about it. But about a year later, I ran into the managing editor in the hallway and he said, "Oh by the way, Charlie, I've been meaning to ask you about that helicopter bill on the off-shore story."

This kind of value judgment aside, what about responsibility for production of pictures that have to be reshot or of additional material produced because the original material is not up to snuff? When there is a failure to produce a set of acceptable pictures and the question exists of the need for a substantial amount of retakes, I feel the whole situation has to be reviewed thoroughly by both the photographer and the client. The first question is what happened? Who was wrong? Were you late? Did the client's people not show up? Were the models, if any, late? Or unprepared to work? Or did you shoot everything as planned and have something go wrong in the processing? Did you lose some or all of the film out of the car? Was a camera stolen at the airport? There are so many factors that can result in failure that it would be impossible to list all the possibilities. The main thing is to first find out what went wrong and then go about correcting the situation.

What happens, for instance, if you travel halfway around the world, ship your film to the lab, and instead of receiving a batch of processed film, get a printed slip saying, "We're sorry, something happened, and here's a check for the replacement of the film"? This has happened to photographers over the years, though admittedly less frequently in recent times. If the assignment is over a long period of time and involves a great deal of shooting in many different localities, as occured when I went around the world for an airline, break up your take into smaller batches and feed them to the labs piecemeal. Do this so there can be no possibility of one machine breaking down and ruining a whole take that would be impossible to reshoot.

GOOF-PROOFING YOUR ASSIGNMENT

Are *you* goof-proof in your methods of shooting and getting your assignment finished? When shooting complicated color situations, whether on a factory floor or in a studio, you can diminish your chance of failure with the use of Polaroids or bracketing, often both, and also by using different cameras or film

backs. Then splitting your takes for shipment to processing labs will be added insurance. When shooting news stories or fast-moving people or things, and there is no opportunity for test shooting, you have to do as much as you can to predetermine your needs and exposures. If you are shooting aerials of a plant or a city, don't wait until you are aloft before trying to determine your exposures. The light level of what you shoot from the air will be on the ground, so determine what it is at ground level, not by exposure from the airplane. Earlier I covered pretested emulsions, camera and equipment checks, and spare equipment availability. Equipment failure should never be a factor, yet unfortunately it too often is. Usually this can be avoided by thorough testing of equipment before starting the job. It's true that a camera can be dropped or some other piece of equipment get banged around during transit or during a shoot. If this sort of thing happens, it's your fault in the eyes of your client, and it is your responsibility to make good somehow even if it means (to use an old show-business expression) "taking a bath," paying for the reshooting even at a great loss. Naturally there will be occasions when neither expense nor time can recreate the situation and all you can do is hide your head and take the consequences of probably unbillable costs and fees.

However, if it's not your fault or, as in the case of some advertising photography, the art director may simply not like the pictures for "aesthetic" reasons, even though they may be fine technically, what do you do?

In advertising photography there are some clear "reshooting" guidelines and customs. Frequently they are written into the contract or purchase orders. If they are not, then make sure they are, including an arbitration clause. Usually if there is a failure in concept and not a technical one, and the art directors are not happy with the pictures because the model isn't right or a garment object does not appear to their liking despite the photographer having followed the preconceived layouts, the photographer usually is paid half the predetermined fee plus all expenses. He is not expected to (and should not) reshoot without a new fee under such circumstances. There could be value judgments here as to what constitutes acceptance. If the photographer has clearly failed for technical reasons *within* his control and has produced no usable images at all, the responsibility for reshooting is clearly his. But under "custom of the trade" the photographer is supposed to be given the first opportunity to do a retake before the client looks elsewhere. Yet because personal judgments are often involved, there is usually no easy agreement on what constitutes "acceptable" photographs, so it is not unusual to have to resort to arbitration.

There are formal arbitration organizations such as the American Arbitration Association as well as more trade-oriented groups like the Joint Ethics Committee (JEC), a totally voluntary organization made up of representatives of photographers, illustrators, and art directors.

However, since it is a voluntary organization, any referral to the JEC must be agreed on by all parties before it will enter the case. Whereas the JEC has no actual enforcement power, the participants usually accept its recommendations. For further information regarding the JEC, write to P.O. Box 179, Grand Central Station, New York, NY 10017.

Suppose there *is* the possibility of reshooting a situation—a machine that hasn't gone anywhere or people who haven't left the area in which you were working or a mountain still in place (even Mount St. Helens kept blowing its top for example). How do you deal with situations like these? By reshooting at your expense if it is totally your fault, or at half fee plus expenses if it's not your fault but you want to maintain good relations with the client. But use good

judgement here—don't offer to spend $5,000 to recoup a $1,000 assignment. It is better to take "the bath."

Usually the bills will be paid for services rendered even if the client is unhappy about what is produced. The main point to be emphasized here is that in editorial situations there can be no option for payment on the part of the client or editor based on whether the photographs are acceptable if all the other technical standards of quality are met. Also in the editorial world a technical failure, even if it is the photographer's fault, will rarely result in nonpayment if his track record up to then has been good.

Part of the reasoning behind this philosophy is that the client's picture buyer or editor should be experienced enough to know in advance whether the photographer has the ability to produce the pictures requested, and therefore there should be no question about payment for those services even though the editor may be unhappy with the end results. This presumption of knowledge on the part of the editor doesn't always work. If it turns out that the editor is untrained and unknowledgeable, disastrous results can occur. This is apt to happen more often with new picture editors whose principal training has been in fine arts rather than in photography. A case in point: I once was assigned to produce a coverage of a large pharmaceutical plant in upstate New York for a medical magazine. The picture editor herself had been a photographer of many years' standing. She had led her bosses to believe she had more knowledge than she actually had, and it was this lack of technical expertise that nearly caused me to have to reshoot an assignment that should not have needed reshooting.

When I finished the job she had given me, turned my film in to a commercial lab with instructions to deliver directly to her, and from the field I left for an assignment in Georgia for another magazine, I called and found her in a state of near hysteria. "Nothing is any good," she said. "Everything has a terrible blueish-white cast to it, and all has to be reshot." There was no arguing with her at a 1,000-mile distance, and I agreed to reshoot but insisted that we meet that Saturday morning in New York with the developed film so I could see what went wrong. However, she was too agitated to wait and had already dispatched another photographer to partially reshoot. When I arrived back in New York and met her at her office, she threw the pictures on the light table. (I use the word "threw" advisedly because that's exactly what she did.) I looked at the pictures and couldn't find one single thing wrong with them. They were beautifully lit, cleanly and properly processed, and so far as I could detect, perfect in every respect including content. I must have looked at her like she had lost her mind because she grabbed the transparencies that the other photographer had sent in and said, "Look at these—this is what I wanted." What she wanted were pictures with a bright green cast over everything.

It finally sank in; the other photographer (and every photographer she had ever used in this kind of situation) had shot 35mm film using available light, only in this case the "available light" was from fluorescent or mercury-vapor fixtures. I deliberately had *avoided* this situation by using strobe units and daylight-type color film. One would think she would have known this, having been a photographer herself, but I later learned that she almost never had shot color film on her own. This editor had never realized or known that most factory or production areas are lit either by fluorescent or (even worse) mercury-vapor lighting, so when she came face-to-face with photographs made in such a production area, not knowing how to deal with photographs lit correctly, she thought there was something wrong. I won the battle but lost the war, because I refused

to reshoot. Not only did I have to threaten legal action to get paid, but I never got more work from that publication.

I have had occasional problems when trying to apply editorial guidelines to advertising, especially when it come to asking for advances. Sometimes the photographer's demand for an advance is not so much a matter of getting money "up front" for out-of-pocket expenses, but also is in some measure a guarantee that payment for his services will follow.

WHEN TO THROW IN THE TOWEL

"Acts of God" is a phrase in legal contracts from another era and can cover a multitude of difficulties. Usually these problems are less "godly" and more human and in truth often reflect acts of omission rather than commission in that someone—photographer, client or one of a dozen persons in between—has not made proper preparations or has forgotten to do something. This puts the photographer and the client in a situation where each has little or no control, and usually they wind up at the mercy of people who either could not care less about the photographer's problems or, unfortunately and often, are down-right incompetent.

A perfect example of this was when I was covering the Op Sail celebration in 1976 for *Smithsonian* magazine from a navy helicopter. After weeks of negotiation and hours of conversation with the navy, I was finally airborne and took my place in a long line of helicopters covering this marvelous and complex celebration. I was doing fine photographing the parade of ships up New York harbor when suddenly the pilot cheerfully announced that he had to pull out of line to refuel at a New Jersey base. I immediately grabbed the intercom and, using language that the FAA would have frowned on if it had been broadcast, said, "What! You're supposed to have six hours' worth of fuel on this bird and we've been airborne less than an hour, and even if you came up from New Jersey you shouldn't have to pull out now!"

"Well," said the pilot, "that's true but we'll have to go clear back to New Jersey and that won't leave us enough reserve to fly much more now and still get home again."

"Why not refuel at the naval air station here in New York?" I asked.

The pilot said, "We can't do that because we're not cleared to draw fuel from that station."

By this time I was beginning to wonder how many different navies we have in this country! In desperation I suggested refueling at LaGuardia Airport and suggested I would be willing to pay the cost of refueling, but the pilot said that if we did that, we would have to provide fuel for the other six helicopters in the squadron. I rejected this because I had no illusions about the editor accepting a fuel bill for 3,000 gallons of aviation fuel I didn't use. The pilot was adamant in his decision to return to Lakehurst Air Station and pulled us out of line. We were quickly followed by the rest of the helicopters in the squadron and thus I, and many other working press people, missed most of the parade. I was saved only by what I had already shot before we were pulled out of the line. So on this latter part of the story I was "dead" and had to throw in the towel.

This is a classic example of lack of preparation by third parties whom you are forced to depend on though you are completely at their mercy and often have little recourse if they fail in their responsibilities. In situations like this, the chances are there would be no problem about being paid for your time, although some hard-nosed art directors or purchasing agents might well say, "I

don't care what happened. You didn't deliver the pictures so we're not going to pay you." If you have properly protected yourself in your purchase agreement, you should be able to cover such eventualities.

Unusual situations like this, which are neither the photographer's nor client's fault, are difficult if not impossible to anticipate, but there are other potential problems that might be a little more predictable and thus easier to spot. The photographer must somehow learn to be omniscient and sense impending trouble. For example, if you are sent to do a portrait and the man is not on the site, or the building you thought you were to photograph actually doesn't exist, you ought to know this ahead of time, if at all possible. I was once instructed to cover a plant in New Mexico as part of a large annual report, and ten minutes before I was to leave for the location I learned that it hadn't been built yet! The client, an electrical manufacturer supplying the materials, had shipped them four years earlier and *assumed* the plant was built and running.

Or once when I was sent to Pittsburgh to cover a night baseball game at a new stadium, I arrived only to find that a violent rainstorm that afternoon had caused the evening game to be cancelled. Try explaining this to a client who was planning on these pictures for his annual report that was closing (or so they thought) in two days and try invoking the "act of God" clause. This could cost a fortune in lost printing time at the printing plant! My emergency solution on the spot in the baseball case, chosen without consulting the client because it was a weekend and I couldn't have reached him, was to find out that there was another night ball game going on in Cincinnati. I chartered a plane and made some night aerials of that park, which is similar to the other park in appearance from the air, and I was able to substitute it for what had originally been requested. Susequently I learned that there *were* considerable differences that the art directors covered up by judicious placement of overlay type. I probably could have easily invoked the "act of God" clause here, and instead of knocking myself out by dashing off to Cincinnati with a rented plane, I could have repaired to the Pittsburgh Press Club bar and finished the assignment there.

BE FLEXIBLE

In planning your schedule beforehand, try to keep some flexibility in it. You may need to make some outdoor pictures that may later be difficult because of forecasts of nearing bad weather or, conversely, if you hit a spell of good weather at the beginning of an assignment, try to get all your exteriors made before the weather changes. If you are inside and the weather suddenly turns good, be prepared to interrupt your interior work and take advantage of the favorable weather. The same goes for other occasions. If you hear of something or some situation you may have missed in your briefings, don't be so rigid in your scheduling that you avoid taking advantage of the new situation to shoot.

Time your work carefully. If you are working indoors with many people around you, plan to stop shooting a half hour before the shift ends so you are not caught in a stampede to the locker room or exits and you, your cameras, strobe units or wires will not be knocked over. Go through your schedule methodically so you don't have to backtrack over an area where you have already worked and possibly further disrupt the people there even though you limited those disruptions in the original shooting.

If you are working in some industrial area or other crowded facility, the chances are that when it comes to meal breaks, your local contact people will suggest you have lunch with them rather than eat in the company cafeteria or lunch room. While this may be more agreeable, since most industrial cafeterias

are uniformly disappointing, it may be advisable to use these facilities if available to save the time spent in getting in and out of a plant or office building and finding some restaurant of better quality that can feed you and your team. However, if you do wind up eating outside the building, avoid drinking at lunchtime, not because of morality but simply so as not to inhibit your ability to function maximally when you return. More simply put, getting "bombed" at lunch time is an automatic road to "bombing out" on the job. On some locations I have often skipped the noon meal entirely to save time for shooting, or have sent out for sandwiches and coffee in order to avoid interruption on the job. This is particularly true when you have overlapping shifts on a job or when the weather is unreliable and you have to take advantage of every minute of shooting time.

MEETING DEADLINES

Earlier I mentioned that one of the first things I do on arrival in a new city is make a reservation to leave. This is not as flippant as it sounds. Getting you and your film to where it has to go after a job is done is an important part of the whole performance. Deadlines can be critical, and thousands of the client's dollars as well as your payment may depend on whether or not you get your pictures made, processed and delivered on time.

Editorial deadlines are considered sacred by anyone in the journalism field. In order for the presses to print on time, layouts have to be closed, prints and engravings made, type set, a million other bits of information all locked into place at the right time and in the right position, and the photographer's job in getting his pictures in is no small part of the total teamwork required for the makeup of any publication that uses photography. Deadlines are not restricted to newspapers and news magazines. Every other publication, whether it's a tiny neighborhood supermarket giveaway, a high school yearbook or a glossy annual report from some multinational company, is scheduled to be printed at printing plants that can be located anywhere in the world (and in this age of satellite transmissions that's just about where most of them seem to be).

Why are press times so sacred in journalism? The answer is not found in the romance of the smell of printer's ink but more in the hard dollars-and-cents world of advertising. An advertiser pays a lot of money to have his commodity or service advertised to a readership of guaranteed size, and if the paper or magazine or television message doesn't get before the public at the time it is scheduled, the ad agencies and publishers are usually stuck with penalties in the form of reduced revenues or even lawsuits for breach of contract. Much the same holds for the production end. A magazine or newspaper is a tremendously complex enterprise, and the scheduling at printing plants has to be precise. Critical arrangements have to be made for the number of copies run, the amount of paper on hand, the back-up press capacity for breakdowns or expansions for last-minute runs due to fast-moving news. There are many reasons why a missed printing deadline can be enormously costly to a publisher. At one large national publication group that publishes six major magazines, press availability has to be allocated in such a manner that each separate edition will get through the system on a precise schedule or it will affect the one that follows it. Therefore the photographer who misses his deadline, especially when a critical story is involved, is in for a hard time indeed.

This sense of timing and urgency of proper delivery does not rest only with newspapers or magazines. It is just as important to the publisher of that routine

brochure or that same high school yearbook. How effective is a yearbook if it comes out after graduation? Or the throwaway sheet hits the supermarket after the sale is over? Apply this thinking to the company that is putting out a large annual report. The corporate laws are very strict about stockholders' meetings and publication of financial data that make up the heart of an annual report. The company that is issuing it has to rely in turn on the graphics department of its agency or art service house, and the same necessities of magazine publishing are brought into play: engraving, makeup and typesetting—all on time. The corporation that misses its deadline for this publication is in just as deep trouble as the magazine that fails to come out when scheduled.

With all these complexities, it is important for the photographer to know that what he is delivering to his client is in proper condition and ready for printing and will not require extensive work at the printing plant to get it in shape.

Even though photography came of age in the 1830s, it was not until the end of the century that the reproduction of photographs via the printing press became commonplace. Over the ensuing years the basic principles of halftone engraving remained constant, though the technology and handling became increasingly sophisticated. The capabilities of presses to reproduce fine photography increase all the time, yet these early constants must always be kept in mind when producing photographs for reproduction.

Traditionally there have been three basic systems of halftone reproduction. They all begin with the halftone screen, where a photograph or other type of graphic art is rephotographed onto a sensitive plate with a halftone screen interposed between the original picture and the plate. The screen is composed of fine diagonal lines that will break up the image into tiny dots, with highlights and gray areas etched away. Depending on the various tones in the photograph, a pattern of dots will evolve so that when a plate is made and ink passed over it, and the plate is then applied to a piece of paper, the densities of the ink or lack of it will result in the highlight, halftone or shadow values of the photograph. How that image is then applied to the paper is embodied in one of the three systems mentioned. These are lithography (or photo offset), photo engraving (letterpress) and intaglio (photogravure). Each is an improvement in printing over the one before and the costs naturally are commensurate.

Until recently most newspapers were printed by the letterpress method. That is, an engraving was made after the halftone screen produced the image on a sensitized plate, type was set in "hot metal" by the typesetting machinery, and the whole thing was locked into forms and put on the printing press. Ink was then rolled over the forms, and the paper, coming from giant rolls, passed over and pressed onto them, with the resulting images. The little dots on the halftone plates prevented the ink from smearing and allowed for the gradations in the photographs, and the quality of the photograph was controlled by "resolution" of the engraving screen, or the number of dots (or lines per inch) on the plate. Because newsprint traditionally is a soft paper and absorbs ink easily, the trend was always to use a "coarse" screen for newsprint (usually about 60 lines per inch), and because the ink had a tendency to block up in the shadows, the quality of the newsprint photograph generally prevented much of the detail in the photograph to show. Deep blacks and pure whites were most difficult to handle and always have been in the traditional newspaper letterpress method. One advantage of the letterpress system was that it was fast and the type and halftone plates generally had a pretty long life so that large editions of the papers could be run without replating. On the big papers a complicated set of duplicate drums or "stereotypes" were made so that any number of presses could

be run simultaneously when the editions ran up in the hundreds of thousands and perhaps millions! For this reason it is important that the printed images presented by the photographer be on the contrasty side because the coarse screens of the newspaper cannot separate out the fine gradations of tone very well, although sometimes a uniformly gray-toned print holds detail surprisingly well on newsprint if the "grayness" is unimportant.

When the letterpress system is used with a finer engraving screen on a better grade of paper than newsprint, the reproduction can be superb, with full detail in the shadow areas and rich blacks and bright whites. This is because the portions of the plate that carry the most ink are raised in relief with the halftones and highlight areas progressively etched away during the engraving process; thus the inked sections are blacker and richer.

Most of the older big picture magazines used the letterpress process, but when they died, the big presses were scrapped. Ironically now there seems to be a shortage of this type of press capacity, and the letterpress process seems doomed to follow the dodo into extinction because of the higher cost of this superb method of photo reproduction.

The magazines have different problems. They usually run in smaller editions and at a slower editorial pace, so the printers look for better quality in the paper and reproduction. The second popular process is lithography, based on an old form of art reproduction where an image was drawn on a stone with a grease crayon. The inks would adhere to the stone except where they were repelled by the grease crayon and thus the image would be formed.

The current "state of the art" in printing is offset, though technically the images are not as sharp due to the transfer of the image from the plate to the blanket and then to the paper. But modern printing technology has narrowed the gap considerably as to quality, and the simplicity of the system and its inherently cheaper cost make it the "hands down" winner in terms of popularity among the processes available.

In offset (photolithography) the principle remains the same. The light-sensitive plate, after exposure through the screen, accepts the ink in the shadow areas and those parts of the plate which would be the highlights of the photograph reject the ink. The entire image is then transferred, or "offset," onto a rubber blanket, which in turn is put into contact with the paper and the image is printed. This system permits the use of harder, less absorbent paper, and thus a finer engraving screen can be used with as high as 180–200 lines per inch (120 lines is a good average). This will allow for much better gradation in the halftone areas and deeper and richer blacks in the shadow areas.

Earlier I mentioned the proliferation of small town and small city papers. One of the main reasons for this growth has been the improvement of the offset process of photo reproduction, coupled with advances in computerized "cold type" production, which eliminates or reduces the need for the traditional "hot metal" shop at the standard newspaper. There is no question that this switch-over also adopted by many big city papers, has caused not only consternation, but also numerous labor problems with unions fearful of their members losing their jobs (with the unions' subsequent decline in membership and power). But with the retraining of machine typesetters to the new processes, attrition of older employees, and employment elsewhere on the same paper, the offset process has moved into the newspaper business in a big way, and many of the big old-line publications are modernizing their equipment to this newer process of printing, based on one of the earliest known methods of reproduction.

Newspapers, with their big rotary presses and enormous printing cylinders capable of high-speed runs from tremendous rolls of paper also lend themselves to a finer type of printing called gravure (or rotogravure). Some readers may remember the old sepia-tinted weekly supplements that came with most Sunday editions in years past. Considering the times and press capability, the quality of reproduction of the old rotogravure sections was superb, and today many of the four-color supplements of our current Sunday papers are printed by a second- or third-generation process of the old rotogravure system.

In gravure printing the process is reversed from the conventional letterpress system because shadow areas are etched away on a copper plate or drum, and these indentations in the plate are filled with the ink, with the paper literally pressed into them, which is where the term "intaglio" derives, meaning incising (or carving into) the image rather than raising it as in the relief process. The quality of reproduction that can be obtained is probably the best and under the hands of highly skilled people can come very close to equaling the quality of the original photograph. Knowledgeable people in the printing industry feel that gravure is the printing of the future. Up to now it has been restricted to comparatively short runs, produced for the most part in small European shops with the highest quality presswork available.

Here, too, technology is developing and there are new methods of preparation of the copper plates and rolls that are helping to cut the relatively high costs of gravure printing. So far, quality gravure printing for the most part is restricted to the "sheet-fed" process—that is, one sheet at a time is printed on a flat press with one color at a time, so that a four-color sheet has to be handled four times before the printing is finished. With the popularization of the high-speed offset "web" presses, which can run enormous quantities of continuous printing from a big single roll of paper (called "the web"), and with incredible color registration of images, printing experts feel it is only a matter of time before a similar capability is established for gravure printing and the superior quality that comes from this process. For the photographer, the use of the gravure process means a finer (up to 300 lines) engraving screen than even the best offset process offers and the best possible reproduction.

MEETING PRINTING REQUIREMENTS

It is up to the photographer to find out just what printing process is being contemplated, what kind of engraving screens are to be used, the weight, quality and finish of the paper, and so forth. With this knowledge he can then bring out the proper quality in the photograph for best reproduction. If he gets involved somehow in book publication he will also have to be knowledgeable in discussing with his editors what is needed to bring out the maximum quality for each printing process used.

With a knowledge of the type of print quality used, what else should the photographer be aware of when he delivers his finished product ready for reproduction? Where better quality reproduction is wanted, many photographers and editors prefer a rich print on a double-weight glossy stock, but matte dried. In this method, the print is reversed on the drying drum so the ferrotype plate will *not* come in contact with the print surface. The glossy stock will retain some luster that can capture the luminescence inherent in the print. Full matte or semi-matte papers are rarely used for reproduction because they tend to mute the tones of the photographs, however well they pick up detail.

When it comes to sizing, the preferred practice is to deliver a print equal to or somewhat larger than the final engraving that is to be made. Enlargement of a

print always increases grain structure but reduction of a print to a specified size does not. So get the best-quality print you can from your negative and print it according to the printing process that will be used.

There are a few "musts" before final delivery. Spotting is one. Every enlargement, no matter how carefully printed or how dust- or scratch-free the original negative is, will inevitably show minor imperfections in the final print. These imperfections can be eliminated by "spotting," which doesn't require any great skill but rather, patience. Spotting is the covering of a spot by touching up the print with tiny dabs of blended opaque ink to cover and match the general tone of the print around the blemish. The tendency to ignore this final finishing process is growing, and these uncorrected blemishes are beginning to show up on a lot of presswork, indicating equal sloppiness on the part of printers and production supervisors. A clean, well-spotted print should be a matter of pride to the photographer and a sure sign of his sense of professionalism.

Borders should also be considered. Some photographers think that a borderless print is more handsome, and for exhibition use it is, but when a photograph is going to an engraving plant for photoengraving, the narrow white border on the print that most enlarging easels provide for allows for a grip on the print in the engraving camera holder. It also minimizes the chances of smudges and marks on the face of the print. The white border not only serves as protection for the image but also gives the art director a place to put his cropping and sizing marks when a print is scaled for reproduction. When the reproduction work is completed and the print returned to its file, the border continues to act as a buffer against damage and preserves the print for future use. I have found that when a print has become quite old and worn around the edges, a later trimming of the border will give it an almost new and fresh appearance, provided it was a good print to begin with.

What about mounting? Unless a print is for exhibition use, do not mount it. Mounts are heavy, expensive, serve no useful purpose and do not enhance the quality of the picture.

GET RELEASES NOW

Although most editorial work does not require the use of releases from people in job situations, especially when made with the consent of the parties, there are some corporate attorneys who feel their annual report should be so protected. Or you want to be able to put some of the outtakes into your own photographic files for other uses and it may be difficult, if not impossible, to get releases later from the people you have already photographed. So if you feel that a release is necessary or it is demanded of you by the front office of your client, then the time to get those releases is while you are there.

Elsewhere in this book I mentioned a situation in Kentucky where in the course of an editorial assignment I ran into a lot of opposition from an influential woman in the community who objected to my photographing some of the local people. Technically this woman had no control over those I photographed, but the company lawyers felt that she could create nuisance lawsuits by encouraging some of the local people to sue me. Such lawsuits, however unjustified, would be costly to defend, so I obtained "general releases" from the people I photographed and thus forestalled any action.

Since the people you photograph on various jobs are probably not professional models and are already being paid for the activities you are photographing, payment is usually not an issue. Also, most model releases either specify a minor amount of money "and other valuable considerations" or specify "$1.00

and other valuable considerations," so you can give the worker at a machine one dollar and perhaps the Polaroid shot you made as a test, which can be considered the "other valuable consideration" and that will usually suffice. The machine worker will consider the dollar a joke but will understand that the passing of the dollar makes it legal so you have a release on file. For general editorial work such as an annual report or a trade magazine in the field in which the worker is employed, this type of release is usually safe enough.

Be sure to get all the information—name, address, and Social Security number of the individual. You don't have to file a report on the dollar paid, because the amount is under that required by the IRS, but if you should have the opportunity to resell that photograph for a larger sum, and pay the "model" a sizable model fee for the additional usage, that Social Security number will probably be needed. It is a good idea to make the release in duplicate, turning one copy over to your employer and keeping the other for your files in case an occasion for reuse arises after you have left.

PRODUCTIVITY

In fulfilling assignments, you will often get questions about productivity from your clients. How long is it going to take? How much can you do in any given time? The governing conditions on the site are always both unknown and yet controlling factors. If you are working on a commercial job with a view camera involving complicated lighting set-ups and you can produce five to six situations a day, that is good production. If you are working freely with small hand cameras, obviously your productivity rate will go up. On a magazine essay not too long back involving about ten days in the field, with a good mix of indoor and outdoor situations, much conference and travel time between locations (all within a 200-mile radius), I turned in about 50 rolls of 35mm color film, which gave more than enough material for eight pages of editorial matter. This particular story called for a high degree of mobility, including photographing from small boats and big Coast Guard cutters at night, some laboratory pictures, several interviews with political people, and in general as broad a variety of situations as one could ever expect to encounter in any story. So five rolls of film per day as an average, while it may sound low, is actually fairly good production.

The use of the motor-driven camera can be a misleading factor in assessing productivity, and *quantity* produced with a motor drive camera is no substitute for *quality*. Except in rapid-action photography, all the motor drive does is consume large amounts of film and processing and often does not result in any more usable pictures. It may in fact create problems of "missed" pictures because of the constant need for reloading at critical times. An editor I know once complained that she received more than 20 rolls of film for a one-column headshot. It can go the other way, too. Always provide enough material to cover the situation adequately from as many conceivable viewpoints as are practical because too little production can be just as much of a shock to an editor as too much.

Among picture users one question frequently asked is "Why do photographers shoot so much? Are they simply taking a buckshot approach in the hope that if they shoot enough pieces of film they are bound to come up with something useful?" Hardly, and while the example of the photographer who shot 20 rolls of film for a one-column headshot is excessive, it is not unusual. Most experienced photographers never overshoot because of uncertainty about technique. In any public or news event or even with interviews, situations

174

change from second to second, facial expressions possibly even faster. A photographer never knows what's going to happen seconds later. A classic example of this concerned Dr. Abraham Zapruder, an amateur photographer who was filming the Kennedy visit to Dallas with his 8mm home movie camera, simply for his own enjoyment. Had he stopped after the Kennedy limousine first entered the plaza in Dallas and said to himself, "I have enough to show the President arriving." Or if he had not saved some film and kept shooting, he would not have been able to make the pictures of the assassination. But not all situations are so newsworthy. Whatever happens, there is always the uncertainty of what can occur after you have made each exposure, and that is why most photographers keep shooting continuously until an event is over. It can of course be carried to excess, and the overuse of the motor drive is one way of falling into that trap. Why shoot a burst of ten frames when two or three hand-tripped exposures will be just as effective?

Compared to the other costs of doing any kind of photographic coverage, the cost of film alone is probably the cheapest part of any assignment. But that is not to say there should be no restraint. The big problem with overshooting, aside from the cost of film and processing, is inundating the editor with images and having to assess so many in order to extract the important ones.

One of the great classic yarns about all this involved a national magazine that faced a tight closing on a story of worldwide importance. To the consternation of the editors, within a few hours of press time they discovered they did not have an up-to-date photograph of the wife of one of the principals in the story who, it seemed, was in residence on an estate a thousand miles from New York and a hundred miles from the nearest city that had a competent stringer on the local paper. The editors frantically called the stringer, only to learn that he was already busy for the same magazine on another part of the same story and therefore could not take the picture, but he did offer to call an old-time retired newspaper photographer and have him hurry down to shoot this much-needed picture. In the meanwhile the magazine chartered an airplane to pick up the film and rush it by motorcycle to their lab on arrival at the airport. When the packet was opened in the lab, there was one old-fashioned 4×5 two-sheet film holder from an old Speed Graphic inside. The lab manager opened the first compartment of the holder in the darkroom and it was *empty*. With heart thumping he flipped the holder over and opened the other side, and there was indeed one piece of film in the holder. He developed it quickly and to his relief produced a good usable photograph of the lady. After the panic subsided and the magazine closed, the managing editor got on the phone and roared all the way down to Tennessee, "What's the big idea of sending in only one piece of film?" Back came the calm, measured answer, "Mr. Editor, how many did you need?" So let your productivity fall somewhere in between and produce a good selection and variety for your editors to work with.

GET THE FACTS AND GET THEM RIGHT

During the process of shooting you must prepare yourself for final captions and notes. I recommend several methods of keeping track of unprocessed film. First of all, have a good spiral or ring-bound notebook that you can put in your pocket as you work but with large enough detachable pages to be useful. If you are using roll film, particularly 35mm, obtain a good supply of self-stick labels with your name and address preprinted or rubber-stamped with waterproof ink that you can apply to the leader of each roll of film after you rewind it, but remember not to retract it all the way or you will lose the leader for the label to

adhere to. The label will stay on all through the processing phases and will be in place with each roll as you get it back from the lab. On these labels, which you can prenumber or not as you wish, make brief notes as to what they cover, or use roll numbers in your notebook to identify each roll. If you use Kodachrome regularly, make an arrangement with your authorized Kodak dealer to set up a processing account for your Kodachrome with the nearest processing laboratory so that you can ship directly to the lab and the film will come back to you later (overnight when necessary). You will then be billed through your dealer. When you do this you will be given a preprinted supply of labels that you attach to each roll of film, and the boxes will be returned with labels intact.

The same goes for marking other forms of raw film. Use self-sticking labels that can be transferred to the film protective sleeves, the boxes, or any other method of keeping track of what you've shot and what each packet or box contains. Not only will this assist you in your caption notes, but it will also enable you to double-check that everything has come back from the processing lab and that you actually shipped everything.

PACKING UP

At the end of your shooting, unload every camera body, every film holder, double-check every pocket or nook and cranny among your cases where a roll of film might have slipped, double-check the roll numbers against your pocket log, and remember now to unload that last roll of film from that last camera body you've been saving for that last great shot.

If you are through shooting on this job, repack all your equipment, wiping all the greasy wires that dragged across a factory floor, collect all your Polaroid and other film wrappers and dispose of them—do not leave them around. In other words, *clean up*. Turn in any safety gear you were issued, return all props that may have been borrowed or rented, make sure your factory people return the ladders, the extra extension cords, or whatever else that is not your property, say good-bye to your field people, and head for home. If you are flying, remember to take precautions for X-rays at the security gates. This is not the time for fogging film.

It has always been my habit that when I arrive back in New York, the first stop I make after leaving the airport is to deliver the film either to the commercial labs I use or to the assigning magazine's own lab or night desk.

Follow the same procedure wherever you live. Get rid of your unprocessed film before you do anything else. Then go home and relax. You've got a lot of work ahead of you.

THE FISHEYE LENS gives an unusual shape to a photograph, however, it is one of the most overworked formats used today. But when used sparingly it is a most distinctive and effective eye-catcher. However, too many photographers rely on its short focal length to cover sloppy focusing and more often than not wind up including their toes or belt buckles in the photographs because of the near 180 degree coverage. If the photograph is then squared, much of its unique imagery is lost. Yet it is a superb lens that can often solve problems in an impressive manner. The above photograph was made for an ad and had to show not only the complexity of the urban scene but the global concept of the product (hence the round, horizon-to-horizon shape), still keeping the glamor of the skyscrapers without losing the intimacy of the close-up. It would have been impossible to make this pic-

ture from a conventional aircraft, as even one even equipped with a camera port in the floor would not have given the structural clearance necessary for the extra wide coverage, and if the camera was extended into the slip-stream without adequate protection, it would be swept away. The solution? A motor-driven, fisheye-equipped camera extended below the undercarriage of a very slow moving helicopter (10 knots maximum forward speed). Using a telescoping pole cushioned against the air frame with foam rubber, and the camera remotely operated, I was able to make a set of almost 200 exposures in less than half an hour of expensive air time and still flying within legal FAA limits. In the ten years this set of pictures has existed, secondary sales have exceeded $20,000 and the photographs are still selling.

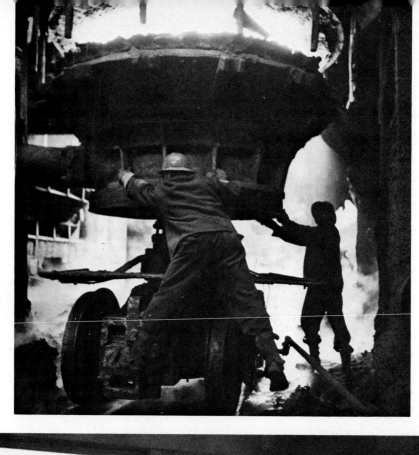

(Above, left) TAPPING A BLAST FURNACE in a steel mill in Ohio. Originally produced as part of an annual report, it was subsequently used by Edward Steichen in his famed *Family of Men* exhibit at the Museum of Modern Art in the early 1950's. Hand-held and made only by the light of the molten iron, it has been used often to depict a symbolic part of American industry.

(left) OHIO RIVER TOWBOAT PILOT HOUSE. This photograph was first produced for a major essay by *Life* magazine on the Ohio River. However, it never ran because of a nine-month-long steel strike in the Ohio basin. Subsequently it was used in other magazines, thus underscoring the need for the photographer to retain secondary rights to the material he produces.

(Above) MUSKINGUM, OHIO, a part of the Ohio River essay. This photograph won the Washington, D.C. Art Director's Club Gold Medal for a color version that appeared in a then newly-published Washington-based magazine. Made with a view camera (as compared with the 35mm-pilot house picture) it demonstrates the need for variety in portable field equipment.

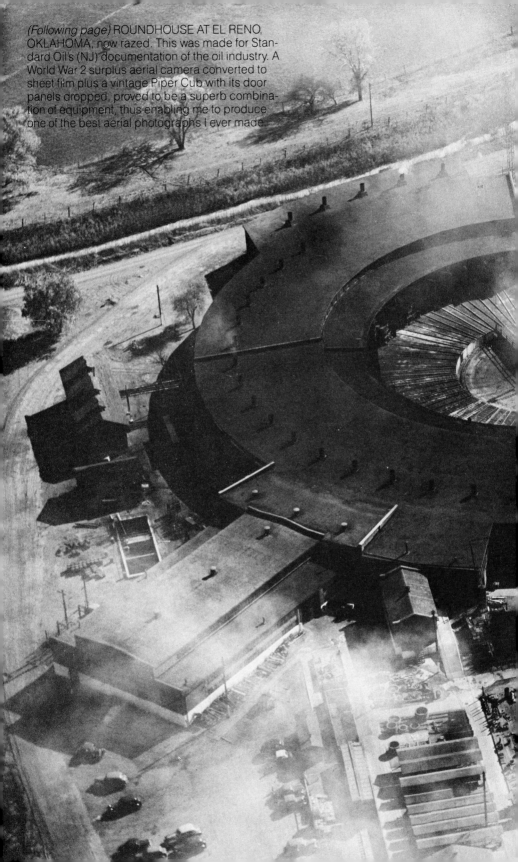

(Following page) ROUNDHOUSE AT EL RENO, OKLAHOMA, now razed. This was made for Standard Oil's (NJ) documentation of the oil industry. A World War 2 surplus aerial camera converted to sheet film plus a vintage Piper Cub with its door panels dropped, proved to be a superb combination of equipment, thus enabling me to produce one of the best aerial photographs I ever made.

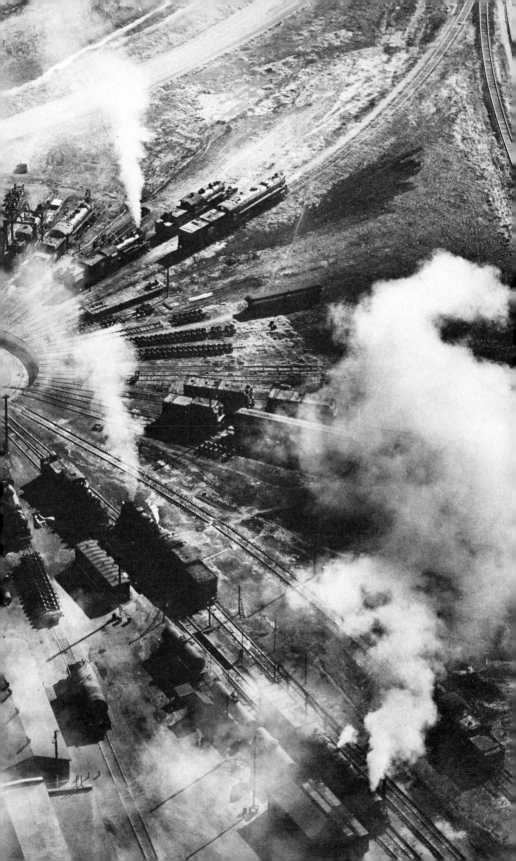

(Above) OIL FIELD "ROUGHNECKS" at work on a drilling platform deep in the Louisiana swamps. A traditional industrial photograph requiring almost as much agility on the part of the photographer as the men on the drilling floor, part of the inherent dangers to the working photographer lies in the surroundings of the job. Greasy floors, flying chains and oil field tools all contribute to the complications of producing useful and dramatic photographs. A twin-lens reflex with sports finder was used.

(Above, right) MIDWIFE ATTENDING A NEWLY BORN CHILD in an isolated Kentucky mountain cabin. As much an industrial photograph as the one of oil workers since it was made for a drug manufacturer's public relations program. It received international attention when *Life* gave it a double spread and it was later syndicated world-wide. While not posing the same dangers to the photographer the oil field tools did, there were other hazards involved in overcoming the hostility of the community to total strangers.

(Right) CONSTRUCTION WORKERS on the interior wall of a new river lock. When faced with dull and routine subject matter it is all too easy to be trapped into making dull and routine photographs. The photographer must be doubly alert to introduce every element of good composition and design that he is capable of offering. While this photograph was made in both black-and-white and color, the black-and-white version is infinitely more interesting because of the stark contrasts of the lock.

PHOTOGRAPHING PARIS FROM THE AIR presented enormous challenges because of the near-paranoid preoccupation by the French authorities over aerial surveillance. Getting through an incredibly tangled bureaucratic web to be permitted to photograph this lovely city at first *seemed* possible, when in fact that privilege is reserved almost exclusively for the French. (And I might add it's not easy for them either). Technically it was simple. All I had to do was smuggle in a British plane, dodge the French radar by flying well under 300 meters, and shoot many exposures while the pilot kept up a running pattern of misinformation with the control tower at Orly airport.

COLOR CONVERSION TO BLACK-AND-WHITE can be done, and done well as this conversion to black-and-white from a Kodachrome made on the Ohio River below Cincinnati will attest. Picture editors are often fearful of a loss of quality in conversions, sometimes rightly so, since each "generation" in the copying process normally increase contrast. Frequently, though, those increases are not noticed since the engraver's screen will diffuse the increases. But when ultimate quality is demanded in a black-and-white conversion from color, the use of the "diapositive" process will retain a maximum amount of gradation in the shadow areas of the original color. In this method a black-and-white internegative is employed in much the same manner as a color internegative is used in making color prints from color reversal materials.

COILS OF COPPER TUBING ready for shipment in a Midwest factory. Compounding the technical problems of producing this photograph for a corporate Annual Report, was the fact that the client permitted no interference in production (and rightly so) while I arranged the lighting. Even though slave-cell operated strobes would have been easier to use, the danger to this equipment in a cluttered factory mandated the use of large banks of flash bulbs. A view camera with an extreme wide-angle lens was used to maintain total sharpness with the large format camera.

(Opposite) THE GEM OF EQUIPMENT (GEM is an acronym for giant earth mover), a monstrous strip-mining shovel located in the Egypt Valley of southeastern Ohio. Part of an investigative reporting story on strip mining for Life magazine, it unfortunately never ran because of Life's initial demise. In order to accentuate the great height and size of the machine, I used a 100° wide angle "Veriwide" 120 roll film camera. This photograph is also a conversion from a color original.

WALL STREET AERIAL photo-
graph. Made from a helicopter
with a custom built "aerial" cam-
era with a fixed-focus "box"
carrying a 47mm Angulon lens
on 4x5 film. By tipping the cam-
era sharply downward I was able
to use the natural distortion inher-
ent in such a wide angle lens to
dramatize the "opening flower
cluster" arrangement of the tall
buildings, and enhance their
soaring aspect. Originally used
in the *New York Times* for a bank
ad, it has sold widely since.

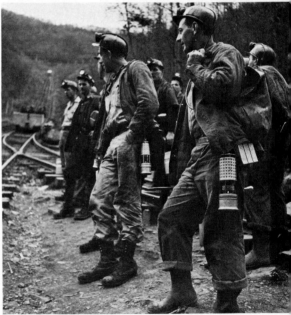

(Above) MAINE COAST DOC-TOR who is flown from remote island to remote island in the winter by the Coast Guard, attends the wife of a lobster fisherman. For feature newspaper use, half the battle is getting out of the location on time.

(Above right) FACTORY WORKER in an aluminum plant in West Virginia. Part of an editorial story on regional economics emphasizing the lifestyles of the workers and their families.

(Right) COAL MINERS SHIFT change in Hazard County, Kentucky. For the photographer, working in dangerous conditions puts a strain on creativity because he is more apt to think about his hide than perfect composition.

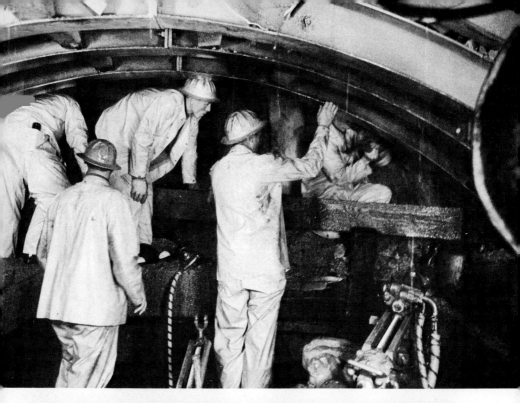

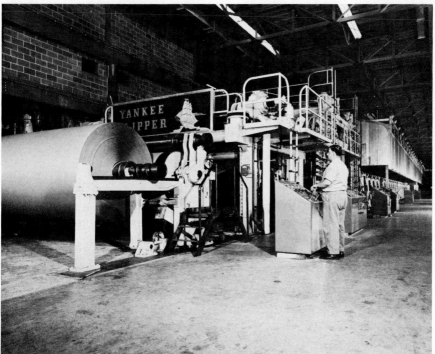

(Above) TUNNEL WORKERS on the Trinity River, Ca. water project. Needed are: waterproof equipment and waterproof photographers.

(Below) BIG LIGHTING/BIG JOBS. Told my client I could not light beyond where it went over the earth's curve. Big bulbs, amen!

FRENCH POLICEMAN AT LES HALLES market (now defunct). Part of an editorial series on policemen around the world, the policeman's gallic charm is evident in his countenance. In travel photography or other similar regional coverages care must be exercised to include enough background material to key the location properly. As a rule releases are not necessary for photographs made abroad but taking the man's name and address and sending him a print will make you his friend. And should a release be required later it will be easy enough to obtain one to properly protect the photographer and the subject. Photographs like this have universal appeal and can be marketed in many ways from brochures for travel agencies to text book publishers, poster-makers and direct editorial users. A 120 rollfilm SLR with interchangeable backs provided black-and-white and color coverages.

CARL MYDANS

Throughout this book I have often referred to that extraordinary time from the early 1930s through the late 1960s as probably the most productive period in the history of photography and photojournalism. No one who has developed any interest in photojournalism can overlook Carl Mydans. Mydans started as a writer, which proved to be a background that has stood him in good stead all through his prolific working career. He became interested in photography as a young man when he acquired his first camera, the traditional Brownie. Like Eisenstaedt, he learned about film development and printing in his home bathroom.

Upon graduation from Boston University's School of Journalism, Mydans free-lanced for the *Boston Post* and the *Boston Globe* newspapers for about a year and then came to New York and got a job with the *American Banker*. It was then that he made what was probably the most momentous purchase of his career: a 35mm Contax with an $f/1.5$ lens, a fine camera and close competitor in its own right of the Leica, which was coming into vogue.

Mydans used his camera for assignments on the paper but didn't stop there; he photographed whenever he could. It was during one of these off-duty periods that he made his first important "journalistic" photograph, a picture of a man haranguing a crowd in front of the stock exchange. The man turned out to be a rather notorious figure who had distinguished himself by getting arrested for throwing a "stink bomb" into a ventilator shaft of the New York Stock Exchange, thus forcing its closing for the first time since World War I. Mydans processed the film in the bathroom of the rooming house where he lived in Brooklyn and then tried to peddle it to the wire services, but he found no interest until he took it around to a competitive weekly called *Time*. An editor took him down to meet associate editor (and picture editor) Dan Longwell, who was becoming increasingly fascinated with the 35mm camera and its potential.

When Longwell learned that Mydans had made this picture with a 35mm camera, he became excited and sat Mydans down and proceeded to talk to him for over an hour. As a result he took Mydans on as a free lancer for *Time* while he still held his job at the *American Banker*.

It was the height of the Depression. Roosevelt was President, and in Washington a photographic group was being put together called the Historical Section of the Resettlement Administration, later to become the Farm Security Administration. The FSA director, Roy Stryker, was also aware of the 35mm camera and sent someone to New York to seek out photographers who could handle this new and fascinating tool. He reached Longwell, who told him about this bright young man named Mydans. The *American Banker* graciously released Mydans to go to Washington to work for the soon-to-become legendary Roy Stryker.

"Stryker," says Mydans, "was one of two men who most influenced my life. He was a teacher of history at Columbia and he brought his profound sense of history to the FSA project." It was at FSA that Mydans was to meet the other man who had an important influence on him, and that was the FSA's art director, Charles Tudor, who moved on ahead of Mydans to become the first art director of the new *Life* magazine. And just as graciously as the *American Banker* released Mydans to join FSA, so did Stryker follow suit and send Mydans back to New York to join the staff of *Life*.

Mydans, one of the pioneers at *Life* before the age of specialization, was assigned to do almost every conceivable type of story that came across the editor's desk. It was during his early years at *Life* that he met a young staff reporter, Shelley Smith, whom he married. They often worked together as a writer-photographer team.

They roamed Europe, the United States and southeast Asia, eventually winding up in the Philippines, where he and Shelley were captured by the Japanese and interned for nearly two years in prison camps in the Philippines and China before they were repatriated to the United States as part of a prisoner-of-war exchange. After repatriation, Mydans was reaccredited to the U.S. Armed Forces and was covering the liberation of Europe when he received a coded tip to return to the Far East to cover the impending landings of MacArthur's forces in the Philippines. Mydans remembers arriving on D-Day-plus-one and following MacArthur through his landing in Luzon, eventually arriving in Japan, where he covered the effects of the bombing of Hiroshima and Nagasaki. Mydans later became Time Inc.'s bureau chief in Tokyo for two years following the end of the war. From Tokyo he covered the first year of the Korean War, eventually returning to the U.S. to continue his career with *Life* until the magazine folded in 1972. But that did not mean he put his cameras away. He and Shelley went to Singapore, where they continued to photograph and write as free lancers before returning home again.

Mydans still maintains his close association with Time Inc., keeping a small office there that is piled high with memorabilia and old and new photographs. He is still working, still photographing and producing, and expects to do so for a long time to come. Thus are legends not only created but maintained, and their work is their monument. Mydans is not content to rest on the "legend" role but continues to pursue an active interest in photography. His door is open to anyone to come in and draw on his experience and observations of the photographic scene.

When asked to assess contemporary photography and photographers, he said, "When I talk about photography, I talk about an 'eye.' I talk about what a person who holds a camera sees through that camera, and I think there is no question that there are just as many young photographers, both men and women, who see fine pictures and create them through the camera now as when

we were their age. But what is confusing about it is that in those days one needed greater skills to use the camera than you need today."

Mydans confirmed the feelings of many of his colleagues that the proliferation of automatic cameras, motor drives and automated exposures is causing photographers to let the camera and its gadgets do their thinking for them. He is concerned that with the proliferation of these cameras and the thousands of photographers using them, combined with a tendency to use color, that the black-and-white photograph may well be on its way to extinction.

He thinks that younger photographers going into the market today are missing a great deal of training by failing to learn how to develop and print black-and-white photographs properly. He feels strongly that even if the contemporary photographer is in a hard-news situation and cannot possibly be expected to process and print, that photographer in order to be better at his job has to know *how* to make those prints so he can demand from the labs the best possible quality that the negatives can deliver.

Mydans concluded by saying, "I think that every young photographer who is serious about becoming a fine professional should start with black-and-white and should start by doing his or her own developing and printing. The photographer should work with his images over and over again until he reaches that point where he knows his cameras and lights so well, is so sure of exposures, that even when he has a meter he should not have to use it, or at least he should be in the position of knowing when a meter has failed or has given a false reading, and proceed to produce superb exposures made with his own expertise."

This is not a throwback to provincialism by a long shot. This is a plea for new photographers to learn their craft well, to understand it well, and be able to extract every bit of feeling and motion that the silver-based image is capable of producing. And only after the basics are understood will it be truly possible for the photographer to work totally successfully in all media, be it color or soon-to-come electronic imaging systems.

CHAPTER 8
AFTER THE ASSIGNMENT

Now that the job has been shot and sent to the lab, what next? How are you going to handle the developed material that will start streaming in soon? What plans have you made for it? Have you established a system for numbering, filing and retrieving? What are you going to do with all the color that's going to come back in little boxes, big boxes, envelopes or paper bags?

There are numerous methods for the initial handling of your raw material as it first comes in. I highly recommend a system that has worked well for over thirty years with very little modification and is permanently expandable to fit a growing file and increasing needs of retrieval and recirculation of pictures.

LOGGING IN EVERY PIECE OF WORK

Primary to the basic system is the establishment of a method of logging in every piece of work that comes in and consigning the paperwork for it to the proper file. Over the years I have established a simple, consecutive numbering system for every job I've done. The following is my procedure for the initial logging in of raw black-and-white or color film.

When a job is assigned, I give it a file or set number and enter it into a log book, which is in the form of a heavy, bound, accounting-type ledger with replaceable pages so the entries can be typed and kept on separate sheets for each year. I then open a job file with that set number in my office and the outside lab I use opens a negative storage file with that same set number. A typical line in the logbook looks something like this:

File #	Date	Location	Client	Subject	B/W or Color & Format
1222	3/31/81	Chicago	Windy City Steel	Annual Report	30-35 32K23EK
					12-120 11-EK6
					12-FP 124-EK (4×5)

When the lab gets the raw black-and-white stock, they develop it and hand-letter edge numbers on every frame in waterproof India ink on the *glossy side* of the film stock (on all work from 120-size upwards) with the *file number and a*

consecutive negative number—e.g., 1222-2, 1222-3, etc. Each 35mm strip is cut into strips of six frames for 8×10 contact sheets. The 120's are also cut to fit the 8×10 contact format. Each strip is marked with the set number and roll number, starting with *M* for 35mm; no letter is used for larger stock, making sure that the factory imprint frame numbers on the 35mm are clear. So a six-frame single strip of 35mm black-and-white should read 1222M-1 plus the factory frame numbers for print ordering.

When the negatives are all developed and edge-marked, I have *two* sets of contact prints made, and every sheet and every frame is correctly numbered and has the number of that photograph assigned permanently. The negatives are then filed at the lab according to their assigned file numbers. As each negative is numbered individually, it is easy for the lab crew to withdraw and return one to its proper jacket for refiling after printing. If a permanent crop on a negative is desired, simply make a contact print if it is a large-format negative or make a small (3×5) enlargement from a 35mm or 120; mark the crops desired in ink on the contact and paste the contact to the jacket permanently, so whoever prints the negative later will have instructions on how you want that picture cropped.

Color is treated in a similar manner. Earlier I spoke of using self-adhesive identifying labels. The numbers on these labels should correspond to your set numbers, that is, the first roll of 35mm color should in this case carry a number of 1222C-1. All Kodachrome is edge-numbered at the manufacturing plant with the month, year and frame number. Most commercial labs have numbering machines for their own mounts, and they also will probably edge-number the slides in the same way. If they do not date them, at least they will number them. If for some reason the house you use does not provide this service (or if you process your own color), you should get a small numbering machine or even a simple movable rubber stamp so that you can number your 35mm transparencies with the same system. Assuming we are dealing with frame #34, your edge mark should read 1222C-1-34. All other color will not be numbered for the moment and if you have received the rolls uncut from the lab, leave them that way so you can retain the edge stickers that should have been transferred to the raw film prior to development. Use this system with negative color too.

At this point you should have all your black-and-white film developed, numbered and contacted and all the color developed and numbered. If this is the system you are using, the same procedures should be followed in numbering either your 35mm work or your larger film sizes. Your subsequent contact sheets should include these numbers as well. The reasons for this basic system thus become clear. In the future when someone wants to know about print #1222-34, you can, in just a few moments and possibly without looking at the photograph, tell when and where it was shot and what the general subject matter is, without having to go through a huge numbered index to chase down the information needed about a specific print.

USING AN OUTSIDE LAB

In my particular organization (Photography for Industry) I never have been a great believer in internal laboratory operations. In New York, where I am based, there have always been a number of first-class custom labs specializing in both black-and-white and color and offering related photo support services such as copying, retouching, quantity printing, etc. The kind of work I do varies widely. Sometimes there will be no lab traffic at all for days and then can come an order for 200 prints, 40 rolls or 20 film packs to be developed. To try to

anticipate this kind of activity would be impossible, so I started with the premise of letting those best equipped to handle expanding and contracting lab services according to demand handle my material and thus free me from that headache.

I am not taking the position that the new photographer should necessarily farm out his processing. On the contrary, most will have no choice but to handle their own black-and-white lab work either because of cost or location problems. Regardless of whether you do or do not operate your own lab, systems have to be developed to best suit your needs as well as those of maintaining an ongoing professional method of operation.

Delivery of your take will vary according to the type of assignment it is. If you are doing an editorial piece for a magazine, the chances are that contact prints and negatives will be all that the editors need to proceed with the story, as most editorial publications do their own picture editing. If you are delivering a color story, editing out the obvious misfires, double exposures, or way-off exposures is about all you need to do for the moment. Some editors at big magazines have in the past insisted that their own staffers do the editing. Yet the two largest of the general news magazines were at direct opposites in approach. *Life* always had a staff to edit the raw film, and very often a story would be closed and on its way to the printing plant before the photographer even arrived back from the assignment. *Life*'s film editors were led by the legendary Peggy Sargeant, who would stand in the darkroom as the film strips came out of the last wash or hung in the drying racks. She carried a railroad conductor's ticket punch in her hand and she would edge-punch each frame she wanted printed with a little code for sizes. By the time the contact prints were made, the story was old hat to her and she already had ordered the enlargements. She had a fabulous eye and rarely missed. *Look*, on the other hand, being a bi-weekly, had more time for their closings and so kept the photographers on tap through the editing and layout stages. These were personal choices of the editors, and each had their own opinions and methods. Remember, though, that these practices were geared to getting news magazines out on time, with little else considered. Many of these theories overlapped and worked their way into other areas of documentary photography. When I worked for Roy Stryker at Esso, I would be in the field for months at a time and never saw my work until long after it was processed. If something went wrong technically, the lab crew would phone me immediately and report to me what they believed to be the problem, such as a shutter sticking or a light leak in the bellows mount. In fact, it was pretty good discipline not to see your work until long after you were back home. You had the chance to do some editing then because your pictures were headed for a file rather than a fast-closing publication.

There have been perennial charges that photographers are their own worst editors, that they cannot judge their own work objectively and that they are too apt to equate the difficulty in obtaining a certain photograph with its ultimate importance to the story. I have never had this problem and believe that this impression was propagated by some of the photographic giants who frequently insisted on total control of their material from cropping to layout selection. But you, as an emerging photographer with a large batch of photographs, will have to do a preliminary edit of the material and get the set in shape so you can present it realistically and cogently for others to make the final selection.

Where do you begin? You begin by going back to your original agreement with the client. What did he expect from you? In what form? Did you discuss prints? How many? What size? Who is going to pay for them? Over the years on

noneditorial assignments I have evolved my own system, which I am passing on to you for acceptance or adaptation.

After getting rid of the blanks, the over- and underexposed pictures, the shots with light flares where you forgot to move a lamp, those you cannot save by cropping, those streaked in development (it happens), assemble the photographs into the sections where they belong. In spite of your instructions to your lab, you may well find that negatives from larger-format cameras have become separated and printed on different contact sheets without consecutive numbers. No matter—simply bring them together for comparison. I assume you've bracketed your exposures, so you must get them together, side by side, for comparison. I'm not talking about news pictures. When something newsworthy is happening, you probably are not going to get much chance to bracket. Eddie Adams certainly couldn't expect a second chance to photograph a Saigon police chief shooting a prisoner a second time. But on a commercial operation where you may even be shooting color and black-and-white with different cameras or with different film, magazines or backs, your final take will result in many exposures of the same situation, and so you must get them together, side by side, for comparison.

Remember that if you are not shooting to a specific layout, and you probably are not in editorial work, try to give the client alternative choices as to whether the pictures are horizontal or vertical and some that can be cropped in any direction. Then boil the "selects" down to an "A" and "B" set, i.e., two or possibly three pictures per situation, depending on whether there are people in the photographs and whether expressions and movements or other factors might make one picture better than its partner.

Treat your color exactly the same way. Lay out your slides on a light table side by side. Examine them with a magnifying glass. Separate them into first and second takes (the "A" and "B" sets) and, if you are lucky, even a third pile ("C") of acceptable transparencies. The same holds true for your roll or sheet color. Lay it out on the table or viewing box and cut the roll film apart or sort the lengths of film uncut. Put temporary numbers on the glassine protectors in red grease pencil, marking them A, B or C to indicate quality. Be sure every transparency has a glassine protector of some sort. The plastic sheets mentioned earlier that will hold 20 35mm cardboard mounts will be fine for the moment, but remember to choose materials that will not cause deterioration over long-term storage.

I raised the question earlier about the projection of 35mm color, but do feel that a few quick projections will not hurt the transparencies, so I often speed things up by running slides through a Carousel projector with a "stack loader" for a quick appraisal of the contents of each box and to weed out the blanks and misfires. After the preliminary weeding out is accomplished, follow the recommended procedure and use light tables or viewers. However, be sure to use color-corrected light sources if you are trying to determine color quality.

PREPARING COLOR FOR DELIVERY

Now you are ready to start numbering the larger-format color. Each transparency should be in a protective sleeve, and here is where a choice of systems has to be made. In most commercial jobs—and this involves both you and your client—it is customary to turn over to the client the first-quality original transparency so he can reproduce from it and in general keep control of it, even though the actual rights he has acquired have been previously spelled out by

contract or other form of agreement. I separate top-quality original transparencies from the rest of the take and usually have either dupes, photocopies or photostats made just for reference so I know what has been turned over to the client and have a record for copyright filing. If your client has a numbering or filing system of his own, you can coordinate yours with his plan. Other clients want me to keep everything because they have neither the room nor the staff to deal with valuable transparencies. In that case I provide an alternate service, but I make a nonreproducible color contact print or machine enlargement of the original so the client can have that for his immediate reference and temporary layout use. Whatever the disposition of the work, that is, giving the originals to the client or keeping them in my files, I mount the transparency and all the other useful "dupes" in the same set, in individual die-cut mounts. I use an 8×10 heavy black paper folder with a die cutout for various standard transparency sizes. These can be purchased in art or photo supply houses, or made to order by paper suppliers.

I mount the transparency in a glassine envelope with a frosted back if available, then tape it inside the folder with double-sided cellophane tape, sealing the ends of the sleeves so they become dust-proof and the cover of the mount will stick tightly, preventing the transparency from being removed without authorization for copying or other uses. On the face I then apply a label with whatever information is appropriate and then am ready to deliver a neatly mounted color transparency that can be easily filed and handled and in general survive a tremendous amount of handling without damage to the original. Some of the mounts I have are 25 years old, and though some of the transparencies have faded, their mounts are intact and ever-protective. I recommend this method highly, and when it is used with a colorful label, editors and picture users over the years will recognize the material as being valuable and carefully packaged, and will give the work better treatment than a bunch of loose transparencies thrown into an envelope and shipped haphazardly.

For handling 35mm color work, I have tried many systems, none of which I am entirely happy with, but I have settled on one method after much trial and error. I file each set of mounted transparencies in small, square, plastic (chemically inert) boxes with file numbers and brief content notes on cover labels. These are stored in shallow steel cabinets such as those used to file blueprints or architect's plans. In this way I can easily locate the box I want and lay out the transparencies I am interested in retrieving and viewing on a light table. Also the work is easily replaced in the boxes and stored. For a while I used Carousel trays for storage and retrieval but these became cumbersome when I had to extract individual slides to go out on approval to an editor. I also had to screen them constantly, a practice now considered unsafe.

Each transparency should have on it the following information:

1. A reference number, regardless of what system you use.
2. Your name, address, telephone number and agency affiliation if any.
3. A proper notice of copyright.

The inclusion of copyright is a "must" that has to be a habitual effort instilled in your own or your contract lab personnel at every level for proper legal protection. Each box of slides should have the set numbers, or if you are using a continuous numbering system in addition to the set and roll numbers as some photographers do, then your opening and closing numbers of each set.

When it comes to numbering the larger-format color, I use a simple consecutive numbering system, which is ultimately cross-indexed and cross-filed according to subject. I do use preprinted caption labels (see samples), but when I

typed up I automatically include a self-carboned 3×5 index card so that all of this information is recorded at one typing. The cards are filed numerically and the pictures by subject according to my classification system. At the same time as the captions are being made up, I start an alphabetical cross-index file by subject so that when a request is received for a certain type of activity or machine or location, the index card will show what jobs covered that subject. The important thing is to start these systems as your work comes in, not five or ten years later when you have two trunks full of unidentified transparencies without the foggiest clue as to what they are, when they were shot, and what restrictions if any apply to them. It is simple enough to do this as you prepare your material for your client as well as for yourself. So do it now.

By this time you have made your preliminary edit, had your negatives or transparencies numbered and possibly captioned, and the contact sheets made. Now what? Again see what your agreement calls for. Prints? Contacts? Original transparencies? My suggestion is that you have a few first-quality 11×14 double-weight prints made of the best of random subjects and a few 8×10 single-weight prints made of others in the set. But make no more than three or four of each size. If you have confidence in your material, you might also think about having a color print or two made, but I generally avoid this step as it is costly and usually the one you order printed is not going to be the one the client will prefer! When you have those sample prints and all the other edited material together, then it is time to get together with your client and either have a showing in his office (if it is no great distance away) or, if necessary, ship them to him by bonded carrier and ask him to call you on receipt so you can discuss them. Eventually you will come to some agreement as to what is ultimately to be printed and then you can order final prints. With some of my larger corporate clients I have also made up contact print books with occasional extra sets for scattered installations through the company empire. These assemblages are made up on preprinted portfolio sheets, bound, and sent to each plant branch headquarters where photographs were shot. Or, as in the case of a major airline assignment, I had several copies of negative color contact print books made up for worldwide distribution so that branch offices could order duplicate color for local printing at later dates.

The important thing now is to deliver your primary effort to your client. Regardless of its ultimate form, there are a few rules of selection that must be observed: (1) quality, (2) uniformity of size or consistency in method of presentation and (3) complete captions and notes, including the date the photographs were made and possibly a written report on your experience in photographing the various locations, with any observations you have made that may be helpful in using the pictures in whatever media is anticipated.

PROTECTING YOUR NEGATIVES, PRINTS AND TRANSPARENCIES

What about the physical objects themselves? A photograph, whether in the form of a print, negative or transparency, is a unique object. When photographs are moved from place to place, change hands and ownership, are worked on, stored or otherwise handled, they can be bent, cracked, lost, have coffee spilled on them, be eaten by insects, covered with mildew, and threatened by a host of other clear and present dangers to their physical wellbeing. How does the photographer protect himself and his property against these and other abuses and misuses?

It starts at the beginning. When a piece of film or a sheet of paper is first unwrapped, extreme care must be exercised in its handling. A film emulsion is fragile and the piece of cellulose or paper it is mounted on is not much tougher. A black-and-white negative, after it has been developed and edge-numbered, should be stored in a chemically inert envelope with a protective paper jacket on which technical information might be noted or a contact print or photocopy affixed that indicates a permanent crop as to how that picture is always to be printed. The negative is then filed according to whatever system is used. That should be the limit of movement for that negative except for travel to and from the enlarger or contact printer. What I am trying to emphasize here is that you should have a policy of *never* letting a negative move beyond your control. It shouldn't be loaned out for printing by any other lab except your own in-house or contract lab. There may be a few instances when a news magazine may call for the loan of a negative for a fast last-minute closing and they need to print it themselves. Decline *unless* a first-class print capable of being copied is available and they understand that if the negative is lost or damaged in any way they will have to assume full responsibility for the cost of making a perfect duplicate negative. Color negative material should be treated much the same way.

Original color transparencies are a different problem. Most quality printers do not like to work from color "dupes" because most of them are not equal in quality to the original. I say most because there are exceptions and there are some labs and technicians who can make superb dupes that in some cases are *better* than the originals. Also, with the news agencies, when there has to be a large and quick distribution of a photograph (such as Sygma Agency's simultaneous distribution of a color photograph of the inauguration of President Reagan by Photographer Michael Evans that ultimately landed on the front cover of fourteen news magazines world-wide.) it would be impossible to use originals, and the dupes used by such news agencies are of sufficient quality for good results.

CAPTIONS AND NOTES

Over the years I have learned that a photograph without proper caption information is a useless photograph. I have already discussed technical methods of keeping track of what is on a roll of film or a box of sheet film—now is the time to make use of those notes. Many journalists who work with 35mm roll-film cameras use their camera frame counters carefully, and if they are lucky enough to be working directly with a reporter, simply calling out the opening and closing frame numbers will be enough for the reporter to keep track of what is being shot. But most young photographers do not have the luxury of having a writer alongside, so they have to do this by themselves, which is why the small pocket notebook and/or the self-adhesive label, big enough to make a few notes on, are important.

When it comes to applying these notes to the photographs, there are various methods available. I have successfully used two systems, and they can be combined if necessary. When a job is finished, edited and ready for presentation, I make a basic caption list showing every roll number and every frame number that is usable, either in black-and-white or in color. On this list I give as detailed a description of what is in the photograph as possible.

My lab (and most others) always writes the actual negative number of each photograph in soft pencil on the back of each print. This will usually withstand

the washing and drying process and will be readable when the print comes back. There are waterproof inks that will adhere to resin-coated papers (ask your photo dealer). For prints going immediately into a file until some later time, this is sufficient for temporary storage. But for prints or other photographs going out to a client or on approval to an editor or for possible sale or to another person for any use, there are some "musts." Again I repeat that you must include the five basic *W*'s of journalism in your captions: (1) who, (2) what, (3) where, (4) when, (5) why. To these basic five I add a few extras. As an example let us take one single photograph from my files and see what it contains and how it would be captioned when I released it for general circulation for book or magazine use. I am choosing one that was part of a set of photographs made on assignment for *Life* magazine in Chicago at O'Hare Airport as part of a larger general aviation story. This particular photograph did not run in the magazine, but because I retained secondary rights to its use I released it to a textbook publisher who was interested in showing the inside of an airport control tower.

WHO OWNS THE WORK YOU DO?

The answer to this question is that, with very specific exceptions, you do. It's that simple. The new copyright act that went into effect on January 1, 1978, clarified a long list of vague issues regarding ownership of assigned (or, for that matter, unassigned) photography.

Up to that date, there was a general rule that, unless otherwise specified, whoever commissioned and paid for the work owned it. No more! The only way the assigning party can own the work you do is if (1) you are an actual employee in the full meaning of the term—that is, receiving payroll deductions, employee benefits, direct supervision by a superior—or (2) if you sign a "work-for-hire" agreement. This is a specific term used by the Copyright Office of the Library of Congress, whereby you agree that you are being employed to make certain photographs or create other graphic art and that for that period or purpose you are employed by whoever is paying you and you are indeed producing "work for hire." It has to be in writing. It can't be an oral agreement, and it can't be implied. Many of the large magazines and publishing houses who employ photographers regularly, even though they may be free lancers or contract people, have them sign work-for-hire agreements to cover the work they are doing, and thus the employer does indeed own the work. Usually these companies recognized the value to the photographer of certain secondary rights and may specify in their agreements with the photographers that certain rights will be returned to them for other noncompetitive uses or put expiration limits on the agreements, in which case ownership reverts back to the photographer. Many of the professional societies such as the ASMP object to this and are protesting, so the subject is under review by a number of publication groups, and efforts are underway to obtain Congressional revision of this clause, thus giving the artist total control of his work.

When it comes to stock photographs, or any photographs made with an oral assignment, the ownership is yours. Even a purchase order from an ad agency that says they own everything but your right arm is not valid unless you sign a work-for-hire agreement. This does not absolve you of your responsibilities for protection of your work. Your photographs must still carry a notice of copyright for fullest protection, although there is nothing to prevent you from granting the use of that copyright to your client for the use that's intended in the assignment.

It was to specifically protect the artist and eliminate the vagueness of most purchase orders and assignment agreements made between free lancers and corporate clients that this terminology was adopted. For the first time in the history of copyright the law seems to favor the artist over the buyer. I said *seems* to favor, because there are still some loopholes in the law that may favor the corporation, which puts an undue burden on the photographer to protect himself. But I will discuss all of this in more depth when we move on to copyright matters in general.

RECORD KEEPING

Record keeping has always been considered a bore, and there are some artists and photographers who may consider themselves above these chores and whenever possible, relegate them to others. Whoever does this work, it must be done accurately and uniformly so that the necessary information can be found as quickly as necessary.

I am not only discussing the routine keeping of records for rent, utilities, depreciation, lab and field photo supplies, personnel and the like. I am also speaking of keeping records of the jobs you do, all of which are the basis for the bills, captions and notes you supply your clients. Where do you keep your release forms? Your caption notes? Even your roll-film stickers after they have been removed from the processed film? Now is the time to apply your office organization system and make it work.

Earlier in this chapter I demonstrated the logging system I use. Now let us take the mythical job #1222. A file has been opened for it and there is a negative file in the lab. What goes in the office file? Everything that has to do with that job. Every note made either in the field or in the office should carry that number; every caption note, airline stub, car-rental receipt, overhead charge slip, receipts for special rentals or costs—*any* paper produced in relation to that job should have that number on it. Each bill or time allocation or other note should be stored in *that* file and nowhere else. Don't forget your copies of model and other releases.

Include names, addresses of people who helped on the job, model agencies in that area—any information you might want to have for the future. The possibilities are truly endless, but when you need facts you will know where to turn to find out anything you need to know about this particular project.

EXPENSE ACCOUNTS

Earlier I spoke of keeping field records and entertainment records. This area, if there is going to be an audit either by the client or by the IRS, will be the zone of most intense concentration and the cause of most headaches. You can no longer be glib, as were the correspondents in World War II who, it seemed, made careers of outsmarting their magazines when it came to accountability for funds. The legendary Bob Landry, one of *Life* magazine's sharpest correspondents who ever flimflammed an editor, after being queried by teletype about how he managed to spend $500 on taxicabs over a certain period when he was in the Pacific Theater on an aircraft carrier, blithely wired back a deadpan explanation: "Big carrier." But that was then. These days, serious documentation is required.

As the business-management people of the major publication groups began to exercise more and more control over the costs of magazine production—and

that included producing photography and writing—the rules for record keeping got tighter and tighter, and photographers and correspondents often found it impossible to account for even the most legitimate of expenses, frequently winding up "eating" a lot of these costs themselves. This naturally led to more and more imaginative thinking, and when the IRS finally began to breathe down the neck of some of the major publication groups, open warfare was declared on the expense account. One major magazine was even forced to appoint someone in the front office to examine the expense records of the executives, not just the low-men-on-the-totem-pole who could, in theory anyway, be controlled by their editors, but the top editors, bureau chiefs, and other high brass who until then had never been questioned about what they spent on behalf of the corporation.

I got caught up in such a situation inadvertently while in Europe. Having performed an unexpected and herculean task for my bureau chief, I was, in gratitude, taken to the most expensive restaurant in Paris for a farewell lunch before returning home. The luncheon somehow grew to include others from the bureau, and my host blithely signed what had to be an astronomical check before pouring me on the boat train. Aside from the monumental hangover the next day I thought nothing more about it until he called me shortly after he came to New York on a vacation.

"Do you know who Jane __ is?" he asked.

I acknowledged I knew of the lady and her function as an executive watchdog.

"Well," my friend went on, "she just called about your farewell lunch and she reminded me that under current IRS rules we had to make notes about what we discussed, if the amount exceeded a certain sum [and did it ever!], so if the IRS questions us we can substantiate that business was indeed discussed. I told her I most certainly remembered the conversation, and said, 'We were talking about you, honey, and saying as we ordered another bottle of wine, wait till Jane gets this one!'"

So, when you take someone to lunch for business entertainment, be sure to watch your IRS P's and Q's and substantiate your paperwork. It may cost you dearly later if you don't.

THE PHOTOGRAPHER AND THE IRS

What about the intangibles that may be counted as money? There are no fringe benefits except those the photographer provides for himself in terms of personal pension and retirement plans. But there are many things that the photographer does or accumulates in the course of his work that could count as income. Photographers who travel on assignment often have the opportunity to go to exotic places and locales they could never afford to visit on their own, and sometimes these assignments can be combined as business and vacation trips. On some trips members of their families can come along, and share the adventure of the trip—or the hazards.

Combining business and pleasure trips may leave you open to IRS scrutiny if you are audited, so you have to be fairly careful about how you keep your records and allocate your costs. If your spouse or companion does indeed perform a valuable service helping you get your pictures, there is a legitimate reason for deducting those expenses proportionately, especially if you operate as a team. I went through a preaudit inquiry once from the IRS and was called in to explain certain deductions. The IRS man said, "According to your records, you showed

a trip to Europe last year and have taken expense deductions that seem considerable. Didn't you spend any time on vacation or pleasure that some of this money can be charged to?" My reply was, "I covered eleven assignments in nine countries in 28 days, drove almost 1,800 miles, flew another 3,000 miles around the Continent, and rushed back to the States for a vacation with my family on an island off the coast of Massachusetts. And I have the papers to prove it, including the hotel bills for my vacation which show the date I arrived." That ended that line of inquiry and there was no further question by the IRS.

I was once asked, "Is experience tax-deductible?" If you shoot on your own with the hope or expectation of selling your work, then certainly costs incurred are tax-deductible expenses in preparing your profit and loss statement.

Earlier I mentioned that in order for a photographer to move any appreciable amounts of stock photography he must have an ongoing supply of fresh material. One way to acquire it is to shoot it either on special trips or for special projects such as books or audio-visual material. Two things become instantly apparent. One, these expenses are tax-deductible, and, two, you have built your file up considerably. A single cross-country trip (by car) for shooting purposes might take a month or six weeks, cost about $3,000 to $4,000 out of pocket, and result in a couple of thousand images. If you sold just 50 reproduction rights in one year at an average sale of $150, you would show a profit of $2,500 on that set alone, and they would still be in your files for future and continuous use. So experience is indeed tax-deductible in this sense and can be profitable, too.

One way to augment the profits from your trip is to line up as much assignment work as you can in advance. Some photographers who travel widely to stock their files have put together a form-and-map letter (see appendix) showing their itinerary and send it out widely to every corporation they can find along the way or to editors they think might be interested in having assignments done at the locations listed. The letter suggests that they take advantage of this photographer's presence in some location of interest to them. If the photographer also gives them the opportunity to pro-rate the expenses of such a trip, it is amazing how many companies seem willing to spend $5,000 on assignments just to save $500 on travel expenses.

When making trips to add to your files, you must put a good deal of thought into the selection of subject matter, and this may take some correspondence or consultation with editors with whom you may already have established communication. If your experience has grown to the point where you are being called for special material, you might consider keeping a log on the calls you get for pictures you couldn't supply at that time and try to fill in your files with these sorts of pictures at some other time, in anticipation of similar requests.

BILLING

What exactly is involved in billing? What do you need in the way of supporting papers? How do you justify the sometimes strange expenses that are frequently lumped under the category of "expense accounts"? Some can be pretty staggering, some very funny, some unreal or unrealistic, some down-right incomprehensible. The stories of strange items charged back, particularly in the editorial world, are legion, and many have spilled over to the corporate side where often there is less understanding of creativity on the part of the artist. And as artists are creative, it follows that some of their expense accounts can be

rather creative as well. Now, when you're ready to prepare your invoices, comes the moment of truth. Your budgets and accounts had better have been accurate! There are too many methods of cross-checking expense reports to leave much leeway anymore for exaggeration and account padding. Receipts are the key to everything these days, and even the Eskimo sled-dog story, variously attributed to writer Gene Fowler and/or an unidentified *Life* photographer, would probably have come under much closer scrutiny today. It seems that the journalist in question was faced with the need to account for several thousand dollars in advanced expense money for a trip to the far North. Even after deducting the vouchers for trains, planes, hotels, car rentals, etc., he was still shy some $500 and was hard pressed to come up with an answer for what really happened to the money. So reportedly the following items went into his expense account:

Rental of dogsled, driver and dogs $300
Food for sled dogs (100 lb. chopped walrus meat at $1.00 per lb.) 100
Replacement of sled dog killed in accident 50
Flowers for the bereaved bitch 50
Total $500

He got away with it then, but today the accounting department would have told him that the sled probably had a charge-plate machine fastened to it, and the driver a stack of preprinted dogsled rental forms, without which they wouldn't approve the expense account.

So be sure you get and retain, whenever possible, some sort of validation for whatever expense you wish to recover for plane tickets and other travel expenses, hotel bills, car-rental receipts, ticket stubs, receipts for props, model hire, etc. Whatever is necessary for the job and the travel involved, you had better have some paper to justify it— or at least keep those unreceipted charges under $25, because that is what the IRS will allow in unreceipted expenses for entertainment or meals or similar costs.

When it comes to billing these items, as you may be audited in the future and may need those papers, the accepted practice (unless otherwise specified by your particular client) is to photocopy the originals and attach the *copies* to your bills, keeping the originals for your files. Check your client's own procedure on this, as it can vary from company to company. Items on the invoices should be listed carefully within the lump sums for each part of the costs on the main invoice, with the supporting papers attached. These papers should give the details of the charges so that the client is not faced with the chore of going through a long list of small items and can approve the bill in general, allowing the people in the accounting department to verify the details of the individual items. The chances are that your bill will be processed a lot faster that way because most executives will be interested only in the general aspects of the invoice, preferring to allow the finance people to check the accuracy of your columns and charges. The fees and enumerating of field expenses can be a cut-and-dried operation, with the exception of entertainment or other unusual charges, and should pose no real problem so long as you stay with the restrictions of your agreements.

There is, however, one gray area that should be discussed here. Billing for materials, processing, printing and other lab services. Until recently, before the wild surge in film costs due to soaring silver prices, there never seemed to be any argument about the cost of materials. I have always had the policy, and still do, that even though I am not in the photographic supply business I am often called upon to leave town on short notice with large amounts of film and other

prepurchased supplies. And if this happens on a weekend or holiday, getting your hands on the material you need in a hurry may be a problem. So what I have always done is to purchase large quantities of film and other materials in advance and keep them in a deep freeze.

Of course, when I buy in large quantities, I purchase at so-called "wholesale" prices that are considerably less than the retail value of each roll or box of film or other item, and when I bill for these items, I always charge the regular retail list prices. Why? For several reasons, the primary one being that I am always getting stuck with expired film and unreturnable items (although some dealers will take back unused film) and, more importantly today, I have to tie up large amounts of money in film and supply inventory. Therefore I use the differential between wholesale and list price as a means of covering these losses and have never had much of a problem in justifying such charges. However, this is suddenly changing, and some purchasing agents are trying to insist that when I bill for film and materials I must send along receipts. I have refused to do so, openly citing the reason there is a difference in what I am charging and what I paid for the material. Neither would I send an invoice covering my purchase of 500 rolls when I may have used only 50 on a job. I hit a major standoff with one company on this issue that was finally resolved when I refused to supply any material at all, telling the purchasing agent to go out and buy his own film and supply me with it. The problem has persisted, however, so I always make it a point to explain to my clients in advance so there will be no delay in payment.

There are discount houses that will take a roll of color film and process it far more cheaply than the quality custom lab, but I don't use them (nor should you) because there is no control over the way the material is handled and no vouching for the professional capability of some outside lab about which I know little. Furthermore, because I am forced to establish credit lines and maintain accounts with various processing plants and labs, I have to put a percentage markup on the outside lab work, in view of the fact that I still have to assume all the inherent business problems.

This practice should apply as well to the photographer who does his own lab work, whether it is black-and-white or color. All of this takes time and costs money, and so must be built into the cost of a job. How do you assess what to charge a client for developing a roll of film or making a set of contacts or enlargements? The answer is to charge what the professional houses *in your region* are charging (because of possible labor differentials), and you should charge about the same, *plus* a markup for handling, because in this case you have the costs of maintaining a lab. How much of a markup do you put on these services? That's up to you. There are some nonphotographic guidelines I could offer but these are only suggestions you must assess for yourself. Taking the wholesale versus retail film variable, it would appear that a 25 percent markup would be reasonable. You the photographer/businessman have to make that markup decision. But do not ignore it, unless you are so wealthy that money means nothing to you. Otherwise you cannot stay alive professionally.

INTERVIEW
JILL FREEDMAN

While many photographers started in traditional ways by attending art or photography schools, getting a job as an assistant to another photographer, or chasing fire engines and police cars for small-town publications, there are others who chose more unconventional methods. Jill Freedman is a young woman with a huge talent, self-taught, who in a few years has published four books and numerous editorial pieces and approaches photography with an awesome dedication and passion.

She made her first professional photograph when she was about 26, several years after graduating as a major in sociology from the University of Pittsburgh. She told me, "I found out when my last final was, and then got the first ship leaving the country. I was away for three and a half years." She went to Israel, continental Europe, and also lived in London for a few years. When she ran out of money in Israel she became a nightclub singer, but after a while felt that even her singing was becoming "work." She packed that in, came home to the U.S. and got temporary work until she figured out what she wanted to do.

One morning she woke up and decided she wanted a camera. "I had never taken any pictures before," she said. "It came out of nowhere, but I got hold of a camera and went right out on the street and shot two rolls of film. I had them developed, I looked at them, and said, 'That's it. I'm a photographer.'

"Everyone laughed, but that was it. It was the only thing I really wanted to do. I had a total maniacal passion right from the beginning. I still feel that passion. Photography is a total obsession with me, and even though everyone I knew thought I was crazy, I knew better. I then began looking around for some means of earning a living, and it seemed that advertising copywriting was something I could take seriously. I asked friends which was the best ad agency in town, made up some 'campaigns' for their accounts, took them around and was hired immediately. So for the next two years every time I got paid I invested part of that salary in darkroom and other equipment.

"Only then did I start to teach myself something about photography. I didn't want to be anyone's assistant. I didn't want to be influenced by anyone. I

learned the technical things by reading. I got hold of some inexpensive Eastman Kodak 'how-to' manuals and a few other books on technique. I went around to the Museum of Modern Art and studied Eugene Smith's prints. I went through a lot of work and looked at a lot of material—not only photographs, but paintings, sculpture, films and such.

"After I had been shooting (and at the agency) for about a year or so, I went to London, made some pictures, brought them back and had my first show at a small gallery that was part of a photo laboratory. The day that show opened, I went to the copy chief at my agency and told him, 'I quit. From now on I am a photographer.'"

The murder of Martin Luther King had an enormous emotional impact on Freedman and she immersed herself in the civil rights movement as a photographer. After an unsuccessful attempt to get an assignment from a magazine, she joined the Poor People's March on Washington anyway and marched along with hundreds of others, slept in the mud when she had to and documented the trials, pathos and the spirit of "Resurrection City" for the next six weeks.

Still without an assignment, she ran into *Life* reporter John Neary, who after seeing her early contact sheets convinced her to let him take the rest of her undeveloped raw film back to the *Life* lab. Thus she made her first important sale when five pictures were picked up by *Life* magazine. This was her first important editorial breakthrough.

Freedman went on to say, "I was never good at hustling for editorial work, which you have to be and it was always touch-and-go with me. I always took it personally, which you are not supposed to do."

In 1971 her first book, *Old News—Resurrection City,* was published by Grossman Publishers, and Freedman decided that photographic books were the course she wanted to follow professionally. Four years later, in 1974, *Circus Days* was published by Harmony Press (Crown), though much happened between publication dates.

She knew that if she could not get advance backing on *Resurrection City,* it was equally unlikely she could do so with *Circus Days.* No publisher seemed willing to put up enough money for her to devote the time she felt necessary to such a production. Result? She hoarded her small income from odd jobs and the meager advance on *Resurrection City,* borrowed a van from a friend and spent the next four years photographing and honing *Circus Days* to as close to perfection as she could. The fine book that emerged attests to this devotion and care and, more importantly firmly established her reputation and craftsmanship.

Her third book, *Firehouse* (1978, Doubleday), was presold and prepared in cooperation with Dennis Smith, a fireman-turned-author, who lent his expertise in describing the life of firefighters in the form of a brief text. By then she realized her need for a literary agent and secured one. Her current book, *Street Cops,* published in 1982 by Hrper & Row, was also presold, but with her reputation clearly established, she was able to command an advance big enough to allow her to spend the time that this book demanded.

She told me that perhaps she is her own worst enemy because of her passionate desire for perfection and her reactions to rejection or criticism. But this is the only way in which she can work freely. She chooses her own subjects and works on them at her own pace, refining and re-refining the finished product to her standards, although she does not ignore the feelings and the advice of her editors or publishers.

Freedman functions simply enough. She usually gets an idea of what she wants to do and doesn't wait until someone tells her what he wants. Each

project thus becomes a labor of love. She shot the pictures for the circus book in seven weeks of one-night stands, but it took her four years to edit, print and prepare the final manuscript. This is typical, and while it may not presage great earnings, it is the way she likes to work, and she feels happiest and most productive in this framework. *Street Cops* took almost a year and a half to shoot and a total of four years for preparation, including the writing. As for her methods of preparation and work ideas, she says she usually works in one of two ways, and as far as book projects are concerned, she had to learn the hard way. The first two books were sold solely on the merits of the pictures. She had not made an organized plan for the book but badgered publishers with boxes upon boxes of pictures. As she grew more experienced, she realized the necessity of "dummies" or at least some clear plans, for without careful presentation, selling was hard indeed. She feels that most editors are word oriented rather than picture conscious and finds it is important to present them with some visual plan that can be readily understood.

The other method of work she loves is to simply wander around and shoot pictures at random and, as she puts it, "just make pictures." She shoots almost subconsciously and it might take her years before she realizes what concept is germinating in her mind. It is not until after hundreds and hundreds of random photographs are made that Freedman begins to get the idea of what her subconscious is telling her, and a plan then evolves.

Now that she has had her fourth book published and has finished the printing for a major retrospective show at a fine-arts photo gallery, she says she wants to go out and do straight assignment work, which is her first love, since she considers herself a photojournalist at heart. But assignments are not that easy to come by, and she still has to self-generate ideas and present them visually before they can evolve into either book projects or editorial material. She works with a concentration that borders on obsession and says all she really wants to do is shoot pictures.

One strong emotional prop is her intense belief in herself as a fine photographer. She says she really doesn't pay too much attention to the opinions of others about her work. She has confidence that her work is very good and in satisfying her own creative demands knows that eventually this quality will establish itself in the minds of enough editors to assign work to her.

In her own down-to-earth style, she says, "I think things have worked out well for me. The one thing I have always had going for me from the very beginning is the feeling that if no one else liked my pictures it wouldn't have mattered because they knock me out! And if someone didn't like my pictures, it told me that they weren't very smart. And now as I look at them I realize I am doing exactly what I want to do—and I'll never complain about it again, even if I have to become double-jointed and kick myself in the tail to straighten out my thinking."

She has one personal rule: never to photograph anyone who doesn't want to be photographed, except in a hard-news situation beyond her control. She has an exceptional respect for craftsmanship, though she personally is ambivalent about darkroom work, and told me of once having gone to a show and seen a print that needed spotting. She walked out because she felt the photographer had no respect for his craft. This is Freedman's way of demanding the professionalism that is so earnestly desired by photographers and editors.

CHAPTER 9
SECONDARY USES OF PHOTOGRAPHS

There is nothing in the business side of photography that will raise more hackles than secondary uses of photographs that were never intended to be made or paid for accordingly. Therefore it is extremely important to come to full agreement with the client *before you shoot* as to exactly what purposes the photographs were made, what options (if any) for secondary use you grant, and what rights are being sold. When you submit your bill it is of the utmost importance to spell out in the invoice exactly what rights you are granting and that you insert the clause "© (year), (name) All other rights reserved." (This will even protect your work against uses by methods or processes that haven't been invented yet.) If you do this, there will be fewer misunderstandings about what you are charging for and what uses the client may make of these photographs.

The change in the copyright law was a milestone in clarifying the secondary use situation. There is a good market for secondary uses of photographs by the photographer under certain conditions. The first condition is that the photographer must organize his material in such a manner as to make it accessible to publishers or other users of photography on demand. Another important point is to remind the client, as previously noted, that you are free to use the pictures for other noncompetitive purposes but will continue to protect his interests. Also, when photographs are purchased for a specific purpose and the photographer "reserves all other rights" the only question left is what to charge for those secondary rights.

The matter of rights to photographs made on assignment for advertising poses different problems. I am concerned now with photography of products or services. As a rule, these pictures have little secondary publication value except for other trade advertising done by the company that originally commissioned the photographs. Also by custom most advertising fees charged are, in comparison to editorial payments for the same type of space, considerably higher—usually three to four times as much—and rightfully so because the buyer is usually buying all the rights to the photographs and has the option of using them as he wishes in on-going advertising. This attitude is now changing to

196

some extent. Photographers are becoming more and more reluctant to give unlimited, open-ended rights to a photograph at any price, and photographers usually limit use by building into agreements a cut off point as to how long a picture may be used, or the number of insertions in a publication or series of publications the ad may run. This feeling of limitation has come about by the experience that befell many of the old movie actors who, in all innocence, sold their rights to the film producers without reservation, because in those days there was no television or any other foreseeable second use of old films. In later years, when television became a huge consumer of motion pictures, the actors who were still alive (or their estates) found that they got absolutely nothing from the enormous sales of these broadcast rights by the film companies to the broadcast groups.

This began happening in advertising photography as well. Advertising photographs were made on assignment and some of them became classics and were used over and over again with seemingly no limits on their use. Also pictures have had a funny way of turning up in unusual places. One photograph I know of was shot for an airline calendar some years back, and suddenly turned up as a poster, then later as a jig-saw puzzle. There are cases where models have sued advertisers for using pictures in other media and for other purposes than their model releases called for, or even implied. (See "releases.")

Recalling the philosophy, discussed earlier, that an artist should share in the fruits of his own endeavors, advertising photographers are beginning to spell out very carefully how long a photograph or set of photographs is to be used in advertising, and what remuneration is to be expected from additional usages over and beyond the primary intentions of the advertiser. The advertising photographer is learning to say that he will not automatically grant all usage for photographs or other graphic art for purposes which may not even have been invented yet, i.e., electronic or satellite transmissions, and other modes of image reproduction to come.

The retention of secondary rights by advertising photographs has grown to such proportions that just a few years ago a major stock picture agency was formed by a number of these leading advertising and editorial photographers for the main purpose of exploiting the secondary market in advertising photography.

This group, composed of many of the so-called "stars" in the business, concentrating on the advertising market and some of the very highest paid editorial markets as well, has been so successful that it has opened several branches both in this country and abroad. This could not have happened if the member-photographers had not retained secondary rights to many of the advertising photographs they originally produced on assignment.

So the retention of secondary rights to photographs, even advertising pictures made specifically for one client of one product or service, has become a growing and lucrative market for the photographer, and he is finally learning to protect these rights.

BUILDING A FILE

Building a photo file is almost like digging a well—you have to start at the top rather than the bottom. In other words, you must have worked regularly to have established a decent backlog of photographs that are then worth trying to market. With just a handful of pictures on hand, the potential return is quite limited and it is not until you can either develop a specialization in one or more

subjects, or amass a group of specializations within a general category, that these collections can begin to pay off.

Suppose you have been working in a specific area for a year or two and by now feel you have enough pictures (and the secondary rights) to start marketing them. How do you go about it? There are essentially only two directions to take. One is by setting up a photo library, file, or collection (whatever you wish to call it), getting it publicized, and starting to market it in some organized way, either through personal sales efforts (yourself or with salespeople), direct mail, or simply through listings in appropriate reference sources. Or, you can sign with a good stock picture agency and let them do the marketing of secondary rights—or for that matter, of original rights, if you have shot pictures for some reason other than assignments. I will discuss both in detail, starting with the independent operation.

SETTING UP A STOCK FILE SYSTEM

The first step is to set up a classification and filing system that will not only cover all bases at present, but be ever expandable so that as you grow professionally, your file will grow with you, and you won't be faced with the problem of being unable to find something you shot two or three, or even ten or twenty years back.

I spoke also with Joe Barnell, a fine photographer of 30 years' standing with a long and successful client list of blue chip corporations, who is now a principal in Shostal Associates, Inc. Shostal Associates, Inc. is a well-established and respected stock picture agency that deals only in color for a variety of outlets. Barnell reminded me of a particular photographer in his group who started out with an independent file and established a beautifully correct system that worked fine—for him. He understood it and knew where the pictures were and how to find them. What he failed to do was establish a system that someone else could operate when he went off on assignment or was otherwise unavailable. Result? Utter chaos and the loss of major sales. A reminder: Publication groups that need pictures from outside sources seem to have a habit of waiting for the last minute before contacting a picture file, and then they have rigid deadlines, so if a picture cannot be located and shipped almost immediately, the sale will be lost. It follows, then, that a simple, workable system that is almost self-explanatory has to be developed. When it comes to classifying and cataloging photographs, this can become complicated.

I started my system many years ago, basing it on a system that was used in a government photo library, adapted by one of the major oil companies, and after much trial and error it has evolved into what I now use. Basically it breaks down into two principal headings: 1) Geographical locations, and 2) Specific subjects, irrespective of location. Thus, my master file has a section for every state in the Union, and every one of twenty-six countries I have photographed. I also have a subject file that now, in addition to the States and countries listed, covers some eighty specific subjects, industries, and processes.

I have also established a simultaneous alphabetical cross-index card file which will combine and reflect all categories as much as possible.

As my business grew after World War II, so did its picture file. The first major coverage I did happened to be in the steel industry. So, when I started my file, the first classifying letter, *A*, was given to this industry. Then, as I continued to work and photographed a great variety of subjects, I simply added letters of the alphabet for each category until I ran out of letters. Then I

continued with a double-letter system beginning with *AA*. This can, theoretically, go on forever.

Eventually the file began to take shape and, as my business expanded and became more specific within the *A* (steel) group, I broke that letter down into more specific categories.

 A-1: Mills and furnaces, exteriors
 A-2: Mills and furnaces, interiors
 A-3: Fabricating
 A-4: Marketing
 A-5: Aerials
 A-6: Transportation

I mentioned earlier that whenever I send raw film out for processing, I always order two sets of contact prints. The reason for this is that if a particular steel mill is in Ohio, one of those contact sheets goes in the Ohio State file (1-Locations), and the other into the *A* file for "Steel" (2) including the number of the subclassification. In addition, each photograph (as indicated previously) has already been numbered by set and negative number or color number, and these numbers, too, fit neatly into the system. Color is not duplicated but is simply cross-referenced on the file jacket as to where the primary subject of importance in the picture is. So an aerial photograph of a steel mill in Cleveland might be filed under the A-5 classification, and on the jacket of the Ohio State file would be a notation that steel mills in Ohio would be found under A-5. Where the photographs are a broad coverage of one specific company, one extra set of contacts is made which goes into the job file.

Earlier I mentioned that part of writing a caption was to include a snap-out carbon index card which carries all the vital information for that picture. That card also shows the negative or color number and the file location. This system is basic to any format I use: color, black-and-white, contacts, or enlargements.

There are many other systems, and any system that works, is expandable, and simple to follow is a good one, but you must have one if you are going to function successfully in the secondary rights area of photography.

It has been my policy never to make enlargements of photographs on speculation or for file purposes only, as it is almost impossible to predict who will want what photograph in what size, or when. Over the years I have, however, accumulated a large group of enlargements made on request and returned after publication, which I keep purely as reference material, because by the time they come back to me they are often well-worn. I file those prints using the same system, and occasionally if someone needs an enlargement in a hurry and the quality of one on hand is reasonably good, I can save time and money for my client by releasing one of those prints.

PICTURE RETRIEVAL

Retrieval of pictures from such a system as this is easy enough once it is understood, but with the sizeable growth of picture collections, some of them consisting of millions of pictures, there has been a sustained search for a modern computer-operated retrieval system. Several stock picture agencies now use computers for logging, billing, and tracking down pictures once they have been sent to a client, but there is no existing electronic system I am aware of as yet that can make a judgment about a picture, pull it from the files, and get it to the client. There have been some spectacular developments made in computerized

storage and retrieval of images, and in some experimental models of laser/disc/videotape systems, well over 100,000 color images per disc can be stored and retrieved rapidly. Another system involves the transfer of images to videotape, a system already in use for making television commercials, and this too shows a remarkable potential. In both systems the images recovered are beautifully reproduced on a monitor screen, but so far there is no reproducible "hard copy" availability, though developers of this equipment anticipate the development of this capability shortly. By "hard copy" I mean an image that can go to an engraver for reproduction. A second and serious drawback to both systems is the high unit cost of getting a single image into the system. It is hoped that before long this problem will be solved, but in the meantime, the photographer will have to learn how to find a set of photographs, screen them down to working size and get them to the client.

STOCK SALES: GETTING STARTED

How does the beginning photographer who is operating independently start selling his pictures? The consensus of many of the stock picture agency people I spoke to is that it will probably require a combination of many efforts on the part of the photographer to get started as a stock photo source, the principal one being specialization.

The first job is to select the market area of concentration, and the various guide books mentioned in Chapter II will be a good starting place to locate the publishers or outlets you are interested in reaching. Next comes the preparation of lists of available material, but remember previous comments on how ineffective some lists are for a picture buyer, due to vagueness and lack of specific information. Then you have to consider the publication of a booklet, or brochure, or mailing piece showing your picture file to the best advantage you can afford, and what you can do and offer photographically to an editor or publisher. This can be accomplished in large part by mail and perhaps a few strategic phone calls.

Do not by any means ignore the local level. Exploit every method you can by getting exhibits in such diverse places as a local library, chamber of commerce or tourist and visitors bureau. Somehow neighborhood banks seem to be a good place for exhibits of this type. Don't overlook community centers, school and college buildings, libraries and any other place where there is bound to be a fair number of passersby. Ad agencies frequently have exhibition space available through their art departments. Press clubs are a fine opportunity for exposure, also. Most of the clubs in the United States at least, as well as many of the foreign clubs, have exhibit areas, *need* pictures for exhibition on an on-going basis, and provide an excellent audience.

It is obvious that the more people who see your work, the more will know about you as a source of photographs. Many viewers may be working in the publishing field on books, newspapers, or magazines or in ancillary industries such as printing and related services. Touch base with all local commercial art studios, as they may be designing publications and ads for advertising media and might be able to use your photographs from stock.

Getting yourself listed as a source of materials is essential and easy. Virtually all the publications in Chapter II carry free listings, plus paid space ads are made available for the kind of services you offer in the way of picture files and new photography. Take advantage of the availability of such promotional listings. And if you think you can afford it, consider paid space ads in other trade

publications in the graphics field. But once you have accomplished all of these tasks, should you sit back and wait for people pounding on your door? Not unless you are wealthy and don't need the money. Running a picture file is a continuous operation. Not only do you have to maintain communications with actual or potential clients, but your file must keep growing and be constantly updated. This is true whether you operate as an independent photographer or work through an agency. Only in this way will the picture users learn that your material is fresh and up-to-date and will keep them coming back for more. Sometimes it doesn't seem to make sense; you may think you have covered a subject thoroughly and sit back thinking there is no need for more, but it doesn't always work that way. Even though a machine or process in some industrial location is designed to last twenty years or more, you won't be able to move 20-year-old photographs of it unless it doesn't exist any more and thus the picture is important for its historical value.

I know of one situation involving pictures of Grand Coulee, the huge dam built during the 1930s, and covered extensively by a photographer in 1969. He kept moving those pictures for years until, much to his chagrin, he discovered that there had been extensive renovations of the structure after he had made his photographs, so his pictures had become out-of-date. The only way he can move them now, is to tell his client when these pictures were made. He tells his clients that there have been changes though it may well be that these changes are not important to the users. They should still be made aware of them.

I have lost several sales because the date on the caption label indicated when the picture was made without regard to the continuing validity of the picture. One picture editor suggested that I remove the dates from the pictures, as apparently that is what some agencies she deals with have done. Why not indeed? I thought. But I finally decided against it, as it would have ended copyright protection, which requires that the picture be marked with the year it was "offered for publication or first produced for publication." The loss of copyright protection is greater than the loss of an occasional specific sale. It wouldn't be fair to an editor to let him have a picture that you know is out-of-date even if he doesn't know this.

GETTING THE MAXIMUM MILEAGE OUT OF A PHOTOGRAPH

Published photographs seem to improve with age and become more valuable long before they fall into the classification of historical photographs. Earlier I suggested that there was a trend in textbook publishing toward more exclusivity in photographs, but I pointed out that it is only a *trend* so far. There is still a lot of "safe" picture use, so that the more a picture is published, the more that particular photo is seen and the more people remember it and ask for it. Consequently, it is worth more. So it follows that efforts should be made to perpetuate certain pictures in your collection for repeat business, and thus the photographer running a stock picture file must learn to avoid the trap of being talked into lowering the price because the picture has been used several times. In the case of original color, if the transparency is lost or damaged whoever loses it cannot take the position that it is "worn" from use and therefore has a lower value.

How do you push one photograph over another? At the outset, the photograph in any set that attracts the most attention will also probably be the best one you have in that coverage. If that photograph is published, and you can get your hands on a sizable number of tear sheets, those printed sheets can become not only a mailing piece for you but can effectively draw attention to that

particular image. By limiting the choices of pictures in the group you show, you increase the statistical chances of a particular photograph being reused.

REPRESENTATIVES AND REPRESENTATION

What's a "rep"? Do you need one? *Rep* is simply an abbreviation for "artist's representative" or personal sales agent. The rep is your paid emissary who will present you to your market, fight for you with the agency art directors, and in general try to get you work. This is usually done for 25 percent of your fees, although commissions can vary. Reps work in advertising or illustration fields for the most part, but occasionally they will sell an editorial piece or annual report or book, although the highest-paying accounts are in advertising photography. Studio operations generally keep the photographer confined, so having a rep is often the only way he can get work in the advertising world. Good reps have generally built up clienteles of their own among art directors (ADs) in whatever field of specialty in which they have had experience, including still life, illustration, food, fashion or even television and audio-visual programming. Most reps are independent business people themselves, although often when they are working for a very busy and successful photographer, they can be principals in the business and thus draw percentages of the profit rather than a commission. One rep told us that a bad rep is worse than no rep. Unfortunately there seem to be more good photographers around than there are good reps, so it is a buyer's market. Finding a good one can be a tricky and time-consuming experience but, in general, if your market is in the advertising/studio/still life/fashion worlds, it will probably be best for you to sign an agent or a rep.

But supposing, experienced or not, you want a rep, how do you go about getting one? That's not easy because, as mentioned earlier, there seem to be too many photographers and not enough good reps for a limited market. SPAR (P.O. Box 845, F.D.R. Station, New York, NY 10022) will do two things: they will publish your name and specialty in their publication program, indicating that you are searching for a rep, and, for five dollars and a stamped self-addressed envelope, they will send you a list of their members whom you can contact directly by letter or mailers or by phone to see if you can work out a meeting of the minds.

Four other principal directories also carry rep listings: *American Showcase,* the *ASMP Book* (telephone numbers only, no addresses), the *L.A. Work Book* and the *Art Directors Index.* The rest is accomplished by word of mouth or sometimes means finding someone who will not be totally dependent on immediate income from sales. Someone well-to-do with the personality, time and drive to get into the field is ideal to take on the job and try to make something of it, for both of you.

CONTRACTS: PHOTOGRAPHER AND REP

Most agreements between reps and photographers are cemented by formal contracts, although there are many who pride themselves on working strictly on handshake agreements. It is wisest to agree on all terms in writing before the association begins. Of prime importance to any agreement is a thorough understanding of all the problem areas involved in repping—where the troublesome parts may be and how the commissions are determined, as the percentages can vary widely. Generally, these problems can be broken down into the following categories:

1. *Identification of accounts*: "House accounts" are usually identified as those clients the photographer already had before the association with the rep began. Most photographers do not like to pay commissions on their house accounts unless the rep takes over and services them fully and continues to bring in new work. If this occurs, the commission is usually about half-what newly acquired work would bring in from an account the photographer did not previously have. Further, if the photographer has already been doing editorial work, has built a reputation in that field, and the rep takes over, it usually means a lower commission because the pay scales for editorial work are considerably less than advertising rates. Normally the advertising photographer who continues to do editorial work does so primarily for publicity from credit lines rather than the fees *per se*, so even new editorial accounts brought in by the rep are generally considered house accounts. Commissions should be paid even though some photographers feel that editorial work is all theirs, because if maintaining editorial accounts requires help from the rep, there should be no hesitation about paying for this service. Also, as some reps get a percentage of the total business in the studio, the editorial work cannot be ignored when it comes to totaling annual activity.

"New work" is all the new business that the rep brings in. It should include reactivated old accounts that have been dormant for some time. If an old account has been dormant for at least a year and the rep succeeds in selling them on new activity, a full "new-work" commission should be paid, but the actual period of dormancy must be determined as a result of negotiation between you and your rep.

2. *Termination*: For whatever reason a contract with a rep is ended, it is generally accepted that a rep will continue to receive residual commissions for at least six months after termination of the agreement. With negotiation, this period may be extended and has in some cases been extended for as long as two years. This is probably one of the most sensitive areas of disagreement and should be clearly spelled out in the contract. The terms and conditions may vary widely, especially if the rep has invested money in the operation. The rep under this condition may have to be considered as a full or limited partner. Usually thirty days' notice is required to cancel an agreement, and procedures for clearing up all accounts must be worked out in advance.

3. *Billings*: Normally the photographer does the billing in agreement with the rep, although occasionally the rep does the billing, especially if he or she is older and more established than the photographer. Here too are the seeds of discontent if either party feels that the other is "holding out" on payment of commissions or fees. In book publishing it is often the practice for the agent to do the billing, and many authors are equally unhappy over this arrangement for the same reasons. Only mutual trust permits these problems to be worked out equitably. In my office I provide the rep, agent, or photographer, if I have sold the work of another, an exact copy of the invoice as it goes to the client with every pertinent fact on it—dates, P.O. numbers, terms, etc. It is my policy to pay all commissions within five days after the client's check clears, unless there is some dispute over the amount received that may affect the rep's commission. When this occasionally happens, the rep is paid when the matter is settled. If the sum is sizable, the contract may call for the funds to be deposited in escrow until ajudication.

4. *Expenses*: As a rule, expenses are not commissionable and care must be taken to properly account for expenses "off the top" if the job is billed on a

flat-fee basis. "Off the top" means that all chargeable expenses are deducted before any commissions are paid.

5. *Other charges*: What happens when a rep sells a stock picture from your files for an ad or for possible inclusion in the layout of a new shooting? This may be resolved by simply deducting a flat 10 percent off the top of the billing to recover only partial reimbursement for the overhead of maintaining a stock file. Promotion and advertising costs must be looked at realistically, and probably the best way is to assess and share these costs on the same percentages as the fees are based. They must be discussed by the photographer and rep to determine what kind of promotion and/or advertising are needed, and whether these efforts are affordable, before such programs are initiated.

6. *The written agreement*: Most photographers and their reps operate as independent contractors and the agreements between the two should spell this out clearly so that there is no misunderstanding of the respective roles. In this way, both the photographer and the rep are protected against the actions of the other. As there will be taxes, insurance and IRS procedures to be dealt with, it is important that this independent contractor status be described in detail in writing. There are a number of so-called standard agreements, but I have never seen one that was uniformly acceptable to all parties without negotiation. I suggest that you get copies of representative agreements from SPAR, PACA or ASMP, compare them, make notes on where there are differences, and iron these differences out in your discussion with the rep-or photographer-to-be; then have an attorney draw up a simple, uncomplicated contract to be signed by both parties. Because so many contracts of this nature may involve individual interpretations, the last clause in your contract should make provision for arbitration of disputes.

Most photographer-rep agreements are based on commissions on sales made. This puts a serious burden on the new rep and somewhat less on the older one who may be repping other photographers who have already built their own reputations. The ability of a young new rep to survive until the young new photographer starts getting assignments is seriously limited and is one reason why there are probably fewer than three hundred active reps in the New York area plus a handful of agencies that represent photographers and artists. Most knowledgeable people feel that it takes a year of knocking on doors and showing a photographer's work before an important return can be expected. Thus, it might make sense for the photographer to pay an advance against commissions plus out-of-pocket expenses to keep the rep going for a fair trial period.

REPRESENTATION BY AN AGENCY
There are some agencies that represent hundreds of photographers and have huge numbers of pictures in stock, and there are the small, almost custom, operations that function on a much less grand scale but also may not have the financing, capital and staff to present as effective a sales program as the larger agencies. The photographer has to make the hard choices here. The large agency will undoubtedly have more gross traffic, but the individual photographer's contribution may well be diluted among the work of hundreds of other photographers working through the same house. The smaller agency, having fewer photographers, can pay more attention to you but may not have as many calls as the larger ones, so in actual dollar returns, working with a smaller picture agency rather than a larger one may not make much difference to the individual photographer.

SELLING PICTURES TO WIRE SERVICES AND NEWS SYNDICATES

In general the wire services and news syndicates rarely take the production of free lancers except for hard news items that were not covered by the regular working press. The Associated Press (AP) is essentially a cooperative owned by the subscriber newspapers, whereas United Press International (UPI) was owned by the Scripps-Howard Newspapers organization but has just been sold. Both services not only have their own subscribers but sell commercially to any who wish to buy their pictures. Each has its own set of staffers and each uses stringers to a great extent. The services occasionally buy features and will "stockpile" the material they do buy for resale, either to their subscribers or syndication services, or to a picture researcher who walks in. When these services do buy news material, it has to be delivered with speed to the nearest bureau. The participating newspapers *do not* pay for the pictures on a per-picture use basis—they pay the wire service a general fee for the service. So if your picture appears in one or fifty papers, you won't get any more out of it. What they offer you and what you accept is what you get, to put it simply. The magazine picture agencies are different. There is a participation plan in the final sales, and this is where there is an opportunity to earn a great deal of money.

SELLING PICTURES TO NEWSPAPER SYNDICATES

The newspaper syndicates are not much of a market for the free lancer either, because they use similar distribution systems as the wire services. The wire services themselves have their own syndication services such as AP's syndication service called Wide World. Out of 25 syndicates listed in one press guide, only about five really buy free lance feature material to any great extent. Again, the photographer has to be warned that more often than not the price received is based on a direct sale and *not* on participation by the papers that buy the syndicated material. The major syndication groups that might buy photographic features are: Chicago Tribune–New York News, Los Angeles Times–Washington Post, New York Times News Service, Scripps Howard (UPI parent corporation), Newhouse News Service, and a few others. In general I suggest that the regular wire service or syndication groups are not a good market for stock photography, except for some hard news or feature items. Be extremely careful about what rights you are granting.

MAGAZINE NEWS PICTURE AGENCIES

Long-time editor John Durniak, whose professional background includes stints with *Popular Photography* (editor), *Time* magazine (picture editor), *Look* magazine (managing editor of the short-lived new edition), and who currently is at *The New York Times* (picture editor), believes that the so-called "new wave" of French-directed picture agencies has really turned photojournalism around and probably saved the entire profession from withering away. Four new French agencies have come alive with a brand of get-up-and-go photojournalism and have fostered the rise of a number of successful independent photographers. Collectively the four new agencies, Sygma Photo News Agency,

Gamma-Liaison, Contact Press Images and Sipa—Black Star, plus the well-established Magnum cooperative, are now accounting for over 30 percent of stock news magazines sales worldwide. Some new groups have been put together, and they also structure themselves along similar lines.

The new breed of photographers who work for these agencies all have one characteristic in common that sets them apart from their predecessors. The "new" picture agency photographers are not affiliated with particular publications, whereas David Douglas Duncan, Robert Capa, Paul Schutzer and Larry Burrows, for example, were either staff members or photographers under contract for the big picture magazines.

The new photographers, among them David Burnett, Eddie Adams, Douglas Kirkland, Jean-Pierre Laffont, David Hume Kennerly, Lie Heung Shing, Chuck Fishman, Annie Liebovitz, and others range all over the world on assignments created by their own organizations, share the underwriting of the costs with the agencies, and can earn upwards of twice what the best-paid magazine staffer can bring home. When they are on an important story, which is often enough, they can make it *very* big.

Not all the members of these groups earn six-figure incomes, but annual take-home returns range from $25,000 to $60,000 and more plus a residual income from stock sales that may equal their annual participation pay every three or four years.

The agencies move their people swiftly and operate quickly with word-of-mouth honesty. An oral promise is as good as a written one, and any failure on their part to stick to their word would travel throughout the industry like wildfire. These agencies generate a tremendous *esprit de corps*. They overcome all obstacles to bring out strong, moving journalism of the highest impact. The agencies also seem to have an instinct for knowing not only what would sell but *how* to sell a story. Jean-Pierre Laffont's great essay on *Child Slavery Through the World* was almost impossible to sell in advance, and with only one small guarantee and $20,000 of his own money, he turned in an incredibly touching and sensitive story that, at last count, had grossed over $300,000 and was still moving.

Gamma-Liaison Agency says that their best-selling story was Matthew Naython's coverage of the Guyana mass suicide that grossed over $250,000. The other agencies have had similar successes. Each of them has its own methods of working. Some work with a handful of closely-knit photographers, others with a broad spectrum of people they can count on scattered all over the world. The one common denominator of these agencies is their French heritage, deeply influenced by the French journalist's wish to maintain the traditions and styles of great journalism and the derring-do that characterized the old *Life* magazine and *Paris-Match*. Lucky indeed is the photographer who has the talent and freedom to become associated with any of these agencies.

INSIDER: ELIANE LAFFONT, SYGMA PHOTO NEWS AGENCY
Eliane Laffont of Sygma Photo News Agency says that it is comparatively simple, provided the photographers meet Sygma's criteria of photojournalistic ability, youth, world-wide political sophistication and mobility.

Laffont defines photojournalism as "information through photography," so the first requirement is that the photojournalist have the ability to secure that information on a bit of film. Youthfulness is very important, but not the only criterion, to Sygma because this agency requires that a photographer be free of complex family ties so that he is mobile enough to get up in the middle of the

night, fly halfway around the world and stay on a job long enough to produce the needed pictures. This is *not* to say that Sygma discriminates on the basis of age. Far from it, because some Sygma photographers, who have been with them for as long as ten years have already married, raised families and so forth and are now concentrating on producing stories in depth that take longer to do and do not require the field rigors of hard news photography of an immediate situation. Youthfulness to Sygma also means having the flexibility to get a job done under any circumstances—the ability to sleep on a bed of stones without room service and not requiring expensive hotels or deluxe accommodations that could cause high cost and time delays. This could also mean moving into some poverty-stricken community to establish the necessary trust and rapport for an in-depth coverage of that community.

Worldly political sophistication is a must for a Sygma photographer because the world political scene is Sygma's "beat." Laffont commented on how young French students who have completed their formal education in their early twenties already know who the political leaders are around the world and have a good grasp of these leaders' politics and economics. Unfortunately, she feels that their American counterparts do not seem to have that kind of knowledge.

The last requirement is willingness to "gamble" with the agency. It is Sygma's policy to share the expenses of a story with the photographer, with those expenses coming off the top when the profits are divided. As mentioned earlier sometimes those profits can be high, but sometimes they are not, and occasionally both parties may lose money on a story. But the photographer has to be willing and able to bear his share.

Given all the above the rest is easy, Laffont says. Sygma always looks for young, aggressive and talented photographers willing to make a commitment to work for the agency every day. A phone call assuring Sygma that the photographer does indeed possess all of these attributes will usually result in an interview. Laffont will look at his portfolio, and discuss with him Sygma's method of operation, and if she feels that the photographer has the talent and experience as a journalist, then there is a good chance that photographer will be offered a trial period with the agency.

SELLING TO STOCK PICTURE AGENCIES

The regular stock agencies that handle much of the sales of secondary rights to photographs operate at a somewhat slower and less frenetic pace than the news picture agencies, and the lure of the big buck for the photographer is not there. There are substantial sales to be made, nevertheless, by photographers through these agencies, and they are certainly worth exploring. But how does the new photographer get into one of these groups? It is easier than joining one of the hard-driving French news agencies mentioned above. Nevertheless these agencies also have high standards of ability, ethics and procedures that must be respected if you want to work with them.

Most stock picture houses need a constant flow of new and fresh material and most will be happy to see the work of new photographers. But don't swamp them. All of the agencies have the same dread of being inundated with pictures. This was experienced in a dream related to me by a principal in one of the larger stock agencies. She told me that she dreamed one night that for some reason every picture agency in New York had closed except hers, and when she went to work the next morning there were hundreds of trucks and drivers from UPS,

Federal Express, and the Post Office all stacked around her door with thousands of boxes of 35mm photographs!

Don't laugh. It sometimes seems that this happens at several of the agencies I know. Joe Barnell of Shostal Associates, Inc. told me what Shostal's procedure is for acquiring the work of new photographers, and I know that their practices don't vary much from those of their competitors. He told me they are happy to find new material but it has to be done within a framework of practical operating procedures. This, he said, applies to photographers who call them, as well as those whom they may solicit on the basis of something they saw that caught their interest. From his conversations I have assembled a set of ground rules.

The first step for any photographer who wants to approach a stock picture agency is for him to write or telephone and ask if they are interested in seeing his work. Do not—I repeat, *do not*—under any circumstances send in any photographs "cold." It is unfair to send strangers material in this way because as responsible agents they will immediately be concerned with the safety of the pictures and the cost of returning them if they don't want them.

After you have decided whom you want to contact, and have clarified in your mind or listed on a piece of paper what you have that might interest the agency, contact them and ask if they want to see your material. If they do want to see your work (and most agencies will) ask for an explanation of their particular policies, then make a selection of the broadest cross-section of your pictures that fits their specifications. Pay close attention to the number of photographs the agency says it wants to see. One agency does not want to see more than one hundred the first time, another not fewer than two hundred. An agency's requirements vary with its needs, and those needs must be respected.

The material should be clean and professional in appearance and presentation. (See Chapter 8 on preparing captions and other information, and when you send your work make sure you have made some preparation for its safe return at no cost to the agency.) When they have seen your work and have come to some conclusion about whether they want it or not, they will contact you and tell you what they want, how they want it, and other details. One sure way to get instant rejection is to bury the agency with a barrel of unsolicited work, and you can be almost certain that the only way you will get it back safely is by *air freight collect*.

Your pictures should carry all the information discussed in Chapter 8 and a clear statement to the agency as to what rights you own (or don't own, for that matter), and whether you are represented by, or your pictures are with, any other agency, and under what circumstances.

Another situation to be aware of is that some larger agencies require a contract to be signed in advance of submission of pictures. If they then decide that you can't work together, then the contract is nullified. Some agencies don't want to be put in the position of editing and sorting through a mass of photographs if the photographer then decides he wants to go elsewhere.

Operating an independent photo file is a tough business unless the photographer is satisfied with just occasional sales until he can build his files up to the level where the number of pictures becomes meaningful to an editor or general trade source. For this reason the photographer who wants income from secondary use of his photographs has to consider the stock photo agency and the pros and cons of belonging to one. As I wear two hats (running a small independent stock agency as well as operating as a working photographer) I attempt to look at this from both sides.

First the pro-agency side: An agency that is already established will be the natural recipient of calls for picture uses you may never even have heard of or—even more to the point—an agency will be the recipient of calls for uses that may not even have been invented or perfected yet. These requests may be for videotape, videodiscs, laser transmitters, new marketing and distribution systems, or some new-fangled publishing venture. If you choose to go with an established, responsible and trustworthy agency (and if a good agency accepts you) you will be in good company, because an agency of this type will only deal with photographers who have good material, and in some cases include among their photographers many of the big star names of the business. They will do the billing, the logging out of pictures under appropriate leasing memos, see that the pictures are protected and sue anyone who abuses the images, and in general relieve you of the entire headache of marketing, handling and billing. Sounds good? It is in many cases, and I heartily recommend that qualified photographers work with qualified agencies. Ordinarily, as an agency member photographer, at the end of each fiscal quarter you will receive a statement of activity and a check for the pictures sold. Agencies vary and some are notoriously lax about business procedures. Also, some complaints are received because the photographers themselves do not fully understand the role and duty of the picture agency and its capacity for handling your material and the paperwork that it entails. This was made quite apparent when the ASMP set up its own stock picture committee to assess some of the complaints that its members had made against some of the picture agencies they were supplying. It turns out that after a number of joint meetings with the PACA agencies who represent many photographers in the ASMP, most complaints were based on ignorance on the part of the photographers as to how much and what a picture agency could actually do for a photographer, as well as a lack of understanding of the agency's problems in dealing with its clients.

The negative side of joining a picture agency must be examined, however, and the main objections of some photographers to joining an agency are listed below.

1. The agency usually takes a high commission, about 50 percent of the sales, as compared to a literary agent's commission of 10 to 15 percent, or a theatrical agent's percentage (which is about the same), a studio representative's commission of about 25 percent and ad agency commissions which generally run to 15-17½ percent commission on media purchases. So why the difference? That lies in the amount of internal handling and paperwork that the picture agency has over the other types listed. A literary agent works with a single manuscript and there is usually a photocopy or carbon around if the original gets lost. Not so with an original transparency. The studio reps are dealing with larger dollar numbers and fewer sales so that it requires 25 percent of a fee to barely earn a living for the average rep. The ad agencies are frequently buying media space in five-to six-figure or more dollar amounts, so their total commission can reflect a pretty healthy profit.

The picture agency is a singular sort of operation. It needs space to store and work with pictures, and the need for accessibility in high-rent business districts where publishers can reach them is apt to be expensive. Dollar amounts of sales are frequently low; a textbook sale of a single color picture for inside use currently falls somewhere in the $125–$150 range for a quarter-page reproduction. And after a picture researcher or buyer has selected fifty or a hundred pictures that need to be logged and checked in and out eventually the buyer

may purchase the rights to use two or three and frequently doesn't buy any at all. Therefore, you can understand why the handling costs are so high and why the commissions have to be as high as they are.

2. Picture agencies generally demand a long-term period to hold the pictures in their files, currently about five years. Why? Because it takes a long time to get pictures in and out of publishers' offices, and for picture buyers to make their selections (if any). Book publishing, which is where the majority of agency traffic is, is notorious for its slowness and it is rare that book publishers will ever make their selections and permit billings within the accepted time specifications of the agencies. Also, it takes a considerable amount of time and money to catalog and list pictures in promotional materials, and agencies don't want to spend that on pictures if they are not going to have them long enough to sell them.

3. Picture agencies are frequently accused of slow payments. Taking parts 1 and 2 into consideration, the photographer can now understand why this will often happen. Most clients seem to delay making their selections and then are even slower about issuing purchase orders and processing the bills quickly in some cases.

4. Picture agencies demand certain exclusivity with the pictures they carry from any single photographer, and the reasoning in this case is understandable. The agencies are competitive and don't want to try to sell a photograph only to find that the buyer then bought the same, or a close duplicate, from a competing agency or directly from the photographer for less money. And it goes beyond that. There could be a rights question here; an agency does not want to be put in the position of knowing someone else is selling rights to a photograph that their agency holds, not only curtailing the agency's market, but also possibly leaving it open to a legal problem involving those rights. Most of the better agencies don't demand total exclusivity on the entire production of a photographer's work. What they do want is exclusivity on a single subject, that is, the best pictures of any given subject, and they don't want to see some other agency peddling the same story and the same pictures by the same photographer. As to those photographs the agency doesn't take of another subject, that is an entirely different matter and most, but not all, agencies won't object to independent sales or sales by another agency of a noncompetitive type of photograph by the same photographer.

There are other complaints and other pluses but all in all I feel that the new photographer might very well consider the plus factors as outweighing the minuses and go with an agency if he feels he wishes to let his secondary sales be handled by others.

Where are these agencies? There are probably several hundred photo agencies throughout the United States—that is, any firm or individual photographers who want to sell photographs, either their own or from a collection of other photographers, will call themselves a photo agency. Many are listed in the classified directories of the city in which they are located. Since, as we mentioned earlier, the center of publishing in the United States seems to be New York, it follows also that the majority of the agencies are in New York, but there are a number of others located around the country as well.

Because of mutual problems in this field, some fifty leading agencies have formed a trade association called the Picture Agency Council of America (PACA) to establish standards of ethics and try to work out problems of practice with such groups as the ASMP and other photographers who need to know more about the agency business. There are many types of agencies, some overlap-

ping in coverage and they are often quite competitive. Some deal essentially in news coverage but sell stock photographs from these coverages that they themselves might initiate to other groups such as the wire services, syndicated news services and news agencies. The PACA agencies deal primarily in stock pictures sold over a longer term but often handle assignment work as well. There are close to a hundred agencies, including some mentioned above, in the current issues of *LMP* and *MMP*. Write for a listing of PACA members: Picture Agency Council of America, Inc., 60 E. 42nd St., New York, N.Y. 10017.

POTENTIAL PAYMENT PROBLEM AREAS

In the area of primary payment—that is, payment for the use for which the photographs were made—there is usually little argument once those ground rules are established. It is the secondary uses by the corporate or advertising client that cause the most trouble because most book and magazine publishers buy only specific rights to a photograph, and secondary uses are usually paid for according to accepted codes of the professional societies.

Before an answer can be arrived at to the question of what to charge for secondary rights, one has to know who wants those secondary rights and for what purposes. Is it the original client, or someone else? This is important because it is obvious that concessions may have to be made to give the original client an option for the use of the photographs he has ordered for one specific purpose—i.e., an annual report or advertising layout in some other medium. But suppose you have been given an assignment to simply build a public relations file for a client, knowing that those pictures are going to be distributed at no cost. The only way to handle this is to charge enough in your original fee to cover the loss of subsequent sales. If you make a placement of some of these pictures on the client's behalf as a public relations tool, and there is a source of payment for those pictures such as the space rate from a magazine or newspaper, then those payments should go to you.

Another area in which there seems to be some friction is in the corporate annual report field. If a company hires a photographer to cover its plant(s) and possibly photograph the firm's executives for a specific annual report for a specific fiscal year, it frequently occurs that not all the photographs are used, or some are repeated in the annual report for the following year. What happens then? If the photographer is on secure grounds with his client in the form of an agreement as to what the purchase order specified, then he should politely but firmly remind the client of the agreement. If the photograph has never been used, and a new annual report, for example, is produced in a different fiscal year, the new annual report should be treated as a new publication, and because this is a new use of the photograph and a page rate should again apply. (For suggested page rates for publications other than books and magazines see appendix). Sometimes if the secondary use is minor, as a goodwill gesture you might consider granting a reuse without fee. If a picture has run, and they want to run it again, a page rate figure should be paid for the reuse, and if the photographer wishes to be generous in terms of personal public relations, he can look on this reuse as a secondary use and apply the same percentages of the page rates that book publishers generally do.

Though book publishers tend to buy specific rights, among some book publishers there has been a growing tendency to blur the lines of purchase and photographers are urged to look carefully at the purchase orders they may get from these houses, especially those which publish many volumes in different

areas, to make sure the publisher is not trying to usurp blanket rights for all their publications for a single payment.

One thing the photographer should guard against is the unauthorized use by clients of pictures he has made for editorial or general public relations uses in national space advertising. I have always been very careful to spell this out clearly but have also been "generous" in allowing the clients to use these pictures for what is generally referred to as "trade" advertising. The circulation of this type of publication is usually limited in scope and will not reach a broad general audience, and if you make some special arrangements for credits in trade advertising, it may be a potential source of revenue for you from other people in the same field and also a source of good tear sheets.

One restriction on trade advertising use that I insist upon, is advertising by third parties. For example, if you have photographed a particularly interesting process in the foundry of a company you are working for, and they use this photograph in their annual report, that was what the picture was made for. But if you then get a call from the manufacturer of the machine that was in the process you photographed for that annual report, and he wants to use that picture in an ad for his company because it shows how his product is being used, what is the answer? The only positive one can be (1) if the original client approves the use of the illustration as the location is in his plant, and (2) payment for its use is made at standard trade ad rates, as that third party had absolutely nothing to do with your getting the original assignment.

Clearance by the original assigning company is very important because a release is going to have to be signed permitting the use of an advertising photograph made on private property. So do make certain that your own client understands this, because in a gesture of goodwill to the third party your client may have "given" him the right to use the photograph without realizing that he didn't have that right to give.

CONDITIONS OF SALE AND SPECIFIC REPRODUCTION RIGHTS

Over the years I have evolved "condition of sale" statements which are always added to my invoices. By specifying all the options a client is buying before you start work and making sure all the options are stated in the purchase orders or memoranda of work, you will then eliminate any cause for friction when you bill. Below is a sample listing of possible items that should always be on the invoice forms. (See appendix for sample forms).

RIGHTS GRANTED: All photographs covered herein © 198__ by _____

1. For use in 198__ Corporate Annual Report for the _____ Corp.
2. For internal public relations use in company printed matter of the _____ corp.
3. For all external public relations use by the _____ Corp.*
4. For all trade advertising by the _____ Corp. for one (or more) years from date of invoice.
5. National Consumer Advertising options granted subject to agreement on additional fee by the _____ Corp. and/or their advertising agencies.
6. Third party use excluded in any media except by agreement of the photographer and payment of additional fees by the third parties.

All other rights reserved

*(Note: here if desired, and agreed upon, you can put a time limit or requirement of additional fee.)

The above limitations are examples of the policies of most members of the ASMP and PACA associated photographers. Some photographers will give a client anything he wants, some make rigid demands for payments for any use other than those originally specified. Most will fall in between, and in the final analysis, you have to set your own terms and make your own agreements. But be aware that what we have discussed above is rapidly becoming the custom of the trade with those photographers seeking to obtain maximum mileage from their photographs. Whichever of the six (or all) items above you choose, the most important line after any of the above recommendations is the *All other rights reserved* line.

RETENTION OF NEGATIVES

The tradition of selling specific reproduction rights to editorial clients is well established, and the right of retention of negatives by the photographer has been upheld by the courts on more than one occasion. The basic legal concept here is that the negative is an intermediate stage in the production of a photograph, and as such is a part of the uncompleted work or effort going into the completion of a finished product. But for all practical purposes, if you do not have the negatives, you do not have the rights, even though you may have retained them on paper.

For years many of the large magazines vacillated on the question of who really owned the negatives, but were clear in their assertion as to what could be done in the matter of secondary use of the photographs. It was not until the new copyright law went into effect that the rules became more sharply defined and *in the absence of a specific "work for hire" agreement, you own everything.*

There still remains an area of discontent when the client does not know this and subsequently tries to exercise rights he doesn't have, or accuses the photographer of selling pictures for some other use. It is in the hope of eliminating this kind of conflict, that I suggest you make sure everyone concerned understands not only the legal aspects of the matter, but also the customs of the trade, which may not be clearly defined by rule of law.

I mention this now because of the importance of secondary rights to a photographer's total annual income. The concept that photographers, by retaining secondary rights, can be more effectual in moving pictures than the client, can be an inducement for the company to turn the business in your direction rather than to a competitor. Why is this so? All companies other than publishers, large or small, are engaged in the production of their primary product(s) and really are not in the publication business. They recognize the need for photographs for various purposes and thus commission them. After use they are pretty much disinterested in what happens to the pictures unless there is some "return" for secondary use. The word "return" here does not necessarily mean money. What return they may be looking for is the public relations value of having these photographs get into the media, and what better way than to have the photographer who makes them assure that media entry by pushing hard for their secondary use, as under these circumstances the photographer would receive additional payment.

A book publisher I deal with regularly still comes to me for oil industry pictures even though they know the pictures are available free from the oil companies, and many publishers do not like the idea of "hand-outs" despite the appeal of the free pictures for their budgets. Also, when they request photographs from some company, they will usually get a highly "sanitized" set of pictures which will show the company without warts or blemishes and most

times without reality as well. There is also the time factor involved. Most picture editors will try to locate the photographers directly (even though they may be out-of-towners) rather than deal at long range with some company that has moved to the Southwest or the West. Once an editor knows of you as the source of a certain kind of picture, he will come to you and speed the selection process considerably by dealing directly. Also, if you have built a good stock file on a given industry or subject, the editors will be apt to turn to you first for a picture.

SECONDARY REPRODUCTION RIGHTS BILLING

Billing for reproduction rights is simpler and less complicated than billing for a shooting job, but there are some ground rules that have to be observed if the photographer is to protect his rights and prevent misuse. The cardinal rule is that you must bill for a specific use only and reserve all other rights.

Until recently there have been some pretty loose definitions of what certain rights were, and terminology was adopted that was frequently not specific enough to apply to the actual sale. Even after the adoption of some of the preliminary codes of practices and standards by the professional groups (i.e., ASMP, PACA, and more lately the ASPP) definitions were by themselves still hazy and there was little agreement as to what they really meant.

What, for instance, does the term "one-time reproduction rights" really mean? Does it mean you can print the picture just once on a single sheet of paper? Or does it mean you can print it once in one specified book, magazine, brochure, annual report, etc.? If you state on your invoice that you are selling the rights to reproduce a picture in a book printed and distributed in the United States, and get back a purchase order with an endorsement saying they are buying the North American rights, is that the same? Of course not. Then again what are North American rights? Does that include Canada or Mexico or both?

I talked with Jane Kinne, President of Photo Researchers, Inc., one of the best-known stock picture agencies in the country. Photo Researchers is one of the 50-plus members of the PACA. Kinne reflected the thinking of the photo agency's membership and the hundreds of photographers they represent cumulatively. She pointed out that the expression "North American rights" is terminology used by publishers and really applies to publishing entire books rather than pictures because books sold represent a royalty to the author who wants the widest sale possible, whereas pictures do not draw royalties. What the photographer should be concerned with is the place of manufacture and subsequently the place of distribution, so that you would have a "United States English Language right," which would mean a book produced in the United States printed in the English language and sold in the United States. It might also include a right to distribute in Canada which would involve an additional fee. In actual practice, however, when a book is manufactured and its primary distribution is in the United States and is so specified in the billings, if a few copies are distributed in Canada or elsewhere, then little fuss is made about additional payments. But if the Canadian distribution is an important part of the edition and since the Canadian government is now pressing for local production, a fee for such use must be paid. Or, you might grant a right to distribute through the English-speaking world, which would call for an even larger fee. The final grant would be a right to a publisher to lease his production to another publisher. All of these situations reflect different fee structures. "One-time" is good only when it is followed by a delineation of what "one-time" means, such

214

as "one-time United States English Language rights in a hard- or softcover edition of _____ (the title of the book)" or for a magazine, the rights granted could be a "one-time right to appear in the issue of _____ Magazine dated _____ ." When it comes to selling stock photos to advertising agencies, it gets more complicated and here the photographer must be clear in specifying what language, what publications the ad will appear in, how many insertions are allowed, etc. All of this must be carefully detailed or there can be an implication that the photographer really doesn't care how many times the photos are used and where they appear. As in the billing for a shooting job, the bottom line must be *all other rights reserved*.

A NEED FOR CHANGE IN BUYER ATTITUDES

There is a real need for change on the part of the new picture user in a correction of the unfortunate attitude of "why should you charge so much money for these pictures when you have already been paid for them?" This cliché died hard but it did seem to die—or so I thought. Now it is cropping up again with alarming regularity, and I wonder if this is partially due to a new generation of picture editors and art editors, trying out their wings, or perhaps some of the old ploys are being revived to use against the new and younger photographers who have not been around long enough to understand the basics involved.

However it is interpreted, the answer was the same twenty years ago as it is today. When a photograph is made, it is made for a specific purpose. If it is made by a professional for a professional purpose, the chances are it has fulfilled its intended need. If a new need is created those new needs have to be recognized as a market. In between times (and these "between times" can be anywhere from 50 minutes to 50 years) the pictures have to have a home. They have to be filed, stored, captioned, retrieved, generally kept in good condition and accessible. This costs money, takes time (which is money) to log and be "de-logged," all of which must be charged for even though the pictures themselves may have been made and paid for by someone else long ago. So, whenever you have just made a set of photographs and delivered it to the client, or have resold an existing set of pictures, there is a vast amount of handling and paperwork that must be dealt with, ranging from the general detailed billing for a new job to a billing for secondary usage of a three-year-old photograph.

In my opinion there is almost no photograph in the world that cannot be reused for some purpose other than for what it was originally produced. The trick is to bring the maker and the buyer together, and that is a job that probably consumes as much effort as the original production of the picture. It is the *raison d'être* for the stock photo agency, the photo file, or even the lone photographer with a trunk full of unprinted photographs. I cannot overemphasize the importance of the photographer retaining his rights and, in some cases, possibly controlling the ongoing use of his work.

PROTECTION OF THE CLIENT

While the above discussion has to do with the protection of the photographer, how about protection of the client? The client has rights too, and one of the things he is entitled to is exclusivity, or protection against misuse of his photographs. In the stampede for protection of photographers' rights, frequently the rights of the client are overlooked, but they should not be forgotten.

If, under current practice the photographer retains secondary uses to the

pictures, he must be extremely careful about letting those pictures out where they can be picked up, used or even misused by competing publications or corporations. In industrial situations particular attention has to be paid to process security. Also, the terms of releases obtained on a client's property, or in behalf of a client, do not always give *carte blanche* rights to the photographer for other uses that can be harmful to the client, or model for that matter.

There is a question of conscience here that must be answered. If you are hired by some corporation and you find them doing something that is in serious violation of some standard of safety or environmental protection, do you blow the whistle on them? Sometimes this is called "biting the hand that feeds you." How do you handle something like this? If you see an industrial client dumping toxic chemicals into a river, should you photograph it and then go running off to the EPA?

Answers to these questions can be a matter only of conscience, and I certainly cannot make any definitive judgments. Thus, I feel that the seriousness of the violation has to be the governing factor as to whether the photographer sticks his nose into the situation or does nothing about it. I can, however, relate a few brief examples of behavior by other photographers who were faced with these decisions. One free lance photographer who frequently worked for a large lumber company in the West, did indeed blow the whistle on his client whenever he saw a major conservation/ecology violation, but the company did nothing to retaliate. When I asked why they continued to use him I was told that he was the best man available for the job and the company preferred his expertise as a photographer and took his whistle-blowing with equanimity. In another case a photographer I know reported a serious pollution violation by the middle management of a company to the company president. The company president not only thanked him but sent him a check saying the amount of the check was far less than the fine they would have had to pay if the violation had been discovered by the EPA. This photographer also kept working. But I also know of other occasions where the photographers looked the other way in fear they would lose the accounts.

EDDIE ADAMS

I talked at length with Eddie Adams, a Pulitzer Prize–winning photographer and a powerhouse of a performer in the world of photojournalism who has spent most of his career with the Associated Press, *Time* and newspapers. You have seen Adams's pictures from literally all over the map. He won his Pulitzer Prize with the now-famous photograph of a Vietnamese police officer shooting a presumed guerrilla in cold blood on the streets of Saigon. His self-originated essay on the plight of the Asian boat people won him the prestigious Robert Capa Gold Medal Award from the Overseas Press Club, yet he had a tough time selling the story idea to his bosses at the Associated Press. It was Adams' deeply moving story that became page-one news all over the world and triggered the acceptance of the Vietnamese and Cambodian refugees in this country. His versatility is awesome, and he is equally at home in a studio shooting a *Penthouse* story as he is doing a major cover story in Turkey for *Time* magazine.

How did he get started, and is there something to be learned from his experience? While still a student in junior high school in New Kensington, Pennsylvania, near Pittsburgh, he began making 16mm movies of home-town weddings. His father borrowed $150 for him, and he bought an entire studio that was going out of business, the prize possession being an old Speed Graphic. His school asked him to take still pictures of school activities— covering the basketball games for the school paper, yearbook photos, etc. He began to do wedding photography, producing an entire album for about $20-$25, and peddled the pictures to the local newspaper, the *Daily Dispatch*. When he entered high school, he was given a part-time staff job after school, which turned full-time upon graduation.

"As far as getting started is concerned," says Adams, "the most I have ever learned—and this is advice to anyone wanting to get into this field—is to start on a very small newspaper and *not* come to New York where there are ten thousand other people to compete with. On a small newspaper you learn to make the engravings, so you also learn the printing process, and you do all your own darkroom work. Sometimes you get a chance to lay out your own picture pages, so you have an awful lot of control over what you do. They'll give you nice displays. It was the best learning process I ever experienced, and in all my later years I never learned more."

Adams to this day feels very strongly that a small newspaper is the best place to start, and for a career in photojournalism there are more opportunities now than ever before in local newspapers. "Pick up any of the small or even medium-sized dailies. They have more pictures, more picture pages, more picture stories than even the old *Life* magazine had. The new technology they are using results in excellent reproduction, and there are actually many more publications than there ever were in American publishing history. I just saw some figures that say there are close to 12,000 dailies, weeklies and small magazines using good news photography today."

Adams went on to join the Marine Corps, saw service as a photographer in Korea, returned to the *Daily Dispatch,* and started up the career ladder to the Battle Creek, Michigan *News,* the Philadelphia *Inquirer,* part-time on the Pittsburgh *Post Gazette,* then to the Associated Press, *Time* magazine, back to the Associated Press, back to *Time,* and is currently with both *Time* and *Parade* magazine.

Adams to this day feels very strongly that the small newspaper is the best place to start, and for a career in photojournalism there are more opportunities than ever before.

CHAPTER 10
YOUR LEGAL RESPONSIBILITIES: PROTECTING YOURSELF AND YOUR CLIENT

Photography and the law have been in a tempestuous marriage ever since there were recordable images and litigious lawyers. Photographers and publishers, picture users, and those photographed, have often sued each other or acted in concert to sue others in all manner of actions, including invasion of privacy, libel, piracy, copyright violation, nonpayment of bills, petty larceny or grand theft, and almost any other offense against the private or public interest. In other words, the photographer is no different from any other creative artist in that he is bound, protected or abandoned by an incredible number of laws, statutes and regulations. To try to enumerate them all would be an exercise in futility. All I can do is hope to cover general points on how the photographer protects himself in the normal course of business or secures to him what is due under the law.

The most important factor in protecting the photographer's business life is the clear spelling out of all agreements, including contracts, leasing and delivery memos, invoices and assignments of copyright. Avoid useless and complicated verbiage. I have always felt that too much is written in fine print that no one wants to deal with. I have seen leasing memos that run into several pages and contracts that cover three or more pages. A good invoice, memo or letter of agreement concisely written will say it all . . . and better.

What is the photographer responsible for? Like any businessman, he has to cover all the aspects of doing business in his own state. In addition, he may be liable for special actions resulting from his activities: copyright violations, improper use of models and model releases, physical damage to property, getting hurt on the job or creating some condition where someone else gets hurt. It boils down to what kind of insurance the photographer carries. Under most state business laws he has to carry insurance on his staff, if any, liability for any damage he may incur in the course of doing his job and proper insurance on his equipment and the equipment or property he borrows or rents or uses on location. Under other laws he may or may not have to contribute to various state and federal unemployment insurance, medical insurance, disability and work-

man's compensation programs. In my small shop in New York in 1982, I am averaging about $3,500 a year for all forms of insurance, from camera floaters to general liability policies to cover accidents, such as the cracked plastic bubble on a helicopter or a tool that fell out a window. This does *not* cover my personal auto insurance but does include commercial vehicles such as trucks, platform equipment, station wagons, location trucks and so forth, rented and used on the job.

In addition to the standard business policies mentioned above, there are several coverages peculiar to photography that you should consider.

Camera insurance: "Floaters" or "all-risk" or "marine floaters," as they are variously described, protect the photographer against loss or damage of his equipment, wherever it may be at the time of loss. The most common is the policy that will pay you a stipulated amount for your lost, stolen or damaged equipment. The amounts are based on equipment costs or replacement value. These values must be constantly updated to take into account such factors as inflation, wear and tear, and the availability of replacements, whether new or used. Photographers should keep a careful eye on the market value of their equipment. For example, one model of a camera purchased new in 1965 and no longer manufactured today commands a price of three to four times the original purchase price, not because it is a collector's item but because in the eyes of some experts a comparable camera has never been manufactured. So if that camera is lost, the photographer may have to pay through the nose to replace it and the insurance policy should reflect that increased value rather than simple depreciation being deducted for age, wear and tear. Note that some companies retain the option of replacing lost equipment, and you must be careful of what you accept as part of your contract with an insurance company. Not all lenses or cameras are alike, even if they are of similar manufacture, and in your contract for coverage, if the insurance company retains the option of replacement, insist on a proviso that the replacement must be of equal quality to the item lost.

My cameral floaters in 1982 cost slightly under 3 percent per thousand of valuation, so a photographer with about $10,000 worth of equipment would be paying approximately $250 to $275 per year.

If you are running your own studio or processing operation, special equipment should be insured. Water processing, refrigeration, filtering equipment, temperature and humidity controls and other systems should be itemized on the policy. They can all be protected through standard fire, theft and casualty coverages, but special equipment should be carefully itemized.

Film and Negative Insurance (on the job.) The movie industry some years ago developed a "raw stock" insurance program that protects producers from accidents during field production or actual damage to the exposed raw stock (film). The ASMP, in conjunction with an insurance underwriter, has developed a five-point program for still photographers called PHOTOPAC that has similar if not all the protections of the raw stock policy. Note, however, that some of the elements may be covered by other policies the photographer has, so if you opt for the PHOTOPAC, be sure to double check your other coverages.

The basic elements are:

1. Equipment: usual camera floater-type insurance.
2. Props, sets, wardrobe: protects against accidental damage but not theft.
3. Extra expenses due to delays caused by accidents on the set.
4. Property damage liability: standard third-party damage liability also protects against lawsuits by third parties damaged.

5. Negative film, faulty stock, camera and processing problems: does not cover photographer's goofs, but almost everything else.

Negative or Transparency Insurance (Valuable Papers Coverage). This is tougher to cover and most photographers don't bother with it because premium costs are high and the individual return per lost image is low. The only protection you can buy that makes any sense is large-scale coverage on an entire collection of work, i.e., as much as a million-dollar policy on a collection of 50,000 negatives or transparencies. Each individual negative or image would only be worth $20 in this case (for insurance purposes only), and the loss of a single picture or even a few would not be important enough financially to justify filing a claim. However, if you had the entire collection covered, with a deductible for partial loss, and your entire studio burned or was largely destroyed by a disaster, then a blanket policy on your life-time collection of work would at least give you some means of attempting to rebuild your files.

The safest way to protect photographs that have to leave your studio is for the client to assume the risks involved, as specified in your leasing memo, and his responsiblilty is automatic if he retains the pictures under the requirements of the memo. Most publishers and printers carry a form of "valuable paper insurance" that specifically covers lost or damaged artwork. Therefore, if they do lose your material, regardless of how they respond to you, your leasing memo is a valid contract with them for the safety of the photographs and it is highly likely that they are insured against loss. As for damages to someone else's property, the multi-peril policies mentioned below will cover most situations. Make sure your policy specifies that your general liability policy will cover the property of others for any reason. Otherwise, in the event of a claim, the insurance company may take the position that they will protect you only if your negligence is involved. If you do damage or lose someone else's property and there is no negligence on your part, they may be off the hook and you can get stuck. So be sure you cover *all bases* with your broker when you discuss these policies.

THE PHOTOGRAPHER'S RESPONSIBILITIES

Can the photographer be sued? If you are a staffer, your employer assumes the risk for any damage you create in the field. If you are a free lancer, that's another story, and you must be adequately protected—and you must also protect your client.

What kind of special insurance do you need? This will vary from state to state and will also depend on what kind of photography you are doing. If it is general commercial work that may take you to a couple of dozen plant locations in the course of a year and may include some high-risk areas, probably the best form of insurance you can carry is something generally known in the insurance trade as a "special multi-peril" policy. This sort of policy is not very expensive and the one I carry covers me for up to $300,000 of general liability, plus it includes a number of other coverages ranging from my own office equipment to some medical payments and other losses. This particular policy costs $200 per year. Of course, the premiums will vary with the total coverages requested, but I have found that $300,000 is an acceptable amount of protection. If I need something special for a particular job (such as covering a sea trial of a $20,000,000 tanker), I purchase special insurance and add it to my general expense for the job. But operating normally, I do not anticipate doing more than $300,000 worth of damage to anything on any job I am on, and short of setting fire to a multi-

million-dollar oil refinery, I think I am adequately covered. When I apply for a street permit to shoot in a public place, the city agency usually accepts the $300,000 policy as adequate coverage against most situations. If you feel that is not enough coverage, discuss it with your broker.

There are a few other policies you might consider holding. If you do a lot of aerial photography (as I do), you need a special insurance policy. This is the same type offered to professional pilots or anyone else in the aviation industry who has to fly a great deal in nonscheduled aircraft. This policy is especially important to have if you fly on government aircraft for nonmilitary purposes, because in order to fly on any of those planes you usually must sign a waiver absolving the government of responsibility.

Once I ran into a situation where I had been scheduled to fly on a government plane and had signed all the necessary waivers. Yet my authorization to fly was cancelled at the last minute. Why? I was given several unsatisfactory answers, but finally one government official told me that probably the government couldn't make the waiver stick and was really afraid of its liability in case of an accident. So, the easiest way to get out of this dilemma was to cancel the flight authorization altogether. Keep this in mind when dealing with government or private air transportation and doublecheck your own protection.

Other policies worth considering are health and accident policies. Sometimes it is difficult for the free lancer to get adequate coverage at reasonable rates, but if you are a member of professional groups such as the ASMP, your membership makes you eligible for protection at group rates. For the free lancer, disability policies are very important, since if you get hurt on the job you will not have any sick leave or workman's compensation to protect you and your family. So get the best possible coverage you can find and remember that, in the case of membership in professional organizations, the savings you make in group policies may very well nearly offset your membership costs in the organizations.

The question of coverage for employees in the field should also be studied. If you have a staff in a studio or even in the field, your employees are usually covered by your regular workman's compensation policy. But if you go out to some area away from home base and hire someone to act as an assistant, gofer or chauffeur, and he or she gets hurt on the job, what then? Under most state laws you would be liable for not having proper workman's compensation. You can't always get away with calling every one you hire an "independent contractor"—not if they work with you on a regular basis. If you hire someone who operates under your direction, you are an employer and the workman's compensation boards will not consider it any other way. The only way itinerant help can be legally considered independent contractors is if they are engaged only on this basis. If they have their own letterhead invoices for their services, have a local base of business, and conform to the general practices of their own state, they will be considered so.

How do you, as a sometime employer of a driver, electrician or stylist, protect them (and yourself)? The simplest and most direct way is to take out a temporary policy to cover the period of employment, and either terminate it when the job is over or try to work out a permanent arrangement through your broker to give you credit for the unused term of the policy until you next need help and reinstate it. Do not under any circumstance attempt to hire anyone in the field without proper protection, because if he gets hurt you will be, too. Also, by clearly establishing the independent contractor status, if it does exist, you are also protected against damage suits and embarrassing questions by the IRS

because you failed to make the proper deductions and make quarterly employee payments to the IRS. With the proliferation of pension funds for even occasional labor, as in the movie industry, the status of anyone you hire must be clear.

What else can the photographer be liable for other than normal business pitfalls? The specifics of photography can always open doors to trouble when pictures are not produced according to plan. Withdrawal of verbal promises for space in publications, given when the photographer convinced his client he could do the work but failed to do so, is lamentable but not actionable. Under the new copyright laws, liability for the photographer diminishes, as he already owns what he produces, and if the pictures are printed improperly, the responsibility is the publisher's.

The mere act of making a photograph, regardless of how it is used later, is in itself not illegal. Only its *use* may be actionable. Even photographing in highly classified military areas does not automatically become a crime if the photographs are never developed, which might occur when unprocessed films are confiscated. An examination of most military or security regulations will show that the terminology they usually use involves the *dissemination* of unauthorized photographs. Nor does merely erecting a sign by some over zealous patriot prohibit photography and make the taking of pictures a crime. In order for such a sign to have any legal meaning, some statute or ordinance must be passed by an authority with jurisdiction in the matter.

While the photographer has to pay attention to and obey the laws of the country or community, he should stand on his own rights and not bow to any threats of legal harrassment or police intimidation that prevent him from making or using the pictures he is legally entitled to produce. Doing this may be easier said than done. The NPPA's *Press Photographer* frequently reports confrontation incidents between working press and local law enforcement officials at the scene of a crime, accident, or other newsworthy event. Some of these confrontations have become pretty nasty, occasionally resulting in violence and arrests. Fortunately these confrontations are diminishing because the courts have become more and more responsive to the First Amendment guarantees regarding freedom of the press, and law enforcement officials are indeed beginning to accept these dicta.

These are the hard ways of securing one's rights. There are other methods less taxing, such as the following incident. A reporter and a photographer were doing an investigative journalism piece on a matter of public interest (i.e. news). They were stopped and harrassed by the local police, who while not actually charging them with any direct offense as far as "illegal" photography was concerned, obviously were making it difficult for them to work. Things were getting pretty sticky until the reporter reached into his pocket, extracted a small card he evidently carried just for this purpose, on which was printed the First Amendment to the Constitution of the United States, and he proceeded to read it to the cops. Dumb amazement was the main reaction by the police officers, and finally one of them shook his hand, reached into his patrol car and called his superior on the radio. "Hey, chief," he said, "we stopped those guys from _____ Magazine like you told us to, but one of them is reading us the First Amendment to the Constitution about Freedom of the Press. What do we do now?" Back came the answer, "Leave those nuts alone and get the hell out of there!" The "nuts" were thus left to proceed with shooting the pictures they were after.

COLLECTION

What about collecting money that is due you? Most reputable companies will pay within standard practice periods, such as 30 days after the invoice date. Yet during this time of high interest rates some companies with a poor cash flow will try to delay payments. Other clients, particularly advertising agencies, are notorious for slow payment. They usually fall back on the old story that they have to bill and collect from their clients first before they can pay their suppliers, often extending payment of the photographer from 90 to 120 days. I have refused to accept this because it is for the most part untrue, and I begin to pressure accounting departments of companies that are more than 60 days in arrears.

As any small businessman will attest, the larger companies are not reluctant to charge you interest when your payments are slow, but when you turn around and apply the same tactics to them, their howls are frequently monumental. With one particular agency I had to fight my way to the top of the corporate heap before I could find a responsive official and tell him that they had to pay interest or pay in full within 30 days. He finally agreed to payment in full. This type of activity is time-consuming and frustrating and does not make for good relations between photographer and client, but it must be done or *you* may suffer a fatal cash-flow problem. I recommend that you incorporate in your invoice form a statement that interest of 1 to 1½ percent per month will be charged on accounts 30 days or more in arrears. Some companies and the U.S. government, given an option of a tiny discount for payment within 10 days, will often exercise this option. Once I submitted a bill to the U.S. government for a print for $5.00, giving a 1 percent discount for payment in 10 days. Sure enough, on the ninth day after billing I received a check for $4.95.

Just as you feel it is the duty of companies to pay you promptly, you cannot disregard your responsibility for paying your suppliers equally promptly. If your accounts receivable are slow, you will be placed in the embarrassing position of having to stall payment to your suppliers.

Probably the least painful way of maintaining business credit ratings is to borrow on short-term notes from your local bank, pay your own accounts promptly, and repay the notes when the receivables come in. This is the same procedure followed by many large corporations. Interest rates, high these days to be sure, have to be built into the general cost of overhead for doing business. There is no truly economical way of getting around this problem. There are some companies (factors) who will buy your receivables, but usually their discount rate is so high that it is much wiser to borrow from a bank to cover your bills. You will find that, high as the current short-term interest rates are now, the factoring companies cost even more.

For studios in fixed locations that depend on walk-in traffic for portraits and other commercial work, one answer to slow collections is in the bank credit-card system. Again this means paying the bank a discount on your sales, but it may be cheaper to do this and have a steady cash flow than to be stuck with extremely slow payers or even nonpayers. The bank card system will not work, though, with traffic that is corporate-oriented and most certainly not in non-walk-in areas. With this traffic you have to depend on other methods for keeping your bills moving. Since much photo work involves the reproduction of pictures, one way is to use the copyright system to best advantage. If a photograph of yours is duly protected by copyright and you have followed all the necessary procedures to secure the copyright, the use of your photograph with a subsequent nonpayment is an infringement of copyright. There are substantial

penalties for infringement, and if *willful* infringement can be proven (and *willful nonpayment* is one form), the penalties become quite severe. The problem here is that the amount of money due has to be substantial in order to make a Federal infringement case plausible and worth pursuing through the courts. Also actual damages have to be proven before a Federal judge can make a determination, and he can reserve his decision on a substantial redress. But the use of the copyright law should not be ruled out, and when and if the occasion arises it should be discussed thoroughly with your attorney to see if it makes sense to go this route. Remember, though, that mere *nonpayment* may not be considered "serious damage" by some Federal judges.

There are other ways of collecting what is due you, which involve turning over your account to a collection agency. But like the factoring companies, a collection agency's percentage of retained fees is apt to be quite high, and there is nothing that will arouse the anger of a client, even if he is by now an ex-client, more than a call from a collection agency. But desperate needs sometime require desperate action. Even so, you should consider the costs of the collection process, and the ill-will generated, before you choose the collection agency route.

Short of a full-scale lawsuit when the dollar numbers are high, pressing of claims in small-claims courts is often quite feasible. The amounts covered by state courts vary. In New York state the upper limit is $1,000, and there are a few booby traps to watch for. The theory behind small-claims court is that the claimant of a relatively small amount of money should not be forced to use (and pay) a lawyer for collection of a small sum. In actuality it often doesn't work that way, because if you are suing a corporation in small-claims court and that defendant is represented by a lawyer, the presiding judge will make it quite clear that you as the plaintiff had better be represented by a lawyer as well! So there goes your saving of lawyer's fees, particularly if you lose the case. Also, even securing a judgment in a small-claims court does not necessarily guarantee that payment will be made because enforcing the judgment, if there is a failure to pay, can also be a time-consuming and costly effort. Still, if your claim is near the limit and you are dealing with an individual rather than a corporation, it may very well be worthwhile taking your case through the small-claims courts. Many states do provide for night sessions and the costs are minimal. So don't shrug this off without investigating its feasibility.

There are some other ways of collecting money due you. If you are a member of a credit reporting service (for which you pay an annual fee) such as Dun & Bradstreet, reporting unpaid bills to them will eventually affect the credit ratings of the companies concerned and may spur them to clean up their indebtedness. If you are a member of an agency with membership in the Picture Agency Council of America (PACA), the council itself has a legal system of reporting and acting on claims; their action may help speed up the processing of your claim. However, you have to be a member of one of these agencies and they have to handle the processing of your bill. Whatever method of collection you use, the basics are that your paperwork must be in order and the terms of sales or sales of rights have to be clear and indisputable.

RELEASES: IMPORTANT LEGAL CONSIDERATIONS

Next to copyright, probably one of the most misunderstood areas of interest to the photographer is the entire subject of model releases, building releases,

invasion of privacy and libel. There are some general rules and some specifics and each is subject to variations. In general, when covering a news event or item of public interest such as might be published in a newspaper, magazine or television program, model releases are not necessary. When photographs are used for advertising or "trade," usually for the sale of a commodity or service, releases are necessary although this is not always the case in all states or countries. There are blurred lines of definition because a magazine or newspaper that publishes photographs is presumed to be publishing newsworthy items in the public interest. If the photographs used are designed to encourage the sale of a magazine or newspaper, does that make the newspaper or magazine an item of trade? (See *Arrington* v *The New York Times* on page 227.) Certainly, as the publication is being produced with an eye toward making a profit. So again taking into consideration the cross-over problems, let us look at the whole release question.

First of all, a release is exactly what the word implies. It *releases the photographer or his agent or client from liability* for the use of the photograph in whatever item of trade or communication in which the picture is used. As mentioned earlier, most frequently a release is needed when there is an advertising or commercial use of the pictures, and a release is generally not needed when there is essentially a news value in the use, especially if the picture is made in a generally accessible public place. Also, as discussed previously in the editorial situation in Kentucky, there was clearly no advertising or trade intention for the use of the pictures; but releases were obtained in order to avoid legal harassment by a third party.

What constitutes invasion of privacy is a most frequently misinterpreted issue. What constitutes permission granted for the use of a photograph of a person or a building? How many times has a camera been pointed at someone who says he will sue for "libel" if the picture is used? Remarks like this should not be given a second thought. Libel means making a statement that is untrue and thus damaging to someone's character or reputation. If you stuck a camera under the window shade of someone's apartment and made a photograph of the people in the room, that would most certainly be invasion of privacy, but if you photographed some man in a theater or nightclub and it turned out that the woman with him was not his wife, you have not committed either a libelous action or an invasion of privacy. If you used the photograph in a news item, there still would be no course of action for those photographed—if they were photographed in a public place, involved in a public event. If the photograph of someone at the nightclub table taking a drink was used as an ad for a certain brand of liquor, that would be an invasion of his privacy but not libel so long as you didn't alter any facts. But you would be responsible for using the photograph without permission. If you trespassed into the situation, that would be invasion of privacy and a release would be required, but if you were in a public place or even in a private area with permission to be there, it would not be trespassing.

The *intent* of the use is critical, however vague the lines of definition are. I mentioned earlier that if a photograph of a person is used in an advertisement, a release must be obtained for the use of that photograph in that manner. Yet even this comes into conflict when in some cases the "fair-use" principle can be applied. In a well-known case, a photographer for a national magazine made a picture while on private property, a resort, and without specific permission of the property owner or the person photographed. It was a picture of a woman lying under a palm tree at a beach some distance from the camera. The purpose

of the photograph was to illustrate an article on this resort area. When the story appeared, this particular picture was printed less than one-quarter of a page in size, with no identification of the woman. At the same time, an ad was prepared by the publisher's ad agency, touting the article as the reason the public should buy that magazine, and in the ad the picture was enlarged to almost a full newspaper page in size. When the picture was blown up to the larger scale, it appeared that the woman in it was a well-known movie star, and her agent sued, claiming that the use of her picture for advertising was an invasion of privacy.

The case was dismissed on the "fair-use" basis; that is, the photographer did not know who the person was and the picture would have been made at the beach anyway and published whether there was anyone in it or not. No identification of the woman was made in the copy, so there was no attempt to capitalize on the fact that she was a famous theatrical personality. If you get in trouble inadvertently, have your attorney examine the issues closely to see if the fair-use theory can be applied.

In selecting a proper model release (see the appendixes of this book for a sample), you must consider a number of things. There has been litigation concerning advertising photographs when the model has charged that the pictures published were not for the uses intended at the time the pictures were made. In one well-publicized situation, a model posed for an advertising photograph reading a book in bed. The client was a publisher and the picture was intended to stimulate the sale of books. There was no problem or litigation with the ad that was produced. However, the picture was subsequently sold to a bed-sheet manufacturer and, with some suggestive overtones added to the copy, was used to promote the sale of sheets. The model objected, sued and won her case on invasion of privacy grounds because the second ad portrayed her in a derogatory manner. She won her case even though she had signed a "broad-form" release giving the photographer and agent the right to "use the photographs for any purpose." The court ruled that it was clear that the model in this case did not intend to allow her photograph to be used in this suggestive manner and felt the ad did cast her in an unfavorable light.

Releases can be written precisely to protect the photographer against this kind of negative reaction, and if you feel you are getting into situations like this, it might be wise to talk with an attorney to determine what your model releases cover in the way of secondary sales. If you are doing a straightforward piece of photography, even though secondary sales are contemplated, you should have little to worry about. Even though everything you have done is legal and correct, you will often have no control over what some third party may have in mind. You can protect yourself in your sale of the picture by specifying that the picture is sold *without release rights* to the secondary buyer and that you will be held harmless in any action incurred that may arise due to the buyer's use of the photograph.

ARRINGTON V *THE NEW YORK TIMES*

Photographers and uses of photography have always had to walk a tightrope when it comes to publishing freedom, the Constitutional guarantees of the First Amendment notwithstanding, and just as we thought that all bases had been covered as far as releases were concerned, a new threat has arisen to that freedom.

At this writing, (and it is certain that the matter will not be settled in the highest courts for some time to come) a new challenge to freedom of the press has come to light that threatens the very existence of every free lance photog-

rapher and photo agency doing business in the State of New York. And since New York is the seat of most American publishing, it is a serious threat indeed.

I am referring to a new case before the judiciary, *Arrington* v *The New York Times*, which, in the opinion of a number of leading attorneys in the publishing field, has resulted in one of the most bizarre decisions ever handed down in a publishing case. In brief, a prominent photo agency sold *The New York Times* a reproduction right to a photograph, made by one of its photographers, of what appeared to be a black businessman walking in the street carrying an attaché case. The story was used in connection with an article in *The New York Times* on black business people. *No* pejorative remarks of any sort were made in the captions or the text. The man in the photograph sued the *Times*, claiming an invasion of privacy, even though he was on a public street at the time he was photographed. When the case went to trial, *The New York Times* was exonerated of any wrongdoing under the First Amendment of the Constitution, but here is the "zinger." The judge also ruled that the photographer and his agency, by selling the right to reproduce that photograph, sold it for the "purpose of trade," thus putting it in the same category as an advertising photograph that is used to encourage the sale of some object or service. And the use of a photograph for the "purpose of trade" *does* require the use of a release. Under all heretofore established procedure the use of a photograph in a news context does not require a release, but one made by a free lance photographer would. The judge did not clarify why the same photograph, if made by a staff employee of the Times and used by them in this situation, would *not* require a release.

The implications of this ruling if allowed to stand, are tremendous. Theoretically everyone who attends a football game and is photographed seated in the stands by a free lance photographer would be entitled to sue, although if the picture were made by a staff photographer and then published, there would be no such right.

As a result most of the large press and broadcast organizations have filed *amicus curiae* briefs, as have the majority of the professional journalistic societies, in the hopes of overturning this strange decision, which, if unreversed, could put every photo agency out of business, and shut off a large part of the supply of photographs used by the major publications of the world.

Since final resolution of the Arrington case may take years, the ASMP's attorneys have recommended that the following disclaimer be placed on *all invoices* to protect the photographer against future action under the Arrington ruling.

"Client will indemnify Photographer against any and all claims and expenses, including reasonable attorney's fees, arising out of the use of any photograph(s) unless a model or other release was specified to exist, in writing, by Photographer. Unless so specified, no release exists. Client will also indemnify Photographer against any and all claims and expenses, including reasonable attorney's fees, arising out of the use of any photograph(s) that exceeds that granted by any releases provided by Photographer."

I know of an author who, when putting a book together under contract to a major publisher, purchased publication rights for a photograph he wanted to use editorially. The photographer granted a general release for editorial rights but also included "publicity rights." The picture was used, fully credited, and there was no complaint from anyone. Unfortunately, the publisher then ran an ad for the book, using this picture among others. The photographer demanded more money for the use in the ad, not from the publisher but from the author.

228

He in good faith asked the publisher for this but the publisher refused, claiming that the "publicity rights" granted in the release were the "same as advertising" and that the publisher would not pay an additional sum.

The photographer threatened to sue the author, who consulted his lawyer. The latter reaffirmed a long-accepted trade custom, that publicity and advertising are *not* the same, are not interchangeable. He suggested that the author refuse to pay the photographer and have the photographer seek redress from the publisher directly, since the author had nothing to do with authorizing the ad layout, purchase of the media space and all the other requirements of publishing an ad. It is a well-accepted trade practice that in *any* publication it is the publisher who is responsible for the content of the publication, not the editors or authors. However, the photographer refused to deal with the publisher and continued to harass the author even though he had no legal responsibility in the matter. In order to avoid the cost and nuisance of defending a lawsuit, the author eventually paid the photographer out of his own pocket.

The whole mess could have been easily avoided if either one of two options had been exercised by the author. If the release had been written more clearly in the first place to permit advertising use of the photograph, chances are the photographer would not have demanded an additional fee since he would have probably been most happy to see his picture used in a promotion that might well have brought additional work to him. Failing that, if an extra fee had been stipulated for advertising use, the publisher would probably not have used that photograph in the ad since he had several hundred others of comparable quality to choose from that were free. Furthermore, if the author had stood his ground, he could easily have been separated from the case, as he obviously was not the publisher of the ad and had nothing to do with its preparations.

Using the first option would have been infinitely easier and simpler. Be aware of this kind of nuisance claim and be certain that releases are drawn accurately and clearly.

Building releases can be tricky, and there is no real body of law on whether they can be demanded except in advertising use. Even here the rulings are unclear and can often be protected by "fair use." I had a curious situation develop when a prominent photographer (and friend) leased one of my aerial photographs of a section of a city in which a well-known building was pictured among thousands of others. The other photographer was doing an ad for an elevator-manufacturing company that had supplied the elevators for that particular building, and my photograph was made part of a composite photo prepared by the second photographer, who incorporated the exterior of the building but also included other components reflecting the elevator installation. When the ad ran, I received an irate phone call from the building owners, who threatened to sue me and the other photographer for including their building in the ad. I defused the problem by pointing out that I had not prepared the ad and furthermore that the picture of their building in a mass of other buildings made in a public area would not be interpreted as improper. So you see, photographers can be embroiled in situations not of their making and for which they should not bear any responsibility.

What is the situation involving private property in an ad? This has to be dealt with carefully, and probably a good part of any legal action will depend on the words used in the text. The mere showing of a building in a public place without comment cannot be considered either libel or an invasion of privacy by the photographer. It is up to the producers of the ad to obtain the necessary building releases and assume responsibility for the ad copy. Interiors of a pri-

vately owned building might present other problems, but logic dictates that you would not be inside a private building without permission to make photographs for advertising purposes. If you sneaked into someone's property to make photographs without permission for editorial use and were caught in the act, the legal problem would be one of trespass and invasion of privacy. The same goes for other private property photographed for advertising. Use standard releases and also remember that the new copyright law will protect you because you own everything you shoot (except work made for hire). You need not seek permission to use a photograph from whoever commissioned you.

This is not restricted only to advertising use. The whole intent of libel and invasion of privacy extends across a broad area of photography including the editorial world. It even involves the free photographs that are distributed by a government agency if the persons in the photographs object to the editorial context of their use. Once during the time when the FSA program was underway, one of the photographers made a picture of a poor family in the doorway of their cabin in a poverty-stricken area of the deep South. The caption, written by the photographer and affixed to the print, simply gave the date and location and was limited to a statement of the essential facts, just stating, "Farm family in the doorway of their home in west Texas." The picture was picked up by a magazine and used in an editorial attack on the very same government program that provided the photograph. The caption added pejorative comments about the family and clearly offered a number of editorial opinions. The family ultimately sued the magazine, the government agency and the photographer. The latter was quickly separated from the case because he hadn't said anything in the way of editorializing about the family and any viewer could form whatever opinion he wanted from the picture. There was clearly no libel or invasion of privacy. The magazine did have the responsibility for what they said editorially about the picture and for their subjective remarks about the family and the publication was held responsible for its comments.

So, even if a release has been signed, the release itself does not carry the right to abuse, degrade or otherwise subject anyone to ridicule or cast him in any other unfavorable light. This question arose recently with the publication of some historic documentary photographs that clearly identified some families as having been poverty-stricken when the government agency made those photographs 40 years ago. The question now is, does the publisher have the legal right to publish photographs that the subjects might consider degrading even though their status may have changed over the 40-year period? This has not yet been resolved in the courts but it does present a perplexing question of ethics to be considered by the photographer who may attempt to market pictures of this nature.

Trespassing for the purpose of making unauthorized photographs presents certain legal questions that at best are confusing. There is no question in the mind of some attorneys that photographing on private property without the permission of the owner is an invasion of privacy even if the premises are open to the public, as a restaurant or shop might be. One attorney suggested that photographing the owner of a shop on the street in front of his building, if the building is clearly recognizable, might also be considered an invasion of privacy, even if an editorial purpose rather than advertising is intended.

First Amendment rights of freedom of the press do not negate the rights of personal privacy within the confines of one's private property, and the news photographer should be aware of this. When a TV or a photographic crew practicing the new form of "journalism by confrontation" descends on a busi-

nessman suddenly and without warning in the hope that he will become flustered and say or do something improper, it has been held to be an invasion of privacy by a court in New York. Does this concept protect against the use of a long lens to shoot onto private property from a public way? Probably not. While there may be some justification for using this kind of photograph in news journalism, there is no justification whatsoever for using pictures made under these conditions for advertising or trade purposes.

So it is back to basics here. It is the intent as to how a photograph is to be used that must be the deciding factor on releases. How you handle the legal questions arising from these intentions is the critical question. The release is a protective device, but it is not foolproof or all-encompassing.

One final thought. When a minor is involved in a photograph, the signature of the minor is usually worthless. Therefore it is imperative to have any releases involving minors signed by their parents or legal guardians.

LEGAL PROTECTION OF YOUR WORK

If the movement of a negative is restricted, the chances of harm coming to it are minimized, so with decent care in handling there need be little worry about loss of an irreplaceable black-and-white or negative color photograph. It is when the original color has to start moving in the stock picture market that the troubles start and multiply.

When the stock picture traffic first began to grow, photographers and agencies were pretty casual about securing physical protection for their images. However, as the markets expanded, business increased but the number of transparencies lost or damaged began to multiply alarmingly. This casual attitude toward the safeguarding of photographs began to change when users began getting sued for large amounts. At this time the leasing or delivery memo began to take better form and became the transmittal vehicle for the movement of photographs between photographer and user, or agency and user. As the problems increased, some of these memos became tougher and tougher in an effort to stem the rising tide of abuses. Even the transportation companies began to get into the act because as photographs began to move between cities the responsibilities of the carriers became more important. It took long, hard years before ground rules were established to determine what an unsold photograph was worth, under what conditions the photographer releases the photograph to the potential user and what the user's responsibilities for the safeguarding and return of pictures. Only after numerous court cases were filed and won by photographers were some norms established as to what a picture is worth even when it is sent to a potential client without any assurance of its use.

Even more critical was the determination of what a photograph that *may never have been seen* by either photographer or user was worth. That issue was resolved in a landmark decision in 1949. (Lake vs. Railway Express Agency 98 NY SupII 202 NY Supreme Court.) This was exciting for the photographer and gave him a solid foothold in establishing the value of his pictures, seen or unseen. In brief, a photographer named Thomas Peters Lake, shooting *sheet* Kodachrome (now long defunct) shipped some 40 sheets of exposed film to Kodak via the Railway Express Agency. At that time REA would deliver exposed film to Kodak in Rochester, New York, and pick up developed film to deliver it to the photographer in New York City in very quick time—usually 36 hours from pick-up to delivery. In this case, Kodak as per arrangement processed the raw film and handed it back to REA, who promptly lost it! The shipment was insured for

$5,000, and when Lake tried to claim this amount, the REA claimed that the amount was simply a limitation of liability on the shipment and Lake would have to prove the pictures were worth $5,000. This seemed to be a tough one because no one at Eastman remembered what the pictures looked like, Lake never saw the finished transparencies, there was no such thing even as a Polaroid in those days for comparison, and no one really knew how many good exposures he had out of the 40-odd pieces of film he had shipped.

But the court came to the rescue. The judge ruled that since Lake was an established professional, from his sales record he could be expected to sell about 18 of those finished sheets of film. It could be safely assumed that since Kodak had not reported any technical difficulties in the processing plant or materials at the time of handling, that the "take" was neither better nor worse than his average. Therefore he ruled in Lake's favor, awarding at that time about $4800 for the set, even though no one really knew how many blanks, damaged sheets, etc., were in the lot, or about $266 for each of the 18 pictures estimated salable.

Thus, a value for an unsold (and in this case even as unseen) image was established. Photographers and agencies became more adept in handling and evaluating materials, and they now clearly stipulate a dollar amount on the resale value of lost photographs. Note the term "stipulate" here, because in legalese that's pretty critical as it means that both sides accept as fact that this is the value of the photograph. There were some earlier legal pitfalls in the terminology used in some of the leasing or delivery memos. For a long time after the basic values were established, some memos stated that the client would be responsible for a *minimum* of X dollars for the loss of a transparency. "Not legal," claimed the more knowledgeable lawyers. A client has to know what he may be liable for, so the responsibility for a fixed or maximum sum as to the value of a photograph has to be stipulated before a claim can be made for its loss.

So far there have been several court cases that were decided in favor of the photographers for lost transparencies and other photographic material, and as of this writing about $1,500 seems to be an average amount stipulated for the value of unsold rights. This is something the photographer should pay attention to in preparing his own leasing memos. At no time have I put a fixed value on the loss of a *piece of film itself.* When an original is lost, what the photographer is claiming is for reimbursement against the loss of *resale* income or, if we refer back to the Lake decision, what the judge felt was what the photographer could *expect to sell* in the years to come. The number of pictures and the dollar awards that the judge made were commensurate with 1949 prices, but the principle has stood the test of time and is a solid base for evaluating unsold rights of a photograph.

COPYRIGHTS: WHAT THEY ARE, WHAT THEY DO, AND HOW TO GET THEM

WHAT IS A COPYRIGHT?

Essentially, a copyright is a form of ownership of a piece of property that can be bought, sold, traded, willed, inherited, donated, divided or combined with other objects to form some new entity. Yet in certain cases you must grant its "fair use," as will be discussed later.

The important point for the photographer is that it is an effective method of preserving his or her rights and keeping them from being used without permission or payment *if demanded.* In the world of communications where photographers operate, it is a vital communications tool, roughly equivalent to a patent. Almost any written or graphic works of art, literature or method of bringing these works to the public (e.g., the printed page, electronic transmission, or a framed canvas on display) are eminently copyrightable, and should have copyright protection.

HOW LONG DOES A COPYRIGHT LAST?

Under the old law (Copyright Act of 1909) it was good for twenty-eight years after the date of registration and renewable for another period of twenty-eight years; thus copyright protection expired either twenty-eight or fifty-six years from the exact date of registration. Under the new law, (Copyright Act of 1976, in which most laws became effective in 1978) for work produced after January 1, 1978, the copyright is for the life of the author *plus* fifty years. There are other details which cover unusual situations created by overlapping times due to the change of law, but the Copyright Office's *General Guide to the Copyright Act of 1976* has a detailed comparison chart that should be carefully studied to note the differences in the coverages of the laws. Write to the Copyright Office, Library of Congress, Washington, D.C. 20559.

It is your artistic expression that is at stake here and your right to pick the fruit you grow. In an overwhelming percentage of photographs used in publications, there is no attempt on the part of the printers or publishers to steal the work from the artist. Or is there? If no copyright law existed, would there be a greater use of art material in publications without payment or effort to locate the rightful owners? This is part of what makes the copyright procedure so important, even though infringements of copyright are rare. There have been too many instances of common rights of ownership being violated by others, and thus there is a need for such laws.

The question of whether it is worthwhile or not certainly should be answered affirmatively. Yes, it is worthwhile to copyright your work, if for no other reason than that it makes known to the world that this work is *yours*—you created it, you own it, and you are proud of it, and woe unto anyone who misappropriates it or misuses it.

The 1909 law, which was in effect until 1978, listed fourteen classes of material that could be covered, including photography. The new law makes no change in these groups except to add several new classes of work that did not exist in 1909. So photography, long established in the old law, is firmly rooted in the new one as well. It is up to the photographer to implement these provisions by exercising his right of copyright.

WHO MAY COPYRIGHT?

Under the old law, whoever paid for a job had the right to copyright it, as did the creative artist if he specifically reserved his right of ownership. The original copyright law used the term "writings of an author" which made possible the copyrighting of a work by someone other than the author. The new law substitutes the phrase "original works of authorship," which leaves the door open for as yet undiscovered means of communication, preserving for the author his rights to his work in as yet futuristic media. In essence, if you made it, you can copyright it unless you did it under a "work made for hire" agreement.

WHAT IS A "WORK MADE FOR HIRE"?

The Copyright Office defines it as "a work prepared by an employee within the scope of his or her employment" or "a work specially ordered or commissioned for certain uses specified in the statute, but only if there is a written agreement to consider it as a "work made for hire." This sounds rather specific, and it would seem to require a written document from the client using the words "made for hire." A number of lawyers I have spoken to feel that this is definite and clear and the words "work for hire" must be used. Not so, says another authority on copyright law, who takes the position that the terminology of a document that clearly specifies the commissioning of a specific work or project can be interpreted as a "work for hire" agreement even if the words themselves are not used. So, be careful in what you sign, and don't depend totally on the use of words "work made for hire" as the decisive factor in determining whether your agreement is valid or not. Artists or other creators of literary works who are employees of the United States Government are exempted from copyright privileges if the work they produce is part of their job, but, curiously, their work can be copyrighted abroad.

REGISTERING A COPYRIGHT

This is very simple. You need to obtain a copy of Form VA from the United States Copyright Office, Library of Congress, Washington, D.C. 20559. If you are transferring the copyright to someone else, or you are trying to register a copyright for a work made by someone else, you will need a Certificate of Transfer or an Assignment of Copyright form. Some Post Offices carry these forms. Fill out Form VA, enclose two copies of the photograph if published, one if unpublished, and write a check for ten dollars to the Registrar of Copyright. Make sure *your name* is on the check. Form VA should be followed precisely. Complete instructions are on each form. Fill in every space that applies to you and your work. The law itself specifies the use of the "best edition" of work that has been published before registration with the Copyright Office for "deposit purposes," (i.e., filing). But what is "the best edition"? For a photograph, the Copyright Office will accept several different forms as "the best edition." Listed below are the Copyright Office's preferences.

1. The *most widely distributed edition.* This can be tricky; I ran into a problem with the Copyright Office recently in the matter of registration of a photograph made on a 35mm color slide. Remembering that a slide is a positive photograph, I thought I was being helpful to the Copyright Office by enclosing Type *C* prints from the slide for copyright registration, as I had been distributing both 35mm slide copies and *C* prints. This started a chain reaction, however, requiring a lot of discussion with that Office before the matter was resolved. Was a Type *C* print the best edition of the slide? I thought so, but the Copyright Office had its doubts. However, it was eventually accepted by the Copyright Office as a "best edition of the work," since the prints were accepted by my clients, and the copyright was subsequently issued. If you are using 35mm slides as your normal method of distribution of your work, the Copyright Office will accept high-quality "dupes."

2. Next in preference is an 8×10 glossy print. The Copyright Office will accept other sizes or finishes if necessary, but they must be of "best quality" to meet their needs.

3. They also prefer unmounted prints to mounted ones for space-saving reasons and, if possible, archival quality rather than the average standard paper,

printing stocks and methods of processing. They will definitely accept a good 8×10 glossy print as a "best edition."

But, ten dollars per registration? Isn't that a lot of money considering how many images a photographer takes in the course of a year? To register all of them would be practically impossible and costly beyond belief. This is not quite as bad as it sounds as you can register groups of images.

What the new Copyright Act really means is that a photographer cannot sue for an infringement unless the photograph has been registered in the first place. And here is where the change in the law of 1976 has not worked too well for the photographer as compared to the 1909 law. Since some of the photographs published prior to the new law can also be covered by the old law, I will discuss some of the ramifications of each law. I will also show you how to save money by copyrighting a large body of images simultaneously.

WHAT'S "NEW" IN THE NEW COPYRIGHT LAW

In the 1909 law the protection of artists was made subservient to the interests of purchasers of the material, and the artist remained the low figure on the creative totem pole. Witness that part of the old copyright law, ruling that those who paid or commissioned a work were the rightful owners of the copyright in absence of other agreements. The new law takes almost the opposite position—i.e., in the *absence of* a specific agreement in writing, such as a "work for hire" agreement, *the artist* owns his work completely and irrevocably.

Unfortunately, there are regressive aspects to the new law that do not always work in favor of artistic freedom. The "work for hire" regulation, while an improvement in many ways, as in its absence the artist does own everything, also puts a terrible economic pressure on the artist, implied or otherwise. Why? Because if he doesn't sign this agreement he may not get any work from those companies requesting such agreements, in spite of their protestations to the contrary that the signing of a "work for hire" agreement is voluntary. It is for this reason that the professional photographic societies are fighting this regulation and are trying to get changes enacted to eliminate the more objectionable—and unfair—parts of the law. Another vital change that works against the photographer is in the registration procedures and the loss of some rights as compared to the old law. In general the new law is a considerable improvement over the old one, and the photographer should take full advantage of the copyright law to protect his work.

Under the old law, once a work was created by the artist (photographer), he had an automatic "common law" copyright that was good forever or until the work was published. Then, if it was "published" with notice of copyright, i.e., a formal written notification to the beholder of the photograph that it was copyrighted, the author received what was called "statutory copyright" which protected him fully, except that he could not sue for infringment until the copyright was registered with the Copyright Office.

The early law did not specify how long the holder of the statutory copyright could protect his work without formal registration, but merely that it had to be registered before a suit for infringement could be filed. In a case that went all the way to the Supreme Court, a well-known newspaper columnist sued a newspaper for an infringement on a column he had written some seven years earlier and as he held a statutory copyright, he won his case.

Also, under the old law the court was obliged to award statutory damages in a proven infringement, and these damages could run as high as $1.00 per infringe-

ment, with each printed copy of an article considered an infringement. There was a limitation at the time of 5,000 copies per edition, but if the photograph or article ran in forty different newspapers via a syndicated service, and each had a circulation of over 5,000, for argument's sake there could be a statutory award of $200,000.

This changed with the new copyright law, with the Copyright Office now requiring that the photograph be registered within three months of the date of first publication in order to be eligible for statutory damages. If the photographer does not register his photograph within the three-month period, he does not lose the right to protection, but judges are expected to award considerably smaller amounts in case of infringements.

Awards can be made for proven damage by 1) infringement or, 2) if elected by the copyright holder, statutory damages. Under the new law they can range from $100 to $10,000, with special awards up to $50,000 in the case of willful infringement. However, with so much of this left to the judge's discretion, filing for infringement in the Federal courts can be expensive and uncertain. This applies for the most part to photographs made after the new law went into effect. However, copyrighted photographs made and "published" before the new law went into effect can, under certain circumstances, and in some states, be prosecuted under the old law, which set mandatory damage payments. If you should fall into this category, have it explored thoroughly by your attorney.

I have mentioned "publication" and "publication with notice" which are critical terms in copyright language. When the term "publication with notice" is used, it means the physical notation on the photograph of a copyright notice. This traditionally requires the symbol © of copyright, the word Copyright, or the abbreviation "Cpr.", along with the name of the owner of the copyright, and the year of first publication. In the United States, any one of the above is legal and acceptable. However, only the symbol © is accepted internationally. These notices, in the case of photographs, must be applied where they can be easily seen on the photograph. In the case of a black-and-white or color print, they can be on the edge or the back of the photograph, or on a transparency or slide mount.

Under the old law, if you failed to put notice of copyright on a photograph and published it, the picture generally fell into the "public domain" and your copyright was lost. The new law is more liberal. You are still required to put full notice of copyright on the work, and while you cannot sue for infringement until a registration is officially filed, you are given a chance to properly apply your copyright notice or file notice of copyright ownership in the event that you have inadvertently left the notice off a small number of copies. If you have put a notice of copyright on pictures and the users have left them off (or trimmed them off or blocked them out) then your rights are not lost, but you are presented with the complication of proving your ownership of the images.

One sticky area of interpretation under both laws is the definition of "publication." Does it mean that the photograph actually has to be printed before considering it published? No. The word publication itself derives from the Latin *publicatus* which means "to bring before the public." The Copyright Office defines publication (on their form VA) as follows:

"'Publication' is defined as 'the distribution of copies or phonorecords of a work to the public by sale or other transfer of ownership, or by rental, lease, or lending.' *A work is also 'published' if there has been an 'offering to distribute copies or phonorecords to a group of persons for purposes of further*

distribution, public performance, or public display.' The statute makes clear that public display of a work 'does not of itself constitute publication.'" (Emphasis added)

Note particularly those lines in italics because this information is critical for photographers who submit photographs for possible sale to a publisher.

If you shoot a set of pictures on July 1st, then send them to a publisher for possible sale, even if the publisher *does not buy any of them,* these pictures are still considered as having been published. If you had proper copyright notice on the pictures when they left your possession, it is considered "publication with notice of copyright." If on July 1st the publisher accepted all or some of those pictures for printing, and published them in an issue bearing a date a month or more later, then July would still be the date of "first publication" insofar as the Copyright Office is concerned. If the magazine copyrights the entire magazine, including your photograph, that copyright protects only the use of the picture in the magazine, but does not really protect you against other infringements. You still have to register a copyright with the Copyright Office if you want to preserve *your* copyright.

If you produce something for a publication, hand it over for printing, and they run it, you can and should demand, as part of your agreement, an assignment of copyright *back to you* if the work was copyrighted in the publication's name. Traditionally, in books where the publisher actually secures the copyright to a work, *your contract* with the publisher should have a clause in it clearly stating that the publisher will secure the copyright *in your name.* This is important, so examine your book contracts carefully to make sure this clause is in place.

Because it is quite clear that photographs offered for sale or use by a publisher are considered "published," it is important that every photograph so offered be done using one of the recommended delivery or leasing memos with all questions of use and rights properly described and acknowledged.

One of the biggest sources of trouble in the copyright laws is the "fair use" interpretation. "Fair use," up to the 1976 change in the law, was never clearly spelled out but evolved as a custom to be defined later by the courts. The new regulation did, for the first time, define it (see below) and we quote the Copyright Office "General Guide to the Copyright Act of 1976" as to their specifications of "fair use."

1. "The purpose and character of the use, including whether such use is of a commercial nature or is for nonprofit educational purposes;
2. "The amount and substantiality of the portion used in relation to the copyrighted work as a whole;
3. "The nature of the copyrighted work; and
4. "The effect of the use upon the potential market for or value of the copyrighted work."

Terminology of the regulation aside, what "fair use" really means is the right of people who do not own the copyrighted material to use it in their own work on a limited noncompetitive way. One way of looking at it is to measure whether by using your work without compensation you are competing with yourself. Another way "fair use" might be explained is that if you own a piece of land on an ocean front, you may keep people off your land but you may also have to grant access to the beach in the public interest.

But the real measurement of fair use also has to be based on the intent and purpose of the production using your work. We can illustrate by summarizing a

legal situation where copyright infringement was claimed. Some years ago one of the TV networks filmed a guided tour of the White House. In the course of filming the interior of the building the cameras came to rest for a moment on a painting on the wall and then moved on to other things. The artist whose painting was shown on the TV screen claimed infringement. Was he supported by the courts? No, because the fair use principle was applied here as the network was able to prove that whether the painting was there or not they would have been doing that documentary in exactly the same way. This was considered a fair use of the painting.

So, be prepared for an occasional unauthorized use of your work and make sure that if you claim an infringement or copyright damage, the user is not protected by the fair use concept.

The section dealing with the photographer's library lists a number of books and other publications with more specific information on the copyright laws as they may apply to you. I suggest you read them carefully and use the copyright law to full advantage for protection of your rights to your photographs.

REGISTERING LARGE GROUPS OF PHOTOGRAPHS

Registering a large number of photographs individually can be costly, yet some photographers feel they need protection of virtually their total output. How do you accomplish this legally without going broke at the rate of ten dollars per image? There are two ways of lowering the cost of copyrighting photographs. The Copyright Office is flexible and reasonable in the systems required for registering large groups of unpublished photographs. Nevertheless there are some guidelines that must be followed:

1. The materials to be deposited (i.e., the unpublished photographs you wish to have protected by copyright) should be grouped in an orderly way.

2. They should be grouped under a single general title such as "The Collected Photographs of _____, © 198___".

3. All the photographs submitted in this manner must have been created by the same person.

Pin up a large number of photographs on a wall. On an $8' \times 12'$ wall you can get, at most, 172 (8 × 10) photos, or four times' that amount in 4 × 5 contact prints. Shoot one clear black-and-white picture with an 8 × 10 camera if you have one or on as big a film size as you can and make two sharp, clear, 8×10's of this group. Register this single photograph for the $10 fee, send one print for unpublished images along with completed copyright forms, and you're covered. With groups of published photographs in periodicals, pin them up in the same way organized by month of publication (but only those covering a twelve-month calendar period) shoot and register it under forms VA and GR/CP.

This method is technically acceptable to the Copyright Office *if* every image to be copyrighted is clear, sharp, flat and readable. A better system is to bind large numbers of photographs in book form. You don't need a bookbinder for this, any simple method of fastening the pages of photographs securely together will be accepted for the single $10 group registration fee. However, you must follow an organized and acceptable format. You can use bound contact sheets, keeping all the black-and-whites together, and color contacts or 35mm dupes in another group. You can group the 35mms in countless pages of sleeves, or make up color contacts if you use negative color. The deposit materials must be the same size in all cases. Transparencies have to be either 35mm transparencies

mounted in cardboard or plastic, not in glass mounts. Contact sheets or other photocopies should not be less than 3″ × 3″ in size and not over 9″ × 10″, but 8″ × 10″ is preferable. With color you can also supply color photocopies such as the 8×10 photocopies of 35mm slides that are now available at a reasonable cost from retail copy centers. The great advantage of group picture registration is that once registered, you do not have to register again when individual photographs are published later. To sum up, the general use of copyright by the photographer is highly advisable and is an element of the defense of your rights. It can also be an important weapon in protecting your financial and legal rights and interests. Although somewhat complicated, it is by no means an insurmountable system and can normally provide simple protection for the photographer without the services of a lawyer. It is only when there is need for a lawsuit for copyright infringement, or using the copyright law to protect your rights, that engaging an attorney who is knowledgable in copyright matters would be advisable. The very act of copyrighting your work should inhibit most potential infringers.

One last thought on copyright litigation. The procedures of filing, registering and receiving notification by the Copyright Office can take a long time. Considering the volume of registrations that Office has to deal with (frequently hundreds of applications are received in one day in many classifications) it is amazing how quickly, in general, these are processed. But when litigation looms and the copyright has to be registered before suit can be filed, the normal time it takes to process a copyright claim can seem quite lengthy, and may seriously slow down the adjudication process. Thus the Copyright Office has a procedure for expediting the registration when speed is essential. They do, however, request that you not apply for "expedited handling" unless absolutely necessary, as it really does disrupt the orderly function of the Copyright Office.

BERENICE
ABBOTT

I have a special regard for Berenice Abbott, who, like Alfred Eisenstaedt, began to work as a photographer in the 1920s. She has consistently produced landmark photography covering a wide range of subject matter from portraits to splendid views of great cities, and even macrophotography of objects and physical phenomena. Even now, into her eighties, Abbott has the vigor and stamina to get into a car in New York City during a snowstorm and to drive back to her home in Northern Maine by herself, where she lives and works.

My personal regard for her stems from the fact that she was my only formal teacher of photography, and my two semesters of study with her at the New School for Social Research in New York during the late 1940s laid the groundwork for my own professional career. I salute her for this along with her devotion to and insistence upon quality and creativity. When I first started to study with her I asked a mutual friend to tell me something about her. I was told, among other things, "She's a hellion on technique, and if you try to cut corners she'll have your head—so watch out!" This was all part of her unyielding commitment to craftsmanship and professionalism, and talking with her today—some 40 years later—that strength is still apparent.

Abbott was a student at Ohio State University until World War I interfered, and she left her studies. She went to New York, taking with her a desire to become a journalist, though she later chose to be a sculptor. She led what she called a "desperate existence," doing odd jobs of any sort for sheer survival, including a try at debt collection, at which she did not do well. After three years doing such work, she went to Paris and got a job with Man Ray, an American artist who was experimenting with photograms, but earning a living with conventional portrait work. She did Man Ray's darkroom and finishing work, and it was with his encouragement that she tried making some portraits of her own.

Portraiture was then (and probably still is) a word-of-mouth business, so she began building a clientele by referrals. Abbott worked with Man Ray for three years during the 1920s before setting up a small studio of her own in Paris, where she began concentrating on the artists and writer of her community.

Starting with a 5 × 7 glass-plate view camera, she graduated to an early refex camera and soon developed a good reputation for making fine portraits with this type of camera.

I asked her what she charged for portraits in those days, and she made a point of saying that she charged whatever Man Ray charged because she did not want to compete with him on a price basis. She said it was hard to recall what she actually did charge, but it seemed to her that she was getting about 1,000 francs per sitting, which would have then been about 35-40 U.S. dollars.

At first, she said, she felt a little guilty about competing with Man Ray on any level as he had taught her all she knew about photography, but when people began coming to her because they liked her work on its own merits, she discarded these qualms.

She had begun to do well in Paris, but when she came back to the United States on a brief visit, she was overwhelmed by the spectacle of New York and felt she had to photograph and live in that city. So she closed her Paris studio and arrived in New York, just a few months before the Wall Street crash and the onset of the Great Depression. When the crash occurred, she felt this would not affect her as she had no money invested (nor did she have any money at all). She simply did not realize how that crash would affect everyone in the country, portrait photographers included. But as she had just opened her studio in New York, she kept plugging away at her portraits and concentrated on personal portraiture as she had in Paris. And as in Paris, more by word of mouth than anything else referrals came in New York too and she slowly acquired a following.

Her first editorial assignments were for *Fortune* in 1930-31, when she did a series of portraits for that magazine. Following that assignment, requests for her to do editorial work began to come in. She got her assignments then, as photographers still do today, by showing her work to editors and being persistent about it. True, there was not the competition that there is today, and she is well aware of that. Nevertheless, she thinks that the principles are still the same: in order to become known, your work must be seen, and if you see enough people and your talent is persuasive, your chances of getting work are good, though by no means automatic.

Abbott was fortunate enough to be chosen to participate from 1935-38 in the now-famous Federal Artists Project, a Depression-born program initiated by Franklin D. Roosevelt that gave artists, writers and other creative people a chance to earn a living. Abbott felt lucky to be part of this program, and it was during this period that she produced many of her fine photographs.

She began teaching at the New School for Social Research in 1935, and in 1939 her first book, *Changing New York*, appeared. It has since become a classic. She has had a number of books published since. *Berenice Abbott: American Photographer*, a new book about her, by Hank O'Neal, introduction by John Canaday, is published by McGraw-Hill, 1982. (O'Neal is also the author of *A Vision Shared*, St. Martin's Press, 1976, a magnificent book on the photographers of the Farm Security Administration.

Abbott had always been interested in science, and when the "New York period" had run its course at the end of the Federal Artists Project, she tried to get into scientific work. As a woman, she found doors closed to her, so she began taking on more commercial work. Speaking about priorities early in her career, Abbott explained that she loved photography first, and that she would photograph whatever work she could get in almost any field in which she felt competent. She told me that she never felt "precious" about her photography,

that she had always loved it in its many forms, and that she would continue to do so.

Abbott sought work by traditional methods: she made up portfolios, went around and showed them to editors, did some teaching, and gradually began building up a reputation that brought her more into commercial work. This gave her a chance to make a living and also to experiment with the things that fascinated her, such as developing new processes to improve scientific photography because ordinary photographic methods didn't seem good enough at that time for the work she wanted to do. She thought that the photographic equipment available to her at that time was limited, so she began designing her own cameras, tripods and lighting equipment, including an innovative spring-loaded pole for mounting lights that is now known as a "cat pole."

I asked Abbott about her feelings concerning craftsmanship, and about her satisfaction (or lack of it) with the images she sees today. Her answer was, as always, direct: "I haven't seen too many images that have impressed me!" When asked what she looks for and doesn't often find in contemporary photographs, she told me, "Significant subject matter, carried out with technical skill." She feels that this combination is lacking in photography today, except for the possible exception of sports photography and some photojournalism, which catch her fancy because when she was active, the lack of good fast optics and high speed emulsions precluded capturing much of the action we see detailed today on the pages of newspapers and magazines.

As for most of the photographic prints she sees, she is disgusted at the lack of quality. She feels that far too few photographers are taking the time to learn to make excellent prints of their work. As for having someone else print a photographer's work, she admits that it is hard for her to find any printer who meets her personal printing standards, although she recognizes that many photographers do have their work printed by outside printers.

On photographic education, she disagrees with some educators who are emphasizing an art background to the detriment of technical training, as she feels that the technical side of photography must not be neglected. She feels it is good to have an artistic sense, but thinks that if young photographers begin by studying painting it may render them self-conscious about the medium, which could be detrimental to their general training as a photographer. "Self-conscious artiness is fatal," she says, "but it certainly would not hurt to study composition in general." Having a basic understanding of composition would help construct a better organized image, she said.

It is her opinion that photographers today have become human rubber stamps in that they repeat themselves and tend to photograph the same things. Abbott feels they are passing up the realities of life around them in favor of imitations of other mediums. "Many photographers don't see and think enough," she commented.

When I used the word "abstraction" referring to photographic work, she became quite vehement and said, "Abstraction in photography is ridiculous, and is only an imitation of painting. We stopped imitating painters a hundred years ago, so to imitate them in this day and age is laughable."

I asked her if she had any gems of wisdom for the young photographer today, and she said, "None. They should just go out and photograph and stop talking about it. That's the only way they are going to find themselves. They can't do it in their heads—they have to go out and do it in the camera and get it on film."

CHAPTER 11
BASIC OPERATING NEEDS

BASIC EQUIPMENT FOR THE PROFESSIONAL

Putting together a kit of basic equipment depends so much on a photographer's area of specialization that listing recommended equipment is difficult. I am speaking not only to the photojournalist and the commercial studio operator but also to the in-house corporate and industrial photographer.

Equipment for the photojournalist has to be portable. Probably the most useful single invention for the traveling photojournalist is the small telescopic-handled cart that can stack four or five cases totaling about 75 to 150 pounds for wheeling through airport corridors.

To properly equip the new photographer for a broad range of capability on a professional level in 1982 involves a capital investment of about $5,000.

Going beyond the 35mm system is essential if you accept Ed Thompson's and Arnold Drapkin's assessments of craftsmanship in architectural, fine-arts photography, industrial or general studio work. There are other specialty cameras that can often be put to good use, but the new photographer should evaluate his immediate potential for this work and decide for himself if unusual cameras are worth their very high cost. Within this group are extremely wide-angle cameras with viewing angles in excess of 120 degrees (some new ones announced recently have a full 360-degree coverage). These cameras can do wonders but they are also "gimmicks" that must be used sparingly.

Two, possibly three different film sizes are basic. A 35mm system is mandatory, backed up by view camera capability, preferably a 4" × 5" monorail with appropriate swing lenses and accessories to save money over the larger 5" × 7" and 8" × 10" formats. Medium-format 120-roll film size is optional in either 2¼" × 2¼" square (6×6cm) single-lens reflex or the so-called "perfect" format of 2¼" × 2¾" (6×7cm), in either single-lens reflex or rangefinder types. Later, if need requires and budget allows them, you could invest in such specialty cameras as the "superwide" or underwater varieties. Underwater equipment is mentioned here not for actual underwater use *per se* but for tough environmental applications.

INSIDER: Ralph Morse

To assess the basic field equipment kit for the new professional I asked the advice of Ralph Morse, a veteran 30-year staffer with the old *Life* magazine, currently with the Time Inc. group of publications. Morse is noted for his coverage of the space program for *Life*. Over the years he has developed an amazing faculty for getting equipment to some of the strangest places. One rumor that he denies is that when the astronauts first landed on the moon, Morse was already there to cover their arrival. Morse is probably the most peripatetic photographer I know, and he reaffirmed my thinking that simplicity of equipment must be the touchstone for the emerging professional and agreed that a wise selection of basic equipment has to be an early priority not merely because of cost but also for reliability and dependability. He advises the new professional to avoid the highly complicated automatic cameras that are advertised to do everything. Not only are they horrendously expensive, "they are nearly impossible to service!" Some are in the shop more often than on location, he commented.

Morse's basic survival kit includes three 35mm bodies, six lenses with focal lengths of 20mm, 35mm, 85mm, 105mm, 200mm and 300mm, and a minimum of one motor drive. He recommends two motor drives if the photographer expects to do much remote work. He does not recommend the use of zoom lenses for the initiate because if a zoom is substituted, for example, for three standard-length lenses and is dropped on a concrete floor, then not one lens is out of service but three. Other specialty lenses such as the fisheye or the extra-long focal length lenses from 400mm up should also come later in the professional's career, in his opinion.

Morse's choice as a second camera system is the 4″×5″, preferably the variable-swing monorail type. An older "press" type with some swings on it will do for starters as well. He opts for only three or four lenses, starting with the 90mm wide-angle, a 135mm and a 200mm. As the sophistication and flexibility of the new photographer grows, Morse suggests that he might expand his lens inventory to include the wider-angled 65mm and perhaps some of the convertible lenses that can expand the working focal lengths to 400mm or 500mm. Ten film holders, possibly a roll film adapter, and most certainly a Polaroid back should complete this kit.

As for the medium-format camera mentioned earlier, Morse is ambivalent about it because of cost versus use. He says that even though he has uses for almost any system because of the variety of photography he does, he rarely uses his own 2¼″×2¼″ single-lens-reflex outfit, though there seems to be a vogue in the fashion studios for the square-format single-lens-reflex even though most of the finished photographs are cropped into rectangular shapes for publication. Thus the 35mm should be absolutely adequate for handheld use, and when superiority of 35mm Kodachrome 25 over most 120 film stocks is considered, the need for the square format declines, in Morse's opinion.

As the photographer's experience grows, he can begin to think more about specific camera equipment, including the addition of medium-format cameras. One of the best uses for the mid-size camera is for aerial photography, where negatives larger than 35mm are thought more desirable because of the detail required over a large area and the use of a studio camera would be impractical. Today the 6×7cm format with the near rigid body, pistol-grip handle, interchangeable lenses and film backs makes an ideal aerial camera and also can be used successfully for sports or other action photography where lightness of weight and mobility are essential. Wide-angle lenses, macro lenses, bellows

extenders and the underwater rigs can all come later when there is more money to spend and clearer direction toward specialization.

As for portable lighting, Morse takes the same approach—simplicity. Two or three portable flood lamps that are nothing more than plain sockets and variably shaped reflectors possibly selected from the Smith-Victor line, among others (with socket extenders for possible flash bulb use), alligator-type clamps or even ordinary sockets with reflector-type photofloods will often do as adequate a job as some of those nifty rigs all neatly stowed in a fancy case and costing $1,000 and up for the set. Two or three lightweight folding stands that reach eight to ten feet in height and can be weighted with anything that happens to be lying around will also cover most situations; and larger ones (to a 16-foot lift) are still available for under $100. Only when the young photographer has reached the high billing stage should he think of the 18-foot rollaway stands costing around $300 each.

When discussing the reflectors above, I mentioned a bulb extender for possible use with flashbulbs. Flashbulbs? Didn't they go out of date? One #2-type flashbulb will give out about the same light as 25 pounds of strobe gear, and it will take about 35 to 50 pounds of strobe equipment to equal the light emitted by one #3-type bulb. When you have to light a large industrial area, it's a lot easier and cheaper to string up eight to ten large flashbulbs than to "pack train" the equivalent amount of electronic gear that is easily knocked over, with the resultant smashing of $150 flash tubes. Flashbulbs can all be fired in sync by a variety of low-cost boosters and adapters on the market.

It seems ironic that on the fiftieth anniversary of the invention of the flashbulb, two of the three major manufacturers of large bulbs have discontinued them, but Sylvania is still marketing its line and plans to continue production for the foreseeable future. So don't be afraid to use flashbulbs. They are efficient, light in weight, and their cost can usually be billed as part of your operating expenses, whereas the cost of your own strobes is a capital investment that is hard to recover on a per job basis. Nor do you have any cost for transporting them once they have been used up.

And a warning to those who have never used big bulbs before. Be especially careful how you load them, making sure all electrical circuits are disconnected. If a big one goes off in your hand while you are inserting it in the holder, you won't die, but you will sure wish you had.

This penny-pinching dictum suits strobe lighting as well. I recommend the small 100–200-watt/second portable (battery/AC pack) strobe units without automatic or dedicated capability. The young photographer's mind should still be agile enough at this stage in his life to figure out exposures by guide numbers and leave the automation to those having more money or those covering hard news who may have to follow some VIP around through a variety of lighting situations and distances. As for the larger strobe equipment, I think that when the need for that stage has been reached, two or possibly three 600–1000-watt/second AC-powered strobe packs with extra heads, an umbrella or two plus a couple of slave cells will cover most situations requiring additional light in the field or even a small studio.

All of the above plus a good sturdy tripod and one or two good meters, including a strobe or color meter if possible, should give the photographer a good base to grow on.

When it comes to moving this equipment, Morse carries the three 35mm bodies and their lenses in one sturdy foam-filled aluminum case that he can hand-carry on board an airplane and stow under this seat. Everything else,

including film, extra-length lenses and lighting gear, he ships via air freight and thus (in the United States) avoids subjecting the film to X-ray contamination. As for shipping film rather than carrying it, Morse prefers shipping it, maintaining that if your fresh roll film is lost in travel you can always buy more at the drugstore.

INSIDER: MARTY FORSCHER

As for buying used equipment, I don't unless it is a specialty item with a good reputation that can be thoroughly tested before purchase. If and when I buy a used camera or lens I try to buy it only from the original owner in order to get some idea of how the camera has been handled. If you find some piece of equipment that looks okay, have it tested and examined by an expert and make your sale subject to its passing all tests. Lenses, unless they were abused or the coatings have deteriorated, don't wear out; diaphragms as a rule can be kept in good and free working order; shutters and release mechanisms can all be kept in good repair. Electronic components are a different story, and a thorough technical appraisal must be made before a purchase is completed.

New York–based Marty Forscher, probably the best camera repairman I know of anywhere, is known for a long history of innovative adaptations and repairs to some of the most complicated photographic equipment ever made. He and I talked at length about durability, repair and maintenance of all photographic equipment.

Forscher agrees with Morse about the need for a professional photographer to keep his equipment down to the simplest minimum. Citing a few of the biggest photographic names of our time—Duncan, Cartier-Bresson, Haas, et al—he said, "The common denominator among all those guys is that they use very basic equipment, mechanical in nature rather than electronic. Many of them don't have meters on their cameras. There are points to be made on behalf of each type of equipment, but the primary concern is that equipment has to be dependable. There is a direct relationship between simplicity and dependability.

"I am not opposed to technological growth," he continued, "but I find that with technological growth there comes a certain amount of dependency. One measurement I use to identify the professional is his familiarity with his equipment and his procedure in making a photograph. In this age of sophisticated technology, photographers often allow the instrument to override their own judgment, and that's wrong. It makes sense to make your exposure based on the meter reading, but protect yourself; never doubt your judgment and at least give it the benefit of making a few exposures predicated on your judgment. Usually you will find that *you* are right."

As for professional equipment he considers trouble-free, Forscher said, "Traditionally over the years the 35mm mechanical cameras like the M series Leicas, the Nikon Fs and F2s and the Canon F1 have been the backbone of the professional photographer's working gear. They are still being used, but all of them have had many of their mechanical components replaced by electronic functions. However, there seems to be a trend toward bringing back mechanical override capability so that if the electronic functions fail, the camera is still operable at the higher shutter speeds. Cameras with a combination of both make the most sense to me."

On the subject of the view camera, Forscher feels that some of the older and most reliable ones still being produced are the Deardorffs, Sinars and Cambos, all representing a standard of excellence that the photographer can rely on.

Forscher continued, "You can lay out guidelines and parameters about equipment, but the important thing to know is that you cannot live with only one camera. If you have a need for one camera, you must own two; if you have a need for two (for color and black-and-white), you should have three."

Forscher told the story of a photographer on a job shooting black-and-white and color whose color camera jammed. "He came and screamed at me! I just looked him in the eye and said, 'You're a professional photographer and you are not prepared to go on an assignment!' and I said, 'You can't possibly go out without the minimum of equipment, and if you need to shoot both black-and-white and color and you have only two cameras, you are not prepared.' You have to be prepared for the worst and from where I stand the worst always happens."

When asked where the biggest source of trouble is in the field, Forscher said, "Rough handling! But I don't want to be judgmental about this since I've seen professional photographers at work and I know it can be a very rough business. You have to understand the environment in which you work and have to take as many precautions as possible. I find that a lot of professional photographers are not adequately equipped. They are out in the field ill-prepared. They often go to Rome or Cairo or Bombay and there is no Marty Forscher around so they become frantic and phone me. I tell them to call the biggest newspaper in town or the news bureau of press organizations like AP, UPI, Time-Life, etc., and see if they can get some answers."

On transporting equipment, Forscher feels it advisable to hand-carry cameras on board aircraft, or at least the bodies and meters if not the lenses. The bodies are the most vulnerable and they too suffer from "jet syndrome." That is, when you put cameras on an airplane they're exposed to high-frequency vibrations and very often the screws vibrate and sometimes fall out. Every photographer should carry a set of small screwdrivers and tweezers as part of his travel kit, and every now and then, when he is sitting around a hotel room, he should check for loose screws, possibly back them out a turn or two *(do not take them out)* and put a dab of nail polish on the threads. That will lock them down permanently. Also be careful of batteries. They should never be left in a camera. The little batteries such as are used in electronic circuits sometimes explode after being subjected to the stress of flying, and if they will do that out in the open, think of what would happen if the explosion took place in a camera body. Professionalism is more than being able to create a fine photograph; it also means arriving on the job with dependable equipment in the best possible condition.

Considering the reality of working in the field, I want to add a few choice items based on my experience:

1. Never, never let a camera lie around in the sun without protection over the lens. The lens is a light-gathering instrument and can focus enough of the hot sun's rays to drill a hole through a metal shutter.

2. Never leave a camera, light meter or any other sensitive equipment in the glove compartment of a car or locked in a trunk in hot weather. Temperatures in these compartments can reach nearly 200 degrees and melt film, ruin batteries and electrical circuits, not to mention that unattended equipment is a temptation for thieves. David B. Eisendrath, Jr., the well-known and innovative photographic writer, says that a vinyl-covered locking steel cable, such as the type used for locking the hoods of automobiles or bicycles, can often be slipped quickly through the handles of camera cases, securely lashing them together while you wait for a taxi at an airport, thus foiling the grab-and-run thieves. You can also loop these cables through the iron parts of bed frames in hotels to inhibit theft.

3. Always carry a small kit of pocket tools, including jeweler's screwdrivers, pliers and especially a good loupe that will stay in your eye socket, or at least have a headband so that you can use both hands to make minor repairs. Two of the most important items I carry in my emergency kit are rolls of tape: standard "gaffer's" type plus a roll of the black light-proof paper camera tape available in all photo supply stores that can be used to make a quick patch on a cloth curtain shutter (and still roll with the spindles) or seal up a cracked camera body. Include a couple of small rolls of lightweight bell wire for emergency flash or strobe hookups, some tripod coversion screws and one "vise-grip" type plier with a swivel ball head fastened to one of the handles. This can make a marvellous and tough temporary tripod, light or prop holder. It can be clamped onto the back of a chair, a water pipe or almost anything else the jaws can span. Be careful, however, to protect the surface of whatever you clamp onto, to avoid marring it.

RENTALS AND OTHER SUPPLEMENTARY EQUIPMENT

I have been discussing the necessity for the new photographer to assemble, for as low a cost as possible, a reliable kit of cameras, accessories and supporting equipment. There will be times, however, when you have a big lighting job and find it impractical to string miles of wire for flashbulbs or don't have enough hands around to reload the holders after each set of lamps goes off; or when that specialty camera you thought you would never need is suddenly called for.

What is the answer? Rentals! There is no shortage of strobe and other lighting equipment for rental in almost every major city in the country, and if you are in doubt, a call to the manufacturers or distributors of the gear you want will quickly uncover someone near you who has the equipment for rent. I suggest that you do not go out and invest thousands of dollars in lighting or specialized camera equipment if you can rent it. Renting also means no maintenance or cartage headache. When you rent lighting on the spot, you know it's going to work, or if it conks out, the owner or service organization is usually available to fix it. You can probably rent enough strobe equipment locally to light up a huge public hall for less money than it would cost to air freight and deliver the same equipment from your studio, or if you are traveling to a remote place where there is no possibility of renting, then renting and shipping by air from the nearest major city would probably be less expensive than dragging it from home base.

The same applies for cameras. If you need something very specialized, it is likely that as a professional you can either borrow it from the manufacturer's representative at no cost or rent it reasonably from stores that specialize in camera rentals throughout the country. How do you locate these companies? Many are listed in the classified pages of local telephone books. In the newer photographer's reference books there are all sorts of listings for equipment rentals. A call to the nearest professional colleague in whatever organization you belong to will also probably give you a lead toward who has what you need wherever you are. Get in the habit of stuffing your ASMP or NPPA membership list in your camera case. Besides having someone around to have a drink with, it may be extremely valuable for local assistance.

For example, a year or so ago I needed to use one of the so-called "superwide-angle" cameras. To buy a new one would have cost $1,000, and I

was convinced that it was the best camera to do this particular job the way I envisioned it. I found the name of the U.S. distributor of this camera in the pages of one of the photographic magazines, called him and arranged to borrow one. In a half hour it was on its way to me by air and I was using it within six hours on a location 2,000 miles away. Rental pays.

Rental fees for specialized equipment are part of any job, and when billing for expenses you are expected to include them. This practice is not confined to commercial work but extends to every photographer who works on assignment and for that matter to every staffer on the payroll of a publication or corporation. When you are hired as a photographer, it's your talent that is being hired. It's not an extension of the "have gun will travel" philosophy. A craftsman is expected to bring his tools, but there are limits to what can be expected of the photographer. The new photographer should not have the slightest hesitation to add these rental bills to the specific expenses of the specific job, as it is customary for a client to pay for the use of extraordinary equipment.

Other rentals that the client will pay for without hesitation are odd-ball items like a cherry picker or high-lift truck needed to photograph traffic (if negotiated in advance). Do you need a high-lift platform, and the local public utility or sign factory doesn't have a bosun's chair or a snorkel truck? Try the airport career, whose trucks usually have high-lift platforms so they can roll food cars to the galleys of a 747, which stand thirty feet off the ground. The possibilities are infinite, but the thing to remember is that rental of extraordinary equipment is quite an ordinary procedure.

SETTING UP A GOOD HOME BASE

Your home base will say much about the way you conduct your affairs. You do not want to do business with some publication or client that looks like it won't make it through the end of the month, nor do you want to give others the impression that *your* business is unstable or disorderly. Just about the only visual impressions you can make on any of your clients will be those created by yourself, the external appearance of your office, studio or darkroom. These tangible indications express your ability to run an efficient, well-managed operation.

Do you need an office, studio or darkroom? The answer depends on the kind of work you will be doing. For photojournalists the answer is probably "no" to the questions of whether darkrooms or studios are needed. In this case, the business side of things can probably be taken care of in your house or apartment, with the minimum of a typewriter, filing cabinet and a few pieces of other office equipment. Some have rented desk space in commercial buildings; even a store front has possibilities if the rent is cheap enough, or you can share commercial space. Photographers planning to move into commercial work will need a studio, however, as well as some kind of office setup.

Do you need a darkroom? If you follow Arnold Drapkin's dictum that the photojournalist should know how to develop and print superbly (not merely adequately), you'll find that the best way to learn is in your own lab. You can take all the courses you want at the best of the technically oriented schools, but the final test will come in your own darkroom. After you have spent hours and hours of tough printing, you may begin to appreciate the craftsmanship of the W. Eugene Smiths and other masters.

I am referring to black-and-white processing and printing because even though you should know how to process and print color materials, many profes-

sionals feel it is unnecessary to own a color-capable lab at the outset of a career. There are some excellent small color-processing kits, but the necessity for computer-controlled chemistry, the heart of the modern color-processing lab, is beyond the means and even the practicality of the beginning professional. This limitation extends to the active photographer who does a reasonable volume of color work. But "reasonable" is a debatable word. A journalist who goes out for three days and shoots twenty rolls each day may think he is producing a lot, but chemicals for even sixty rolls will barely "wet" the inside of the tanks of the larger professional color labs. One of the major professional color labs in New York has a capability of hundreds of rolls of film an hour, all precisely controlled by computer for chemistry, temperature, replenishers and all other aspects of fine-tuned processing. Several authorities are absolutely convinced that even the most skilled and careful home processor of color materials cannot do a job comparable to any of the big commercial processors.

Also, the use of a color lab for professional work extends to other related services, and in the end it is wisest for the new professional to establish a good working relationship with the nearest well-equipped and competent color lab and let them do the fine processing required. With modern communications even the most remotely located photographer in any of the fifty states is but a few hours away from a professional custom lab that can handle all his needs.

Black-and-white processing and printing present other problems. In spite of the wider use of color in news, general interest and specialized magazines, there is still a substantial amount of black-and-white photography being used, and editors are rightfully demanding the highest print quality. Also, many news publications, from newspapers to magazines, need the prints almost immediately, as most news publications publish more frequently and have shorter "closing" times than those using color. So, does the new photographer need a black-and-white lab? Yes. Again, it depends on the circumstances of the individual. If you fit any or all of the following qualifications, you should have your own up-to-date black-and-white processing lab:

1. *Location.* If you are more than twenty-five miles from a quality black-and-white custom lab or a local lab that cannot provide immediate service.

2. *You are working for a newspaper or other news-gathering organization and do not have access to the lab at their plant.* Ditto if you are doing public relations or other corporate work and the company for whom you are working does not have lab capability or other equipment and facilities you need.

3. *If you are working on the local level as a stringer or for a variety of customers,* including walk-in trade and home, local, institutional or political clients.

4. *If you like to experiment and get the very most out of your negatives* and are generally dissatisfied with the work turned out by the commercial outfits. There are other influencing factors, including start-up costs, maintenance and the necessity for keeping the darkroom up-to-date. The growing technology of black-and-white as well as color processing makes it almost mandatory that the photographer stay current not only with his equipment but on new processing methods and techniques as well.

From the outset of this book, I planned on avoiding any discussion of highly technical processes or procedures, leaving that for the technical experts, but I will mention chromogenic technology to illustrate the problems of keeping up with the market and the high cost of remaining contemporary. Chromogenic films are a new breed of black-and-white film processed in "C-41" color chemistry and then printed normally. According to some experts this system produces superior sharpness, tonal gradation and every other feature sought in

black-and-white photography. It also appears to be particularly good with very large blow-ups of 40″×60″ or larger, and some experts are championing a changeover to this system. I do not wish to recommend any particular brand of film or type of processing but mention this only to demonstrate to the new photographer that he must be aware not only of new products and processes but of the necessity of considering the costs of such changeovers.

Therefore I feel it is important for the new photographer to establish a good relationship with the technical representative of each of the major film, chemical and equipment suppliers in his area. Most of them are only an "800" number phone call away, and when a problem arises they are only too happy to help. Since these services are free, you should not hesitate to use them. Make a point of having this information handy so you can use it when the occasion arises. Don't wait for a crisis. When you are in the process of installing new equipment or a new chemistry system, discuss your new installation with the experts.

When you decide to go with one system or one distributor, you will find a lot of technical doors opening for you, from the planning of darkrooms to water systems and filtration, even silver recovery if the volume of your work suggests it might be appropriate.

THE BASIC DARKROOM

I talked with a number of darkroom experts, including Ralph Baum, the founder and president of ModernAge Photographic Services, one of New York's oldest and finest custom processing firms, and Elizabeth Cunningham, an acknowledged specialist in the lab equipment field. The essentials of their recommendations are that a basic installation, costing approximately $5,000 (a capital investment), should act as the springboard for an efficient, modest-sized black-and-white lab and give you the option of doing some limited color printing and processing for little added cost. The basics should include the following equipment.

1. A good sink, minimum size 42″×60″, with direct drain so maximum washing systems can be used. Also an extra drain outlet if installation of a silver recovery·unit is planned. Baum also recommends a second, somewhat smaller sink with a separate drain for smaller-scale temperature control.
2. Four 16×20 trays.
3. Temperature-controlled water system with mixing valves, faucets and a large visible thermometer.
4. Nikkor-type stainless-steel rolls and tank capabilities of 2–10 rolls. (Installation of large deep tanks is not recommended until volume is over 40 rolls per day.)
5. Conventional hard rubber tanks for sheet film. Recommended film carriers are standard stainless-steel holders, four to a hanger.
6. A good condenser-type enlarger with flexible capability (35mm to 4×5). If larger negatives are anticipated, perhaps a used 8×10 enlarger can be acquired.
7. Contact printing system—either a standard contact printer or a large piece of optically clear ¼″ plate glass for contacting with the enlarger.
8. Professional-quality safelights and foot-switch-operated white lights over final fixing bath. If possible, an electrical interlock to prevent white light when paper supply is unprotected.

9. Washing equipment with a substantial water supply close to normal processing temperature. May be installed in a non-dark area with a print drop slot in the wall of the darkroom.
10. A work table of sufficient size, at least 28" from wall to provide access to all sides.
11. A small paper cutter.
12. Film dryer. Baum suggests a homemade one constructed of a steel clothes-storage cabinet with a small, well-filtered warm-air blower at the base to circulate warmed air at low speed.
13. Print dryer. With resin-coated papers, mechanical dryers are becoming obsolete. Some photographers still prefer heated chrome dryers that can be used for either ferrotyping or matte drying.
14. Ventilation, for temperature, humidity and dust control.
15. Slide copier or negative-duplicating equipment, handling 35mm to 8×10 transparencies and larger opaque material on copy stand. They need not be in "dark" area.
16. Small items: chamois cloths, compressed-air sprayers, static-reducing compounds, rubber gloves and tongs, a clean area for mixing and storing chemicals, brushes and spotting colors.
17. Refrigerator, for substantial film and paper stock supplies. (Long-range film storage should be in a freezer at $0°$ or lower.)

EQUIPPING A STUDIO

The new professional photographer must make the hard choice of whether he needs a studio in the first place. In many larger U.S. cities there are fully equipped studios for rent. Quite often the owners of these installations have extended periods of "down time" due to lack of business or being out on location and are only too glad to rent their space on a daily or even longer basis. So do not eliminate the possibility of renting a studio rather than taking on the burden of trying to equip and maintain your own.

However, if you decide to go the studio route, what do you really need? Again, Cunningham, Baum and others recommend that a modern fully equipped studio have the capability of strobe or other artificial lighting such as quartz or common tungsten. A source of natural daylight from perhaps a large skylight, or the new roof "bubbles," might be useful. Also required are the usual collection of scrims, flats, overhead banks, spots, booms, dollies, extra cables and overhead cable carriers if possible. Add your tripods, tables, and all other supporting gear, filters, gelatins, studio lights, formers, etc., and the total bare bones cost will probably come close to $10,000, considering that the average cost today of one 2400-watt/second strobe powerpack is close to $2,000. To this must be added the extra heads, stands, cables, slave cells and what-nots that could cost as much as the original powerpack. There are other pieces of equipment that belong either in the studio or lab, such as flat copying devices or electronic slide and transparency copiers. This equipment is becoming increasingly more useful to the studio, lab or agency that has to send many copies of a single transparency to a news service or other distribution organization. Some agencies are even now considering the installation of color Xerox capability so that nonreproducible 8×10 reference prints from 35mm transparencies can be airmailed world-wide for not much more than the price of the postage. All this and more has to go into a studio/lab operation, and acquiring all the equipment and constructing the actual space can be very costly in both time and money.

SUPPORT PERSONNEL

If you have a lab, do you need a staff? If so, *how* do you staff it? The acquisition of support personnel may require progressive steps beginning with the self-employed photographer functioning as his own lab chief, technician and studio assistant. But if you have gone beyond the beginning stages and are now generating enough business to require help in the lab, whom do you hire and what should you expect from them?

Availability of help will vary with the community. In New York there seems to be a chronic shortage of good lab people compared with the number of labs that are around. Printers and other highly skilled technicians are always in demand, but general assistants in the studio may outnumber the jobs available. We think it unrealistic to expect the beginning pro to be able to employ more than one person, at least for the first few years, though some of the more established studios employ as many as five persons.

When the new photographer starts to look for a staff, he should turn to talented younger people who want to be photographers and utilize their desires, knowledge and love of the medium. There is a real advantage to hiring smart beginners to work for you. You probably will not have to correct any bad habits or practices an older and presumably more experienced person might have already developed and bought with him. Do not overlook hiring handicapped workers. They can be especially useful within the confines of a darkroom area.

The same goes for office help. While you probably will need a person with standard office skills—typing, telephoning, filing, etc.—it might be wiser to find someone who has a background in art or art history or who at least has a feeling for graphics. Such an individual will be of inestimable value in selecting, editing and generally working with photographs. In New York and other states, there are programs of "cooperative education" both on the high school and college levels that provide part-time students in some specialty relating to your work who will work eagerly and devotedly for you as part of their training program. The advantage to you is either very low or no cost, depending on the program. The disadvantage is mainly one of short-term duration geared to the length of the school year.

Part-time help should not be overlooked, either. But whomever you do hire, do it on a straightforward, systematic and professional basis. Follow all local regulations insofar as working conditions, taxes, insurance and other benefits are concerned. If your business begins to flourish and it looks as if you are going to need additional permanent help, don't think it is too early to look into medical insurance plans and, even though it may seem light years away, employee retirement and pension plans. When the businessman is young and first starting out, all these things seem to belong on another planet. They don't. They are all part of the way a professional organizes a lasting career.

ORGANIZING, MANAGING AND PROTECTING YOUR HOME BASE

As for organizing and managing your office, the simpler the system you put in, the easier it is to manage. What *kind* of picture filing and retrieval plan you select is not particularly important as long as you select a good plan and stick with it, making sure it is self-expanding so you don't have to reorganize your entire system every few years.

SAFEGUARDING NEGATIVES AND TRANSPARENCIES

The physical protection of your work must be an objective developed early in your professional career. Although I am not talking about classification systems *per se* (which are discussed in the chapter "After the Assignment"), the physical protection system must be a type that will be compatible with your basic filing and retrieval system. Every image should be well protected at all times. Perhaps you feel you are not yet ready for fireproof and fire-retardant safes—not many of us are—but you should at least consider them, as some commercial labs and big corporate picture collections indeed use these storage methods. Black-and-white negatives of different sizes should all work together in a compatible system. All film should be edge-numbered as described in Chapter 8: the 35s cut in strips of six frames, the 120s in strips of frames that will fit a #10 envelope, and the 4×5s in individual jackets. Each negative or negative strip should be first protected by a chemically inert sleeve before storage in the customary paper jacket. Under no circumstances should you put an unprotected negative in any of those Kraft (brown paper) jackets because the high sulfide content in that type of paper can have a deleterious effect on the negative. Every outer jacket should have all pertinent file identification numbers on it. Indicate set numbers, date of processing, and paste contact prints or photocopies showing crops on the jacket if you have decided you want a negative permanently cropped and printed in a certain way. In the case of roll film, where there are opening and closing numbers on each roll, it will be of help in later retrieval to have those numbers listed on the jacket so the printer doesn't refile the negative in the wrong envelope. The negatives should all be kept in sturdy steel files. I have for many years successfully used standard 4"×6" steel card file drawers (many are stackable) with the center divider removed to accommodate a full-length #10 envelope of negatives.

Storage of negatives and transparencies is important. Humidity and the tendency of emulsions to mold are critical factors in planning their preservation. The cabinets should be in a well-ventilated room, and they too should be ventilated with small two-inch grilles inserted in the upper and lower back part of the cabinet, such as are used by carpenters for eave vents in house construction. You might invest in a dehumidifier or consider continuous air conditioning, especially if you are in a high-humidity environment, as it accomplishes the same purpose.

Fire control and other preservation tactics are also necessary. Don't store your negatives or transparencies in an area where a pipe could burst or rain waterflood the cabinets, for example. You might consider raising your cabinets off the floor and covering them with waterproof material. I doubt that even a heavily insulated fireproof cabinet will keep the heat of a major fire from damaging the emulsions. However, an adequately protected steel cabinet will probably save your negatives from sprinkler damage.

Other security systems should be considered. It is unlikely that your negatives or transparencies will be stolen, but cabinets should be kept locked. Rigid security against theft should be considered, and with the increase in crime and the near impossibility of getting adequate burglary or casualty insurance in some areas, casual attitudes about the safeguarding of your capital investment must be abandoned in view of pragmatism. If the premises are frequently unattended at night or on weekends, a secure burglar-alarm system should be installed. There are several types of systems available, and if you live in a small community with a fairly efficient and mobile police force, the silent alarm may

be the best since it will ring for assistance quickly and the chances of catching the burglars are relatively good. However, in larger and more heavily crime-ridden areas, an audible alarm, plus a direct hookup to a police station, would probably be better. However, it is necessary to secure a system that is efficient and well designed because with the increasing incidence of false alarms caused by inferior systems, many police departments have been ignoring calls, assuming they are false alarms, and some departments are even charging the owners of these systems a fine for false alarms. However, if you have invested $10,000–$15,000 in lab, studio and office equipment, the question of protecting your investment is a reasonable one and is a matter that the photographer must consider. Also, your insurance rates will be lower with a good system. A good photocell-activated system covering about 2,000 square feet with two automatic dialers, one for police and the other for your residence, can be installed for about $1,200.

Some of your thinking on this subject should carry over to your transportation methods as well. Thefts from cars are a continuing problem. Burglar alarms for cars are useful, and some insurance companies allow for a lower rate if they are installed, but I think the best insurance is never to leave unattended equipment in autos. If this is unavoidable, consider the ingenuity of the photographer who had a heavy safe bolted to the floor of the trunk of his car and carried his cameras in the safe.

INTERVIEW
BEN FERNANDEZ

Ben Fernandez, chairman of the department of photography at both Parson's School of Design and the New School for Social Research in New York and one of the brightest and fastest-rising names in contemporary photography, had an unlikely beginning to his career. Born in New York and 'street wise' in his youth, he put in two years at Columbia University, expecting to become a physical-education major. He made the swimming team and helped to support himself by working nights at a photo lab. He gave up school to become an operating engineer at the Brooklyn Navy Yard. Gradually he became more interested in photography. He bought a third-hand Leica and joined the Tri-County Camera Club in New Jersey. The Navy was then beginning to phase out the yard and offered him the option of moving to California or Hawaii as an operating engineer or being retrained in some other capacity. He expected he would be taught computer programming, but to his amazement they offered to retrain him as a ladies' hairdresser.

After a few choice and explicit descriptions of where the Navy could put their hairdressing program, he decided to make photography his profession. He had a friend who, though no photographer himself, was a personal friend of Alexey Brodovitch, art director at *Harper's Bazaar,* Russian émigré, famed teacher and counterpart of *Vogue's* Alex Liberman. Brodovitch's art direction was breathtaking and innovative, and his photographers' workshops were famous and influential in the development of many great photographers, among them Arnold Newman, Ben Somoroff, Ben Rose and Richard Avedon.

Fernandez's first publication in a major newspaper came in 1966 when *The New York Times* ran pictures he had made of a draft-card burning. He began to be published more frequently during the next six months and felt he had really arrived when he had a *New York Times Magazine* color cover of an anti–Vietnam War demonstration. In July of 1968 he had a book published by Da Capo Press called *In Opposition: The Right of Dissent in America in the 1960s.* During that same month, a show of his photographs called "Conscience, the Ultimate Weapon: The Role of Dissent in America in the 1960s" opened at George Eastman

House in Rochester and became one of Eastman House's longest running exhibitions.

As an educator, Fernandez is a great believer in using photography as a tool for social communications. He prides himself on being one jump ahead of trends because, as he has said, "By the time it became fashionable to photograph dissent in America, I was already beyond that and ready to move on to something else." He did not leave dissent photography because it was no longer needed, but he felt that it would survive without him. His photography was his measure of protest, and so by 1968 he was using photography more in the cause of political action than of political dissent.

On a personal basis Fernandez became close to the Kennedy family through a most curious way. Like many other photographers, he eked out part of his livelihood by photographing weddings. A lot of this work seemed to be around New York's Plaza Hotel, and on several occasions Robert Kennedy was present. Fernandez, refusing to act the "paparazzo," did not make any pictures of Kennedy or other celebrities who were there, relying, he says, on his own good taste not to encroach on the private lives of these people. Evidently Kennedy became aware of the photographer who did not invade his privacy. As a result, Fernandez was invited to photograph the communion of one of the Kennedy children. Through this assignment, he met the rest of the Kennedy family and by doing so also became involved with the civil-rights movement. He met and became friendly with Dr. Martin Luther King, covering much of King's civil-rights work and eventually producing a book with him called *Trumpets in Freedom* for a Canadian publisher.

Fernandez won a Guggenheim Fellowship in 1970 that allowed him simply to go out and make photographs; he then operated a commercial studio in New York for about six years. Photographic education began to interest him, and he started a novel free school for children in the ghetto, with its headquarters in the basement of the Public Theater. "Combatting Mental Poverty" became the theme of his educational project. He knew that in order for children to combat mental poverty they needed education, and photography, he felt, was an important educational tool. The only charge for his courses was the agreement by some of the students that they would teach successive classes of children coming into the program. In this way he established a nearly self-perpetuating system of keeping the school going.

To Fernandez, education in photography is now his main activity; his dual chairmanships in two prestigious schools have presented him with an opportunity to develop photography as an educational method. Fernandez strongly believes that a socially aware photographer will be a better commercial photographer. This is the keystone of his educational philosophy, and he anticipates that many of his students will go on to fine careers in photography within this humanistic framework.

His approach to photographic education is far different from the approaches used by most schools and colleges. In his own earthy way he compares photography to a social visit to a friend's house, saying, "When you visit someone, you don't come without a present." Pursuing this analogy, he adds, "When you come to photography, you don't come empty-handed either. If you do, you'll get empty pictures. This means that you have to bring something with you— you must have a point of view, a position, something to say. Photography is not a field in which you can develop something out of nothing. A camera just sits there, like a pencil. It does nothing without a thought. If you have no thoughts,

you are not going to be a photographer. If you want to be a photographer, you have to start having something to say.

"Usually that means you need some sort of education," he continues, "because education helps you to formulate and condense ideas so that you can then relate to something. In photography, you want to amplify that something. You want other people to understand it, and thus you start developing what I call a 'visual vocabulary.' With a pencil, you have to learn your ABC's; with a camera, you have to learn the basics, too—composition techniques, color balance and so on. In that respect, photography is no different from any other sort of learning."

Primary to any photographic education, Fernandez thinks, is the need to spend at least two academic years learning all there is to know about film, cameras and optics, as well as the many ways of extracting the fullest photographic image from any shooting. Color must be included, and with the advent of electronically produced images, the student should also learn what image-producing problems have to be dealt with in that medium. There are many ways of learning the technology of photography, he thinks, but the key to all of them is the thorough grounding in a knowledge of the capabilities of film and tape. Without this understanding, all efforts to produce fine photography will fail. The bottom-line question Fernandez asks is "Will the student be able to speak visually?"

He cautions, though, that the student should never be so carried away by technique that he loses sight of his objective. Fernandez has seen too many young photographers get so caught up in technique that they lose the emotional impact of making good images. The photographer has to walk the thin line between technique and creativity, and it is unimportant how many ways he knows of doing something, Fernandez thinks, so long as he knows the best way. He should be able to use his knowledge without being confused. Thus, he must know, for instance, the qualities and capabilities of the wide-angle lens or of the view camera or of any other special tool that has to be used in special circumstances. In addition to the two years spent on optics, film and processing, another year is needed to learn about other mechanical requirements of photography.

"What I get nervous about," he adds, "is the student who gets so caught up in the theory of an idea that he never executes it! And that's the part that's frightening. Every job is a learning experience and each time he should come back a little wiser. Come to the job with knowledge, but expect to leave it with more. And don't come with just enough to make yourself look like a fool. You don't need to embarrass yourself or your client."

He cautions against the student accepting too much from the manufacturer. Fernandez warns about having the machine do the thinking rather than the photographer. This is where every bit of knowledge about lighting, exposure, motion, depth of field, etc., should be brought into play in order to create the best possible photograph of any situation.

"It's the false notion that pictures are made easily, as the result of new automation, that tends to make so many pictures look alike, have the sameness (and dullness) to them. The photographer caught in this trap is one who does not experiment with lighting, motion exposure, and thus does not bring anything new to the problem. This is where these minimum years learning the craft of photography are so important."

He also stresses the importance of camera clubs, at least for the beginner. He feels they are an excellent arena for the exchange of ideas, especially for the student who is not taking technical courses anywhere else. The basic aim of

camera clubs, he points out, is to improve photographic technique rather than content.

Fernandez worries, too, about the direction he sees photography taking today. Knowing virtually nothing about art, young photographers are choosing the camera to produce an art form quickly, with little or no effort. The result, he says, is banality and dullness and, even worse, outright copying of someone else's style. When Diane Arbus had a major museum exhibition some years ago, for the next year all Fernandez saw were "knock-offs" of Arbus's style. Those photographers were looking for a rapid success without understanding the true art form involved. He also feels that the young photographer today is being taken advantage of by persons or schools fostering the illusion that photography is easy and that, in order to earn big bucks, one doesn't have to learn too much or "bring too much with him." He blames much of this attitude on manufacturers who want to make photography look painless in order to sell equipment and materials.

Fernandez tells his students that if it is monetary success they are looking for, they may very well be disappointed. He reminds them that for every highly successful Richard Avedon, Arnold Newman or Irving Penn, there are probably thousands of photographers who will never produce anything remotely resembling that body of work. But, he says, "If a photographer has what I call the *L* (for *longevity*) factor, he will probably make some fine photographs in his time." Fernandez then adds, "The photographer must also have *chutzpah*, and if he doesn't have it, he will never make it."

Fernandez approves of continuing education for the photographer because any new education is a plus factor, especially if the photographer has a need to know something about a new phase of photography. He is also concerned about the photographer's commitment to improving his skills or point of view and his commitment to photography in general.

He therefore feels that the people he is after as students or other hopefuls are capable of making decisions, and have arrived at the point where they want to explore themselves with the camera. Those are the people who are going to make good photographers, because they are curious and they work with their cameras to solve their curiosity. As a byproduct of all this they can look at their "curiosity" and enjoy it vicariously. So his main thrust is for photographers to develop a point of view, and he feels that education is probably the most practical way to do it.

CAPITALIZING ON—AND EXPANDING— YOUR NEW REPUTATION

PHOTOGRAPHY AS A FINE ART

Exhibits, galleries, and fine-arts publications—this is truly a difficult area as far as making any money for the new photographer is concerned, but by no means can it be ruled out completely, for there are striking opportunities in this field.

There has been a tremendous increase in the gallery sales of fine-arts photography due to the proliferation of photo galleries which are devoting themselves exclusively to this form of the art. In New York 20 years ago there were perhaps one or two galleries that were art galleries by definition but handled fine-arts photography as well, although the photo end was really a sideline. In recent years, however, many major photography galleries have opened and some well-established art galleries have added photographic departments. There are now probably 20 in New York alone and another 200 scattered across the country, not to mention major cities abroad. But is this a good market for the newcomer? Probably not, unless the photographer is very avant garde and has come a long way very fast. In order to be shown in a major gallery for print sales, a solid reputation resulting from years of work is required. Ansel Adams, long considered the dean of American photography, particularly in the area of landscapes, can now command $5,000 at a gallery for a print, and he is represented by several different galleries. At a recent auction one of his prints of "Moonrise Over Hernandez" sold for $47,000 and reportedly resold privately for $70,000. Gordon Parks, the noted photographer, recently had a show in New York where some of his color abstractions in print form sold for $6,000. Richard Avedon, the well-known fashion photographer, had a major show at an important gallery where some of his prints sold for as high as $7,500.

Lesser-known names in the smaller galleries can do fairly well. Marjorie Neikrug, who runs a fine gallery in New York, has a constant parade of well-known and lesser-known photographers on view, as well as an extensive collection of historic photographs and artifacts. Many of her print sales are in the $200 to $300 range but can go as high as $20,000. The art gallery market is not restricted to New York. There are galleries in Chicago, Texas and California, all

selling from the highest to the lowest ranges quoted above. Museums that buy and sell constantly are a big market for the galleries. There are some curious stories about museum acquisitions (via some galleries) that are reminiscent of the yarn about the wholesale grocer who peddled a carload of spoiled sardines through several levels of commerce and remarked, when someone protested that they weren't fit to eat, "Of course not; they are only for buying and selling."

True or not, gallery sales, or even exhibits with direct sales, can lead to other things, primarily getting the photographer's name around to the public. Gallery exhibits invariably require posters, and there are some posters that are almost as much in demand as prints themselves, in the same manner as posters of art exhibitions are in themselves a form of collectible art.

Nongallery exhibits can lead to sales, even if they have not been held in commercial art galleries. Frequently photographers can get free exhibit space in other public areas, such as a press club, bank lobby, community center or recreational building. I know of one exhibition program of waterproofed photographs held out-of-doors in a major public park that brought a good response to the participating photographers. Many advertising agencies make exhibition space available to upcoming photographers because they want their art directors to see fresh materials. It doesn't always produce work, though, for the photographer.

There is also a growing market for corporate art photography on a purchase basis, but nonstaff. Years ago the great photographic files were frequent sources for employment of working photographers. The Standard Oil of New Jersey picture file was a model for many smaller companies. Most no longer exist to any great extent. One major public utility not too long ago explored the idea of making grants to photographers on a public-service basis but dropped it when they ran afoul of cost-conscious noncreative executives whose only awareness was of the potential reaction of stockholders to expenditures that wouldn't even have caused a flicker on the computer when it came to totaling up the annual statement. Yet they have little hesitation in spending vast amounts in the public-broadcasting area by sponsoring and contributing to programming that, however subtly played, does flash the logo of the corporate benefactor before the public. While this takes care of the corporate conscience in contributing to the arts, it does little for still photographers. It seems ironic that so many of the huge corporations that have profited handsomely from the world of still photography have done so little in supporting genuine creative photography as an art form.

INSIDER: GENE THORNTON, CRITIC

As fine-arts photography becomes a part of the photographic world, so does criticism play a part, and I spoke with Gene Thornton, a well-known photographic critic. After attending a small liberal arts college, he later studied at the Art Students League and Columbia University, did some painting, but never worked as a photographer. He wrote the art page for *Time* magazine, and when the much-respected critic Jack Deschin retired from *The New York Times*, Thornton began to write on photography for the *Times*.

When he first started writing criticism, he didn't know very much about the technology of photography. As far as he was concerned, "pictures" were what he was used to writing about and, while photographs were made in a different way, they were still "pictures" and he approached them in the same way. It was not until he gained more experience that he began to see photographs in a

somewhat different light. He writes about photographs not as journalism but purely as fine art for display and sale. He knows few photojournalists and has little professional association with them, except when occasionally a journalist/photographer may appear in a gallery exhibition, such as W. Eugene Smith or Richard Avedon. Thornton agreed that art photographers were coming out of the art rather than the journalism schools, but that a good photographer in the commercial/journalism field need not have an art background, though it might be helpful. After conceding that he knew of no reason why any photographer would look on fine-arts photography as a potential source of primary income, he admitted that there were many around, however unrealistic their beliefs. He thinks that the influences in their training determined the audiences they were looking for—that is, a photographer who had his training in the history of art might tend to have his photographs influenced by painters, and others trying to fit into the modern art mode might be more influenced in having their photographs resemble photographs rather than paintings.

I asked Thornton what he looked for in reviewing the work of a photographer unfamiliar to him. He said he tried to approach the work with an open mind, realizing that there were few around today who did not "borrow" heavily from someone else or show strong influences of another photographer or painter. As a photography critic and writer, when he starts to review a work the first question he asks himself is, is this something I can actually write about, or what can I say about it? Is it a unique vision, or derivative? I asked him how many shows he viewed a year and he said he had seen many more than he had reviewed, feeling that in too many cases there was nothing to write about that would demonstrate the uniqueness or originality of the work.

But he continues to look and every now and then will spot a genuine new and fresh talent, even though most of the shows he sees are by photographers who have exhibited before. When I asked him if he discerned changes or improvements in a photographer over a period of time that were noteworthy, he said occasionally this did happen but it would be more readily apparent when a photographer changed his style markedly; for example, Lee Freidlander's change from "street photography" to view-camera work with possibly a lot of influence from Atget. Another photographer who apparently went through the same kind of artistic change was Joel Meyerowitz.

Craftsmanship is tough to measure in fine arts photography because often it is difficult to see what the photographer is trying to achieve. Certain photographers try to make a photograph look like it was made "accidentally" or haphazardly, to give a certain cachet to the image, and it may require superb craftsmanship to produce this accidental image. He mentioned one woman photographer who was making what he thought was a very conscious effort to have things look "accidental" but that's the way she attempted to show her work. He has also seen prints where there has been a conscious effort to make things go wrong, and if he knows the photographer and knows he can print "properly" and with quality, then he will give consideration to this "reverse" craftsmanship. But on balance it seems that the ground rules are different in fine-arts photography except where "straight" images are presented and superb printing is essential.

Talking about the enormous increase in the number of photographic galleries since he first began writing photographic criticism, Thornton said photography has entered the market in a way that far exceeded the expectations of dealers who sold paintings, etchings and engravings. This is partly a result of what was happening in the art world. It might have been the end of an era of the

availability of good, reasonably priced paintings. With galleries having all that space but nothing fresh coming in and with the rise in general interest in photography, it was a natural succession for them to take in photography. A second contributory factor, he speculated, might have been photography's general condition. The magazines were dying, advertising space was being reduced and television was preempting much of the advertising dollar, so the photographer sought new outlets in the fine-arts markets.

Thornton was skeptical that fine-art photography could be a viable source of income for the new photographer. Some photographers claim a living from their art photography, but he felt, as Capa did, that those who sold even moderately well in the galleries usually had the cushion of a teaching post somewhere. He noted a curious phenomenon in that while many well-known journalists and commercial photographers are showing in the galleries, very few gallery photographers can attract enough recognition to earn editorial or commercial assignments. Thornton also feels the gallery route is not the steppingstone to commercial fame because for the most part gallery photographers generally look down on commercial photographers and think commercial work is beneath them.

I asked him why any young photographer, knowing that earning a living in the art market is so precarious, would pursue it unless for purely artistic recognition, in itself dubious considering how little space is available in the press for photographic criticism. Thornton replied, "Well, they certainly do not think in the same terms as a commercial or journalistic photographer does. They think of themselves first as artists who happen to use the camera instead of brushes. They are used to the idea that artists do not necessarily make a living and they think it is wrong, but they are used to it. Maybe they are naive and confused when they hear that the Avedons and the Adamses make a lot of money and why shouldn't they, or perhaps when they start they don't know they cannot make a living and enter the field blindly."

ADVANCING YOUR REPUTATION THROUGH GALLERIES AND EXHIBITS

Working in the creative arts is different from other jobs in that you do not leave your work behind you when you walk out the door. Photography becomes part of your very existence, and many of your personal pleasures from photography will come from exhibitions, other public showings, or the sale of prints in a gallery. All can enhance your income.

The photographic gallery is a potential market for the beginning photographer, though it has its limitations. Money is only one reason for participation in a gallery. Much satisfaction comes from recognition, or the pleasure received from knowing that your photograph is being purchased for its beauty and not, as one old newspaper man once told me, to simply prop two columns of type apart in a printing form.

Today, sales by a major gallery are an important, if not the primary source, of income for many photographers, particularly those who do not actively pursue journalism careers or specialize in studio work. Yet a number of so-called commercial, or journalistic, photographers have made it into the big galleries—i.e. Avedon, Parks, Penn, Smith, et al., where their sales can command four- and five-figure dollar amounts.

Most gallery operators were trained as fine art dealers, curators, lawyers and other diverse activities, none of which required any professional handling of a

camera. One outstanding exception is Cornell Capa, former *Life* staff photographer, brother of famed war correspondent-photographer Robert Capa, and now director of the International Center of Photography in New York. The Center not only mounts important photographic exhibitions, but provides many other services as center of photographic learning and as a photography museum.

INSIDER: KEN HEYMAN

In New York, where the majority of the fine arts photographic galleries are located, a new gallery called "Photograph" opened and, contrary to established custom, was owned and operated by Ken Heyman, a well-established photographer of the sociological scene. Heyman has had a long career in photojournalism, is well-known for his collaboration on several excellent photo books by famed Columbia University anthropologist Margaret Mead, and all together has published fourteen books. I asked him to explain the enormous rise in popularity of photography as a fine arts market and the large increase in the number of galleries across the country.

He attributes this to a curious situation in the educational system for photographers and photography. Photography, he says, was, and still is, the number one hobby in this country, yet even thirty years ago the idea of taking photography as a college credit course was virtually unheard of, with only one college in Rochester giving such courses. Today, he pointed out, there is a directory the size of a telephone book of college courses in photography. In his opinion the directions taken by these courses were steered by institutions who required their instructors to have degrees in education. Even though there were virtually no advanced degree programs in photography around, most colleges refused to hire working journalists without photographic education degrees to head or teach photography courses. Therefore the only "qualified" teachers were those in the college art departments who had their Masters or Doctorates in art history or art education. Consequently the photography taught was an artistic appreciation of photography. Thus, thousands of young people have been graduating with some photography experience and feeding into this growing art photography market. It is from this art-oriented group that the pressures come to be shown in the galleries rather than the pages of a magazine or newspaper. Heyman feels that the serious artist/photographer, coming out of a university with a degree in photography, is not much interested in knowing how to do an assignment but is more interested in learning how to develop styles that he can exhibit and sell through a gallery.

He went on to say that because some of the prices earned by art photographs have been so extraordinary, it has given impetus to the young person who wants to be an artist/photographer. Many schools now are actively feeding this market. Teachers urge their students to paint on the photographs, destroy them, tear them, paste them back-to-back—in short, to try *anything* in order to evolve a personal, saleable style.

So, for the art photographer it is more important to develop a style, no matter what it is. What is important to the gallery is that the work should also have some beauty or mysterious quality that makes it attractive.

Heyman emphasized that the average journalist photographer does not understand the art photo buyers, yet he may think his work is of gallery quality without realizing the demands of the market.

Referring to an exhibition held several years ago at the Museum of Modern Art called "Mirrors and Windows," Heyman said the title itself is a fine expression of the meaning of photography, and separates what is art from what is

journalism. The "mirrors," he says, are the Cartier-Bressons, and Alfred Eisenstaedts, the journalists of the world, because they reflect without an interpretation, but compose in their unique special way, what they see on the outside. The art photographers are the "windows." The most successful ones are not necessarily the Ansel Adamses but are more like Duane Michals, one of the more intelligent photographers who creates his own world. He expects viewers to enter his window, or soul. He is a true artist creating in his own style, and he now sells enough so that he does not have to do straight commercial work any longer, even though for many years he built a good reputation in fashion photography and produced a good deal of other excellent commercial work.

As for making a living from gallery sales, Heyman feels there is no question that some photographers make a very good living from the sales of unusual forms of photography. He also confirmed the discussions we had with Marjorie Neikrug of Neikrug Gallery in New York on the high percentages that most fine arts galleries have to take in order to stay solvent. He added that when photographs are sold at special exhibits, an extra 10 percent has to be taken out for the higher costs of participation in the exhibition, i.e. mounting, framing, promotion, etc. He suggested that a new photographer exhibiting for the first time in a gallery could expect his pictures to sell in the $200 to $400 class per print.

EXHIBITION OUTLETS

Sales to or through galleries are not the only outlet for personal photography. By personal photographs I mean those which are not produced for reproduction in a newspaper, magazine or other graphic media, but are made for the pleasure of seeing them hanging on a wall in someone's home or office or exhibit space, whether public or private.

Hanging one's pictures in a gallery or selling them in an outdoor exhibit are only a small part of the efforts required for exhibiting your work. It is virtually impossible for a new and unknown photographer of any age to achieve top museum exhibitions because of lack of space, money, and often, all too sadly, talent. It is only the established "name" that will draw in the audiences necessary to support any institution that depends on public support from endowments, grants, gifts, or admission fees.

There are many institutions that, in whole or part, are devoted to photography, to helping develop talents and directions for new photographers and in turn can, by participation on the part of the photographer, be a source of stimulation to achieving much desired goals in photography. One preeminent organization is the International Center of Photography ICP on New York City's "Museum row" on upper Fifth Avenue. In eight short years it has achieved the near miraculous position of being the primary "House of Photography" in the world. Dreamed of, conceived by, and directed by Cornell Capa, it has fought its way through the tightest of budgets with limited grants, all too little public funding, and far too little active support from the new working photographers it is trying to help, in order to achieve its prominent position. ICP is a vital institution occupying five floors of a large building full of galleries, classrooms, workshops, a museum book store, and meeting rooms, all staffed by 40 people not including volunteers, teaching staff and part-time employees, all devoted to making this the primary center of photography anywhere.

ICP does have galleries and exhibit space and indeed shows many photographers who are new and relatively unknown. But like so many other institutions of a similar or near similar nature, they are swamped with requests for exhibits that they cannot possibly handle. In its caring way, however, it at least has set up machinery for dealing with the hopefuls, both new and old, who want to achieve recognition of their photography. This does not mean that anyone who secures an "audience" is going to have a show. Far from it. Only a tiny percentage of them can be accommodated, but many have been pointed in other directions, to other institutions which could use their material, and to additional classes and workshops within the ICP to broaden their concepts and interests in photography. Many have had their work published because of leads given them by staff of the ICP and, because of new directions, to rechannel their photographic efforts. The curating staff is currently directed by Mrs. Ruth Lester, formerly contributions editor at *Life* magazine for many years. She is sensitive and caring, so that an appointment made by phone or letter to her will usually result in an interview, and often some pretty solid advice about the next move to be made in that person's photographic life.

However, failure on the part of the photographer to achieve any actual exhibit support from ICP is not a reason to lose interest in this organization. On the contrary, membership in the ICP by the new professional photographer, regardless of where he lives, is important and useful because it will keep him in touch with the photographic community, and keep him aware of artistic trends and developments through its exhibits, bookshop and traveling shows. There are other institutions in other parts of the country that provide some of the same services, but they usually are part of larger museums with photographic departments, and are not wholly devoted to photography.

DISPLAY AND EXHIBITS—THE PERSONAL SIDE

In my office I have a small but ongoing traffic with people who want my photographs for personal display, and aside from the small fees I charge for these sales. (I like to limit them because this is not a primary source of income.) I enjoy having the personal satisfaction of making my work available to someone who will obtain pleasure from it. As a result, I have sold photographs to friends and strangers alike, to interior decorators, and corporate art buyers. Most of these opportunities are probably also available to you in your area.

There are many other ways of securing space for your photographs. Personal exhibitions that can be moved throughout the area where you live for display in public and private institutions not only will provide a great deal of satisfaction but will publicize your name until a recognition level is reached that will start paying dividends.

Even donating photographs to charity or public service auctions can be a good source of personal publicity. When these pictures are auctioned off your name and your work will come before a very large audience.

Personal exhibit programs can be expensive but can also be charged as legitimate promotion costs. I know several photographers who organize well-designed traveling exhibitions of their work, reserve public meeting rooms in major hotels around the country, and invite every art director, picture buyer, museum curator and director, and anyone else who could possibly be interested in their photographs to come to an opening cocktail party of the exhibit. Everyone likes "openings"—especially when there is an open bar—and a good publicity program can usually result in substantial local press coverage. One

photographer told me the return he receives from jobs that come in because of this approach far exceeds his costs.

Public speakers bureaus and booking organizations will often book photographers (those who have interesting material or are well-known) for lecture and slide tours before all sorts of private institutions and service club audiences. The fees are good, considering that little more is needed than a good projector, a reasonable stage presence, and an interesting set of pictures.

TRAVELING SHOWS

Traveling shows, like a photographer's personal portfolio, require careful thinking and selectivity of material, and their design and construction are critical factors. A show, just as a portfolio, should have a theme, as it is the deciding factor as to where this show is exhibited and under whose auspices. The most critical decision in planning a traveling show is whether it will travel by itself and be hung, or set up, by others at the destination, or whether the photographer, agent or anyone else will travel with the unit and do that work. Once those decisions are made, the next step is design and construction. Will it be made of free-standing panels, or single sheets to be hung on a wall? Shall they be framed, matted, or mounted, and if so, on what sort of material? Weight is always a factor in anything that has to travel, as are durability and resistance to damage. For this reason I always automatically rule out any pictures that are framed or mounted behind glass, as they can break easily during transit. Plastic, such as Plexiglass, is quite expensive and also scratches easily.

For sheer simplicity there is nothing that looks better in an exhibit area than a beautiful borderless print that has been carefully spotted and dry-mounted on a foam-filled mounting board with a Kraft paper sheet mounted on the reverse side to reduce curl. A wet-mounted "wrap-around" print is even more handsome and is far more resistant to damage than a conventional one. In this process a print is made with an allowance of at least 4 inches on all sides of the print area. The print is soaked in water. A piece of ⅛-inch or ¼-inch tempered cardboard is cut to the size of the print, the edges sanded smooth, and the cardboard covered completely with a casein type of glue. The print is applied *wet* to the mounting board. All air is squeezed out. The extra paper is then wrapped around the back and glued to the other side and allowed to dry. (The print will shrink and pull itself tight when drying.) If a piece of heavy wrapping paper (30 lb. weight) is counter-mounted on the back of the print, the whole picture will dry into one tight, cohesive unit that can then be spotted and even lacquered. The prints can be drilled for corner mounting, or hangers can be applied to the back. These "wrap-around" boards are very tough and will last a long time.

Panels can be designed as complete units, and they can be large, even up to 48″×72″. I find a 48″×60″ panel practical, and make the most of its area by using several pictures, along with caption materials.

Another professional way of preparing an exhibit is to design your panel to one-half or one-third proportion with pictures and type scaled to proper and proportionate sizes. Assemble it in paste-up form and rephotograph it to the size of the print desired. This final print is then dry- or wet-mounted or even glued onto large sheets of lightweight aluminum. The entire exhibit can be assembled thus in one packing crate. You could even design and have aluminum tube legs made to allow the exhibit to be bolted to them so as to be freestanding.

The traveling show is an excellent method for a new or young photographer to reach a very wide audience. While the initial costs may seem high, if the show is well-constructed and scheduled for considerable movement, it should amortize its cost over several years.

Traveling shows can also be assembled as single- or multiple-projector arrangements with appropriate mixing and dissolving equipment, which can be rented at a reasonable cost. This type of exhibit requires a protected environment, but the rental of space such as an office building lobby can be obtained cheaply, and there are usually building personnel around to protect the installation.

CAPITALIZING ON ONE'S NEW REPUTATION

Resting on one's laurels is not the way to get ahead. Photography is a graphic art that requires the photographer to keep his name in the public eye or he will be quickly forgotten. After the exhibits and traveling shows are completed, the listings printed, the mailings mailed, then what? It is up to the photographer to seek out some on-going method of maintaining himself in the public eye.

One of the obvious places to find a new audience is in teaching, as there is an ever-growing demand for this education. (See section on education.) The teaching should not be left to those who simply have had academic preparation as their groundwork. Several well-known photographers have begun to spend more and more time teaching. I am often startled at the amount of work that comes back to them through their students, many in small workshop situations but some through larger and more formal academic outlets. Many of the students are not photographers but want to learn about photography to broaden their own professional skills.

These students may be in the process of becoming public relations people, art directors, picture editors or buyers, and even movie producers-to-be. So if in the course of their instruction they meet a teacher who is knowledgeable about the craft they are seeking to learn, what better place to turn the need when it arises but to this same person who has already demonstrated his knowledge of the field?

Many local publications in your area might welcome a photography column from you for little or perhaps even no cost for a few trial issues (although if the column should take hold and prove popular you should be paid for it). This would be a fine way for you to sharpen your photographic image and keep you in the public eye.

GRANTS AND OTHER FUNDING FOR PHOTOGRAPHERS

Small but satisfying sources of limited income for photographers are grants from government and private foundations. I stress the words *small* and *limited* because those are the operative words. In spite of literally thousands of photographers who apply each year for Guggenheims, Creative Artists Public Service (CAPS) grants, National Endowment for the Arts (NEA) grants, and to the National Endowment for the Humanities (NEH), as well as smaller groups, the total number of recipients annually is miniscule, estimated to be fewer than 100.

Probably one reason for the amazingly few grantees is that many foundations are limited by law or charter to distributing their grants to nonprofit institutions.

It is rumored, though difficult to substantiate, that most foundations will not as a rule give grants to applicants over 40. This is not to say that younger photographers should not be recipients of these stipends, for they, like their elders, need all the help and encouragement they can get.

With an increasing trend toward funneling these funds toward nonprofit organizations, there has been a growing movement among artists, photographers included, to band together and form nonprofit groups to work cohesively on broad social projects and thus make themselves eligible for grants. Other partnerships are worked out in the academic fields, where a photographer teams with a professor to document some social program and thus make themselves both eligible for funding, with the university actually receiving the grant from the foundation and doling out the funds to those participating in the project and keeping a percentage for "administration or handling" charges.

There are a number of individual grants available to photographers. One is the W. Eugene Smith Foundation grant, established in 1980 to provide a grant of $10,000 to a deserving young photographer who wishes to follow in the tradition of the late and superbly gifted photographer. This grant was increased to $15,000 in 1982.

In spite of the unimpressive numbers of awards to grantees, I recommend that the serious artist of any age pursue this area of interest, and who knows— perhaps he'll be lucky. There are a number of publications that offer information on grants available in photography. Among the best of these are: *Grants in Photography*, by Lida Moser, (AMPHOTO, 1978); *1982* (or current year) *Photographer's Market*, (Writer's Digest Books, 1982); *Photography Market Place* (Bowker, 1977); and *Gadney's Guide to 1800 International Contests, Festivals & Grants*, by Alan Gadney (Festival Publications, 1980).

CONTINUING YOUR PHOTOGRAPHIC EDUCATION

In photography, the question of education, whether primary, advanced or continuing, is vexing because there are so few real measurements of its value to the budding photographer. Nevertheless, many young photographers feel a need for more formalized instruction to fill gaps in their repertoires. Some want to branch out and teach photography, which usually will require a degree for qualification. There appears to be as much need for refresher courses, or new education for established photographers, as there is for younger professionals (or professionals-to-be). The problem is what to study and where.

There are many settings in which the photographer may advance his or her knowledge. Over 75 institutions of higher education in this country teach photography or photojournalism, and their curriculums are as varied as their locations. In addition, there are literally hundreds of workshops, short courses and summer-vacation programs from Maine to San Diego, not to mention thousands of local community centers, church groups and high schools at which photographic instruction is offered. Care is needed in choosing a course, however.

THE WORKSHOP VERSUS THE COLLEGE DEGREE

If the comments of Thompson and Drapkin about the lack of craftsmanship in current photographers' work are to be accepted, it follows that the new photographer should look seriously at the "holes" in his training or think about

what he didn't study when at school rather than what he did. If he agrees that something is missing in his training and that he should do something about it, what direction does he follow? Go back to school and do it all over again? Hardly. Study on his own with a series of good basic books? Perhaps. (I suggest that he dig into some recommended later in this chapter.)

A growing and more popular method of further training is the "workshop." Workshops take place in hundreds of locations all over the country and at all times of the year. Their audiences vary from barely knowledgeable amateurs to seasoned pros, and their locales range from New England to the West and the Southwest. Many teach highly technical subjects to professional and scientific photographers. Some of these are quite important. The Maine Photographic Workshop in Rockport, Maine; the Lightworks in Minneapolis; and the Institute of Arts in Kalamazoo, Michigan, are examples. In selecting a workshop or series of workshops for the continuing education of the professional, however, I do suggest a careful study of them to select the ones best suited to your individual needs as a professional.

But what about the self-taught professional who suddenly realizes that perhaps his self-teaching or experience wasn't good enough or whose education fell by the wayside while he was just trying to survive and run his own operation, or who has had little contact with his peers? If time and money permit, this professional might take specific courses in some special technique of interest. For this person, the older, traditional schools of photography might be the best bet, as many offer courses not leading to a degree or certification for teaching.

I questioned several graduates of a well-known school that offered a three-year accredited program leading to a degree and discovered that in the course of that three-year curriculum there had been one session devoted to the view camera, one on lighting and a couple on the high technology of electronic circuits in cameras, but nothing whatsoever on the business side of photography. There were a lot of discussions on ethics, on photography as a fine art and on printing, but not much more. Such a course of study might be fine for the person seeking a liberal- or fine-arts degree and who perhaps is aiming at being an art editor or picture researcher. But I do not see much practicality in it for the striving professional who is trying to make a living from a studio or photojournalism. So be cautious and search out what you need, keeping an eye on practicality and usefulness—particularly if there is a sizable tuition fee.

Any discussion of photographic education for the new or older photographer may be—pardon the pun—academic, since most such photographers probably feel they have absorbed as much instruction as they can hold, whether it was in a workshop, a seminar or a college-level course.

Within the academic system there has often been controversy about teaching methods and curricula. Thus, the student, new or old, should consider carefully the many options available, including some conventional academic training or the newer methods, such as suggested by Ben Fernandez, Ken Heyman and Cornell Capa, all well-known photographers who not only have proved themselves as fine photographers but have moved beyond active shooting into teaching or gallery and museum operations. Critics of fine-arts photography also have a place in this discussion since much of their published opinion has a direct bearing on the public display of photography in galleries and museums.

Learning photography with a view toward running a commercial studio or becoming a photojournalist is one thing: teaching photography for one's living is something else. It could be an interesting outlet for established photographers

and might also be the economic salvation for many. Unfortunately, too many photographers who have worked hard to establish careers and reputations have seen themselves bypassed for academic positions. This is because traditionally there seems to have been little room for the teaching of "practical" or "applied" photography at the college level by qualified, formerly working photographers or editors. There is a curious history to this situation that is deeply tied in with fine-arts photography. Let us look more closely at the relationships between academia and fine-arts photography.

According to a recent survey there are only about 75 institutions of higher learning in the United States teaching degree programs in photography. Almost all of them operate through their fine arts departments and ultimately grant BFAs or MFAs (bachelors or masters degrees in fine arts).

A few journalism schools are also granting bachelors or masters degrees in science for some technically oriented students in communications photography. I know of no doctoral programs in still photography except in the fine-arts programs. One hopes that in time this will change. It also appears that there are only about 90,000 students in the United States enrolled in these BFA- or MFA-degree or credit programs. Only a tiny percentage will go on to doctoral studies.

One interesting spinoff from this fine-arts training is that these very students have become the heart of the market for fine-arts photography by acquiring a taste for still photography as a fine-arts collectible. It would also appear that the majority of the photographers who supply fine-arts photography to the 200 U.S. galleries that market it are, for the most part, the instructors in the BFA- and MFA-college programs. The protective blanket of their academic salaries and tenure ensures that they will not have to deal with the day-to-day exigencies of covering fires or politicians or producing layouts or commercial work. Usually the college-level people have free laboratory and studio space available, travel opportunities and, most important, the time to produce fine-arts photography as part of their academic schedule. Most BFA and MFA photography instructors are members of the Society for Photographic Education (SPE), a professional group loosely modeled on the ASMP but with membership restricted for the most part to fine-arts teachers.

Much of the funding for photography degree programs comes through the college-level programs funded by grants from the National Endowment for the Arts. Individual photographer's grants also came from such sources, but many of these are rapidly being cut back, and the individual grants, though still funded, are frequently extended over a two-year period, effectively reducing the available amount by 50 percent.

The market for fine-arts photography has softened considerably due to national economic problems. Several prestigious galleries are in trouble: one is on the market, and another needs a serious infusion of major capital to stay alive. Print sales amounts have dropped considerably. Annual returns to the photographers from gallery sales have in some cases not exceeded a few hundred dollars, and this is not enough to provide impetus either for the photographer or the gallery.

Recognition of these problems was apparent at a recent annual meeting of the SPE where requests by students for more "practical" courses prompted the SPE to schedule talks about such mundane things as "survival" and other subjects geared to bringing the photographer a more direct financial return. If such requests continue, the SPE may have to change its directions and focus.

Hence there may be new opportunities for the experienced "practical" photographer to turn to teaching courses to enhance his earnings.

The absence of degrees held by the "applied" photography teacher has not been solved as yet, though there are two routes that he may follow to qualify. One is for the photographer to accept adjunct professorships. The other, though more time consuming and costly, is for those experienced photographers who already have a degree in almost any discipline to return to the teaching institutions and acquire an advanced degree that will give them the credentials needed to teach in institutions of advanced learning.

Cornell Capa explained the reasons for other new directions in photographic teaching. He also explained the role of the International Center for Photography in influencing the social awareness of the new photographic student.

"Photographers, like many artists," he says, "are solitary beings. In the mid-1930s when I and many of my contemporaries belonged to one of the first magazine-oriented photo agencies called Pix, photographers wrapped themselves in secrecy regarding their work. A radical change took place with the formation of cooperative agencies such as Magnum, the now-defunct Scope, and others. These agencies gave photographers a chance to see their colleagues' work with little danger of piracy of the work. By the early 1970s we saw a rash of workshops, seminars and schools that brought photographers into the educational scene.

"All kinds of things started to happen when photographers began to discuss their work and share it with others. What we were seeing up to then were only the professional photographers who were working for publications. But gradually they were outnumbered by many young people, a heavy preponderance of them women, who began studying photography and teaching it as a profession. At that time there were no galleries that sold photographs and very few people who bought them. It wasn't until the 1970s that the market expanded, that galleries were formed, and that photographers began to make superb prints for sale. These prints became one-of-a-kind, collectible objects, and that uniqueness even included Polaroid prints."

Capa also spoke of the development of the SPE and the opportunities presented for its members to make fine-arts photography under almost ideal economic conditions (so much for the concept of the starving artist). He agreed that most of the successful fine-arts photographers are indeed within the halls of academia. But he did not play down the importance of the qualified, nonacademically trained professional who can indeed earn substantial fees by lecturing in workshops, seminars and noncredit teaching institutions. Capa feels that a qualified professional teaching these courses can earn between $10,000 and $16,000 a year on a part-time basis, not counting his sales through his normal sales channels. A full-time teacher should do as well as a tenured BFA in a formal institution.

I asked Capa if many of the 140 or more lecturers he has used at ICP in the past eight years for his weekend workshops and seminars have had to cancel their appearances due to work conflicts. He said that ICP has had to cancel only five lectures because of time conflicts, and for these, fortunately, the center was able to substitute other qualified people. There is no doubt that the experienced free lancer who wants to build a lecture/seminar income has to be careful about accepting conflicting shooting commitments, but often, when a conflict does occur, the photographer and institution can find mutually acceptable solutions or substitutes.

On the subject of the training and planning necessary to succeed, Capa talked with great admiration about Douglas Faulkner, an extremely successful and versatile photographer who makes a specialty of nature and underwater photography. "Faulkner loves the water," said Capa, "loves being underwater and trains himself to explore the world he is vitally interested in. He has learned as much as there is to be learned from reading and studying what this underwater world is about. He has obtained, created and built the equipment he thinks he needs to get those pictures, which are more beautiful than the naked eye can see because photography often makes the invisible visible. His work demands that he be in the right place at the right time and, most important, have an idea of what he is pursuing.

"But whether it's under water, in the air, or on the street, it is the same. The photographer must be able to distinguish those things that are to be photographed from those that are not. A certain amount of excellence and quality of mind are necessary, otherwise the photographer is a 'one-shot person'—he may become known for the one shot that brought him fame. But he won't be able to repeat it."

Capa quoted Edward Steichen who, when asked by a younger photographer: "How come the same lucky accidents seem to happen to the same photographers?" answered, "No chance!" The photographer may have had the skill to produce the "lucky shot," but he can only do it once.

INSIDER: CASEY ALLEN

I talked with Casey Allen, adjunct professor of photography at New York University, where he has taught photography for twenty-five years, who has also taught at the School of Visual Arts in New York for another five. While he has been an active photographer, Allen considers himself primarily a teacher of photography.

Allen agreed that proper preparation for a career in any field is a key to professionalism and that this is needed by formally trained photographers as much as by those who have learned by acting as assistants in studios or as beginners on small town publications or by other self-taught methods. He feels strongly that in spite of the large number of institutions teaching photography, there are very few in the United States he considers worthwhile as sources of professional training. The better schools he mentioned are the Brooks Institute in California for commercial training, the Los Angeles Art Center, Boston University, the University of Missouri School of Journalism, Rochester Institute of Technology and Syracuse University.

Allen suggests that the big problem with academic training in photography is that it is mostly comprised of "make-work" programs. He feels strongly that a photographer can learn all he has to learn technically in about a year and that four-year programs are superfluous. If it were up to him, Allen said, he would rather have a student concentrate on a liberal-arts program during the first two years, picking up another language and doing very little photography *per se*. The last two years should be reserved for technical and aesthetic training in photography.

When I questioned whether the young photography student would have the patience to wait two years before becoming directly involved with photography, Allen answered that "the problem with most young photographers is they have no background and you can only put as much into a photograph as you have to offer. If you don't have that liberal-arts background, and if you don't have a

wide awareness of what's going on in the world around you, your pictures are going to suffer from it." And, added Allen, this is where the photography programs are failing. They are concentrating too much on photography and not enough on liberal-arts education. He quoted one well-known photographer he had interviewed on his television show ("In And Out of Focus") as saying that "perfection is normal." What the photographer meant, Allen said, was that *technical perfection* is normal. What is needed is more practice, he says, and young photographers are not getting that useful practice in the schools. The best photography experience available today, for the potential photojournalist he feels, is for the young photographer to get a job on a small town newspaper. However, if the photographer is anticipating a career in advertising or fashion, Allen highly recommends working as an assistant to an established professional in the field of his choice.

Allen thinks that every photography school that is trying to turn out successful journalists or successful commercial photographers should develop summer internships or exchange programs where a student can attend classes for part of the enrollment and work actively in the field for another part. In this way, the student can get that much-needed liberal-arts education and still develop and master the skills needed for professional practice.

He also feels strongly that the schools are funneling their students more toward the "art photography" concept rather than more practical directions.

Allen feels that an aspiring photographer should experiment with various formats. For instance, the larger format of the view camera provides excellent discipline for any photographer because of the additional time and care necessary to create a photograph.

He assumes that at this early stage in their careers, most young photographers are not making a full-time living from photography, so he suggests that courses in writing be added to their curricula. He feels this is important because the young photographer often has to deal with editors who are more often concerned with the written word than pictures and because photographers have to compete effectively with writers who are taking the pictures to illustrate their stories. He thinks, too, that most writer-produced pictures are terrible because of the lack of technical training and that all the writers are doing are pointing automatic cameras at a subject and hoping that they can't miss producing an image.

"To make it as a photographer," he says, "one has to be one-third businessman, one-third salesman, and one-third photographer. The business side has become very complex and many photographers fail because they don't know how to file for local and sales taxes or make appropriate deductions on their income tax returns. Many photographers don't keep proper records.

"Salesmanship, too, is very important. Without it, the photographer cannot survive. A good agent can be very helpful in this area."

THE PHOTOGRAPHER'S LIBRARY

As do many other artists, the photographer frequently works alone. He is often alone when he is composing a photograph or solving some technical problem, even though he may be physically surrounded by people with whom he cannot communicate. If he is covering hard news he has little time for conversation either with colleagues or whomever he is covering. If he is working in a factory he cannot spend much time in useful conversation about his craft with a man on a lathe or a crane operator, or if he is photographing nature or the out-of-doors, there is usually nobody with him on a mountaintop. So much of his knowl-

274

edge will come from books, from looking at other photographs and from observing how they are used. The most reasonable answers to the problem are in the photographer's own library. True, there are many who can take opportunities to visit local museums, but there are also many photographers who do not have access to a museum, photo center, press club or a well-stocked library. Therefore the photographer needs to establish a small but basic library of nontechnical books to help round out his concepts on photography and to see what other, and perhaps older, photographers have done before him and not, as Arnold Drapkin says, charge into a picture buyer's office to announce the invention of the wheel or show some photographs that are copies of photographic work already produced by someone else.

Some of the things that the photographer can learn from this primary collection of books will be drawn from the experience, the trials and tribulations of his historic and contemporary colleagues. Good books can make the new photographer's path easier and perhaps make him a better photographer.

The following recommended books comprise a small library that will give the photographer a capsulated history of his art, some of the accomplishments and the landmarks of achievement, and give him a look at what his contemporaries are doing. If you have a deep interest in the history of your craft, these books should find a permanent place on your bookshelf, along with others of your own choosing.

BOOKS ON THE HISTORY OF PHOTOGRAPHY

The history of photography is fascinating because it has moved so fast in so few years. In fewer than 150 years since the development of the first permanently fixed image, not only has photography become a multi-billion-dollar business, but a communication system for millions of people all over the world. The history of photography is well covered in the following books:

The History of Photography by Beaumont Newhall. The Museum of Modern Art, originally distributed by Doubleday and Co. (1949). Now available from Little, Brown & Co.. First published in 1949 as the result of a Guggenheim Grant and revised in 1964, it has become a classic of its kind.

A newer and more exquisitely beautiful book is *Fox Talbot and the Invention of Photography* by Gail Buckland. Published by David Godine, Boston (1980). Buckland's treatment of Talbot's pioneering effort in the development of a permanent image is sympathetic and sensitive. Seventy pages of well-produced photographs of Talbot's early work make this a "must" for anyone interested in the earliest history of the permanent image. There is also much to be learned of Talbot's experiences not only in the development of his processes but how he fared in the marketing of his work. Buckland, a superb researcher and curator, is active in the United States and England. She also produced another important book on photography, which is:

First Photographs by Gail Buckland. Macmillan Publishing Co. (1980). This handsome picture book contains over 200 "first photographs" in such diverse categories as animals, art, government, history, explorations, labor history, sports, transportation, war and peace and dozens of other subjects covered by photography from its first development in the 1830s to the present. It includes the real "first photograph" of the flag raising at Iwo Jima, not Joe Rosenthal's historic and well-publicized picture that was actually a reenactment of a photograph made several hours earlier by Marine Sgt. (Navy) Photographer Louis R. Lowery. Such is the stuff that Buckland's book is made of, and because of its

historic accuracy, this volume deserves a permanent place in the contemporary photographer's book collection.

In a similar but much more contemporary vein is *Great News Photographs and the Stories Behind Them* by John Faber. First published by Thomas Nelson & Co. in 1960 and revised, updated and republished by Dover Press in 1978. Faber has done a splendid job in amassing 140 historic news photographs covering 70 events from 1855 to 1978, from Roger Fenton's early Crimean War coverage through the turn of the century, the turbulent postwar periods of two World Wars, and other disasters including the Hindenburg explosion, the bombings in Wall Street, the sinking of the liner *Vestris* and many others. Because of the times, the equipment used was a far cry from that in the hands of current newsmen, and these pictures will teach an important lesson to younger photographers who have never heard of anything larger than a 35mm.

Another book on your bookshelf falling somewhere between Buckland's historic volumes and John Faber's collection of classic news pictures should be *The Camera and Its Images* by Arthur Goldsmith. Ridge Press, Newsweek Books (1979). This beautifully produced volume covers the development of the camera and photographic work from the early nineteenth century to the present. It pays homage not only to the early pioneers but to the current photographic greats as well. It is a fine bridge between the past and the present in photography.

BOOKS ON CONTEMPORARY PHOTOGRAPHY

Turning to the more current news gatherers, two books of merit on a more individual level are: *Photojournalism: The Professional's Approach* by Ken Kobre. Curtin & London (1980). *Shooter* by David Hume Kennerly. Newsweek Books (1981). Both are personal approaches to photojournalism. Kobre, an active freelance news photographer with a long list of newspaper and magazine credits, now heads the photojournalism department at the University of Houston. His book includes a wide selection of fine photojournalism by working newsmen and newswomen, as well as some excellent step-by-step details in preplanning and executing, finishing and laying out magazine and newspaper stories. It will be useful to the young photographer specializing in photojournalism.

Dave Kennerly's *Shooter* is an excellent autobiographical tale of his rise and emergence as a fine photojournalist who eventually was appointed President Ford's personal photographer in the White House. Kennerly has now returned to active news photography and is based in Washington, where he covers a wide variety of political and other types of newsworthy stories. This is an easy-going tale of his experiences, particularly where he rubbed lens covers against the elbows of Washington VIPs, and some of his stories are amusing. But many, such as his adventures as a combat photographer in Vietnam, are less so. The most unfortunate part of this otherwise fine book is the title, which seems to be a spinoff of a nationally broadcast television program that included Kennerly and other photographers and was called "The Shooters." The Kennerly book is in its way an interesting diary, if you wish to call it that, and reflects the spirit of the modern photojournalist, especially if there are political overtones to his coverage.

The National Press Photographers Association has published several annual volumes called *Photojournalism* (some in cooperation with Newsweek Books), which are a selection of the national NPPA photojournalism awards entries, which in turn cover the major news events of the year by members of the

NPPA. These are excellent and handsome volumes and show the best in newspaper photojournalism for the year of publication.

BOOKS ON THE DEVELOPMENT OF DOCUMENTARY PHOTOGRAPHY

Earlier books, particularly those reflecting the development of documentary photography, have important historic value and are still first-rate reference sources. Some are out of print, but if the eagle-eyed browser should spot a copy of any of the following titles in a used bookstore he should grab it.

The Best of Life. Time-Life Books, 1973.
The Compassionate Photographer by Larry Burrows. Time-Life Books, 1972.
Self Portrait by David Douglas Duncan. Abrams, 1969.
War Without Heroes by David Douglas Duncan. Harper & Row, 1970.
The Eye of Eisenstaedt by Alfred Eisenstaedt. Viking Press, 1969.
Witness to Our Time by Alfred Eisenstaedt. Viking Press, 1966.
Words and Pictures by Wilson Hicks. Harper Brothers, 1952.
More Than Meets the Eye by Carl Mydans. Harper Brothers, 1954.
The Picture History of Photography by Peter Pollack. Abrams, 1958.
Photo Journalism by Arthur Rothstein. American Photographic Publishing Co., 1956.
The American West in the Thirties by Arthur Rothstein. Dover,1981.
In This Proud Land by Roy E. Stryker and Nancy Wood. New York Graphic Society, Ltd., 1973.
A Vision Shared by Hank O'Neal. St. Martin's Press, 1976.
The Concerned Photographer Vols. I & II by Cornell Capa. Grossman, Viking, 1968, 1972.
Industry and the Photographic Image by Jack Hurley. George Eastman House/ Dover, 1981.

This list represents a small sampling of the many fine and informative picture books, both in and out of print, which the young photographer who takes his work seriously should make an effort to obtain.

BOOKS ON MARKETING AND LAW FOR THE PHOTOGRAPHER

There are other titles that belong on the photographer's bookshelf which deal more with marketing and business efforts and are good reference works. There is some overlapping among them, particularly in the three books dealing with copyright and the law, yet each seems to have covered points that the other two do not go into in much detail. For additional reading, I recommend the following four books.

Sell Your Photographs and *The Complete Marketing Strategy for the Freelancer* by Natalie Canavor. Madrona Publishers, 1980. This book appears to be directed more at the amateur trying to turn professional rather than the established young professional, but it covers the field of selling and many other aspects of marketing such as portfolios, promotion, etc.

Selling Your Photography by Arie Kopelman and Tad Crawford. St. Martin's Press, 1980. This is a book written by two practicing lawyers. Kopelman was Executive Director of the ASMP for five years and Crawford is active as general counsel for the Graphic Artists Guild, a trade organization of commercial artists similar to ASMP.

Photography: What's the Law? by Robert M. Cavallo and Stuart Kahan. Crown Publishers, 1979 revised edition. Cavallo is active as an attorney in the photog-

raphy field and is the former general counsel to the ASMP. Stuart Kahan is now executive director of ASMP.

The latter two books reflect on the various associations the writers have had with the ASMP and its members, and both go into depth on the legal aspects of photography, although the Kopelman-Crawford book goes further on the general marketing and business of photography than the Cavallo book. Both deal with copyright and contracts involving photography. You should own one or the other, or both if you can afford them.

The Copyright Book, A Practical Guide by William S. Strong. MIT Press, 1981. This book deals strictly with general copyright matters, including photography. It is also useful for the photographer because he can easily see how other aspects of the copyright law apply to nonphotographic work, and if his efforts should take him out of the world of photography into writing, film making, or any other area, this book will give him a solid grasp of copyright in all its aspects.

BOOKS ON WRITING FOR PHOTOGRAPHERS

With more and more photographers producing text pieces for their photographs, as well as captions, the new photographer should have a good dictionary and a good thesaurus at hand. There are many available and your bookstore will provide comparative material. Two other books on writing are important. The first is a small, slim volume by William Strunk, Jr., called *Elements of Style*, written in 1935 and later revised with an introduction by E.B. White, Jr., in 1959. It is reprinted constantly in inexpensive paperback editions. *Elements of Style* has become a classic among writers who seek to learn to use language clearly, concisely and effectively. I know of one prolific writer with a lifetime of experience who keeps a copy on his night table, and if he awakes at night and wants to read something, he picks up his dog-eared Strunk and reads a few pages again and again, never seeming to tire of it, finding freshness each time he reads it. This short book is a must for all photographers who want—or are called upon—to write.

A second writing manual I do not hesitate to recommend is a more parochial volume called *The New York Times Manual of Style and Usage*, NY Times Books, 1979. Most major press organizations internally publish what they call "style books," usually for their own employees and contributors, delineating the way that particular company uses words, titles, abbreviations, etc., and in general offering considerable guidance. Most style books are restricted in circulation to the staffs of their respective companies, but the *New York Times* style book is available to the general public and is on sale in most bookstores.

These two books should give the young photographer some insight into the language he uses when filing his copy or detailing captions for publication.

BOOKS ON THE AESTHETICS OF PHOTOGRAPHY

The vast number of photographic books being published makes it impossible to include everything, but we would like to call attention to a few unusual books.

Susan Sontag's controversial essay *On Photography*, published by Delta Books, Dell Publishing Company (1980), from earlier writings published by Farrar, Straus & Giroux, is a philosophical analysis of photography as perceived by Sontag. It has been both applauded and attacked by the photographic world. The contemporary photographer who is concerned with the sociological perception of photography will find it interesting reading. I disagree with Sontag on many issues she raises, but these are my own subjective judgments.

Two other photographic books, one published by Curtin and London and the other under the Lustrum imprint, both distributed by Van Nostrand Reinhold, are curious books worthy of consideration.

Contact: Theory (Lustrum) is a handsomely produced, black-and-white book of the work of 43 photographers, many well known, others less so. Each contribution is a set of contact prints from a particular shooting and one or more of the photographs selected by the photographer for enlarging, printing and publishing. I liked the photographs much more than the explanations of some of the photographers, and felt that some of the reasoning was pretentious. The importance of this book is in showing why the photographer selected certain images for printing and what they were supposed to mean both to the photographer and the audience.

High Contrast is also an exercise in the production of photography as art. Here the pictures are printed in very high contrast, almost atonal in quality, and simply express a different way of producing photography. Included are how-to-do-it sections on achieving these strange and often interesting variations of the finished print.

In trying to build a photo library, one must remember that it is an open-ended process. There are always new books coming out and many desirable ones quickly go out of print. The photographer who wants to keep his thinking current should not only carefully read the book review columns in the various photo magazines but also keep a watchful eye on the major literary review publications of the larger and more influential newspapers in his area. Most photographic supply stores do not stock many books, claiming that heavy normal sales traffic precludes allocation of much counter space to the display of books, so the photographer has to get the books he wants in regular bookstores or perhaps by mail. Collecting photographic books should be an ongoing habit and money should be allocated for the purchase of new books just as surely as one allocates general overhead expenses.

INTERVIEW
GORDON PARKS

Gordon Parks comes as close to being a Renaissance man of the arts as anyone I can think of. Photographer, painter, filmmaker, composer, writer, dramatist, and possibly possessor of a few other talents I am not aware of are all embodied in this gentle, sensitive man. Born in Fort Scott, Kansas and raised in Minnesota, Parks first became interested in photography while working as a dining car waiter on the North Coast Limited running between St. Paul, Minnesota and Seattle, Washington.

Parks became tired of railroads, just as Ed Thompson did, but for different reasons (see page 51). In the evening, while the other waiters retired to the bunkhouse car to gamble, Parks would remain in the dining car to read, look at magazines, and try to get some insight into the outside world. Once, while on a stretch of lonely track, he picked up a book or magazine that contained some of Dorothea Lange's Farm Security Administration photographs and some work by other FSA photographers.

"I became very interested in these pictures, and how they were used to depict the Depression era. Then I read Erskine Caldwell's *You Have Seen Their Faces* done with Maggie (Margaret Bourke-White), and suddenly the photograph became a very interesting vehicle for me."

Until then Parks did not have the slightest bit of photographic experience, and had never had any desire to make a photograph. "I returned to Chicago on the layover of that trip and went to the art museum where I looked at some paintings. The feeling was in my blood, my psyche, whatever you call it, and that same afternoon I saw a film on the sinking of the gunboat Panay by Norman Ally. When the film was over and he jumped out on the stage in a white suit, I thought that was tremendously glamorous. So when I got to Seattle, Washington, I spent my last twelve bucks on a camera in a pawnshop, an old Voigtlander Brilliant. I think I bought it for its name, not for its action, because it wasn't a very good camera. The same afternoon I got the camera I fell into Puget Sound trying to photograph seagulls and some firemen fished me out with a long pole, but I held onto the camera. I never took the film out because I didn't know how. The guy in the pawnshop had put it in for me.

When I got back to Minneapolis I went to Eastman Kodak and asked them to take the exposed film out and develop it for me. Apparently the salt water didn't hurt it too much because when I came back the guy at the counter asked how long I had been shooting pictures. When I said this was my first roll, he said, 'Really? Well, you have a good eye and if you keep this up we'll give you a show.' I said, 'What do you mean, a show?' He said, 'Well, we'll put your pictures in the window.' I got really busy then and in about four months Eastman Kodak gave me my first show in a store window in Minneapolis.

"This was in 1936 or 1937. It made me realize how much I wanted to *be somebody*; I wanted to get off that railway so bad and I used the camera to do it. I had thought of painting, but that was too time-consuming and too hard. I also wanted to sculpt, but that was too remote. Here I was, way out in Minnesota and already with a wife and kids, thinking it would be years before I could make any money from it. But in any case I went for photography, and that was it.

"I got my professional start by taking pictures for a very exclusive store for women called Frank Murphy's. I had gone in to ask to shoot some fashions for them even though I had never made a fashion photograph before. Just as Mr. Murphy was kicking me out of the store his wife turned around and said, 'Frank, what does the young man want?' He replied that I wanted to make fashion pictures and that he had told me they had all their work done in New York or Chicago. I felt smaller and smaller, and was just about out the door, when the woman said, 'How do you know he can't shoot fashions, Frank?' She got some fine clothes together and some fashion models and I double-exposed every picture but one, but she liked that one. I redid the pictures and continued shooting until Marva Louis, Joe Louis' wife, came by, saw the pictures and asked who had shot them. When she found out, she suggested I come to Chicago. I did and started making pictures of rich ladies at the behest of Marva. By then I was also doing other things that I wanted to do on the South Side of Chicago, more documentary-type photographs."

When the Community Art Center saw his South Side pictures they encouraged Parks to apply for a Rosenwald Fellowship, even though no one had ever received one for photography. "So I applied," he said, "and I was judged by other photographers who turned me down flat until Peter Pollack, historian and writer, said that was ridiculous." He submitted the application to a school of artists who accepted Parks for the fellowship, with every judge voting "yes."

By then Parks had met FSA photographer Jack Delano, who suggested that Parks work out his fellowship at the FSA project in Washington. Delano put him in touch with Roy Stryker, who wanted to use Parks, but was reluctant to subject him to the racial discrimination Stryker felt he would encounter in a town as "southern" as Washington. (Parks found out later that Stryker had told the Rosenwald people this was the only reason he hesitated to use Parks, as the lab was staffed almost exclusively by southerners.) But the Rosenwald people evidently convinced Stryker to take Parks on, and when he came to Washington, Stryker said "Okay, you are going to have to work out things your own way."

The first thing Stryker told him to do was to go out, look around Washington a good deal (Stryker did this with all his photographers, giving each a long introduction to the area they were working in) and to buy a coat. So Parks walked into the most elegant department store in Washington but he never got the coat because no one would wait on him. When he went to the movies or a restaurant, it was the same. Racial discrimination faced him wherever he went. By this time the anger in Parks had built to a point where he wanted to use his

camera against racial discrimination. One of his first pictures, and one that he is still extremely proud of, is a photograph of a black woman with an American flag and a mop that he called "American Gothic."

Stryker was shocked, saying "My God, you'll get us all fired!" But nonetheless both he and Parks were proud of the picture. (Until just a few years ago Parks thought the photograph had been destroyed, but has since found it is one of the most popular pictures in circulation at the Library of Congress, where the entire FSA collection was ultimately sent.

Parks was not on the FSA payroll but on a Rosenwald stipend of $200 per month, on which he had to sustain himself, a wife and three children. He worked out his fellowship in the first year with Stryker, and when the FSA was taken over by the Office of War Information, (OWI) Parks was hired by them. He was classified as a correspondent, and assigned to the 332nd Fighter Group, the only all-black fighter group in the Army Air Force. Among the other indignities he suffered was being kicked out of the Port of Embarkation on a trumped-up charge of not having proper papers even though he had just come from the Pentagon with clear orders. Even his Commanding Officer, West Point-trained Colonel B. O. Davis Jr., who was later to become the first black General in the U.S. Army, was of little help to Parks. But he played out his war role and returned to New York, started making the rounds and eventually went to see Brodovitch at *Harper's Bazaar,* who granted him an interview without knowing Parks was black. But when Parks appeared and assured Brodovitch that those photographs were indeed his, Brodovitch said, "I'd like to hire you but I can't because this is a Hearst Publication and they don't hire Negroes."

The friend who had brought Parks to Brodovitch's attention was rightly angered, so she sent him on to Edward Steichen, who was also upset. Steichen sent Parks to see Alexander Liberman at *Vogue,* who said, "Well, I don't know how we are going to do it, but we will," and Parks started taking fashion photographs for both *Glamour* and *Vogue.*

This was a great departure from the documentary style Parks had learned under Stryker, but with Stryker's encouragement he stayed in fashion because, as the latter put it, "After all, you still have to earn a living." Eventually Stryker took him on as part of the Esso crew (for Standard Oil of New Jersey) and tried to keep Parks out of the South as much as he could even though most of the Esso empire lay there. There were extensive Esso coverages elsewhere in the U.S. and Parks was able to deal successful with discrimination when it was thrust at him.

The Esso project had started during World War II and begun to wind down shortly after the War's end, and Parks was invited to join *Life* magazine's staff in 1948. At *Life* Parks went on general assignment duty, doing a little of everything from the front of the book to the back. He thinks in retrospect that they gave him more varied assignments than any other staffer. Some of his more memorable essays were *Harlem Gang Story, Crime Across America, and American Poets.* He also did much fashion work very early on when fashion editor Sally Kirkland sent him to Paris to cover designer collections. It was Park's versatility that took him from fashion to documentary, to photographing crime, poverty, and back to fashion. He learned a great deal from Kirkland, but he also had to learn a whole language with her that was part of the fashion jargon and totally alien to him. He said there were some pretty funny moments in Paris when he was trying to tell some of his French models to use a little "pizazz," because those were the words Kirkland had taught him.

While this diversity may have been something that many other staffers would have liked to avoid, preferring perhaps to specialize, Parks said, "Because I am black I realized that I had to prepare myself for almost anything. There was no way for me to accept specialization. If they said 'we need a good sports photographer' I would say 'Well, I just happen to have one in my back pocket!' And perhaps that was the reason why I did so many different things."

One great watershed in Parks's career was the Flavio story. "It started," he said, "as a typical *Life* story on Brazil, one that contained all the usual family elements: religion, communism, and other conflicts of culture in South America." Parks found this approach uninteresting and went up to the "Favela," a notorious slum perched on a hillside overlooking Rio de Janeiro, looking for fathers who might fit the bill. After a few desultory interviews accomplished with the aid of an interpreter, he told me, "I was sitting beside a tree on the mountaintop and saw this little boy come by with a five gallon tin of water on his head. A beautiful child, but obviously dying of some disease. He smiled at me and I smiled back. I followed him up the steep mountainside to his shack, offering to help him with the water, but he kept refusing. The shack where he lived with six or seven brothers and sisters was indescribable squalor. The father was down at the base of the mountain somewhere, so I just hung around taking pictures of the scene. Eventually the father came back and I explained what I was doing. Because I was so wrapped up in the story I moved out of my fancy hotel on the beach in Rio and moved into the Favela. I stayed for two or three days, to the consternation of my editors who had lost track of me. I went back down after a few days and cabled them and they were sensitive enough to wire back for me to 'keep in touch and continue on the story because it sounds great!'"

Parks spent nearly two months in the Favela with Flavio, keeping a diary all the time, and when he left his last entry was "Today I am leaving Flavio and he asked me if I would be coming back. I said yes, but I knew I was lying and would never go back. I never want to see such poverty again in my life."

When the story ran, *Life* also published the diary as part of the text and letters started to pour in, insisting that he go back. People also began sending money for Flavio—they contributed $32,000 or $33,000. Parks did go back and this time brought Flavio back with him to the National Jewish Hospital, National Asthma Center in Denver, where he received an education and proper medical attention. He later followed up with another story and a book on his experiences with the boy entitled *Flavio*, (W.W. Norton, 1978) which won a best biography award. Flavio is now back in Rio with a wife and three children, a job and a decent life out of the Favela. Parks's involvement was so deep that it became a permanent part of his life, and besides producing great photographs and texts, has brought worldwide attention to his great sensitivity and to his skill as a creative journalist who cares about what he does.

Parks is a most prolific artist, having produced eleven books, five feature films and two documentaries. In addition, he has done much painting, had several major shows, and continues to work and experiment. But he keeps going back to his first love, still photography, and is currently blending some of his skill as a photographer with his skill as a fine artist and producing new work using paint and photography. In reflection, he said when he started out in the creative arts he probably would have tried to become a painter if he could have been able to predict earning a living from it, but being realistic, he chose photography as a career.

He is now preparing a major retrospective show that will open in 1983, and continues to write music. He has already written a concerto for piano, a symphony, five sonatas, and some music for the ballet. All, by the way, without formal musical training. "Everything I have learned," he said, "I had to learn the hard way because I was so poor as a kid. I don't resent the fact that I was born poor, and I suppose if I were given my 'druthers' and someone said, 'Listen, we're going to start you over as a rich white kid and send you to Harvard or Yale, but we don't know how you are going to turn out,' I would take it anyway. I don't appreciate the scars, the buffeting around. Once I broke the blackness barrier, I refused to let my blackness impede me or become a problem. I could not work freely if I were still carrying this thing around on my back. I think what really saved me was going to Europe, where I didn't have to face the problem of racism in America every day of my life. It freed me. I was in Paris more or less permanently in 1951 and 1952, and I covered much of Europe from there. I was able to hear the music of the masters, see the great art, and all the things I couldn't learn much about in America. The Louvre was only a block and a half from the *Life* Bureau on the *Place de la Concorde*. I went to see the French Impressionists at least once a week. I met writers, among them, Camus. It was a whole new opening for me over there. I had a house in the suburbs and my family with me, and when we would drive from Paris to Cannes for a vacation I didn't have to worry where my family would sleep that night.

"I never considered becoming an expatriate. I was determined to use what I learned there and bring it back to America because I felt I was an American and my stake was here. Listen, there are problems as a black man, but I've never let those problems stand in my way. I guess I won't acknowledge them and just go ahead and do what I have to do."

In discussing the question of race and creativity, he takes the same approach as writer Melvin Van Peebles, who said that he is not a black artist but an artist who happens to be black. Parks talked about his last novel, *Shannon*, which was an Irish novel. "Some of those critics," he said, "tried to castigate me for writing on this subject, but I don't hear any complaints about a white writer writing about Nat Turner, so I can write about J.M.W. Turner, the English painter. You don't have to be a pumpkin to photograph pumpkins."

On the craftsmanship of the young photographer, Parks echoed his colleagues by saying, "I think they're leaning too much on gadgetry. They get a wide-angle lens that they know is sharp from here to there, and then proceed to shove it up your nose, get the guy's head lopsided, all in the name of photography. Young photographers do not seem to have any concern with the true ethic of a pictorial presentation. They seem to go for the grotesque things, anything that makes a picture look unusual. They probably feel that they are not good enough to produce a good 'straight' photo, and so will try to attract attention by doing it another way.

"It's like some comics I know," he continued, "who think they have to use obscene language all the time to get their audience juiced up. It really means they are not good enough as comics to get laughs without using obscenity. This is the same way I feel about some of the photography I see today. I think many of these photographers don't know what they are doing and many of the magazines are falling in line with it, too. Unfortunately some fine art directors also go along with this and play the same game.

"I don't think there are enough purists around any more," Parks said. I asked him if a "purist" could earn a living today and he said, "I don't know; it could be difficult because some editors don't know any more than their photographers

do. If I had to start over today I would never lend myself to anything that was not in good taste."

He went on to say that he thought the most satisfying aspects of his still photo career had been his communication with the people he photographed; not so much by expressing his thoughts or feelings, but by permitting those whom he photographed, who had no means of expression, to express themselves through his pictures.

He spoke about photographing the Black Panthers and said, "*Life* used me very well in the 1960s. They never normally sent me on black subjects just because I was black, and when the black revolution came along in the 1960s they tried to do the Black Muslim story without me. I had to walk a very tight line because when I was photographing the Muslims, the Panthers, and Malcolm X, I had to also prove to them that they could not buy me because I was black. And I had to let *Life* know that I had to write and photograph these pieces the way I felt about them, because my neck was on the line. So I was in a most peculiar position. I don't think that at first *Life* thought I was going to remain as objective on this as a reporter should be and I was all set to prove that I could. I didn't know how I was going to do it, but I was determined to do it. I think I survived because I shut my ears to both sides, the magazine *and* the Muslims, and reported what I saw."

He also had to defend himself at *Life* against editors who had strong ideas that either were poorly articulated or were at variance with the way the photographer saw them. He told me about one assignment for *Life* in Pennsylvania where he had to photograph a miner's hands as part of a story he was doing on some "pop" singer who was the daughter of the miner and had just made it big. He arrived at the precise moment when the girl's father was reading a letter from her and he made a strong back-lit picture of the letter with the words coming through and the dirt and grime on the miner's hands very apparent. The managing editor was unconvinced about the picture until Parks went barreling in and said, "What's wrong with it? This is what you asked for plus more." The managing editor said, "Okay, okay what do you want?" Parks replied, "I want a full page." The managing editor said, "You got it. Now get out of my office!" But if Parks hadn't had the guts to speak up for what he thought was right about his perception of his subject matter, the picture would have been killed. And Park's advice to the newer photographer is clear: produce your pictures as you see them and fight if necessary for their survival.

INTERVIEW
PHILIPPE HALSMAN

Ask almost any qualified judge of contemporary photography—photographer, editor, art director, or museum curator—to compile a list of the five most important, prolific, and most talented photographers, and it's almost a certainty that the list will contain the name of Philippe Halsman, who died in 1980 at the age of 73.

Halsman, who amassed a staggering 101 covers for *Life* Magazine, was one of the great portrait photographers of all time, and it is hard to imagine any photographer in the future who can reach the stature that this quiet, gentle man attained. His understanding of humanity, coupled with his great photographic skill produced some of the most incisive portraits of the famous and near famous. Halsman's great wit was probably best exemplified by his famous series of "jump" photographs. Somehow early in his career he got into the habit of asking those who posed for him to jump in the air in front of his camera, and most of his famous clients complied. So many did in fact that a most wonderful book emerged from this collection, among them the spectacular photograph of Salvador Dali leaping in the air accompanied by a bucket of water and a flying cat. I asked Yvonne Halsman (his widow) how many "takes" Halsman had made of this scene and she said it took 26 buckets of water and three cats, 26 times!

Yet Halsman was by no means a saint. He had an iron will and could demolish (verbally) anyone who took him on in any cause he exposed, though more often than not his weapon was the sword of wit rather than a blunderbuss.

Halsman was born in Latvia (now a Baltic state of the Soviet Union) and his father was a dentist who had hopes of his son following in the profession. But Halsman was fascinated with mathematics and so went to Dresden, Germany, to study electrical engineering. It was a training he would find useful later when he had to deal with cameras, optics, lights, and other photographic equipment.

While still a student, he went to Paris to attend his sister's wedding and became so enamored of the city that he never returned to Germany and continued his engineering studies in France. This was difficult because he knew little French, especially the technical jargon needed for his engineering studies.

Yvonne Halsman, when talking about her husband's early days, especially the time before they were married, told me with a twinkle in her eye that "Philippe, always a modern man, had a girlfriend who wanted to learn photography, and when she did not understand some technical point she asked Philippe to explain those things. But he really did not know much more than she did, yet he managed to explain things anyway. But in doing so," she added, "they both got so involved and interested in subject that he dropped the engineering studies and decided to concentrate on photography." All to the dismay of his parents and teachers, who placed photography on a much baser level, relegating it to a niche somewhat below that of most servise trades.

She told me that Halsman had a great interest in faces, that he loved human beings and enjoyed making portraits of them. He opened his first studio, if one could call a large single room in Montparnasse without a bath or running water a studio, in 1932. He never had any formal training in photography, though once he wanted some and turned to a local photographer for guidance. Unfortunately, this man was so secretive of his expertise that he refused to show young Halsman any technique of value, so he had to learn on his own. But he was fast and facile and learned quickly.

I asked Yvonne Halsman how Philippe got started as a portraitist, and she said that first he photographed his family, then his friends, and when he had done work good enough to show, he did what most European photographers did in those days, he displayed them in a window or on a door. In fact, he rented a small place where he could show his work and people did start to come in for sitting.

On a personal and intellectual level, Halsman was an omnivorous reader and was fascinated by the great writers of the time and wanted to photograph them. His first pictures of a "known" writer were those of Andre Gide. Over a ten-year period, he built his business up and because of this love of portraits of writers and artists, he began to develop a reputation for the "unusual." By the time he was ready to leave Paris ten years later, ahead of the oncoming Nazi occupation, one news magazine said he was the best portrait photographer in Paris.

By then he had met Yvonne, who was interested in photography and had come to Philippe as an apprentice student, though he didn't teach formal classes. She started as a "trainee" and later became his assistant. After they were married they continued to work as a team, although she also worked on her own as a photographer. She emigrated to the United States with their first born child, and their second child was born in America.

Halsman's escape to the United States ahead of the Nazi onslaught was not as easy. Not being a French national he couldn't get an exit visa, and as he had already begun to make a name for himself with his photographs of prominent anti-Nazis, it was obvious that his days in Paris were numbered. Fortunately, because of his mathematical interest he had already established a communication with Albert Einstein, who by then was in the United States and who in turn interceded with Eleanor Roosevelt. With her assistance, the International Rescue Committee was able to get a visa for Halsman to leave France.

Setting up shop in the United States came as a shock to the Halsmans because although they had established a reputation in Paris, he was completely unknown here. Yvonne Halsman told us that when they were in Paris they were "happy-go-lucky" and didn't think of the future. His first job was on a retainer with a drawing against sales of his work for the Black Star Agency. After the first year he asked how much he had made and was told that he owed the agency

$2,000. After that he felt he couldn't do any worse, so he struck out on his own and began contacting publishers. He maintained friendly relations with Black Star, however, and they suggested that he photograph Salvador Dali, the Spanish surrealist painter. This was Halman's first real break. Black Star sent the picture to *Life* magazine, who published it in their feature section then called Picture of the Week.

Another important break for Halsman came when the Simon & Shuster publishing company commissioned him to illustrate a book on Wendell Wilkie that sold over 100,000 copies, a large amount even today.

As a new arrival in this country in the early 1940s, Halsman never forgot the early struggles he endured as a photographer. By the end of that decade he had become the first president of the fledgling ASMP and was to spear-head the fight for the dignity and the ability to function of the professional photographer. He fought for the right of a photographer to own his work, for the protection of the copyright law, and until he died he was an outspoken leader in helping the photographer survive. He always had time for the new photographers, always a word of encouragement for them.

Halsman was probably the quintessential magazine portrait photographer, but did not restrict himself to portraits. He loved general journalism and many of his covers were backed up by page after page of fine photo coverage. Nor did he limit himself to known personalities, and although he photographed a number of Presidents, he also paid careful attention to corporate executives. He did not care much for fashion, never having worked for a big fashion magazine. However he did do fashion multi-page stories for *Life*.

I asked Yvonne Halsman to tell me about Halsman's opinion of contemporary photography and photographers, and she said that his photographic thinking was always based on learning as much as he could about the person or situation he was about to photograph. Since much of his work involved famous personalities, he studied these people as well as he could before the shooting so he would feel confident in dealing with their strong points and features.

Yvonne Halsman also told me that when Halsman taught classes he always told his students to learn, read, go to museums, watch films—in fact, watch anything, including television, and absorb everything they saw. He always felt that too many photographers lacked a depth of understanding of their subject matter and did not take the time to research the personalities of the people they were to make portraits of.

These feelings were reinforced as automation increased, and Halsman thought automation seemed to release many photographers from the responsibility of thinking about their pictures. Even though some photographers would claim that the automation freed them from mechanical problems, Halsman always felt that it was impossible to separate the creative from the mechanical problems of getting an image properly on either film or paper.

Mrs. Halsman went on to say that he felt that photographers who did not "think" their pictures out frame by frame too often confused technically correct exposures with good lighting. He always believed there was a vast difference between the two. Automation did not help this, and Halsman felt that each generation of photographers was getting lazier as automation advanced.

Halsman never allowed his thinking to be delegated to others. He designed cameras and lighting systems to fit his particular needs and, like Berenice Abbott, refused to accept standards set by equipment manufacturers as a limiting factor to his creativity. Without this attitude of considering every one of the many

aspects of making a photograph, Halsman felt that the optimum could not be achieved.

I asked what Halsman's response would have been to young photographers' questions on getting started and on specialization, and Yvonne Halsman told me that both she and her husband agreed that a young photographer should concentrate on doing what he likes to do the most. If he likes portraits, then by all means he should concentrate on them, or, if magazine journalism fascinates him the most, he should stay with that specialty, but under no circumstances should he be swayed by what others think he should do. Nor should he be influenced purely by the economics of the specialty—a photographer should follow his instincts.

She said that many young people had come to see her husband over the years with their portfolios, and he would often very bluntly tell them "You are not too good in this but better in that, and therefore concentrate on that phase where you show more talent and promise." He was extremely frank in his opinions and would sometimes tell a young hopeful, "Forget it; do something else." But his encouragement of those in whom he saw talent did sometimes lead to successful careers and high achievement. Mrs. Halsman told us of a young *Life* editor named John Bryson, in whom Halsman saw a great deal of potential talent as a photographer and so worked closely with him. Bryson is now most highly regarded and is a successful photographer who has become noted for his photographs of theatrical and motion picture personalities and situations.

If Halsman saw talent in a young photographer, he would call an editor he knew and suggest that he publish some of the photographer's work, or suggest that the editor give the young hopefuls assignments. Often they did and the assignments were important steppingstones to young photographers' careers.

Mrs. Halsman attributed much of her husband's success to his insatiable intellectual curiosity about the world around him and the people in it, and truly felt it was his own inner feelings as an artist that enabled him to bring out the depth of some of the people he photographed. When I asked her about advice for new photographers she said, "There are always young photographers, and you forget that Philippe was a young photographer once as well, but his aim was to learn as much as he could, to assimilate his subject as deeply as he could because he felt that the more he knew about the person, the better he could photograph him.

"And that is what is lacking in many of the new photographers," she continued, "they do not explore new methods of working." She added her comments to the chorus of more experienced and older successful photographers who are alarmed at the "take-over" by automation of the photographer's mind and eye.

ASSIGNMENT CONFIRMATION/ ESTIMATE/INVOICE FORM

courtesy: ASMP

Assignment Confirmation/ Estimate/Invoice Form

FROM:

TO:

Date:
Subject:
Purchase Order No:
Client:
A.D./Editor
Shooting Date(s)
Our Job No:
☐ Assignment Confirmation
☐ Job Estimate
☐ Invoice

Photography Fee(s) & Totals

PRINCIPLE PHOTOGRAPHY (BASIC FEE)
($_____ per day or photograph, if applicable)

DESCRIPTION

$

SPACE &/OR USE RATE (IF HIGHER)
($_____ per page: $_____ per cover: $_____ per photo)
TRAVEL &/OR PREP DAYS (at $_____ per day)
PRODUCT OR SUBSIDIARY PHOTOGRAPHY

Expenses

ASSISTANTS
CASTING
 Fee/Labor
 Film
 Transportation

FILM & PROCESSING
 Black & White
 Color
 Polaroid
 Prints

GROUND TRANSPORTATION
 Cabs
 Car Rentals &/or Mileage
 Other

INSURANCE
 Liability
 Other

LOCATION SEARCH
 Fee

All forms contained in this appendix section that are credited to ASMP are used by kind permission of the American Society of Magazine Photographers. It should be noted that the agreements are suggested ones, based on ASMP's extensive experience. However, the Society renders no legal opinion concerning their application. Individual modifications are encouraged to fit specific circumstances.

Local
Long Distance

SETS/PROPS/WARDROBE
Set Design Fee
Food
Materials
Props
Set Construction
Set Strike
Surfaces
Wardrobe
Other

SPECIAL EQUIPMENT
SPECIALIST ASSISTANCE
Electrician
Hairdresser
Home Economist
Make-up Artist
Stylist
Other

TALENT
Adults
Children
Extras
Animals

TRAVEL
Air Fares
Meals
Hotels
Overweight Baggage

MISCELLANEOUS
Gratuities
Shoot Meals
Toll Telephone
Other

EXPENSE TOTAL

TOTAL EXPENSES (see 1st column)
FEE PLUS EXPENSES

SALES TAX (if applicable)

TOTAL

ADVANCE

BALANCE DUE

MEDIA USAGE

ADVERTISING
☐ Animatic
☐ Billboard
☐ Brochure
☐ Catalog
☐ Consumer Magazine
☐ Newspaper
☐ Packaging
☐ Point of purchase
☐ Television
☐ Trade Magazine
☐ Other

EDITORIAL/JOURNALISM
☐ Book Jacket
☐ Consumer Magazine
☐ Encyclopedia
☐ Film Strip
☐ Newspaper
☐ Sunday Supplement
☐ Television
☐ Text Book
☐ Trade Book
☐ Trade Magazine
☐ Other

CORPORATE/INDUSTRIAL
☐ Album Cover
☐ Annual Report
☐ Brochure
☐ Film Strip
☐ House Organ
☐ Trade Slide Show
☐ Other

PROMOTION & MISC.
☐ Booklet
☐ Brochure
☐ Calendar
☐ Card
☐ Poster
☐ Press Kit
☐ Other

Subject to all Terms on Reverse Side—Which Apply in All Cases Unless Objected to in Writing by the Sooner of the First Shooting Day or Ten Calendar Days. Usage Limited to Reproduction Rights Specified

Client Signature: _____

STOCK PICTURE DELIVERY/INVOICE

courtesy: ASMP

Stock Picture Delivery/Invoice

FROM:

TO:

Date:
Subject:
Purchase Order No:
Client:
A.D./Editor
Shooting Date(s)
Our Job No:
☐ Assignment Confirmation
☐ Job Estimate
☐ Invoice

RIGHTS GRANTED

One-time, non exclusive reproduction rights to the photographs listed below, solely for the uses and specifications indicated, and limited to the individual edition, volume series, show, event or the like contemplated for this specific transaction (unless otherwise indicated in writing).

SPECIFICATIONS (if applicable)

PLACEMENT (cover, inside etc.) _____
SIZE (½ pg. 1 pg., double pg., etc.) _____
TIME LIMIT ON USE _____
USE OUTSIDE U.S. (specify, if any) _____
COPYRIGHT CREDIT: © 19 _____ (name)

MEDIA USAGE

ADVERTISING
☐ Animatic
☐ Billboard
☐ Brochure
☐ Catalog
☐ Consumer Magazine
☐ Newspaper
☐ Packaging
☐ Point of purchase
☐ Television
☐ Trade Magazine
☐ Other

CORPORATE/INDUSTRIAL
☐ Album Cover
☐ Annual Report
☐ Brochure
☐ Film Strip
☐ House Organ
☐ Trade Slide Show
☐ Other

EDITORIAL/JOURNALISM
☐ Book Jacket
☐ Consumer Magazine
☐ Encyclopedia
☐ Film Strip
☐ Newspaper
☐ Sunday Supplement
☐ Television
☐ Text Book
☐ Trade Book
☐ Trade Magazine
☐ Other

PROMOTION & MISC.
☐ Booklet
☐ Brochure
☐ Calendar
☐ Card
☐ Poster
☐ Press Kit
☐ Other

($)

Total Black & White Total Color

If this is a delivery kindly check count and acknowledge by signing and returning one copy. Count shall be considered accurate and quality deemed satisfactory for reproduction if said copy is not immediately received by return mail with all exceptions duly noted.

TOTAL USE FEES: _____

MISCELLANEOUS: _____

Service Fee: _____

Research Fee: _____

Other: _____

TOTAL: _____

DEPOSIT: _____

BALANCE DUE: _____

SUBJECT TO TERMS ON REVERSE SIDE PURSUANT TO ARTICLE 2,
UNIFORM COMMERCIAL CODE AND THE 1976 COPYRIGHT ACT

Acknowledged and Accepted

Terms and Conditions

(a) "Photographer" hereafter refers to (). Except where outright purchase is specified, all photographs and rights not expressly granted remain the exclusive property of Photographer without limitation; user (or recipient) acquires only the rights specified and agrees to return all photographs by the sooner of 30 days after publication or 4 months after invoice date, or pay thereafter $5.00 per week per transparency and $1.00 per week per print.

(b) Submission and use rights granted are specifically based on the condition that user (or recipient) assumes insurers liability to (1) indemnify photographer for loss, damage or misuse of any photograph(s) and (2) return all photographs prepaid and fully insured, safe and undamaged by bonded messenger, air freight or registered mail. User (or recipient) assumes full liability for its employees, agents, assigns, messengers and freelance researchers for any loss, damage or misuse of the photographs.

(c) Reimbursement for loss or damage shall be determined by a photograph's reasonable value which shall be no less than $1,500.00 per transparency or $ per print.

(d) Adjacent credit line for photographer must accompany use, or invoiced fee shall be tripled. User will provide copyright protection on any use in the following form: "© photographer's name, year."

(e) User will indemnify Photographer against all claims and expenses arising out of the use of any photograph(s) unless a model or other release was specified to exist, in writing, by Photographer. Unless so specified no release exists. Photographer's liability for all claims shall not exceed, in any event, the amount paid under this invoice.

(f) Time is of the essence for receipt of payment and return of photographs. No rights are granted until payment is made. Payment required within 30 days of invoice; 2% per month service charge on unpaid balance is applied thereafter. Adjustment of amount or terms must be requested within 10 days of invoice receipt.

(g) User shall provide two free copies of uses appearing in print and a semi-annual statement of sales and subsidiary uses for photographs appearing in books.

(h) User may not assign or transfer this agreement. Holding or use of the photographs constitutes acceptance of the above terms, hereby incorporating Article 2 of the Uniform Commercial Code. No waiver is binding unless set forth in writing.

(i) Any dispute regarding this invoice, including its validity, interpretation, performance or breach shall be arbitrated in (Photographer's City & State) under rules of the American Arbitration Association and the laws of (State of Arbitration) Judgment on the Arbitration Award may be entered in the highest Federal or State Court having jurisdiction. Any dispute involving $1500 or less may be submitted, without arbitration, to any court having jurisdiction thereof. User shall pay all arbitration and Court costs, reasonable Attorney's fees plus legal interest on any award or judgment.

(j) User agrees that the above terms are made pursuant to Article 2 of the Uniform Commercial Code and agrees to be bound by same, including specifically clause (i) above to arbitrate disputes, as well as the 1976 Copyright Act.

DELIVERY MEMO

courtesy: ASMP

Delivery Memo

FROM: **TO:**

Date:

Subject:

Purchase Order No:

Client:

A.D./Editor

Enclosed please find:

Our Job No:

Set No. & Subject:	Format:	35	2¼	4×5	5×7	8×10	11×14	Contacts
Total Black & White	Total Color							

Kindly check count and acknowledge by signing and returning one copy. Count shall be considered accurate and quality deemed satisfactory for reproduction if said copy is not immediately received by return mail with all exceptions duly noted

Terms of delivery:

1. After 14 days the following holding fees are charged until return: $5.00 per week per color transparency and $1.00 per week per print.

2. Submission is for examination only. Photographs may not be reproduced, copied, projected, or used in any way without (a) express written permission on our invoice stating the rights granted and the terms thereof, and (b) payment of said invoice. The reasonable and stipulated fee for any other usage shall be two times our normal fee for such usage.

3. Submission is conditioned on return of all delivered items safely, undamaged and in the condition delivered. Recipient assumes insurer's liability, not bailee's, for such return prepaid and fully insured by bonded messenger, air freight or registered mail. Recipient assumes full liability for its employees, agents, assigns, messengers and freelance researchers for any loss, damage or misuse of the photographs.

4. Reimbursement for loss or damage shall be determined by photograph's value which recipient agrees shall be not less than a reasonable minimum of $1,500.00 for each transparency and $ for each print.

5. Objection to above terms must be made in writing within ten (10) days of this Memo's receipt. Holding materials constitutes acceptance of above terms which incorporate hereby Article 2 of the Uniform Commercial Code, and the Copyright Act of 1976.

6. Any dispute in connection with this Memo including its validity, interpretation, performance or breach shall be arbitrated in **(photographer's City and State)** pursuant to rules of the American Arbitration Association and the laws of **(State of Arbitration)** Judgment on the Arbitration award may be entered on the highest Federal or State Court having jurisdiction. Any dispute involving $1500 or less may be submitted, without arbitration, to any Court having jurisdiction thereof. Recipient shall pay all arbitration and Court costs, reasonable Attorneys' fees plus legal interest on any award or judgment.

7. Recipient agrees that the above terms are made pursuant to Article 2 of the Uniform Commercial Code and agrees to be bound by same, including specifically the above clause 6 to arbitrate disputes.

Acknowledged and accepted _____

PHOTOGRAPHIC DELIVERY MEMO

courtesy: Photography for Industry/Charles E. Rotkin

PFI Photography for Industry
850 Seventh Avenue, New York, N.Y. 10019
212-PLaza 7-9255 Cable: Photoindus

PACA
MEMBER PICTURE AGENCY COUNCIL OF AMERICA, INC.

YOUR ATTENTION PLEASE!

NO:

DATE:

WE WOULD APPRECIATE YOUR PAYING
SPECIAL ATTENTION TO PARAGRAPH 3
ON THE REVERSE OF THIS FORM. These
fees will be charged unless you contact us
in ADVANCE of the expiration date of the
free period and request an extension of time.

TO:

No. PFI #	DESCRIPTION	BLACK AND WHITE Contact Prints Series Nos. Description

BLACK AND WHITE ENLARGEMENTS
Series Size Finish Description

 PFI Photography for Industry
850 Seventh Avenue, New York, N.Y. 10019
212-PLaza 7-9255 Cable: Photoindus

TO:

PHOTOGRAPHIC DELIVERY MEMO

1) IN THE EVENT OF LOSS, DAMAGE OR DESTRUCTION OF ANY COLOR TRANS-
PARENCY LISTED HEREIN WHILE CHECKED OUT TO YOU, YOUR AGENTS,
ASSIGNEES OR CARRIERS, YOU AGREE TO PAY A CHARGE OF $1500.00 FOR
DOMESTIC (US) AND $2500.00 FOR EUROPEAN OR OTHER FOREIGN COLOR TO
COVER LIQUIDATED DAMAGES FROM LOSS OF RESALE INCOME. YOU SHALL
ALSO BE RESPONSIBLE FOR THE SAFE TRANSPORTATION AND ALL TRANS-
PORTATION COSTS OF THE HEREIN LISTED ITEMS INCLUDING SUCH PROPER
INSURANCE AS MAY BE NECESSARY.

THIS MEMORANDUM (AND THE PHOTOGRAPHS ENUMERATED HEREIN) IS NOT
CONSIDERED A BAILMENT AND IS SPECIFICALLY CONDITIONED ON THE FACT
THAT THESE ENUMERATED PHOTOGRAPHS ARE RETURNED SAFELY TO US
IN THE SAME CONDITION AS RECEIVED FROM US.

2) In the event litigation is commenced by us against you to collect any amount due
hereunder, you agree to pay us our reasonable legal fees, no less than $500.00
plus any disbursements incurred by us in connection with such litigation.

3) A MINIMUM HOLDING FEE OF $_____ will be billed on material held longer than
FOURTEEN DAYS except where PFI is given a guarantee of usage at a mutually
agreeable fee or where other specific arrangements are made in writing at the time
of delivery of these photographs. AFTER FOURTEEN DAYS an additional charge of
$1.50 per day per photograph will be made until the photographs are returned to us.

4) A SERVICE CHARGE OF $_____ will be billed on material requested but not used
unless prior arrangements are made to waive this charge.

5) DAMAGES to transparency mounts caused by re-labeling or mis-handling will be
charged at the rate of $10.00 per mount. Damage to black and white prints caused
by mis-handling will be charged at the rate of $5.00 per contact sheet and $15.00
per 8" x 10" enlargement. Damage to color prints, color screens or other graphic
materials will be charged for commensurately. In the event that a transparency is
lost after engraving, then all separations both continuous tone and screened and all
other related graphic arts materials shall be turned over to us by you and/or your
printers and engravers and shall become our property at no cost to us whatsoever.

6) REPRODUCTION RIGHTS GRANTED: Only those reproduction rights which are spe-
cifically invoiced are granted. All other rights are reserved. No promotional or
advertising rights are granted when pictures are released for editorial use including
reproductions of covers or dust jackets for promotional purposes. Any copyrights
secured for these transparencies shall be reassigned to us.

7) MODEL RELEASES: No model releases or other releases exist unless such exis-
tence is specified by PFI. Licensee shall indemnify PFI against any and all such claims
arising out of the use of any photographs unless the existence of such releases is noted.

8) Delivery and retention of the listed items shall constitute your acceptance of the
within terms.

ACCEPTED BY _____ AS AGENT FOR _____

APPENDIX 5
INVOICE/LAB PRINT ORDER FORM

courtesy: Photography for Industry/Charles E. Rotkin

pfi

Photography for Industry • 850 Seventh Avenue, New York, N.Y. 10019 • PL-7-9255; Cable: PHOTOINDUS

To:

Ship to:

via:

№ 10057

SERIES	CUST. P.O. #	DATE:	TERMS: NET CASH

QUANTITY	DESCRIPTION	UNIT PRICE	AMOUNT
	This is a four-part form; the top copy goes to the client; the second copy goes to Photography For Industry's accounting department with vouchers and is returned for alphabetical file after processing; the third copy is kept as a record of permanent numerical sequencing; and the last copy is for the job file folder. The form is perforated and only the upper portion is sent to the client. Please note the trade association logo (PACA) and the permanent notice of rights reservations. The service this form provides is that it allows original invoicing and lab orders to be completed at the same time, with matching information, thus guaranteeing the accuracy of invoices.		

ALL OTHER RIGHTS RESERVED. All transparencies and other loaned graphic materials must be returned in good condition. A copy of the work, tearsheet or photocopy of the usage must be supplied. Sale of rights shall not be deemed final until same is received.

MEMBER **PACA** PICTURE AGENCY COUNCIL OF AMERICA, INC.

Photography for Industry
850 Seventh Avenue, New York, N.Y. 10019, Tel. PL 7-9255

LABORATORY PRINT ORDER № 10057

Ship to:

VIA:_____ DATE:_____

Spotting: Yes_____ No _____

Credits: PFI Rotkin ☐
 PFI_____

Ordered

By_____

DELIVER BY:

Special Instructions:

QUAN.	SER.	NEG. #	SIZE	FINISH	QUAN.	SER.	NEG. #	SIZE	FINISH

APPENDIX 6
SUGGESTED ADULT
RELEASE FORM
courtesy: ASMP

Adult Release

In consideration of my engagement as a model, and for other good and valuable considera-
tion herein acknowledged as received, upon the terms hereinafter stated, I hereby grant
_____, his legal representatives and assigns, those for whom
_____ is acting, and those acting with his authority and
permission, the absolute right and permission to copyright and use, re-use and publish, and
republish photographic portraits or pictures of me or in which I may be included, in whole or in
part, or composite or distorted in character or form, without restriction as to changes or alterations,
from time to time, in conjunction with my own or a fictitious name, or reproductions thereof in
color or otherwise made through any media at his studios or elsewhere for art, advertising, trade, or
any other purpose whatsoever.

I also consent to the use of any printed matter in conjunction therewith.

I hereby waive any right that I may have to inspect or approve the finished product or products or
the advertising copy or printed matter that may be used in connection therewith or the use to which
it may be applied.

I hereby release, discharge and agree to save harmless _____,
his legal representatives or assigns, and all persons acting under his permission or authority or those
for whom he is acting, from any liability by virtue of any blurring, distortion, alteration, optical
illusion, or use in composite form, whether intentional or otherwise, that may occur or be produced
in the taking of said picture or in any subsequent processing thereof, as well as any publication
thereof even though it may subject me to ridicule, scandal, reproach, scorn and indignity.

I hereby warrant that I am of full age and have every right to contract in my own name in the above
regard. I state further that I have read the above authorization, release and agreement, prior to its
execution, and that I am fully familiar with the contents thereof.

Dated: _____

(Address)

(Witness)

SUGGESTED SIMPLIFIED ADULT RELEASE FORM

courtesy: ASMP

Simplified Adult Release

Dated:

For valuable consideration received, I hereby give _____ the absolute and irrevocable right and permission, with respect to the photographs that he has taken of me or in which I may be included with others:

 (a) To copyright the same in his own name or any other name that he may choose.

 (b) To use, re-use, publish and re-publish the same in whole or in part, individually or in conjunction with other photographs, in any medium and for any purpose whatsoever, including (but not by way of limitation) illustration, promotion and advertising and trade, and

 (c) To use my name in connection therewith if he so chooses.

I hereby release and discharge _____ from any and all claims and demands arising out of or in connection with the use of the photographs, including any and all claims for libel.

This authorization and release shall also enure to the benefit of the legal representatives, licensees and assigns of _____ as well as, the person(s) for whom he took the photographs.

I am over the age of twenty-one. I have read the foregoing and fully understand the contents thereof.

Witnessed by:

APPENDIX 8
SUGGESTED MINOR RELEASE FORM

courtesy: ASMP

Minor Release

In consideration of the engagement as a model of the minor named below, and for other good and valuable consideration herein acknowledged as received, upon the terms hereinafter stated, I hereby grant _____, his legal representatives and assigns, those for whom _____ is acting, and those acting with his authority and permission, the absolute right and permisssion to copyright and use, re-use and publish, and republish photographic portraits or pictures of the minor or in which the minor may be included, in whole or in part, or composite or distorted in character or form, without restriction as to changes or alterations from time to time, in conjunction with the minor's own or a fictitious name, or reproductions thereof in color or otherwise made through any media at his studios or elsewhere for art, advertising, trade, or any other purpose whatsoever.

I also consent to the use of any printed matter in conjunction therewith.

I hereby waive any right that I or the minor may have to inspect or approve the finished product or products or the advertising copy or printed matter that may be used in connection therewith or the use to which it may be applied.

I hereby release, discharge and agree to save harmless _____, his legal representatives or assigns, and all persons acting under his permission or authority or those for whom he is acting, from any liability by virtue of any blurring, distortion, alteration, optical illusion, or use in composite form, whether intentional or otherwise, that may occur or be produced in the taking of said picture or in any subsequent processing thereof, as well as any publication thereof even though it may subject the minor to ridicule, scandal, reproach, scorn and indignity.

I hereby warrant that I am of full age and have every right to contract for the minor in the above regard. I state further that I have read the above authorization, release and agreement, prior to its execution, and that I am fully familiar with the contents thereof.

Dated: _____

_____ _____
(Minor's Name) (Father) (Mother) (Guardian)

_____ _____
(Minor's Address) (Address)

(Witness)

APPENDIX 9
SUGGESTED PROPERTY RELEASE FORM
courtesy: ASMP

Property Release

For good and valuable consideration herein acknowledged as received, the undersigned being the legal owner of, or having the right to permit the taking and use of photographs of certain property designated as _____ does grant to _____, his agents or assigns, the full rights to use such photographs and copyright same, in advertising, trade or for any purpose.

I also consent to the use of any printed matter in conjunction therewith.

I hereby waive any right that I may have to inspect or approve the finished product or products or the advertising copy or printed matter that may be used in connection therewith or the use to which it may be applied.

I hereby release, discharge and agree to save harmless, _____, his legal representatives or assigns, and all persons acting under his permission or authority or those for whom he is acting, from any liability by virtue of any blurring, distortion, alteration, optical illusion, or use in composite form, whether intentional or otherwise, that may occur or be produced in the taking of said picture or in any subsequent processing thereof, as well as any publication thereof even though it may subject me to ridicule, scandal, reproach, scorn and indignity.

I hereby warrant that I am of full age and have every right to contract in my own name in the above regard. I state further that I have read the above authorization, release and agreement, prior to its execution, and that I am fully familiar with the contents thereof.

Dated: _____

Witness

(Address)

APPENDIX 10
SUGGESTED MODEL
RELEASE FORM

courtesy: Photography for Industry/Charles E. Rotkin

PFI **Photography for Industry**
850 Seventh Avenue, New York, N.Y. 10019
212-PLaza 7-9255 Cable: Photoindus

MODEL RELEASE

Date:_____

PFI Job #_____

FOR

Client_____

In consideration of $_____paid and other valuable consideration, receipt of which
is hereby acknowledged, I _____, hereby grant to Charles
E. Rotkin, and/or Photography for Industry, and/or their assigns, the right to
copyright, publish and use without limitation or reservation the photographs made
of me by Charles E. Rotkin and/or Photography for Industry for all lawful purposes
of advertising, publication and/or editorial usage in any media throughout the
world. I specifically waive any right of inspection or approval with respect to the
use of these photographs. I hereby release and discharge Charles E. Rotkin,
Photography for Industry, and/or their assigns, from any liability resulting
in the use of such material and for any liability for what I might deem misrep-
resentation or defamation of me due to distortion, alteration, opitcal illusion
and faulty reproduction which may occur in the development, printing, distribution,
promotion or publicity incorporating the photographs referred to herein. It is
further agreed that Charles E. Rotkin and/or Photography for Industry and their
assigns shall be the absolute owner of the photographs and all negatives, prints,
and color transparencies thereof.

I represent that I am of full age and authority and have full right to make this
release and grant the rights herein granted.

Name_____

Address_____

Social Security #_____

Parent or legal guardian if photographs are those of a minor_____

WITNESS:

SAMPLE MAP—ASSIGNMENT QUERY FORMAT

PFI Photography for Industry
850 Seventh Avenue, New York, N.Y. 10019
212-PLaza 7-9255 Cable: Photoindus

NEW YORK area representative: Judith Rothenberg
CLEVELAND--PITTSBURGH area representative:
 Mrs. Anne Metcalfe (216) ER-1-9959
CANADIAN representative:
 Anderson & Hiller, Ltd., Toronto, Can.

PHOTOGRAPHIC TRIP BEGINNING JUL 25 1980

VIA STATION WAGON⬆ PLANE____ RAIL____

PHOTOGRAPHER: **CHARLES E. ROTKIN**

Note: Travel costs to be charged only from nearest
point on route to plant location.

SUGGESTED RATES AND PRICES FOR THE PROFESSIONAL PHOTOGRAPHER

courtesy: ASMP

ASMP
Assignment Photography

Publicity & Promotion (Assignment Rates, excepted as noted)

In General (Basic Newspaper Press Kit)	250-300	300-350	600-750+
Short Duration* (Newspaper/Press Kit, under 2 hours) In Studio	150	150-175	200+
On Location	150-200	250-275	300-350+
Motion Picture Special (Day Rate)	250-300	350-450	500-600+
Senior Executive Portraits (Public Relations sittings)	300	500-750	1000-1500

Audio Visual Multi Media (Day Rates)

Trade Slide Show	300-350	400-500	1000+
Educational Film Strip	250	300	400-600+

Catalogue/Brochure (Assignment or Per Shot Rates)

Covers (per version)	600-750	1250	1500-2000 (when used)
Fashion Catalogue Per Single Full Figure**	85	125-175	250-300
Per Day (usually single individual hired by major catalogue producer)	750	1250	1500-2000
Still Life Catalogue Per Single Product or Item§ (varies primarily with time required, complexity of lighting, etc.)	75	150-300	1000+ (highly complex)
Per Day (usually single individual hired by major catalogue producer)	750	1250	1500-2000
Brochure Per Day (see rates under Advertising above)			
Per Still Life* (varies with complexity as above)	75-100	150-300	1000+ (highly complex)
Per Single Full Figure** On Location	125-150	200-250	300-350
In Studio	100	150-200	250-300

*Usually for one shot usage. Fees for each additionl shot used, typically $50 to $100.

**Rates are adjusted somewhat lower for ½ views or ¼ views in fashion work. Rates are increased (nearly pro-rata) for each additional figure or item in a single shot. Per shot rates generally include the cost of nominal film and processing with all other expenses additional. With day rates, cover and much brochure work, film and processing is paid for by clients.

Please keep in mind that these are *suggested guidelines* from the ASMP, and are not necessarily the actual fees any particular assignment or stock sale will produce. These suggested rates do not, for instance, reflect a color/black-and-white differential, though such a differential still does exist in some cases.

ASMP

Stock Pictures

E. Rates

1. Advertising
a. Consumer Magazines

These are publications of general or popular interest available by paid subscription or counter purchase. For example, *Life, Cosmopolitan, Better Homes And Gardens, Newsweek, Runner's World, Modern Photography.* Circulation means the total distributed press run of the magazine and is an essential figure in determining fees for the reproduction of stock photos in ad pages.

Today, most consumer magazines offer advertisers a choice of local, regional, national or specialized editions, and a single ad may appear simultaneously in an eclectic mix of selected editions or magazines. When this happens, the circulation figure for the purposes of pricing, is generally considered to be the total of all press runs. When the ad is repeated, or used in another magazine in a subsequent time period, it is considered to be an additional insertion, and an additional fee, computed as a percentage of the original billing (see below) is charged.

Most invoices specify that the rights granted are limited to one year.

National Circulation	¼ page	½ page	¾ page	full page	double page	back cover
Over 3,000,000	$1,250	1,625	2,000	2,500	4,125	3,375
1,000,000-3,000,000	750	975	1,200	1,500	2,475	2,000
500,000-1,000,000	600	775	950	1,200	1,975	1,600
Under 500,000	425	550	675	850	1,400	1,150
Regional Circulation						
Over 3,000,000	750	1,000	1,200	1,500	2,500	2,000
500,000-1,000,000	600	775	950	1,200	1,975	1,600
250,000-500,000	500	650	800	1,000	1,650	1,350
Under 250,000	400	525	650	800	1,300	1,075
Local Circulation						
Over 500,000	500	650	800	1,000	1,650	1,350
100,000-500,000	425	550	675	850	1,300	1,150
Under 100,000	350	450	550	700	1,150	950

VARIATIONS: Insertions: 2 to 3: Space fee plus 25% Rights: One-year unlimited: Subtotal plus 200%
 4 to 10: Space fee plus 50% One-year exclusive: Subtotal plus 100%
 Over 10: Negotiable

b. Trade Magazines

A trade magazine is a publication of specific interest to a service, profession, business or industry. Circulations are generally (but not always) lower than those of consumer magazines. For example, *Advertising Age, Farm Journal, Refrigeration News, Chain Store Age.*

Again, as with consumer publications, it is essential to determine with some accuracy the circulation of the publication and the number of planned insertions. A % above the average price should be charged for each additional insertion.

ASMP

Stock Pictures

Circulation	¼ page	½ page	¾ page	full page	double page	back cover
Over 500,000	$675	875	1,100	1,350	2,200	1,800
250,000-500,000	500	650	800	1,000	1,650	1,350
100,000-250,000	450	575	700	875	1,450	1,200
50,000-100,000	400	525	650	800	1,325	1,100
20,000-50,000	350	450	575	700	1,150	950
Under 20,000	325	400	500	625	1,050	850

VARIATIONS: Additional Insertions: 2 or 3: Space fee plus 25% Rights:
4 to 10: Space fee plus 50% One-year unlimited: Subtotal plus 200%
Over 10: Negotiable One-year exclusive: Subtotal plus 100%
Buyout: Subtotal plus 500%
Reuse after 1 year: 75% of current use fee

c. Newspapers

Newspapers are daily or weekly publications which contain news, articles and features on current events, editorial opinions as well as advertising. Newspaper circulations tend to be concentrated in a particular town, city or at most, a region. Because there are few national newspapers in this country, advertisers wanting a broad coverage must buy space in a number of different papers. Often the same ad is repeated, sometimes in a different size.

A pricing system for the use of stock photographs in newspaper advertising has to be broad and flexible. The following system, used by a number of high volume stock agencies measures the ad size by ¼, ½, ¾ and full page rather than the traditional "column inch" which confuses many photographers. A flat fee, based on size and circulation, is made for the initial insertion. A smaller, additional charge is made for each time the ad is repeated, or used in an additional paper of the same circulation category, up to a total of nine times. Thereafter, the pricing goes back to a flat fee system because it is almost impossible to monitor a widely used ad.

Another form of newspaper advertising difficult to monitor is the prepared "mat" (an inexpensive paper-like engraving with space for adding the name of the local selling outlet) furnished free by manufacturers or distributors for use by local dealers. A flat fee is usually negotiated, limited by a specific time period.

Circulation	¼ page	½ page	¾ page	full page
450,000 & over First Insertion	$450	650	800	1,150
1-2 additional insertions, or papers	Plus $100 per	Plus 125 per	Plus 150 per	Plus 175 per
3-9 additional insertions, or papers	Plus 75 per	Plus 100 per	Plus 125 per	Plus 150 per
10-20 additional insertions, or papers	$1200 total flat fee	1650 total flat fee	2050 total flat fee	2650 total flat fee
Over 21 total insertions, or papers	— Negotiable —			
Circulation 200,000-450,000 First insertion	$350	500	650	825
1-2 additional insertions, or papers	Plus 85 per	Plus 100 per	Plus 125 per	Plus 150 per
3-9 additional insertions, or papers	Plus 60 per	Plus 75 per	Plus 100 per	Plus 125 per
10-20 additional insertions, or papers	950 total flat fee	1300 total flat fee	1650 total flat fee	2000 total flat fee
Over 21 total insertions, or papers	— Negotiable —			

ASMP

Stock Pictures

Circulation	¼ page	½ page	¾ page	full page
Circulation 50,000-200,000 First insertion	200	250	300	350
1-2 additional insertions, or papers	Plus 65 per	Plus 75 per	Plus 85 per	Plus 100 per
3-9 additional insertions, or papers	Plus 40 per	Plus 50 per	Plus 60 per	Plus 75 per
10-20 additional insertions, or papers	600 total flat fee	750 total flat fee	950 total flat fee	1125 total flat fee
Over 21 total insertions, or papers	— Negotiable —			

RIGHTS: one year unlimited use: Plus 200%
one year exclusive use: Plus 100%

d. Brochures & Catalogs

Brochures are advertising booklets or pamphlets. Into this category of advertising literature fall such items as flyers, handouts, mailers and folders as well as catalogs. In considering the price to be charged, one must understand the press run. That will have a great bearing on the fee.

This is a very popular form of advertising and while many runs will be in the lower range, there are many national advertisers who print in large volumes. Be certain to ask if your picture is used inside the brochure or on the cover (as an eye catcher). It is common practice in the direct mail area to purchase pictures for test runs before the "roll out" or mass mail the item. If you suspect this is a test, be certain your client is aware that additional runs mean additional fees.

For one edition, non-exclusive, one year limit:

Press Run	¼ page	½ page	¾ page	full page	double page	cover
1,000,000 & over	$450	575	700	875	1,450	1,750
500,000-1,000,000	375	500	600	750	1,250	1,500
250,000-500,000	325	425	500	625	1,050	1,250
100,000-250,000	275	350	425	525	875	1,050
50,000-100,000	225	300	375	450	750	900
20,000-50,000	200	275	325	400	675	800
Under 20,000	175	225	275	350	600	700

VARIATIONS:
Space-Wraparound cover: front cover space fee + 50% Reuse: An additional press-run: 75% of current use fee
Back cover: 75% of front cover space fee New Campaign: 100% of current use fee

ASMP

Stock Pictures

2. Corporate/Industrial

a. Annual Reports

A yearly financial statement by all public corporations as required by federal law. It becomes an important market because the financial information is usually incorporated in an elaborate big-budget publication that makes extensive use of photographs to portray the company activities in the best possible light thereby impressing stockholders, potential investors and the general business and political public. The development of the annual report as a major public relations vehicle has spawned a select group of independent corporate designers who use highly-paid freelance photographers skilled in this new industrial market.

One time, non-exclusive:

Circulation	¼ page	½ page	¾ page	full page	double page	cover
1,000,000 & over	$550	625	725	900	1,500	1,800
500,000-1,000,000	500	550	650	800	1,325	1,600
250,000-500,000	425	500	575	700	1,200	1,400
100,000-250,000	375	425	500	600	1,000	1,200
50,000-100,000	325	400	450	550	925	1,100
20,000-50,000	315	375	425	525	875	1,050
10,000-20,000	300	350	400	500	825	1,000
Under 10,000	250	300	325	400	675	800

VARIATIONS: Wrap-around cover: Front fee cover plus 50%
Back cover: Front fee cover less 25%

b. House Organs

A magazine or newsletter published by a corporation, institution, or fraternal organization. House organs by definition are generally for distribution within the employee or membership of the publishing company or group. However, in recent years, many house organs have developed external circulations as well. Be certain to clarify the circulation and distribution of the piece. If it is strictly internal, it acts as a service publication and is probably budgeted on the lower end of the scale. If the distribution is external, it acts as a promotional piece and the budget should reflect this.

External: Public Relations/one time use

Circulation	¼ page	½ page	¾ page	full page	double page	cover
100,000 & over	$350	400	475	575	950	1,000
50,000-100,000	325	375	425	525	850	900
20,000-50,000	285	325	375	475	775	850
5,000-20,000	250	300	350	425	700	750
Under 5,000	225	265	300	375	625	650
Internal: Employees only						
100,000 & over	240	275	325	400	675	700
50,000-100,000	225	265	300	375	625	650
20,000-50,000	200	225	275	325	550	575
5,000-20,000	175	210	250	300	500	525
Under 5,000	175	200	225	275	450	475

VARIATIONS: Space: Wrap-around cover: Front cover space fee plus 50-75%
Back cover: 75% of front cover space fee

ASMP

Stock Pictures

3. Editorial

a. Books

One time, U.S. English-language rights only:

	¼ pg	½ pg	¾ pg	full pg	dbl pg	covr, dst jk	wrap arnd cvr	author head shot
Encyclopedia								
Over 40,000	200	250	275	300	600	750-1,000	1,000	325
Under 40,000	175	200	225	250	500	400-600		
Text Books								
Over 40,000	160	185	210	250	500	500-750	750	
Under 40,000	135	160	180	210	420	400-600	600	
Trade Books								
Over 40,000	160	185	210	250	500	550	650	
Under 40,000	135	160	185	210	420			
Paperbacks								
Over 40,000	175	200	225	250	450	475	575	300

VARIATIONS: Unit Openers, frontispiece, etc: Space fee plus 25% Composite covers, per picture:

 ¼ page or less: 65% of full cover fee
 ½ page: 80% of full cover fee
 ¾ page: 90% of full cover fee

Revisions: 75% of current use fee

Rights: One time, U.S. English-language plus right to distribute unlimited number of that U.S. imprint edition abroad: Subtotal plus 50%

 One time world rights — one language: Subtotal + 100%
 One time rights for each additional language: Subtotal + 25%
 One time in five additional languages: Subtotal + 100%
 One time world rights — all languages: Subtotal + 200%

courtesy: ASMP

ASMP

Stock Pictures

b. Record Albums & Tapes

It is difficult, if not impossible, to price record album and tape uses simply on the basis of press run. There is no way of predicting in advance whether the album will be successful and whether there will be increased pressings and to what extent. As with other items where the success of the item is unpredictable, time limit for the use is the most reasonable pricing quotient. If you put the sale on a yearly contract, a successful press run should pay a certain % for each additional year of distribution. This sort of yearly residual fee should protect your rights if the item is successful.

Either album or tape. If both, add 50%

Cover — front:	$450-750
Cover — back:	325-600
Cover — wraparound:	850-1,150
Enclosures (booklets, etc.):	200-450
Test only:	275-425

c. Magazines, Newspapers, TV

Generally, the uses in these fields are determined by the uniqueness of the photograph, the current costs to duplicate the photograph by assignment, and whether the use is journalistic in nature or editorial-illustration.

One time U.S. English language:

Magazines:

Circulation	¼ page	½ page	¾ page	full page	double page	cover
3,000,000 & over	$405	$475	$540	$675	$1,115	$1,185
1,000,000-3,000,000	330	385	440	550	910	965
500,000-1,000,000	255	300	340	425	705	745
250,000-500,000	210	245	280	350	580	615
under 250,000	180	210	240	300	495	525

Sunday Supplements:

	¼ page	½ page	¾ page	full page	double page	cover
3,000,000 & over	360	420	480	600	990	1,050
1,000,000-3,000,000	300	350	400	500	825	875
under 1,000,000	225	265	300	375	620	660

Daily Newspapers

	¼ page	½ page	¾ page	full page	double page	cover
over 250,000 (considered major papers)	255	300	340	425	705	745
under 250,000	165	195	220	275	455	485

TV Editorial Use (average screen exposure):

National use:	$250
Regional use:	$150
Local Use:	$140

Caution: A number of major U.S. publications have business arrangements with franchised foreign editions (look-alike names and format, but foreign owned and managed) whereby editorial material published in the U.S. edition is "available" at very attractive rates. Be careful to specify on your invoice exactly which rights you are granting, and examine carefully the terms and conditions on purchase orders and payment checks.

ASMP

Stock Pictures

4. Miscellaneous

a. Greeting Cards

Considerations involved in establishing prices range from the uniqueness of the photograph to the size of the card to the press run to the fees for model or property releases.

U.S. Rights, Specified Press Run, 2-year Limit:

Greeting cards, retail:	$225-425
Greeting Cards, advertising or promotion:	300-625

World Rights: Add 50%

b. Puzzles

Considerations for pricing involve uniqueness of photograph, the puzzle size, the retail price and the press run.

Standard sizes, Average press run

U.S. Rights:	$375-525
World Rights:	500-700

c. Murals

Considerations for pricing involve uniqueness of photograph, location of mural (e.g., lobby of modern downtown business building compared to small company sales office), time duration (two-week trade show compared to permanent decor installation).

Single mural (6' x 8'):	$550-2,500
PhotoWall, retail:	750-2,000

Note: Prices vary widely because of the wide range of possible sizes, locations, purposes, etc. Some photographers establish a base fee for the 6'x8' size, plus a per-square-foot charge for anything larger. Others inspect the location, then negotiate.

d. Framed Reproductions

U.S. Rights, Non-exclusive, 15,000 press run: $375, or royalty basis: 10% of retail.

e. Exhibit Prints

16" x 20" size

1 showing:	$275
2 to 3 showings:	425
4 or more showings:	575
single in-house showing only:	225

For variations, the following percentages are charged:

20" x 30": Base price + 15-20%
30" x 40": Base price + 35-40%
larger size: class as murals
11" x 14": 85-90% of Base Price

f. Educational Study Prints

16" x 20" size

20,000 and over press run:	$425
5,000-20,000:	375
under 5,000:	325

For variations, the following percentages are charged:

20" x 30": Base price + 10-15%
30" x 40": Base price + 35-40%
11" x 14": 85-90% of Base Price

g. Decorative Fine Prints

16" x 20" size

Personal home use:	$220
Office and business use:	285
Public locations:	375
(stores, lobbies, etc.)	

For variations, the following percentages are charged:

20" x 30": Base price + 20-25%
30" x 40": Base price + 50%
11" x 14": 85-90% of Base Price

Note: Protect the copyright. Historic and "name" photographers are highly rated in the growing collectors market. A higher value is placed on a photograph printed personally by the artist, dated and signed. Laws of supply and demand apply. The above Base Prices are those reported primarily by stock agencies which probably reflect the average market more accurately than individual photographers.

GLOSSARY

Advance. Payments made to a photographer in advance of final billings. Can be applied to fees, expenses, or royalties.

Art. An old newspaper term for any graphic material (photograph, drawing, etc.) that is published.

Canadian Rights. In book publishing, usually 25% in addition to the *United States English Language Fee* for each language, whether English or French. If the book is to be published in Canada, without its primary distribution in the United States or the United Kingdom, the *First Publication Rights* apply.

Closings. The times set for the last bits of material to go into any publication before printing.

Cold Type. Type not made by the hot metal process. Frequently used for hand-made display or presentation to avoid costly machine typesetting.

Comp. An abbreviation for the term "composite," generally used in advertising. An art director will usually prepare a comp as a sample visualization of what an ad is supposed to look like when finished. Illustrations used will either be sketches or photographs taken from other publications. In some cases, ADs will rent or lease photographs from a photographer or an agency for comp purposes, for which only a small fee will be paid. However, the leased photo usually will not be used in the final layout.

Credit Line. Identification of the artist or photographer whose work is reproduced.

Delivery Memo. A form used by photographers or stock photo agencies enumerating the terms and conditions under which the stock photograph is made available to a potential user.

Demographics. A system of sales market analysis of any given area that takes into consideration economic status, and social and family patterns for product marketing.

Double Truck. A term used by magazines for one photograph that covers two full, facing pages.

Droit de Suite. Rights that follow. Legal protection of artists in Europe, particularly in France, where the artist or his estate has an on-going right to revenues in the continuing sale of his work.

Edition (of a Book). This is an often disputed term, and can mean different things to different publishers. Generally, one edition is any number of copies printed and distributed without either illustration or copy changes (see *Press Runs*). If a book is revised or changed, it should be marked as a Revised, or New, Edition, and certain fees and rights are chargeable (see *Revisions*). Where disputes frequently start is when a publisher puts the same work back on press, changing only the copyright date. This is done so their sales people can claim: "a new edition . . . see the copyright date?" However, in such cases, publishers frequently object to paying revised edition fees. Because of this problem there is a growing trend on the part of picture suppliers to put cut-off dates on all permissions, regardless of the number of printings a book has or the number of flat sheets in storage. Discuss this with your stock picture agency, if you have

one, or whatever professional society you may belong to.

ENG (Electronic News Gathering). A form of video taping for broadcast use. Now being applied to the innovative tape/still cameras that are putting together and processing images electronically rather than by conventional silver-sensitive methods.

First Publication Rights. Simply the first right of publication in any medium. Fees to be negotiated as an original work.

Foreign Language Rights. If a book is printed in one language for primary distribution (i.e., in English for the United States), and the publisher wants to produce a copy simultaneously in French or German, then each additional language is paid for at 25% of the United States English Language rights fee. The number of permitted languages vary within the trade. Some publishers will pay 25% for each language up to four, and some 25% for each language up to eight. It is up to the photographer or agency to negotiate the best deal possible.

Hot Metal. System of setting type by machine involving the casting of molten lead into type faces for printing. The line of type is usually called a *slug*.

Keystoning. A "keystone" shape to a print (or transparency) occurs when copying a painting or other flat art work if the camera lens is not set at the center of the painting and the film planes of the copying camera are not exactly parallel to the art work.

Out-Take. Usually the close duplicates from a shooting (or *take*) that may be of acceptable technical quality but are not finally chosen for reproduction because of a slight difference in content. Out-takes are often held by a publisher until a publication is actually closed. Some publishers try and hold not only the reproduction transparencies, but also the near dupes to prevent their falling into the hands of competing publications. The photographer should watch his rights agreement on this practice where applicable.

Page Rates. System of payment by magazines that sets a rate for an entire page of reproduction of a photograph(s) and pays on a proportional rate for the space used. A minimum rate of a ¼ page for pictures covering less than a ¼ page is a trade custom.

Press Runs. In book publishing, usually the number of flat sheets of a printing form that a publisher will print of a certain publication before folding and binding. Frequently the publisher will print large numbers of flat sheets of a publication, but only bind a smaller amount pending sales and do additional binding if sales increase. There is no additional fee charged for books bound from an earlier press run.

Printings. In book publishing, publishers will frequently designate a specific print run as a first printing, second printing, and so on. Unless a fee was negotiated on a circulation basis (or number of copies printed), then fees for subsequent *printings* are not paid for, unless those printings exceed an agreed-upon limit. The ASMP generally recommends a numerical limitation on the number of printings your first fee permits, with additional payment for additional press runs.

Proofs. Printing proofs are test runs from a printing press before the actual production starts. *Color* proofs are similar but involve tests of the color reproduction. Progressive color proofs show the step-by-step progression of the color separations and the correct color inkings. Color bars are standard color tones on a proof sheet and are used for comparison with press work.

Rejects. Different from out-takes in that they are usually of inferior quality and should not be considered as part of the usable batch of photographs submitted

for editing. Sometimes these terms are used interchangeably, but rejects should really be classified as technically unacceptable.

Releases. A written instrument giving a photographer or publisher the right to use a photograph containing the likeness of the person photographed. May be needed for privately owned buildings as well.

Revisions. In book publishing, when the book is restructured to include new photographs or changes of scale in a given picture, then this is considered a *major* revision. The usual fee for a major revision is approximately 75% of the current price schedule. A change of title or marketing grade for text books is considered to be a new book and not a revised book, regardless of the scope of the changes. When the revisions are *minor* (small text changes or occasional repositioning of the same picture without changes in size or importance of placement), usually a 25% revision fee, based on *current* prices, is charged. This should also cover the category of copyright date changes without substantial revisions of the pictures or copy content. One publisher defines a minor revision in textbooks as being if two members of the same class can use the previous and revised books side by side with the material appearing on the same page numbers.

Royalties. A system of payments by publishers to authors. Usually based on a percentage of the list price of a book or, in some cases, a percentage of the gross amount received by a publisher for sales.

Screen Engravings. Used in half-tone reproduction of photographs or art work. A fine screen is interposed between the copy and the sensitized materials to break up the images into dot patterns so that the ink will not run or smudge.

Secondary Rights. All rights to a photograph that exist after the primary rights have been disposed of.

Space Rates. A payment schedule, usually set by magazines or other publications using the magazine format for payment based on an allocated sum for each page. Payments are frequently made to the proportion of space used but the minimum charge is usually for a ¼ page even though the illustration may be smaller.

Spread. Two facing pages of a magazine, newspaper, or book. Can contain a single photograph, or a group of them including text and/or captions.

Stock Photo. Existing photographs that are available for reproduction from a photo library or other picture collection, such as an agency.

Syndication Service. News and photo organizations who distribute existing stories (or even single photos) to magazines and newspapers. Some of the syndication groups are owned by the parent press company of the publications concerned.

Tearsheet. An actual page from a publication that has a photographer's (or writer's) material printed on it. Used by photographers and writers for promotional purposes when large quantities can be acquired.

Trade Books. Books sold "to the trade," that is, through regular book stores.

United States English Language Rights. For use in one edition of a specific publication for distribution in the United States and its possessions in the English language. Minor distribution of individual copies outside of the U.S. is not objected to, but primary distribution is for the United States only.

World Rights/One Language Only. Usually charged to most publishers at a fee of 100% additional to the United States English Language Rights.

World Rights/Multiple Languages. Usually charged at a fee of 50% for each additional language with the four and eight language limitation as described in *Foreign Language Rights*.

INDEX

Abbott, Berenice, 240–242
Adams, Ansel, 260
Adams, Eddie, 217–218
Advances, 130, 167
Advertising photography
 building release in, 229–230
 creative input in, 68, 72, 73,
 135
 directories for, 20–21
 fees and rates in, 69–70, 75,
 111, 127–129
 advances, 130
 hierarchic structure and, 67–68
 picture buyers for, 19, 72
 portfolios in, 73, 86
 reps in, 69, 74–75
 reproduction rights in, 196–197,
 212, 215
 reshooting in, 165
 team, 152
Aerial photography, insurance cov-
 erage for, 222
Agency. See Picture agency
Agents. See Reps
Airline magazines, 34
Airline travel, X-ray problem in,
 140–141
Allen, Casey, 273–274
American Society of Magazine Photog-
 raphers (ASMP), 16, 24, 109,
 110, 112, 118
Annual report photography, 57, 59, 87
 secondary rights in, 211
Architectural photography, 101–107
Arrington v. The New York Times,
 227–228
Art directors
 editorial, 36, 39–41
 listing of, 22
 portfolio screening by, 95–97
Billings, 75
 expense validation in, 190–192
 for models, 63
 rep in, 203
 for reproduction rights, 196–197,
 214–215
See also Fees and rates
Black-and-white photography
 chromogenic technology in, 250–251
 prices of, 109
 processing of, 249–251
Book publishing
 billing in, 203
 classifications of, 52
 of monographs, 52–53, 194–195
 picture buyers in, 19, 56–57
 picture research in, 47–50

self-help books in, 54
 textbooks in, 54–56
 trade market in, 52–54
Books, on photography, 274–279
Brun, Renee, 44–45
Budget discussion
 on assistants and models, 125–126
 on equipment, 123–124
 on field expenses, 122–123
 items in, 119
 on materials-processing costs,
 124–125
 on overhead, 120–121
 payment schedule in, 130–131
 of time estimates, 121–122
 usage specification in, 126–130
Building releases, 229–230

Camera(s)
 air travel with, 140–141, 247
 attributes of, 140
 basic, 243, 244
 insurance of, 220
 maintenance of, 247
 mechanical capability in, 246
 view, 246–247
 See also Equipment
Camera clubs, 258–259
Capa, Cornell, 9, 264, 265, 272–273
Caption information, 45, 49, 175–
 176, 186–187, 199
Chromogenic technology, 250–251
Collection methods, 224–225
Color photography
 delivery preparations in, 183–185
 prices of, 109
Commercial photography, 64–65
 fees and rates in, 129
 public relations, 65–67
 See also Advertising photography
Considine, Suzanne, 45–47
Copyright
 defined, 232–233
 duration of, 233
 law, 106, 187, 196, 235–238
 registration of, 234–235
 for large groups, 238–239
 right to, 233–234
Corporate photography
 annual reports in, 57, 87
 company photographer and, 147, 149
 directories for, 20–21
 house organs in, 58–59
 picture buyers in, 19, 59–60
 for public relations programs,
 57–58
 reproduction rights in, 129–130, 211

Darkroom equipment, 251–252
Day rate, 106–107, 110–111
Delivery memo, 131
Despard, Caroline, 43–44
DocuAmerica project, 118
Documentary photography, 153–154,
 230, 277

Drapkin, Arnold, 12–14
Dry-mounting, 88–89

Editorial photography
 deadlines in, 169–170
 film editing in, 182–183
 picture buyers in, 18–19, 32–33,
 35–39, 56–57, 59–60
 portfolio for, 85–86
 staff positions in, 16
 vs studio photography, 15–16
 See also Specific types
Eisenstaedt, Alfred, 27–30
Equipment
 basic, 243–246
 budgeting for, 123–124
 darkroom, 251–252
 failures in, 161–162, 165
 insurance of, 220, 221
 motorized, 47
 in preplanning, 139–141
 rental of, 123, 248–249
 repair of, 248
 security for, 247
 shipping of, 138–139, 140, 247
 simplicity of, 246
 studio, 252
 used, 246–248
Expenses
 records of, 188–189, 190–191
 repayment of, 130

Family Circle, 38
Farm Security Administration (FSA),
 picture files of, 116–117, 118,
 153, 281–282
Fashion photography, 74
 model in, 62–63, 76–77
 outlets for, 61
 preplanning in, 62
 portfolio for, 87
 team approach in, 61–62
Faulkner, Douglas, 273
Federal Artists Project, 241
Fees and rates
 in advertising, 69–70, 75, 127–128
 for bulk sales, 119
 color-black-and-white differen-
 tial in, 109
 expenses in, 188–189, 190–192
 vs free system, 115–119
 guidelines for, 108–109, 112
 intended usage and, 126–127
 page and day, 106–107, 110–111
 in portrait photography, 136
 reduced, 112–115
 for secondary uses, 211–213
 See also Billing; Budget discuss-
 ion; Payment
Fernandez, Ben, 256–259
Field work. See Location
Filing system, 198–200, 253
Film
 in air travel, 140–141
 editing, 182–183
 insurance of, 220

logging system for, 180–181
 portfolio in, 91
 processing of, 176, 181–182
 sizes, 243
Fine-arts photography, 155, 156
 academia and, 264, 271–273
 critical reviews of, 261–262
 exhibit outlets for, 261, 265–266
 personal, 266–267
 in galleries, 260–261, 263–264
 income from, 263, 265
 personal style in, 264–265
 picture buyers in, 19
 in traveling shows, 267–268
Forscher, Marty, 140, 246–248
Foundations grants, 268–269
Franznick, Phil, 72, 73–75
Freedman, Jill, 193–195
Free photographs, 78–79, 115–119, 230

Galleries, 260–261, 262, 263–264
Geo magazine, 39–40
Government
 free photograph distribution by,
 116–117
 publishing by, 80
Gravure printing, 172

Halsman, Philippe, 286–289
Health insurance, 222
Heyman, Ken, 264–265
Hoban, Tana, 70–71
Hoepker, Thomas, 39–41
Holding fees, 131–132
Housing, on location, 139

Insurance coverage, 142–143, 219–223
Intaglio, 172
International Center of Photography
 (ICP), 264, 265–266, 272
Interview
 follow up to, 98–100
 personal appearance in, 93–94
 presentation in, 41, 46, 75, 93–
 94, 95
Invasion of privacy, 226–227, 230–231
IRS, audit by, 189–190, 191

Johnson, Jill, 76–77

Kunhardt, Philip B., Jr., 81–82
Kupferberg, Stella, 56

Laboratory
 outside, 181–182
 setting up of, 250–252
 staff for, 253
Lange, Dorothea, 10
Law, photography and
 collection process in, 224–225
 harrassment and, 223
 insurance coverage and, 219–223
 lost and damaged work and, 231–232
 releases in, 225–231
 See also Copyright
Leasing memo, 131
Letterpress system, of reproduction,
 170–171

Life magazine, 16, 37, 41, 155
 Eisenstaedt on, 28–29, 30
 equipment inventory of, 123
 film editing on, 182
 masthead of, 35–36
 Parks on, 285
 photographic assignments on, 42–43
Lighting, portable, 245
Literary Market Place (LMP), 20
Location
 company photographers on, 147, 149
 contacts on, 145–146, 148–149, 157–158
 crew on, 125, 159–160, 222–223
 equipment and supplies on, 139–141
 expenses on, 122–123
 insurance coverage on, 142–143
 medical emergencies on, 144–145
 models on, 125–126
 permits on, 141–142
 personal behavior on, 51–52, 149–152
 preshooting preparation on, 158–159
 safety standards on, 143–144
 team on, 151–152
 travel and housing on, 138–139
Loengard, John, 41–43
Logging system, 180–181, 188
Look, 154–155, 182

McLaughlin-Gill, Frances, 61–63
"Made for hire", 234
Mailers, 92–93, 135–136
Masthead, job responsibilities on, 35–39
Mathews, Margaret, 48–50
Magazine Industry Market Place (MMP), 20
Magazine markets
 evaluation of, 50–51
 types of, 33–35
Magazine photography
 architectural, 104
 fees and rates in, 106–107, 109, 110, 111
 news picture agencies in, 205–207
 picture buyers in, 35–39
 portfolio for, 85–86
 reproduction in, 107, 171
 staff relations in, 39–50
Medical trade magazines, 51
Michals, Duane, 265
Models, 62–63, 76–77
 on location, 125–126
 for portfolio shooting, 76, 87
Money magazine, 45–46
Morse, Ralph, 30, 244–246
Mounting
 of portfolio materials, 88–89
 of transparencies, 184
Museums, photography exhibits in, 25
Mydans, Carl, 116, 117, 177–179

National Press Photographers Association (NPPA), 16, 24
Negatives
 crop information on, 181
 insurance of, 221

ownership of, 129, 213
 protection of, 185–186, 254–255
Newman, Arnold, 25, 134–137
Newspaper markets
 directories on, 20
 types of, 31–32
Newspaper photography
 picture buyers in, 32–33
 portfolio for, 85
 press accreditation for, 85
 reproduction system in, 170–171, 172
News syndicates, stock sales to, 205
Newsweek, 37
New York magazine, 38–39
Nonprofit groups, fees and rates for, 114

Offset printing, 171, 172
Overhead, 120–121
Overshooting, 174–175

Page rate, 106–107, 110
Parade, 155
Parks, Gordon, 9, 12, 260, 280–285
Payment
 reproduction rights upon, 132–133
 schedule for, 130
 for secondary uses, 211–213
 slow, 224–225
Permits, 141–142
Photographers
 books for, 274–279
 contemporary, 12–14, 29–30, 47, 49–50, 155, 156, 178–179, 242, 259, 273–274, 284, 288–289
 earnings of, 25–25
 editing by, 182–183
 education of, 242, 257–258, 259, 264
 continuing, 269–274
 exposure of, 17–18
 field behavior of, 51–52, 149–151
 grants to, 268–269
 home base of, 249–255
 initial contacts by, 94–95
 in "new" picture agencies, 206
 presentation by, 41, 46, 75, 93–94, 95
 professional opportunities for, 14–16, 41, 42, 71, 74, 78–79, 218
 professional organizations of, 24–25
 psychological block in, 160–161
 qualities of, 9, 10, 13, 30, 44, 72
 scope of, 8–9
 specialization of, 156
 story ideas by, 36, 38, 44, 50–51, 81–82, 98–100
 subject relaxation by, 161
 as writers, 34–35, 40, 44, 278
 See also Specific subjects
Photographic assignment
 client approval on, 146–147
 deadline of, 169–170
 insurance coverage in, 221–222
 investigative *vs* straight-forward approach to, 145–146
 on-the-spot decisions in, 162–164

preshooting contingencies in, 157–160
problem situations in, 161–162,
 164–169
productivity of, 174–175
releases in. See Releases
reproduction rights in, 129–130,
 132–133, 137, 187–188, 196–197
subject cooperation in, 147, 148
tax deductions in, 189–190
written confirmation of, 133
See also Location
Photographic reproduction
requirements for, 172–173
systems of, 170–172
Photography markets
free and low budget, 78–79
picture buyers in, 18–19
publications on, 19–23
See also Specific types
Picture agency(s)
magazine, 205–207
representation by, 204
stock sales to, 207–211
textbook sales by, 54
Picture Agency Council of America
 (PACA), 210–211, 225
Picture buyers, 18–19
in advertising, 72
in book publishing, 56–57
in corporations, 59–60
holding fees for, 131–132
interview with, 93–94, 95
on magazines, 35–39
on newspapers, 32–33
Picture editors, 36, 39, 45, 166
Picture research, 47–50
Polaroids, for test purposes, 146–
 147, 161
Popular Photography, 44
Portfolio, 73, 75, 83
film, 91
format and presentation of, 88–91
mailing of, 97–98
photographer-model teams for, 76, 87
screening of, 95–97
selection criteria for, 84, 92
for specific markets, 85–87
Portrait photography, 111, 136–137
Postcard market, 78
Poster market, 78
Press cards, 85
Prices. See Fees and rates
Prints
borders on, 173
numbering of, 181
protection of, 185–186
sample, 185
sizing of, 172–173
spotting, 173
Private property, in advertising
 photography, 229–230
Professional courtesy, reduced rates
 in, 114–115
Publicity rights, release for, 228–229
Public relations photography, 21–22, 65–67, 87

Releases
building
editorial context and, 230
for minors, 231
model, 173–174, 225–228
for publicity rights, 228–229
in secondary use, 216
Reproduction rights, 129–130, 187–188
billing for, 214–215
negative retention in, 213
on payment, 132–133
in portrait photography, 137
sale of, 211–214
client protection in, 215–216
Reps
in advertising, 69, 74–75
agreement with, 202–204
agency, 204
listings of, 202
in stock sales, 204
Retakes, 164–167
Rothstein, Arthur, 153–156
Sargeant, Peggy, 182
Secondary use. See Reproduction
 rights
Service charges, 132
Smithsonian, 37–38, 43
Special report market, 77
Speculative photography, 112–114
Spotting, 173
Stettner, Bill, 68–70
Stock sales
file system for, 198–200, 208
to newspaper syndicates, 205
ownership in, 187
to picture agencies, 205–211
to wire services, 205
Stoller, Ezra, 101–107
Story ideas
in advertising, 98
for magazines, 36, 38, 44, 50–51,
 81–82, 99–100
in portfolios, 85–86
in public relations, 66–67
Studio, 74, 252
photography, 15–16, 25
Stryker, Roy, 116, 153–154, 178, 281
Sygma Photo News Agency, 205–207
Taubin, William, 71–73
Tearsheets, 88–89, 99
Textbook photography, 54–56
Thornton, Gene, 261–263
Transparencies
labeling of, 184–185
lost and damaged, 231–232
mounting of, 184
original, 183–184
protection of, 185–186, 254–255
Vanity press, 53, 155
Wire services, stock sales to, 205
Work-for-hire agreements, 106, 187
Workman's compensation, 222
Workshops, 270